CARLETON E. WATKINS

Photographer of the American West

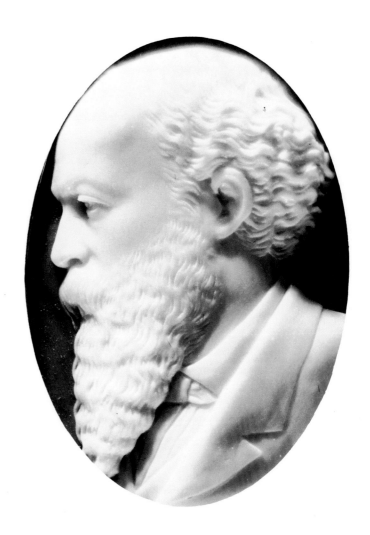

Carleton E. Watkins, P. Mezzars, cameo, c. 1868–1869.
Copy print in the collection of Yosemite National Park.

CARLETON E. WATKINS

Photographer of the American West

Peter E. Palmquist
Foreword by Martha A. Sandweiss

Published for the
AMON CARTER MUSEUM
by the
UNIVERSITY OF NEW MEXICO PRESS
Albuquerque: 1983

© 1983 by the Amon Carter Museum of Western Art, Fort Worth, Texas.
All rights reserved.
Manufactured in the United States of America.
Library of Congress Catalog Card Number 82-24824.
International Standard Book Number 0-8263-0659-4.
FIRST EDITION.

Carleton E. Watkins: Photographer of the American West accompanies an exhibition of the same title organized by the Amon Carter Museum with the co-operation of The St. Louis Art Museum, and on view at the Amon Carter Museum from April 1, 1983 to May 22, 1983; the Museum of Fine Arts, Boston, June 15, 1983 to August 14, 1983; The St. Louis Art Museum, September 15, 1983 to October 30, 1983; and The Oakland Museum, December 16, 1983 to February 19, 1984.

The exhibition is partially funded by a grant from the National Endowment for the Arts, Washington, D.C.

Library of Congress Cataloging in Publication Data

Palmquist, Peter E.
 Carleton E. Watkins, photographer of the American West.

 Catalog of an exhibition sponsored by the Amon Carter Museum and three other museums, held Apr. 1, 1983–Feb. 19, 1984.
 Bibliography: p.
 Includes index.
 1. Photography, Artistic—Exhibitions. 2. West (U.S.)—Description and travel—Views—Exhibitions. 3. Watkins, Carleton Emmons, 1829–1916. I. Watkins, Carleton Emmons, 1829–1916. II. Amon Carter Museum of Western Art. III. Title.

TR647.W37 1983 779'.9978 82—24824
ISBN 0-8263-0659-4

CONTENTS

ACKNOWLEDGMENTS

ASSEMBLING A RETROSPECTIVE EXHIBITION of the work of a photographer as prolific as Carleton E. Watkins is a difficult task. This catalogue and the accompanying exhibit would have been impossible without the generous assistance and support provided by collectors, scholars, and institutions across the country.

For their generous assistance in providing information and for graciously consenting to lend to this exhibition we are grateful to the following individuals and institutions: John Buechler, Bailey/Howe Library, University of Vermont; Lawrence Dinnean and William M. Roberts, The Bancroft Library, University of California, Berkeley; Gordon L. Bennett, Kentfield, California; Douglas M. Haller, Bruce Johnson, Martha Kennedy, Waverly Lowell, and Laura O'Keefe, California Historical Society; Teresa Bodine, Gary F. Kurutz, and Richard Terry, California State Library; Catherine Evans, Phyllis Lambert, Marjorie Munsterberg, and Richard Pare, Canadian Centre for Architecture; George H. Dalsheimer, G. H. Dalsheimer Gallery Ltd.; Jeffrey Fraenkel, Fraenkel Gallery; Pierre Apraxine and Lee Marx, Gilman Paper Company Collection; Elizabeth Shaw and Otto T. Solbrig, Gray Herbarium of Harvard University; Jerald C. Maddox and Bernard F. Reilly, Library of Congress; Jonathan Heller and George N. Scaboo, The National Archives; Craig Bates, Jack Gyer, and Mary Vocelka, National Park Service, Yosemite Collection; Scott Miller and Dorothy Paulsen, Nevada State Museum; Thomas Curran and Therese Heyman, Oakland Museum; John McCullough, Muriel Cummings Palmer, and Mr. and Mrs. William R. Scott, The Park-McCullough House; Susan Seyl, Oregon Historical Society; Van Deren Coke and Dorothy Martinson, San Francisco Museum of Modern Art; Grace C. Baker and J. Roger Jobson, Society of California Pioneers; Jonathan Stein, New

York City; Hilda Bohem, University Research Library, University of California, Los Angeles; Dennis Anderson, Historical Photography Collection, University of Washington Libraries; Ellen M. Murphy, American Geographical Society Collection, University of Wisconsin, Milwaukee; and Daniel Wolf, Daniel Wolf, Inc.

Many others have also provided critical support for this project, and our appreciation is extended to: James Abajian, George V. Allen, Wallace Beardsley, Marilyn Blaisdell, Bekah Burgess, Alma Compton, J. Robert Davison, Ann Fabian, David Featherstone, Louise Fielder, Dr. Robert Fisher, Pauline Grenbeaux, Alan Jutzi, Dr. Ronald H. Limbaugh, Glenn Mason, Pam Mendelsohn, George Miles, Delores M. Morrow, Anita Mosley, Weston Naef, Russell Norton, Blanche Palmquist, John Palmquist, Terence R. Pitts, Shirley Sargent, Nanette Sexton, Paul T. Shafer, Sarkis Shmavonian, Alma F. Slawson, Louis Smaus, Richard Street, Susan Stromei, Julia Van Haaften, Sam Wagstaff, John Waldsmith, Robert Weinstein, and Janet Zich.

Richard Rudisill, Curator of Photographic History at the Museum of New Mexico, deserves special thanks for his role in bringing us together to work on this project and for giving careful and critical readings of early manuscript drafts.

James D. Burke, Director, and Thomas Costello, Director of Development, at The St. Louis Art Museum provided crucial assistance in raising funds for this project. For their assistance in arranging the traveling schedule for this exhibition we are indebted to them and to Judith Weiss of The St. Louis Art Museum, Clifford Ackley of the Museum of Fine Arts, Boston, and Thomas Curran and Therese Heyman of The Oakland Museum. Patricia Cadigan Tucker of The St. Louis Art Museum also provided valuable help in arranging for exhibition publicity.

At the Amon Carter Museum, thanks are due to Jan Keene Muhlert, Director, who has supported this project from the beginning. Special credit should go to Carol Roark, Assistant Curator of Photographs, who handled the permission requests for this book and skillfully attended to many other administrative details of the exhibition. The manuscript of this book has benefited from the suggestions of Ron Tyler, Assistant Director for History and Publications, who has also assisted with the production of this catalogue. Our appreciation is also extended to Registrar Anne Adams and Assistant Registrar Melissa Thompson who efficiently handled the loans for the exhibition, and to Charlott Card, Burt Echt, and Loretta Eubanks who prepared the photographs for exhibition. Additional thanks go to George Boeck, Carol Byars, Carol Clark, Milan Hughston, and Karen Dewees Reynolds.

This exhibition is supported in part by a grant from the National Endowment for the Arts.

Peter E. Palmquist
Arcata, California

Martha A. Sandweiss
Curator of Photographs
Amon Carter Museum
Fort Worth, Texas

Curators of the exhibition

FOREWORD

CARLETON E. WATKINS devoted his life to his craft. He made his first daguerreotypes as an apprentice to the California photographer Robert Vance in 1854, and for nearly forty more years he photographed the American West with a rare energy and perspicacity. He photographed hydraulic mining operations, lumber mills, and the lavish homes of California's new grandees with the same passion he gave to his photographs of Yosemite Valley. Watkins realized that photography's particular merit was that it was at once a useful tool of documentation *and* an art. Thus, he gave equal attention and energy to all of his work: his commissioned photographs of industrial sites received no less care than the artistic landscapes he made for speculative purposes. And as the photographs reproduced here illustrate, Watkins's best images are evidence of extraordinary technical skill, and of the inventiveness and boldness of vision that establish him as one of the greatest nineteenth-century American photographers.

This book is both a catalogue for the first retrospective exhibit of Watkins's photographs and the first thorough study of Watkins's career. Previous studies have focused on limited segments of Watkins's work, particularly on the Yosemite images of the 1860s.[1] Because these photographs achieved great critical acclaim even in their own time, it is not surprising that they should have received so much attention. Moreover, they exist in greater numbers than the commissioned views printed in small or even unique editions for patrons. One of the chief results of Peter Palmquist's biographical research has been the discovery of lost and misattributed works from all phases of Watkins's career: nearly three-fourths of the plates in this book

1. For a survey of previous studies of Watkins's life and work see below, pp. 213–14.

have not been reproduced elsewhere. With this new knowledge of Watkins's work, it is now possible to reevaluate the sources of his style, his aesthetic and technical growth, and the stylistic connections between his industrial commissions and his landscape views.

From Palmquist's research we come to appreciate Watkins's exceptional energy and versatility. No longer can we accept the common view that Watkins was a master only of grand wilderness scenes and that his inventiveness peaked in the mid-1860s before crumbling under the pressures of financial difficulties and artistic fatigue.[2] The industrial photographs and architectural views shown in this exhibition and reproduced here establish Watkins's mastery of a wide range of photographic problems. Moreover, the newly discovered Yosemite views of the late 1870s and early 1880s together with examples of Watkins's later work show that his technical skills and inventiveness were long-lived. His mental stamina exceeded even his physical endurance which, as Palmquist notes, was remarkable.

Several authors have suggested possible models for Watkins's well-known Yosemite photographs of 1861, the body of work that has erroneously been called his first.[3] Certainly, as Weston Naef has suggested, Watkins may have been influenced in his choice of subject matter by the glass stereographs of natural subjects and scenic vistas by East Coast and European photographers whose work was available in Robert Vance's San Francisco studio.[4] Similarly, as John Coplans has proposed, George Robinson Fardon's methodical photographic documentation of the city of San Francisco (published in 1856) may have influenced Watkins's methodical approach to the natural splendors of Yosemite.[5] However, Palmquist's discovery of Watkins's earliest surviving paper print (a two-part panoramic salt print made of the Guadalupe quicksilver mine near San Jose in 1858, Plate 1) and the San Antonio Rancho views (Plates 6, 7), made in 1861 before Watkins went to Yosemite for the first time, suggests alternative sources for Watkins's early work in Yosemite. These views and the series of prints commissioned in 1860 to document the Mariposa Mines (Plates 3, 4, 5) provide evidence that Watkins himself had considerable firsthand familiarity with the problems involved in documenting the landscape before his first Yosemite venture.

To compose each of these early landscape commissions, Watkins had to balance specific directives from his patrons against constraints imposed by his wet-plate negatives and photographic apparatus. Watkins said that his panorama of the Guadalupe quicksilver mine, commissioned to provide court evidence in an 1858 dispute, was made from "the spot which would give the best view."[6] His comment suggests an accommodation between his patron's needs and his own desires and technical limitations. With this experience behind him he accepted the commission in 1860 to photograph "everything that contributed to income and possible future income from Las Mariposas," a project involving the systematic documentation of a large, geographically diverse area that foreshadowed his work in Yosemite the following year.[7]

2. This is a view put forth today chiefly by Weston Naef in two sources: Weston J. Naef in collaboration with James N. Wood, *Era of Exploration: The Rise of Landscape Photography in the American West, 1860–1885*, and Weston Naef, "'New Eyes'—Luminism and Photography," in John Wilmerding, ed., *American Light: The Luminist Movement 1850–1875*, pp. 267–291.

3. Naef makes this presumption in *Era of Exploration*, p. 33, and reiterates it in "Luminism and Photography," p. 270. Pauline Grenbeaux published evidence to the contrary with her discussion of the earlier Mariposa views in "Before Yosemite Art Gallery: Watkins' Early Career," *California History* (Fall 1978): 230–236.

4. Naef, *Era of Exploration*, pp. 80–81.

5. John Coplans, "C. E. Watkins at Yosemite," *Art in America* (November–December 1978): 107–108.

6. See below, p. 9.

7. See below, p. 10.

Much has been written about the importance of the nine-teenth-century federal surveys as patrons of western land-scape photography. Watkins's early work suggests, however, that litigious real estate claimants and ambitious businessmen played an early and important role in the promotion of west-ern photography. Their role might well warrant further study. As with the scientists and military men who headed govern-ment surveys, these businessmen and litigants encouraged photography of commercially unpopular views in remote places and used the resulting photographs to promote their own interests.

An understanding of the context in which these early Watkins photographs were made is crucial to an interpretation of the pictures and to an understanding of Watkins's subse-quent work. Otherwise, it is easy to be carried away in spec-ulation about formal design and aesthetic intent at the expense of more practical considerations. The straightforward com-position and bold graphic elements of [*Rock Formations, San Antonio Rancho*] (Plate 6), for example, if considered apart from the photograph's existence as a courtroom document, might seem to imply Watkins's awareness of the iconographic sig-nificance of rocks in contemporary landscape painting. Cer-tainly, the picture seems to presage the compositional bold-ness that marks his late work. In truth, however, Watkins photographed these rocks because he had to, and he photo-graphed them in a straightforward manner to convey the most information. Watkins thus discovered the potential of rocks as subjects for still-life studies by following the orders of some forgotten land surveyor, not by coming upon Yosemite's Ca-thedral Rocks, or by following Josiah D. Whitney's directions on the California State Geological Survey, or by listening to his patron Clarence King's theories of catastrophism. Simi-larly, though his picture of the lonely house in the bleak, open field at the Rancho (Plate 7) seems an artistic statement about the dismal isolation of new settlement, Watkins positioned his

camera where he did to document several lines of sight for a surveying problem. This is not to say that Watkins executed these views without care or style—each reflects his knowl-edge of how to exceed the technical limitations of his equip-ment through his eye for pictorial composition—but that he made them within the fairly rigid constraints imposed by his employers. Indeed, as Palmquist suggests, it was a frustration with the limitations of his camera for land survey photogra-phy—not a desire to capture Yosemite's grandeur—that led Watkins to order his eighteen by twenty-two inch mammoth-plate camera built for his first trip to the Valley.

Watkins had more freedom in designing the Mariposa views, and these photographs, though lacking the technical proficiency of his later work, provide a model for Watkins's subsequent series of landscape and industrial views. The se-ries combines vistas with close-ups of abstract forms; thus we have images that provide a record of the site's commercial po-tential together with photographs seemingly composed for the sheer delight of making pictures. Watkins evidently took such industrial commissions seriously, not only because he had pride in his work and needed the money, but also because these commissions supported his photographic exploration of new areas. His personal work and his commissioned work were but two parts of a single, passionate calling, and throughout his career he took advantage of subsidized trips to make photo-graphs for his own purposes.

Watkins's consistent devotion to fine craftsmanship and his splendid commissioned views of industrial and architec-tural subjects force us to reconsider any arbitrary division be-tween commercial and artistic photography. Such a distinc-tion, initiated by the Pictorialists and Photo-Secessionists at the beginning of this century and nurtured since then by many photographers, dealers, and critics, represents one aspect of twentieth-century thought that Watkins would have found hard to understand. He aggressively marketed his "artistic"

[*Coast View* #1], albumen silver print, 1863.
The Bancroft Library, University of California, Berkeley.

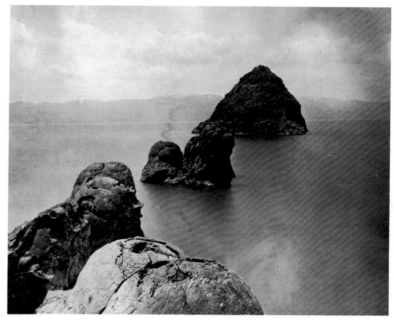

[*Tufa Domes, Pyramid Lake, Nevada*], Timothy O'Sullivan,
American (1840–1882), albumen silver print, 1867. National Archives.

Yosemite views and exhibited his commissioned photographs of mines in his San Francisco art gallery.

The photographic landscapes made by the western expeditionary photographers have been accepted as "art," despite their documentary origin, perhaps because their subject matter echoes the familiar themes of contemporary landscape painting. Industrial and architectural photographs have been given little attention, but as Watkins's work proves, they could have all of the excitement, compositional sophistication, and visual power of the more traditional landscape view. As Watkins shows us again and again, a series of commissioned views might include photographs that in any other context would be construed as "pure landscape." The splendid [*Coast View* #1] (1863), a picture that foreshadows Timothy O'Sullivan's 1867

Tufa Domes at Pyramid Lake, was made while Watkins was documenting a Mendocino lumber mill for its owner.

The industrial commissions in which Watkins sought to balance a description of a site with documentation of a particular type of work are set apart from the mundane efforts of scores of small-town western photographers by the striking quality of abstraction and concern for line and form that lifts them above the purely reportorial image. As with the chaotic upliftings of Yosemite Valley, mills, mines, and machines posed a problem in composition; they seemed to have an inherent order and pattern that challenged the photographer's powers of revelation. In *Malakoff Diggins* (Plate 42), where arching streams of water serve as elements of design as well as actual

Interior Ophir Hoisting Works. The Cages,
albumen silver print, 3⅛ × 6¼", New Series stereo #4154, c. 1876.
The Bancroft Library, University of California, Berkeley.

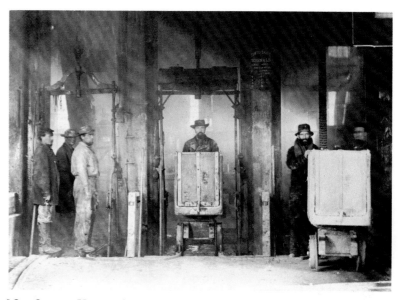

[*Ore Carriers, Virginia City, Nevada*], Timothy O'Sullivan,
American (1840–1882), modern gelatin silver print
from glass plate negative, winter 1867–68. National Archives.

subject matter, Watkins has transformed a noisy, messy operation into a lyrical composition of rhythmical lines. The machines used to refine ore from the Comstock Lode (Plate 56) are treated as a study in repeating pattern; the dark, busy room is caught still, suffused with beneficent light. Similarly, in *Interior Ophir Hoisting Works. Incline Hoisting Works* (Plate 58) the machines are seen to be elegant constructions, subjects that merit treatment as still-lifes.

Watkins's landscapes of Yosemite helped persuade Congress to set the area under permanent protection from development. Nonetheless, industrial commissions did provide a good part of his income, and his mill and mining photographs present a generally benevolent and nonthreatening image of industrial development and growth. Consistently, Watkins transforms the chaos of industrial activity into quiet photographic studies. In *Albion Mill from above Ferry* (Plate 24), he

has positioned his camera so that the mill, nestled at the foot of a deforested hill, is enveloped by serene water—in the iconography of contemporary Luminist painting a symbol of transcendent virtue. The calm, still water seems to suggest that the forces of nature can contain and control the voracious energies of development. In his three-part panorama of the mining town of Virginia City (Plate 55), the air is clear, the heaps of spent ore glisten in the sunlight. The workers that he photographs stop in a characteristic pose (Plates 20, 21), relax to enjoy the disruption in routine (Plate 101), or pose at Watkins's behest to provide a sense of scale in the overall design of the photograph (Plates 81, 83). Only in *Interior Ophir Hoisting Works. The Cages*, a portrait strongly reminiscent of O'Sullivan's *Ore Carriers, Virginia City, Nevada*, is there a sense of the hot grittiness of physical labor.

Watkins did seem aware that industrial development would alter the face of the West. In an ironic pairing of photographs from his last commission at the Golden Gate and Golden Feather Mines (1891), he provided alternative views of the site. In *Eroded Rock, Golden Gate Claim* (Plate 102), the geological formation sits in quiet, pristine splendor, a magnificent rock framed and photographed in all its glory. In *Golden Gate Mining Claim* (Plate 101), Watkins reveals the transitory nature of this splendor as he steps behind the same rock or a similar one and shows the earth being carved out from beneath it.

Watkins's architectural photographs, like his landscapes, were made both for specific patrons and as speculative views for probable sale. It is unlikely that he had a particular patron for his photographs of the Southern California missions or the Casa Grande ruins in Arizona, but he recorded them just as he did industrial sites, with distant views setting the buildings in their surroundings and close-up views emphasizing the bulk and graceful architectural lines of the structures (Plates 72, 73, 79, 80). Occasionally his sense of humor shows through, as in a playful stereograph of the graffiti-marked *Mission San Miguel* (Plate 70) which anticipates Walker Evans's work with billboards and found language in the 1930s. More often though, Watkins's architectural pictures have a strong, quiet self-assurance, a quality most apparent in the photographs made of the Milton Latham estate at Thurlow Lodge in 1874 (Plates 50, 51, 52). These images, infused with an almost magical light, suggest the presence of people we never see. Much as in a view by Eugene Atget or in one of Henry James's long descriptions of a character's house, we sense the palpable presence of the home's residents, feel certain they have just left or are about to reappear. Photographing unpeopled grounds and rooms, Watkins nonetheless conveys a sense of the rhythms of life at the Latham estate. If these were the only examples of Watkins's work to survive, we would still have to regard him as a master of nineteenth-century photography.

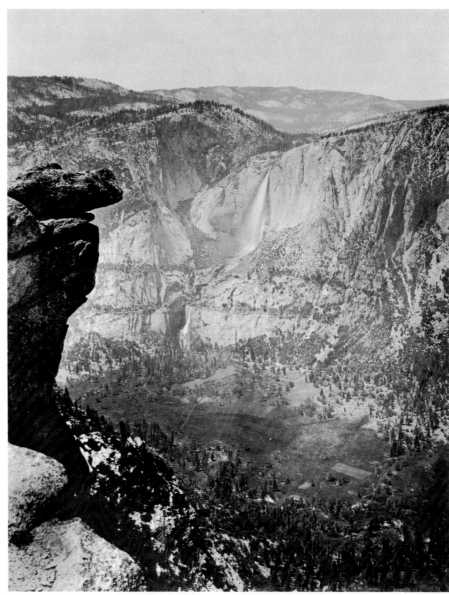

Yosemite Falls from Glacier Point, albumen silver print, c. 1866, published by I. W. Taber. The Metropolitan Museum of Art.

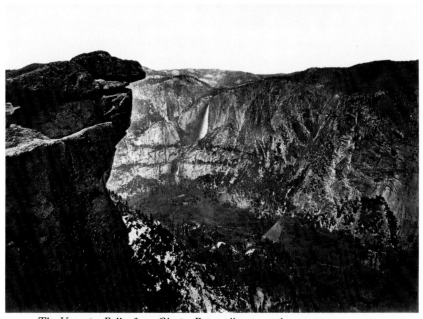

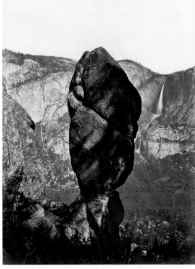

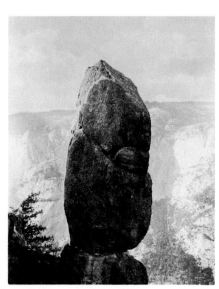

Agassiz Rock and the Yosemite Falls, from Union Point,
albumen silver print, c. 1878–1881. Gordon L. Bennett, Kentfield, California.

The Yosemite Falls, from Glacier Point, albumen silver print,
c. 1878–1881. Gordon L. Bennett, Kentfield, California.

Agassiz Column near Union Point, attributed to Carleton E. Watkins,
albumen silver print, c. 1870, published by I. W. Taber. Private Collection.

Of all the photographs in this book, however, none so leads to revision of our notion of the dynamics of Watkins's career and aesthetic growth as the newly recognized Yosemite views made in the years 1878 to 1881 (Plates 64, 65, 66, 67). As a site that he visited many times over a period of twenty years, Yosemite was a kind of touchstone for Watkins. It was a familiar place, a laboratory where he could test his new ideas. The differences and stylistic growth between Watkins's 1865–66 Yosemite photographs and the later views are dramatic and far greater than the evolution between the 1861 images and the 1865–66 photographs that have been cited as Watkins's masterworks. During the 1860s, Yosemite's monumental forms seemed to impose a structure upon his compositions; by 1881 Watkins is vigorously subjugating these forms to his own aes-

thetic. Where Watkins seems awed by the intrinsic grandeur of his subject in the early Yosemite views, he appears thoughtfully contemplative in the later photographs. This artistic development is apparent by contrasting two views of Yosemite Falls from Glacier Point. One view made about 1866 conveys a sense of dizzying heights, a dangerous precipice, the powerful force of the distant falls. It is a photograph designed to convey a sense of how it must feel to be at this spectacular overlook. The view from the same point some fifteen years later is less a statement about a distinct place than it is a brilliant study in abstract form. Watkins has positioned his mammoth-plate camera so that the top edge of a rock formation in the foreground lines up precisely with the horizon line over the distant mountains. The photograph breaks down into

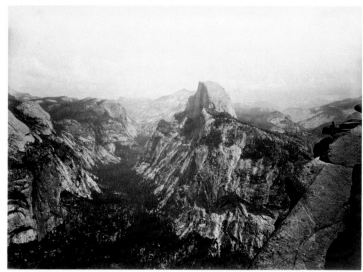

The Half Dome, from Glacier Point Yosemite, albumen silver print,
c. 1878–1881. Gordon L. Bennett, Kentfield, California.

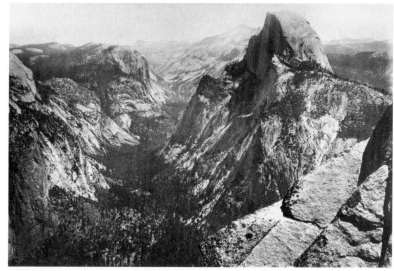

The Half Dome from Glacier Point, Yosemite,
albumen silver print, c. 1866. Amon Carter Museum.

three powerful shapes: the sky, the distant mountain walls, and the dark form of the rock formation which despite its foreground position seems to recede into distant space. It is elegant, simple and bold.

 The other photographs in Watkins's late Yosemite series are similarly bold reformulations of his previous motifs. His c. 1880 photograph of Agassiz Rock, with its clear, sharply defined background and massing of near and distant forms, exhibits a self-confidence absent in a similar view made around 1870 which relies for effect on a simple silhouetting of a dark form against a light and indistinct one. A later view of *Half Dome From Glacier Point* differs essentially from the c. 1866 view in only one detail—the inclusion of a seated figure (who looks tantalizingly like Watkins) in the small observation deck perched on the mountainside at the right. The mammoth Yosemite views of 1861 and many of those from Watkins's subsequent trips to the valley in the 1860s and 1870s include fore-

ground details, curving pathways, streams or discreetly placed branches that invite the viewer into the picturesque landscape to experience it for himself. But in the later photograph Watkins, like the nameless silhouetted man, holds the landscape off at a distance to regard it in its perfect stillness and classic harmony. He seems to be searching for a formal order, not a dramatic gesture of expressiveness.

 This dispassionate detachment from the industrial or natural landscape, coupled with an ability to see it as a collection of abstract forms providing raw material for the photographer's creative eye, represents an essentially modern photographic sensibility. In this way of seeing, it is the photographer—as much as or even more than the subject matter—that imposes a certain order on the final composition. Watkins's fascination with form for form's sake was explored particularly with his smaller, more flexible stereo camera. It is evident as early as 1861 in his Yosemite stereographs (Plates 8, 9, 14, 15),

and reiterated again and again in such images as the starkly geometric *Russian Hill Observatory* (Plate 27). Eventually, it became a predominant theme in his larger format work, as in the late Yosemite views, *Arch at the West End* (Plate 40), or *Cat-Tail and Tules* (Plate 96), where the sole subject of the photograph is the delicate pattern of lights and darks made by the tender grasses.

Watkins's interest in abstract form distinguished him from his contemporaries. He eschewed the dramatic romanticism of his rival Eadweard Muybridge, and there is little evidence that he manipulated his prints or his negatives as both Muybridge and William Henry Jackson did. As an adventurer in his own land, rather than a traveler in an exotic one, he could view the West with an exuberance and self-confidence that an Easterner like Timothy O'Sullivan lacked. If O'Sullivan was unnerved by the vast, lonely stretches of the western landscape, Watkins was challenged and intrigued by them. Thus, while O'Sullivan's landscapes recall early nineteenth-century notions of a sublime full of fear, gloom, terror, and awe, Watkins's bridge the later nineteenth-century ideal of a quiet and contemplative sublime and the more modern sense of landscape as a compendium of abstract shapes.[8] His photographs are more ambitious and adventuresome than the views of his younger colleague William Henry Jackson, who achieved the commercial success that eluded Watkins. Jackson relied on the inherent drama of the landscape to give a cohesive form to his photographs. Watkins was able to take a relatively undramatic vista and transform it into a rich photographic composition of form and line.

Watkins was a risk-taker who never had the long-term steady employment that lent a certain stability to his colleagues' careers. O'Sullivan had several years of steady work with various government surveys; Jackson spent nine years with the Hayden survey; and John K. Hillers worked first on the Powell survey, then secured a permanent position with the United States Geological Survey and the Bureau of Ethnology. Watkins, meanwhile, moved quickly from job to job, hope to hope, refusing to become a mere photographer of San Francisco city views, but never disdaining the commercial jobs that afforded him an income and a means of travel.

It is altogether fitting that Watkins's only known self-portrait shows him in the improbable guise of a white-shirted goldminer. Like the solitary miner with his simple panning device, Watkins was a working man ever hopeful of striking it rich; a loner blessed with ambition but saddled with a business sense that seemed never to steer him right. Dressed in the white shirt of a city clerk he poses for the camera by the side of a well-traveled road, and seems oddly out of touch with the grubby realities of the mining business. Similarly, as a photographer in the competitive atmosphere of late nineteenth-century San Francisco, Watkins was, as Palmquist suggests, out of step with the rapidly changing practices of the photographic business. But he was out of step with his fellow photographers in another sense as well. He stood apart from them in the brilliant boldness and striking modernity of his photographic vision—a vision that continued to grow through more than thirty-five years of work and that is fully revealed for the first time in this catalogue.

—Martha A. Sandweiss

8. For a discussion of O'Sullivan's work see Joel Snyder, *American Frontiers: The Photographs of Timothy H. O'Sullivan, 1867–1874*.

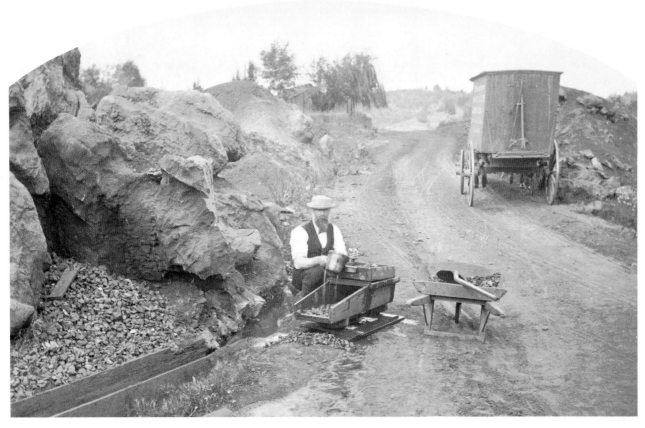

Primitive Mining; The Rocker Calaveras Co., Cal., albumen silver print,
New Boudoir Series #B 3542, c. 1883. California State Library.

CARLETON E. WATKINS

Photographer of the American West

PHOTOGRAPHER CARLETON E. WATKINS (1829–1916) created an unparalleled visual legacy of the American West.[1] Beginning in the mid-1850s, his illustrious career spanned a period of fifty years and covered an immense geographical region—from British Columbia southward to the Mexican border; from the Farallon Islands (in the Pacific Ocean off San Francisco) eastward to Wyoming's spectacular Yellowstone—a land area covering hundreds of thousands of square miles.

The story of how Watkins crisscrossed this vast region is in the best tradition of one man's dedication to his craft. Although he was frequently at the very end of his financial resources and beset by ill health and other misfortunes, Watkins persevered to produce many of the West's greatest nineteenth-century landscape photographs. His total output was truly staggering, with estimates running as high as tens of thousands of images. Thousands still survive, most of them rediscovered only during the past decade because of today's avid interest in collecting pioneer photographs.

Watkins's photographs have long been valued as remarkable historical documents, often the earliest or only surviving record of a particular place or event of long ago. As art, Watkins's images are now collected with the same avidity normally reserved for fine paintings.[2] Yet despite this great acclaim, the life of this artist remains little known and, all too frequently, misunderstood.

Much of this confusion is due to previous writings that have focused almost single-mindedly on Watkins's Yosemite work of the 1860s. This narrow emphasis has skewed our perception of his true significance and ignores the immense and greatly varied scope of his total photographic output. Even more important is the lack of understanding of Watkins's role as a commercial photographer—including the everyday social, political, and economic realities that confront the small businessman of any era. Finally, little has been said regarding his personal outlook, his hopes and goals, or the anguish of his marriage to a shrewish woman (half his age) who ultimately banished the proud old man to finish out his days in a mental institution.

Watkins came to photography by chance in 1854. He was twenty-five years old, had lived in California for three years, and was three thousand miles from his place of birth. His first biographer, Charles Beebe Turrill (1854–1927), a San Francisco photographer who befriended Watkins as an old man, wrote that Watkins replaced a studio photographer who had

1. Watkins's middle name remains a mystery. Most photographic historians have favored "Emmons," largely because a man named Carleton Emmons had been a close friend of Watkins's father during the 1820s. No birth or baptismal record has been located, and surviving public documents list only "Carleton E." or "C. E. Watkins." His daughter, Julia, staunchly maintained that her father's middle name was Eugene: "They say my pappy's name is something else—but it ain't." Her mother's death certificate reads "Carleton Eugene" and probably reflects Julia's influence. Interestingly, Watkins's certificate exists in two versions, "Carleton Emmons Watkins" and "Carleton E. Watkins." The only known primary reference is the April 1879 supplement to the *San Francisco Great Register* (voter's registry), which records a fifty-year-old photographer named "Carleton Eugene Watkins." While Julia is our best source of information concerning the inner workings of the Watkins family, researchers have claimed that she was inconsistent, forgetful, and "not one hundred percent, mentally." Recently a more sympathetic explanation has been proposed to explain these traits, which greatly improves her credibility. Julia apparently stammered severely until about age thirty (a condition induced primarily by the repressiveness of her mother). Eventually a dentist assisted her in developing an improved speech pattern, but she had to concentrate on the mechanics of her speech in order not to stutter. This might account for her hesitancy and supposed confusion during an interview.

2. In recent time individual mammoth prints have been priced as high as $20,000. An impressive early price jump was marked by the May 1979 auction of two albums containing a total of 100 mammoth prints, for a record $198,000 in New York City (New York, Swann Galleries, Sale 1141, lots 226 and 227).

quit his post without warning. He was so successful in adapting to this new trade that he was retained on a permanent basis.[3] From this modest beginning grew a career that lasted until the ravages of the 1906 San Francisco earthquake and fire.

Watkins was born and grew up in the rural village of Oneonta, in upstate New York.[4] Local legend still remembers the time that he and several of his friends climbed the bell tower of the Presbyterian church; here the young pranksters "made balls of cotton batting soaked in turpentine," which they lit and threw into the gathering dusk, "illuminating the immediate surroundings with spectacular effect." On a more serious occasion, at age five, he was saved from drowning through the efforts of his pet dog.[5]

Young Watkins grew into a stubborn and uncompromising adult. As the eldest of eight children of a hotelkeeper, Watkins should have been assured of a comfortable role in his home community.[6] Instead, at age 22, he abandoned his birth-

right and made his way to California. His decision may have been spurred by family discord; in all the years he lived in California he made only one return visit to Oneonta. Moreover, at that time he stayed only a few hours before making a hasty retreat to his life in San Francisco.[7]

When Watkins left for California, in the spring of 1851, his traveling companion was Collis Potter Huntington (1821–1900), later to become famous as a railroad magnate and financier. Huntington, also an Oneontan, had already spent two years on the frontier as a Sacramento shopkeeper. They arrived in San Francisco on 5 May 1851, pausing only briefly to view the destructive effects of a mammoth fire that had ravaged the city on May 4.[8]

Arriving in Sacramento, Watkins assisted in Huntington's store. A fire in late 1852 destroyed Huntington's operation and put Watkins out of work. Within a short time, however, he found employment as a carpenter; by 1853–54 he had re-

3. Charles B. Turrill, "An Early California Photographer: C. E. Watkins," *News Notes of California Libraries* 13, no. 1 (January 1918): 30.

4. Oneonta, incorporated in 1848, is in Otsego County, New York, eighty-two miles southwest of Albany.

5. Willard V. Huntington, "Old Time Notes . . . ," p. 2014, Willard V. Huntington Papers. Information provided by Mrs. Alma F. Slawson, personal communication, 29 November 1979, and by oral interview in Oneonta, 21 July 1982.

6. Carleton was the eldest child of John Maurice Watkins (1806–90) and Julia Ann McDonald (1812–82), both of Scottish descent. Watkins is frequently referred to as "the youngest of five children" in modern writings. This error doubtless dates from Ralph H. Anderson's "Carleton E. Watkins: Pioneer Photographer of the Pacific Coast," *Yosemite Nature Notes* 32, no. 4 (April 1953): 33. Confirmation of eight Watkins children was provided by the following sources: 1) Alma F. Slawson, "John and Julia (McDonald) Watkins" (typescript of notes, 9 October 1965); 2) John F. Palmquist, "Watkins Family Plot" (handwritten notes, 29 October 1979); and 3) John F. Palmquist, "Notes on the Watkins Family of Oneonta New York," all in possession of the author. The children were Carleton, Harriet, Caroline, Albert, Charles, George, Jane, and James. The Watkins's hotel, called

the Otsego House, was an important stopping place for merchants and cattlemen; as many as eight stage coaches arrived daily. It was also a center for social activities, including 4th of July and Christmas gatherings. Among Carleton's earliest memories was the 13 November 1833 spectacle "furnished by an *aurora borealis* accompanied by a very great number of meteors and shooting stars." He was particularly impressed by the gathering together of villagers to listen to Squire Ira Emmons, "a man of scientific attainments," who explained the event (Huntington, "Old Time Notes," p. 2002).

7. William and Karen Current, "Interview with Miss Julia C. Watkins, February 12, 1975," typescript of notes, Research Library, Yosemite National Park, California. Personal alienation may have existed on several levels. For instance, Carleton's politics were Republican and his father's staunchly Democratic.

8. A fine account of Huntington's life is provided by David Lavender's *The Great Persuader*. Watkins and Huntington and other Oneontans traveled from New York to Havana, where they boarded the steamer *Falcon* for Chagres, Panama. From Chagres they crossed the isthmus by mule to Panama City, then sailed on the *Northerner* to Acapulco (stopping long enough to be feted by the mayor), and finally on to San Francisco. Mrs.

located to San Francisco. The San Francisco *City Directory* for that year records him as "clerk, George Murray & Company, bookseller and stationers, Montgomery Block."

San Francisco had already changed radically in the few short years since Watkins first set foot in California. The great fires of 1850–51 had swept away most of the gold-rush shanties, and in their place grew new shops and developing industries of every kind. Whereas in 1847 there were only 459 people in residence, by 1852 the population had skyrocketed to thirty-four thousand; by 1860 it was fifty-six thousand. These "new citizens" had been uprooted from every conceivable place and circumstance of origin. Even New York City, the great receiving center for Europeans, was far less populated with aliens than this polyglot city by the Golden Gate. Nearly everyone was under forty years of age, and only about a third were female.[9]

Despite its frontier setting, San Francisco had also become surprisingly cosmopolitan. Not the least of its many amenities were the numerous photographic galleries. Daguerreotypists had advertised their wares in San Francisco as early as January 1849, and others arrived with every boat. Most of the earliest image-makers were transient; not only

was their work made difficult by the scarcity of daguerrean supplies, but the lure of the gold fields infected nearly everyone. By 1854, however, many more or less permanent photographic galleries existed in San Francisco and surrounding towns such as Sacramento, Marysville, and San Jose.[10]

Photographic portraits predominated. All new arrivals to the region required a "likeness taken on the spot" to send to families and friends as proof that they were still alive and thriving in the land of El Dorado. Outdoor views were far less common. Many daguerreans advertised "views of residences and businesses," but only a handful (such as Robert H. Vance, 1825–76, who became Watkins's first photographic mentor) had actually produced an extensive series of outdoor daguerreotypes of San Francisco and the California goldfields at an early time. Vance's influence, and that of outdoor photography generally, will be discussed shortly.

Watkins's sudden entry into photography is interesting, but not unusual; changes in occupation were frequent and often without discernible pattern. As Turrill explains it, Watkins just happened to be available:

> [Watkins] became acquainted with R. H. Vance, who had a gallery in San Jose, as well as in San Francisco. It chanced that the operator in the San Jose gallery suddenly quit his job and Vance asked the young man Watkins to go down and take charge of the gallery until he got a new man. Those were the days of the daguerreotype. Watkins went by stage to San Jose and the gallery was turned over to his care. He knew absolutely nothing in regard to photographic processes, and was simply for the first few days a care-taker of the place. In that town the great amount of business done in a photograph gallery . . . was on a Sunday. On Friday or Saturday, Vance

Huntington to "Dear Mother and Sister," 24 June 1851, private collection, San Marino, California; citation courtesy of Nanette Sexton. Julia Watkins remembered that her father spoke of reaching San Francisco shortly after a major fire, doubtless the conflagration of 4 May 1851. C. P. Huntington and lady are listed as "arrivals" on 5 May 1851 in Louis Rasmussen, *San Francisco Ship Passenger Lists*, Vol. II, p. 138. Watkins may have returned to the East to purchase supplies for Huntington in 1852. This idea is supported by the fact that "C. Watkins" is listed as a passenger on the ship *Michael Angelo* which arrived in San Francisco on 2 August 1852 (Rassmussen, *Passenger Lists*, Vol. IV, p. 60). This would also explain why Watkins is *not* listed in the *California State Census* of 1852.

9. Roger W. Lotchin, *San Francisco, 1846–1856: From Hamlet to City*, pp. 102–103. For a colorful account of the city before 1854, see Frank Soulé, John H. Gihon, and James Nisbet, *The Annals of San Francisco*.

10. Details of daguerrean activity in early San Francisco are found in Peter E. Palmquist, "The Daguerreotype in San Francisco," *History of Photography* 4, no. 3 (July 1980): 207–238.

visited San Jose to see how the young man was getting along. He had not gotten a new operator, so he showed the young man how to coat the daguerreotype plate and how to make an exposure for a portrait. This instruction occupied only a few minutes and did not go into the minutiae of the profession. Vance told Watkins that when visitors came in on Sunday he could make a bluff of making the exposures and take their money and that when they came back the following week he would have an operator there to make over anything that had to be made over—it being the idea that the young man would not succeed in his daguerreotype operations. As good fortune would have it, he did succeed, however, and no new operator was ever sent.[11]

By 1856 Watkins had moved to James M. Ford's portrait studio in San Jose. Switching to the newer ambrotype process, Watkins specialized in baby portraiture.[12] Although it is difficult to imagine Watkins cooing to an unhappy child, the basic principles of patience and self-discipline required were similar to those needed for successful field photography.

Watkins's transition from baby photographer to landscape photographer was spurred by several successive innovations in the medium. The greatest was a technological breakthrough: the use of a collodion glass negative to make paper

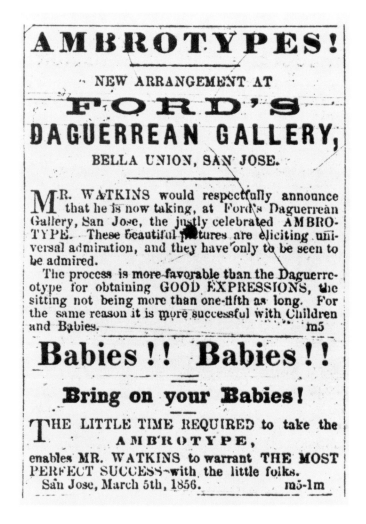

Newspaper Ad for Ford's Daguerrean Gallery, *San Jose Tribune*, March 5, 1856. The Bancroft Library, University of California, Berkeley.

About 1854 James M. Ford became one of the first in California to make ambrotypes, photographic images on collodion-coated glass. The ambrotype was cheaper than the daguerreotype and easier to view. Watkins went to work for Ford in 1856 and learned this new process from him.

11. Turrill, "Watkins," p. 30. Turrill's accounts of Watkins's activities should be regarded as an amalgam of information, rather than a precise chronological account. However, he was the only biographer to know Watkins personally, albeit at the end of Watkins's life. There is no evidence to support the idea that R. H. Vance had a gallery in San Jose; it is far more likely that the story refers to circumstances at Vance's Marysville establishment. Moses Hanscom, Vance's portrait operator in Marysville, left the studio to set up a competing business in late 1854. Watkins may have filled in for him.

12. "Ambrotypes," San Jose *Tribune*, 5 March 1856. It is probable that Watkins was active at this location before this date. By December 1856, however, the San Jose gallery had been acquired by James A. Clayton.

prints. In this process an appropriately sized sheet of glass was cleaned and coated with a thin layer of viscous collodion (prepared by dissolving guncotton in ether). For use, the plate was sensitized in a darkroom or darktent, by dipping it in a silver-nitrate solution. The damp plate was placed in a holder, transported to the camera, and exposed. Processing also had to be accomplished before the plate dried, or it became insensitive. The procedure often required as long as an hour for a single negative. Later the finished negative would be sun-printed onto paper. The earliest sensitized paper, used by Watkins until 1861, was treated with sodium chloride and called a "salt print." After 1861 Watkins printed on albuminized printing paper, which gave greater surface sheen and detail than a salt print did.

The major advantage of the wet-plate negative process over the daguerreotype and ambrotype was that multiple prints could be made. It was also possible to make larger photographs by making bigger cameras that would hold bigger glass plates, and the process itself was relatively inexpensive. Experimentation with the new procedure began in California in 1854, but results were not commercially viable until 1856. In that year James M. Ford (from his San Francisco gallery) began a series of "daguerreotypes on paper," wet-plate views of important buildings and sites in San Francisco. His associate, George Robinson Fardon (1807–86), would later combine these city views into a *San Francisco Album* (1856). Through his working contacts with Ford, it seems certain that Watkins was privy to this project, and may well have been a participant. In fact, Turrill claims that Watkins's first outdoor photograph was called *Over the Plaza*. While no identified Watkins photograph matches this description, the title is extraordinarily reminiscent of the Ford-Fardon series.[13]

13. Ford is known to have produced wet-plate negatives of San Francisco scenes in early 1856. Possibly Ford and Fardon combined their skills in making such negatives (and paper prints) which Fardon later published

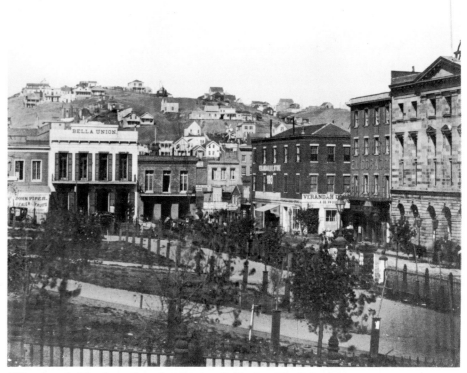

[*View over the Plaza*], attributed to George R. Fardon, English (1806–1886), salt print, 1856. The Bancroft Library, University of California, Berkeley.

Although attributed to G. R. Fardon, there is some possibility that the negative for this view was made by Watkins from the window of J. M. Ford's San Francisco gallery which overlooked Portsmouth Plaza.

as his own; Fardon replaced Ford at Ford's San Francisco gallery in 1857. Nanette Sexton has observed that some prints from the 1856 negatives, labled "Fardon," appear to have been altered from "Ford" on the original negative. Watkins, as Ford's employee, would have surely known of such wet-plate negative and paper print experiments, and since Ford's gallery overlooked Portsmouth Plaza it is not unreasonable to presume that Watkins may indeed have taken the negative known as "Over the Plaza" which appears in Fardon's book.

Watkins's former mentor, R. H. Vance, also became involved in wet-plate negative photography in 1856. From his position as owner of California's foremost gallery, Vance sent his junior partner, Charles Leander Weed (1824–1903), to document river mining on the American River in 1858.[14] Not only did Weed employ the wet-collodion process, but he made negatives (and prints) as large as twelve by fifteen inches. In 1859 Vance sponsored Weed's visit to Yosemite, where he made both stereographic and large-format negatives, the first photographs of this geologic masterpiece. The American River and Yosemite images were displayed in San Francisco, where Watkins undoubtedly saw them.[15]

The antecedents of landscape photography are as old as photography itself. In America outdoor views were made by the daguerreotype process as early as the fall of 1839. By the mid-1840s such images were commonplace, though not nearly so popular as portraits which comprised 95 percent of all daguerreotype images. Photography's major competitor for picturing the American landscape was the hand-painted panorama, immensely popular at this time. These artistic "newsreels" represented faraway places on a moveable canvas. At least five were made of the Mississippi River area alone, the shortest of which was 425 yards long; "audiences sat for two

or three hours watching such pictures unroll before their eyes, while a commentator pointed out scenes of particular interest and a pianist from time to time played 'appropriate airs.'"[16]

Painted panoramas sharpened the public's appetite for travel, but they lacked the "truthfulness" and great detail of daguerreotypes. As a consequence daguerreotype panoramas such as Fontaine and Porter's "Panoramic View of Cincinnati" (1846), composed of eight daguerreotype plates united in one frame, attracted great acclaim.[17]

The California gold rush also spawned an interest in panoramas of the West. One of the most popular (completed in 1850) was advertised to contain 18,000 square feet of canvas (if it was ten feet high it would have unrolled for 600 yards). The advertisement proudly claimed that this pictorial extravaganza had been "visited in New York; Albany, Troy and Buffalo by over 130,000 persons and in Cincinnati by more than 20,000."[18] Such a popular response could be a great boon to the daguerreotypist as well. By early 1851 two daguerreans were already at work producing panoramas of California (and the West generally). Traveling overland from the East, John Wesley Jones made fifteen hundred images "from the Missouri River to the Pacific Ocean."[19] Ironically these daguerreotypes were used as the basis for a new panoramic painting. Also in January 1851, Robert H. Vance arrived in San Francisco by boat and immediately started a three-hundred-image collec-

14. For information on R. H. Vance, see Peter E. Palmquist, "Robert Vance: Pioneer in Western Landscape Photography," *The American West* 18, no. 5 (September/October 1981): 22–27. Weed's photography is discussed in Peter E. Palmquist, "California's Peripatetic Photographer, Charles Leander Weed," *California History* 58, no. 3 (Fall 1979): 194–219.

15. Weed's Yosemite activities are described in Mary V. Hood, "Charles L. Weed, Yosemite's First Photographer," *Yosemite Nature Notes* 38, no. 6 (June 1959): 76–87 and in Peter E. Palmquist, "Yosemite's First Stereo Photographer—Charles Leander Weed," *Stereo World* 6, no. 4 (September/October 1979): 4–11. The Yosemite exhibit was reviewed in the *San Francisco Daily Times*, 19 August 1859.

16. John Francis McDermott, "Gold Rush Movies," *California Historical Quarterly* 33, no. 1 (March 1954): 29–38.

17. Cliff Krainik, "Cincinnati Panorama," *Graphic Antiquarian* 3, no. 4 (April 1974): 7–12.

18. McDermott, "Movies," p. 30. "Admission was fifty cents; children paid half price. Doors opened at half-past six; the panoramas started moving at seven-fifteen."

19. Catherine Hoover, "Pantoscope of California," *California Historical Courier* 40, no. 3 (July 1978): 3.

tion of outdoor daguerreotypes called "Views in California."[20]

Vance's collection was finished by the end of June and was displayed in New York in the fall of 1851. There the images were praised as high art: "They are the most artistic in design, and executed with a skill, evincing, not only a perfect mastery of the manipulatory art, but an exquisite taste for the sublime and beautiful."[21] An unnamed landscape painter raved at the great detail and fidelity of Vance's treatment of nature:

> Not a blade of grass, not the most minute pebble—hardly perceptible to the naked eye—nor the fibres of the bark of the tree—nor the myriad of tiny leaves that compose the clustering foliage—nor the silver stretches in the zig-zag ripple of the water as it glides on, or meanders among the rocks, washing up in its passage the little spangles of gold which have made California the great attraction of the whole world—but are wonderfully portrayed in these pictures in miniature most incomparable . . . there is one [view] in particular, having in it a fallen tree over three hundred feet in length, sharp, angular rocks, etc., which we have no hesitation in saying, is the finest daguerreotype view ever taken.[22]

Although it is difficult to determine how much of the public's enthusiasm was due to Vance's skill as a photographer and how much to the innate visual qualities of California, it is clear that California was a veritable El Dorado for a landscape photographer. The world wanted to see California in every possible way—the "most minute pebble" as well as the exalted grandeur of this Pacific Shangri-la.

Whatever the final impetus, Watkins was involved in large-format outdoor photography no later than 1858, and most probably as early as 1856. His earliest surviving landscape photograph was taken as court evidence in an 1858 dispute involving the Guadalupe quicksilver mine near San Jose.[23] This was an important assignment, one which had a profound bearing on his later work. The finished view was formed by two large salt prints joined together (Plate 1). During his testimony in the Fossat case (on 27 August 1858) Watkins was asked: "Who selected the point from which you took that view?" With characteristic brevity Watkins replied, "I did myself . . . I went to the ground and when there selected the spot which would give the best view."[24]

"The best view" typifies Watkins's overall approach to outdoor photography. From the beginning he sought to reduce complex scenes to basic units, then organized these elements as simply as possible, recording them from the best vantage point. The results are classical, well ordered, and cerebral. The unit approach is clearly evident in Watkins's first major series of outdoor photographs, taken in 1860. Col. John C. Frémont's mining estate (Las Mariposas) lay athwart the fabled mother lode near Bear Valley. Its quartz mines—Princeton, Josephine, Pine Tree, Mount Ophir, and Mariposa —were among the richest gold mines in the world. Working almost one hundred and twenty-five years ago, Watkins captured the Mariposa Estate with precisely the same photojournalistic principles in use today—a long, establishing view (usually from a distant hill or promontory overlooking the general

20. Robert H. Vance, *Catalogue of Daguerreotype Panoramic Views in California.* "These views are no exaggerated and high-colored sketches, got up to produce effect, but as every daguerreotype must be, the stereotyped impression of the real thing itself."

21. "Mr. Vance's California Views," *Photographic Art-Journal* 2, no. 4 (October 1851): 252–253.

22. Ibid.

23. Peter E. Palmquist, "Carleton E. Watkins's Oldest Surviving Landscape Photograph," *History of Photography* 5, no. 3 (July 1981): 223–224.

24. "Deposition of Carleton Watkins," 27 August 1858, United States v. Charles Fossat, in Records of the United States District Court for the Northern District Court of California. In response to questioning, Watkins told the court: "[I] am 29 years old, reside in San Francisco, Cal., and am a photographist."

area); a medium view (such as a cluster of mining structures); and one or more close-up views, showing a single building or construction detail. Watkins was to replay this script many times during his long career.

Although the estate was owned by Frémont, a San Francisco lawyer, Trenor William Park (1823–82), had gained many financial rights by 1857 and legal control of the operation by 1860, when all easily reached placer gold had been removed and a major investment in hard-rock mining equipment was made. This great expense, together with a series of legal battles with squatters and claim jumpers, had impoverished the estate, and new investment money was sorely needed. Because they hoped to attract foreign capital, Park and Frémont hired Watkins to produce a series of photographs that would show "everything that contributed to income and possible future income from Las Mariposas." In early 1861 Frémont took the photographs to Europe, where he "talked to the Rothschilds and Paris bankers [but] to no avail."[25]

The Mariposa commission was an important opportunity for Watkins; it may have been his first chance to use his large camera on a wholly commercial project. The Mariposa estate was forty-four thousand acres, and Watkins traveled from site to site in an open wagon. At each desired location Watkins would erect his conical darktent, in which he coated and processed his negatives. From the streaking and uneven coating of these negatives, it is obvious that he was still having some trouble handling and coating the large plates under field conditions. An inventory of surviving images reveals that Watkins succeeded in making at least forty-nine different images of the Mariposa mining facilities, representing twenty-seven separate sites. Taken as a group, these images are an ideal marriage of landscape and architectural photography, well suited to acquaint an investor with the estate's major assets.[26] Today these photographs serve as a fine visual inventory of this historic region (Plates 3, 4, 5).

The Mariposa images are the largest surviving body of Watkins's work before 1861. Other early works include a few large views of San Francisco, such as *Washerwoman's Bay* (1858; Plate 2). Early views of the New Idria and New Almaden quicksilver mines and Mission Santa Clara, apparently by Watkins, also exist, but their dates cannot be confirmed. So far

25. Ferol Egan, *Frémont: Explorer for a Restless Nation*, p. 512. For an overview of Trenor Park's life in California, see Virginia Bell, "Trenor Park: A New Englander in California," *California History* 60, no. 2 (Summer 1981): 158–171. Recently available correspondence in the files of the Park-McCullough House, North Bennington, Vermont, sheds much new light on the situation at Mariposa in 1860. Frémont, Park, et al. were in a grave financial situation, being at least $1,200,000 in debt. In order to attract foreign investment a promotional publication, *The Mariposa Estate*, was prepared which purported to show "the conditions and resources of the estate . . . documents, including maps, photographic views, etc., being in our possession." In addition to Frémont and Park's financial statement the report contained a supportive letter from Josiah Dwight Whitney, dated 5 December 1860; visiting the Mariposa Estate in December 1860 proved to be one of Whitney's earliest acts as the newly appointed leader of the California State Geological Survey. Whitney undoubtedly met Watkins at or about this time, and the two formed a relationship of lasting consequence. The Park letters also make it clear that Watkins was commissioned to photograph Las Mariposas, although not everyone was certain of his name: "I enclose a photograph by Watson [*sic*] (taken when he was here)." L. C.

Hopper to T. W. Park, 6 January 1861, Trenor W. Park Papers. On 10 January 1861 Albia Selover wrote to Trenor Park from New York: ". . . the photographs of the estate will produce a very grand effect, this morning I entertained C. K. Garrison with them for over two hours, rest assured that they will produce good results." A. A. Selover to Trenor Park, 10 January 1860 [*sic*], Park Papers. It is evident that Watkins's photographs were shown to potential European investors: "the views of the estate were shown to Napoleon [III] on Wednesday last." A. A. Selover to T. W. Park, London, 18 May 1861, Park Papers. Although the American Civil War interrupted these fiscal negotiations, the Mariposa representatives kept the issue open by sending an exhibit of mining specimens to the London Exhibition of 1862. It is likely that some (if not all) of Watkins's Mariposa photographs were included.

26. The Mariposa salt print photographs can be found at the California Historical Society, San Francisco; the Bancroft Library, Berkeley; and

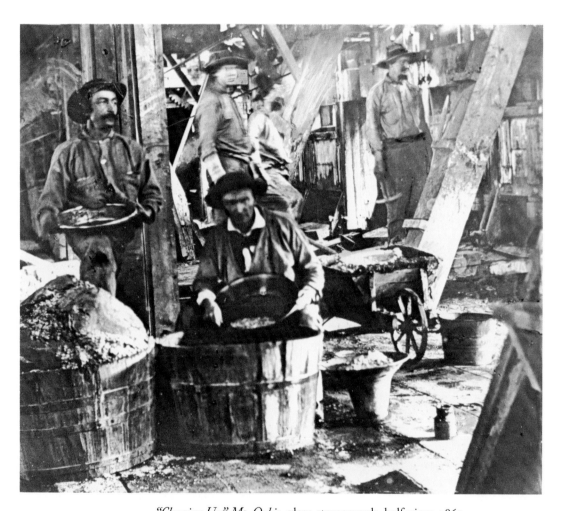

"Cleaning Up" Mt. Ophir, glass stereograph, half-view, 1860.
Collection of Western Americana,
Beinecke Rare Book and Manuscript Library, Yale University.

This remarkable image of miners at work at J. C. Frémont's Mariposa Estate was made in 1860. Photographs of interior mine work are extremely rare for the period.

no example of his early portraiture is known, nor has it been proven that he did outdoor work with either the daguerreotype or ambrotype process. Watkins began experimenting with wet-plate stereo negatives in 1860; he printed his first such negatives on albuminized glass to create transparent views for the ubiquitous stereoscope. Only a small number of these glass stereographs survive today, among them several taken of the interior of the Mechanics' Fair pavilion in 1860.[27]

By 1861 Watkins had gained a fine reputation as a field photographer; his works were large, clear, and well detailed and since the prints were made on paper, they could be used in court cases as easily as maps. In a land case involving the San Antonio Rancho (*U.S.* v. *D. & V. Peralta*), Watkins served as an expert witness, using his camera to document key physical evidence. Thirteen of these images survive, together with nearly sixty pages of Watkins's personal testimony (Plates 6, 7).[28] As in the quicksilver mine case, Watkins's personal responses to questions from the court were ideally terse and to the point.

The case involved a dispute over property boundaries

the Park-McCullough House, North Bennington, Vermont. A series of glass stereographs of the Mariposa Estate are located at Beinecke Library, Yale University, New Haven.

27. Nine examples are held by the California Historical Society and thirty-one are at Beinecke Library (another four are in the Sterling Library) at Yale University. Watkins also made glass stereographs of Yosemite in 1861 (examples at the Research Library, Yosemite National Park), as well as others in private ownership. Approximately 170 glass Watkins stereos survive.

28. "Deposition of Carleton E. Watkins," 8 May 1861 and 26 July 1861, no. 100ND, United States v. D. & V. Peralta, in Records of the United States District Court for the Northern District of California. The San Antonio Rancho estate involved property along the northeast flank of San Francisco Bay, including Berkeley, Albany, El Cerrito, and Richmond. Watkins's photographs may be the earliest surviving views of this region. Two of the court exhibits are panoramas made by joining photographs together.

and required Watkins to translate a natural environment to a lay audience. In the courtroom Watkins used his photographs to differentiate several large outcroppings that had served as reference points in the original Spanish land grant, from all similar features in the same vicinity. The shape, color, texture, and volume of these outcrops were discussed. Their relationship to surrounding terrain became problematic, however, since his choice of camera position determined the way the rocks were aligned with respect to a distant horizon. The following exchange is typical of the dialogue on the matter:

> Q. 88: Suppose between the highest peak of the Cerrito [hill] of San Antonio and the lower peak thereof several lesser peaks intervened? Would not those peaks last mentioned be shown on the photograph if the same were taken from a point due east from said Cerrito and would they not appear as one line if taken from a point southeast thereof?
> Watkins: Taken from a point due east all the peaks on the Cerrito would be shown. They would have to be very small ones to appear as one line from the south east . . . it is scarcely possible to make them appear as one line except [if] the view was taken from due south.

Through his court experience Watkins also began to see a great need for a wide-angle, or all-encompassing view of the landscape. He had already been forced to join two images to form a wider view for the Fossat (Guadalupe quicksilver mine) case, and this continued to be an issue:

> Q. 89: From the point from which said Exhibit no. 1 was taken could you not have shown on the photograph the smaller Cerrito [as well as the larger Cerrito] so that the relations which they bear to each other would be manifest?
> Watkins: I could not have got them both into one photograph.

> Q. 90: Could you not have done so by taking a plate one third or one half larger or by taking two distinct photographs and connecting them together on the same Bristol board as was done in Exhibit no. 3?
> Watkins: I could have done so with two photographs but could not have used a larger plate.[29]

Watkins immediately moved to rectify the problem. First he commissioned a local cabinet maker to construct a camera capable of handling negatives as large as eighteen by twenty-two inches (mammoth size).[30] It is not clear whether this was a completely new camera or an adaptation of his previous instrument to the larger plates; however, no further work is known from his earlier camera after the San Antonio case. He matched the new plate size with a lens that had a wide-angle field of about seventy degrees.[31] Watkins was now ready to tackle one of the earth's most spectacular regions—Yosemite.

By 1861 Watkins had lived in California for ten years, and had been a photographer for six of them; he now called himself a "photographist." With the exception of a few mentions in the San Francisco *Directories* (and of course, his surviving photographs), very little is known of his personal life. During the first few years after his arrival in California the Huntingtons kept track of him. In April 1854, for instance,

29. Ibid.
30. Turrill, "Watkins," p. 32.
31. After an extensive study of Watkins's 1861 camera technique, Nanette Sexton has speculated that Watkins owned "Thomas Grubb's Aplanatic Landscape lens which was patented in England in 1857, but rarely used until the early 1860's." He later employed the Globe lens. Nanette Margaret Sexton, "Carleton E. Watkins: Pioneer California Photographer." The author has had the privilege of exchanging information with Sexton over an extended period of time. Inasmuch as a final version of her dissertation was not available, all quotes are from earlier drafts of this document. To avoid confusion with the completed version, no page numbers will be cited.

Mrs. Huntington received a letter from a relative in San Francisco, where Watkins was still at Murray's bookstore: "I see Murray everyday as well as Watkins . . . they are in good health and I think doing well."[32] Likewise, on 11 October, Collis Huntington wrote his brother Solon: "I heard from Carleton a few days sins [*sic*] he was well, as I believe all the Oneontans are."[33]

For the remainder of the period there is no further evidence of Watkins's activities. Some inferences however may be drawn primarily from external sources and suppositions. Now thirty-one years of age, Watkins must have undergone many life changes, not the least of which occurred in his professional life; from modest beginnings as a clerk in a bookstore he had become a full-fledged landscape photographer. In the process he had made friends, both other professionals and members of local society; some of them were to prove crucial to his photographic progress during the next few years.

His most significant social contacts were surely made in the cosmopolitan drawing room of Mrs. John C. Frémont's new home at Black Point overlooking the Golden Gate. Jessie Frémont was the daughter of Thomas Hart Benton, senator from Missouri and powerful supporter of the principles of Manifest Destiny. She catered to the intellectual elite of San Francisco, among them Thomas Starr King (1824–64), pastor of the First Unitarian Church of San Francisco. Starr King, author of a book extolling the White Mountains of New Hampshire, had also completed a series of articles describing the scenic wonders of California, including Yosemite. These were published serially in the Boston *Evening Transcript* in 1860–

61[34] and created a great deal of public interest in California's landscape. Through Starr King, Watkins received an introduction to Ralph Waldo Emerson as well as to the landscape painter Albert Bierstadt. In the ensuing years Watkins maintained close ties with several Western landscape painters including Virgil Williams, Thomas Hill, Gilbert Munger, and William Keith. Bret Harte, Herman Melville, Richard H. Dana, and others of San Francisco's literary figures also gathered in Jessie Frémont's salon.

Perhaps the most useful introduction, however, was to members of the California State Geological Survey, formed in 1860, under the direction of Josiah Dwight Whitney (1819–96). Whitney and his principal assistant, William Henry Brewer (1828–96), were soon to become Watkins's greatest champions. With their enthusiastic help, he made many useful contacts with the scientific community at Yale University and elsewhere and underwent an even greater metamorphosis—

32. C. R. Saunders to Mrs. Huntington, 20 April 1854, private collection, San Marino, California; citation courtesy Nanette Sexton.

33. Collis Huntington to Solon Huntington, 11 October 1854, private collection, San Marino, California, citation courtesy Nanette Sexton.

34. *Boston Evening Transcript*, 1, 15, 31 December 1860; 12, 19, 26 January and 2, 9 February 1861. Starr King came to California in April 1860. Like Ruskin, Starr King tried to articulate the moral import of nature; he was widely respected in San Francisco and had a major influence on Watkins's attitude towards landscape. He was also deeply involved in pro-Union activism; J. D. Whitney, for instance, called him "the perfect Republican." Jessie Frémont was an astute and influential figure in her own right. Useful insights may be found in Catherine Phillips, *Jessie Benton Frémont, A Woman Who Made History*; also Irving Stone, *Immortal Wife*. Starr King frequently wrote to his friend Rev. Dr. Henry W. Bellows of New York about Jessie, and always in favorable terms: "I rode to Mrs. Frémonts, two miles off, and sat in her lovely cottage, hearing her talk and enjoying it. . . ." (10 September 1860); also, "I have just returned from Mrs. Frémont's where I have made a visit with Herman Melville" (19 October 1860). These, and many additional references to their friendship are found in the Thomas Starr King Papers. For an interesting account of Starr King in California, see Charles W. Wendte, *Thomas Starr King: Patriot and Preacher*.

from talented photographic craftsman to photographic artist specializing in the image of nature.

As a landscape photographer Watkins is best remembered for his pictures of Yosemite. Not only did he achieve many of his artistic successes there, but Yosemite also became more widely known and appreciated because of the eloquence of his vision. Albert Bierstadt, for example, was so taken with Watkins's Yosemite photographs that he called him the "Prince of Photographers" and frequently used his works as models for paintings. In 1864 the United States Congress, convinced in large measure by Watkins's images, moved to preserve Yosemite as forever "inviolate."

Watkins traveled to Yosemite frequently, first in 1861, and again in 1865 and 1866 as part of the California State Geological Survey. He made later trips as well, in 1872, 1875, 1878, and 1879 to 1881. This twenty-year output of Yosemite photographs reveals changes in Watkins's vision; some were due to the complex pressures of adapting to the marketplace, but others were subtle shifts in his perception.

Although Yosemite had been seen by white men as early as 1833, it remained virtually unknown in the eastern United States until 1856. In that year the widely read *Country Gentleman* republished an article from the *California Christian Advocate* which declared the "Yo-hem-i-ty" valley to be "the most striking natural wonder on the Pacific," and predicted its eventual emergence as a place "of great resort."[35]

James Mason Hutchings (1820–1902), a transplanted Englishman, became Yosemite's greatest advocate; he formed

35. "The Yo-hem-i-ty Valley and Falls," *Country Gentleman*, 8 October 1856. The first published description of the valley was printed in the *Mariposa Gazette*, 12 July 1855. The Coulterville Trail into the valley was completed in 1856 and the first hotel in 1858. Early tourists took the ferry from San Francisco to Stockton (about 125 miles) and then transferred to a stagecoach for another hundred miles; the final forty miles was done on horseback, requiring nearly twenty hours of perilous travel.

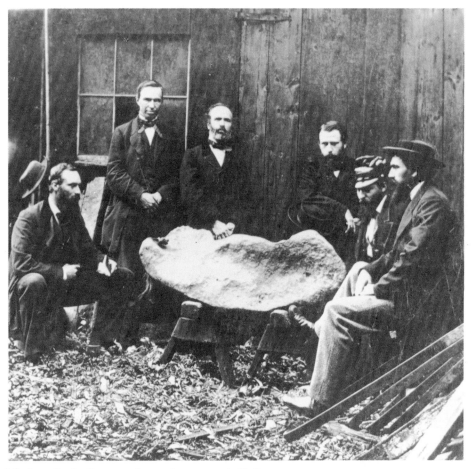

[*Carleton Iron*], albumen silver print, stereo half #410, 1862.
From the Collections in the Library of the Arizona Historical Society.

Members of the California State Geological Survey from left to right: William H. Brewer, William Ashburner, Josiah Dwight Whitney, William M. Gabb, Chester Averill, and Charles F. Hoffman.

the first tourist party to Yosemite in 1855, taking with him the pioneer California artist Thomas A. Ayres (1816–58). During this trip Ayres produced the earliest sketches of the valley which, together with subsequent travel guides, gave Yosemite national publicity. In 1857 a *Panorama of the Yosemite Falls and Valley*, on canvas, was underway.[36] This artistic enterprise enjoyed some success "although it be on canvas," but served primarily as a challenge to more realistic representation, setting the stage for photography.

C. L. Weed was the first to capture Yosemite on glass, in June of 1859. He made at least twenty large negatives and approximately forty stereographic negatives, all by the wet-plate process. The San Francisco *Daily Times* reviewed these images in glowing terms:

> Every important place about the valley, the giant cliffs, the huge pines, the memorable waterfalls and cataracts and in fact all but the reality is vividly depicted . . . each tree, rock, sprig, and cliff seems to stand out boldly and clearly. The great waterfalls, glistening in the sunlight, are seen leaping out from the crags and hang in mid air as clearly as if witnessed in nature.[37]

Despite Weed's accomplishment Watkins, no doubt prompted by friends like Starr King, resolved to capture the true "sublimity" of Yosemite's grandeur. Starr King had visited

Yosemite Falls 2630 Feet, albumen silver print, stereo half, negative 1861, print c. 1873. Collection of Louis H. Smaus.

Travel to Yosemite was still very difficult in 1861, and hazardous as well. This view probably shows the Lady Jane Franklin party which visited the valley at the same time as Trenor Park's excursion.

the valley in July 1860 and his reaction upon reaching Inspiration Point reveals the minister's concept of nature as an extension of God's handiwork: "God's purpose in creating such glories was not to receive our poor appreciation, it is to express the fullness of his thought, the overflow of his art, the depth of his goodness."[38] In any event, large, detailed photographs of the valley would help to share the awesome beauty on a wide scale.

36. "Panorama of Yosemite," *Mariposa Democrat*, 29 April 1857. Known as the "Mann Brothers" panorama, it was painted by "Mr. Claveau," who is also credited with painting "Panorama of the War in the East," which was exhibited in California during the 1860s. Hutchings is known to have employed the services of a daguerreotypist as early as 1854 in order to aid in the production of a lettersheet showing the Big Tree of Mariposa. He often used photographs in the preparation of illustrations for his *California Magazine*.

37. "Ho! For the Yo-Semite Valley," *San Francisco Daily Times*, 15 September 1859.

38. Thomas Starr King, *A Vacation Among the Sierras*, p. xx.

Watkins had many practical matters to ponder. In 1861, taking a giant camera and cumbersome wet-plate apparatus to the remote valley was an immense undertaking. Even without baggage the journey to Yosemite was daunting to all but the most hardy. Trails were primitive and dangerous, conditions which made enormously difficult the task of transporting fragile glass plates on the backs of mules or horses. To accomplish his objective, Watkins had to transport all the needed paraphernalia—mammoth camera (about thirty inches on a side and at least three feet in length when extended), stereoscopic camera, tripod(s), darktent, glass plates (stereo as well as mammoth size), chemicals and processing trays, numerous accessory photographic items, plus sufficient camping provisions for a sojourn of several weeks in the valley.

Watkins's large glass plates weighed nearly four pounds apiece.[39] A revealing comment made during a similar excursion to the valley in 1865, provides some idea of the magnitude of his undertaking: "Watkins [is going to Yosemite] with material for a big 'take' . . . there and back over 2000 lbs of baggage [and] glass for over 100 big negatives."[40] A single misstep by a pack animal bearing a summer's output of precious negatives would have had disastrous consequences for Watkins.

It is likely that Trenor Park helped make Watkins's 1861 trip possible. Renting pack animals, procuring needed sup-

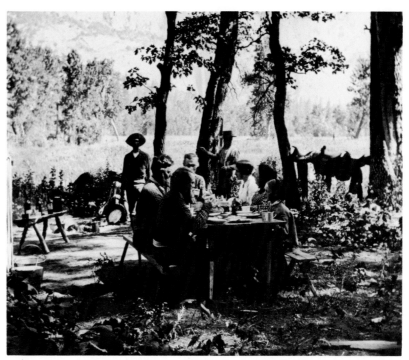

In Camp No. 3, Yosemite [Trenor Park Party], glass stereograph, half-view, 1861. California Historical Society, San Francisco.

plies, and buying photographic materials would have been expensive for Watkins. Since Park and his family visited the valley at the same time, they probably provided the necessary pack animals and trail assistance. Evidence that they traveled together on this trip is nicely shown by a Watkins stereo view of the Park family seated around a rustic table in the valley. Many years later Park's daughter (age thirteen in 1861) clearly remembered that "the descent into the valley from the rim at Inspiration Point was unspeakable—the narrow path dropping down almost direct in some places; the animals unable to step—bracing their legs and sliding down . . . I remember at

39. One of Watkins's eighteen-by-twenty-two-inch negatives is located in the Research Library, Yosemite National Park, California.

40. William Henry Brewer to Josiah Dwight Whitney, 14 August 1865, William Henry Brewer Correspondence with Josiah Dwight Whitney, 1860–1885 [Brewer-Whitney Correspondence]. Some writers have inferred that Watkins traveled to Yosemite alone, or with very little assistance. This is highly unlikely. Mules can carry loads of up to 250 pounds but, even so, it would have required at least a dozen mules to carry the items described. Guides, packers, and at least one photographic assistant—Watkins used at least six during a trip in 1866—would have been needed.

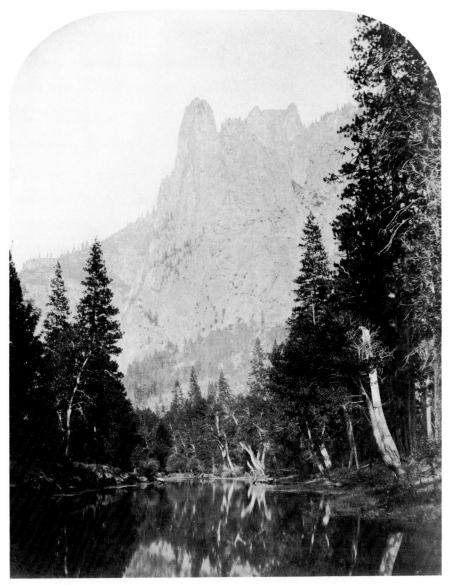

The Sentinel, 3,270 Feet, Yosemite, albumen silver print, 1861.
The Bancroft Library, University of California, Berkeley.

Watkins frequently rose at daybreak to photograph before the winds came; exposures sometimes lasted as long as one hour.

one place I begged my guide to let me get down and walk."[41]

Getting to Yosemite was only part of the struggle. Viewpoints had to be scouted and the darktent erected within easy reach, often precariously on a slippery hillside or granite ledge. Brush and trees as well as the weather were other factors to be contended with. Water was essential and often had to be carried great distances by bucket. Dust and grit frequently settled on the wet negatives or penetrated the working parts of his equipment. Applying a smooth and unblemished coating of collodion was difficult even on small plates in a studio setting; Watkins's negatives, largest in the West at that time, required considerably more skill and patience. Contemporary photographers marveled at Watkins's ability to handle and coat these plates in a darktent only slightly larger than himself. Whitney described the dust in California as "something beyond *anything* you ever dreamed of."[42]

The summer sun warped and shrank camera parts and plate holders. The black darktent was rendered almost un-

41. Eliza Hall Park McCullough, *Within One's Memory*, pp. 51–52. Citation courtesy of Muriel Palmer. In a letter dated 12 July 1861, Mrs. Park notes: "We left Bear Valley [for Yosemite] on the morning of the 8th, our party consisting of Train [Trenor Park], Lizzie, Mrs. Lacy, Cal., Mr. Marsh, Mr. Northrop, Mr. Hays, Mr. Trimmer and myself." The party traveled most of the day before they joined with the rest of their group and prepared for the final leg of the journey. Arising at 5 A.M. the next morning they traveled the remaining 35 miles to Yosemite Valley: "Our camp is just in front of the Yosemite Falls." The party stayed in the valley until July 15th. Laura Hall Park to "My Dear Mother," Park Papers. On 5 November 1861, she wrote: "Mr. Watkins is finishing up his pictures, says he will bring them up here when he gets them done . . . I want to see them very much." Laura Hall Park to Trenor Park, Park Papers.

42. Josiah Dwight Whitney to "My Dear Father," 31 July 1861, in William Dwight Whitney Family Papers. During the 1870s William Henry Jackson used a camera which made twenty-by-twenty-four-inch negatives; however, this is by no means a record. In 1876 B. O. Holtermann and his staff made glass negatives of Sidney, Australia, measuring five feet by three feet, two inches!

bearable by midday and was not much better at other times. Wind caused leaves and branches to move, ruining Watkins's efforts to achieve pictorial sharpness. Often he made his photographs in the predawn light, with exposures lasting up to one hour, to avoid wind and to take advantage of the morning coolness. Under these conditions it was a good day indeed when Watkins was able to complete as many as four of his large negatives.

Establishing an efficient working routine was essential; the photography was time-consuming, and it was important to make the most of each day. William Bell, photographer for the Wheeler Expedition along the hundredth parallel in 1872 wrote that his daily regimen was "not all ease and comfort." Undoubtedly his typical day in the field was similar to Watkins's:

> I arise at 4 a.m.; feed the mule; shiver down my breakfast; mercury at 30°, candle dim, cup and plate tin; my seat, the ground. After breakfast I roll up my bedding, carry it up to be loaded on the pack mule, water and saddle my riding mule, and by that time it is broad daylight. If negatives are to be taken on the march the *photographic* mule is packed with dark-tent, chemical boxes and camera, and out we start . . . having found a spot from whence three or four [views] can be had, we make a station, unpack the mule, erect the tent, camera, etc. The temperature has risen from 30° to 65°. One finds difficulty in flowing a 10 x 12 plate with thick enough collodion to make a sufficiently strong negative without redevelopment, and to have a plate ready for development that has not dried, on account of the distance the plate has been carried, and [the] time intervening between sensitizing and development . . . these troubles are constant.[43]

During his 1861 Yosemite trip, Watkins produced thirty mammoth and one hundred stereoscopic negatives (Plates 8 through 18). The stereo format proved to be economically prudent and encouraged his growing commitment to outdoor photography for sale. Light-weight stereo equipment made fieldwork relatively easy, even in nearly inaccessible locations. Moreover, by 1861 public demand for stereo views was creating a fashion craze. Baudelaire remarked in 1859 that "a thousand hungry eyes were bending over the peepholes of the stereoscope, as though they were the attic-windows of the infinite."[44]

While it has been suggested that Watkins considered stereographs less important than his mammoth views of the same subject, we must not lose sight of the significance of the stereoscopic medium itself. When placed in a viewer a stereograph occupies the entire field of vision, so that the illusion of reality is far greater than with a mammoth photograph.

Recognition for Watkins's first Yosemite images was confined mainly to his small circle of friends. On 31 January 1862 W. H. Brewer of the state geological survey visited Watkins, later noting in his diary: "A rare treat this afternoon, saw a set of magnificent photographs of Yosemite Valley, the finest I have ever seen."[45] He immediately arranged for J. D. Whitney and others to review them as well. The word spread, and on April 13 Oliver Wendell Holmes, a great advocate of photography and particularly of stereographs, wrote to Starr King: "I wonder if you could for love or money procure me a stereoptic view of the great pines?"[46] Watkins immediately posted him twelve glass stereographs, which Holmes later praised as be-

43. William Bell, "Photography in the Grand Gulch of the Colorado River," *The Philadelphia Photographer* 10, no. 109 (January 1873): 10.

44. Vicki Goldberg, ed., *Photography in Print*, p. 124.

45. Diary of William Henry Brewer, 31 January 1862, Brewer Diaries and Journals. On 13 July 1862 Brewer purchased Yosemite views: "Up to Watkins in the morning, selected a set of photographs and a set of stereoscopic slides . . . pd for photos $110."

46. Oliver Wendell Holmes to Thomas Starr King, 7 April 1862, in Thomas Starr King Papers.

ing "in a perfection of art which compares with the finest European work."[47]

As early as November 1862, Starr King had also succeeded in placing Watkins's photographs in the hands of such an influential person as Ralph Waldo Emerson. The grateful Emerson wrote to Starr King, thanking him profusely for the favor and expressing his own satisfaction with the views. This enthusiasm soon bore additional fruit; by December 1862 Watkins's large Yosemite photographs had been placed on display at the prestigious Goupil's Art Gallery in New York City.[48]

The photographic press also praised Watkins's work for its verisimilitude and artistic eloquence; by the mid-1860s Watkins's Yosemite images had become a standard for evaluating landscape photography. The Reverend H. J. Morton, a great admirer of photography and frequent writer for the *Philadelphia Photographer*, remarked on the public significance of Watkins's accomplishment:

> [His] photographic views, which open before us the wonderful valley whose features far surpass the fancies of the most imaginative poet and eager romancer . . . without crossing the continent by the overland route in dread of scalping Indians and waterless plains; without braving the dangers of the sea by the Chagres and Panama [sea] route; nay, without even the trouble of the brief land trip from San Francisco, we are able to step, as it were, from our study into the wonders of the wonderous valley, and gaze at our leisure on its amazing features.[49]

47. Oliver Wendell Holmes, "Doings of the Sunbeam," *Atlantic Monthly* 12, no. 69 (July 1863): 8. In appreciation, Holmes sent Watkins a copy of his published poems.
48. "California Scenery in New York," *North Pacific Review* 2, no. 7 (February 1863): 208.
49. H. J. Morton, "Yosemite Valley," *The Philadelphia Photographer* 3, no. 36 (December 1866): 377.

General French's Rooms—Senate, published by E. & H. T. Anthony & Co., albumen silver print, stereo half, 1869–1879. Amon Carter Museum.

The Watkins Yosemite views that helped persuade Congress to set the area aside for permanent protection are seen here in the office of John Robert French who served as Sergeant at Arms for the United States Senate from 1869–1879.

Such comments had a national impact, and it is understandable that Watkins's photographs should prove instrumental in the preservation of Yosemite. Some members of Congress even used his images as office decor. The Yosemite Bill was signed into law by President Abraham Lincoln on 29

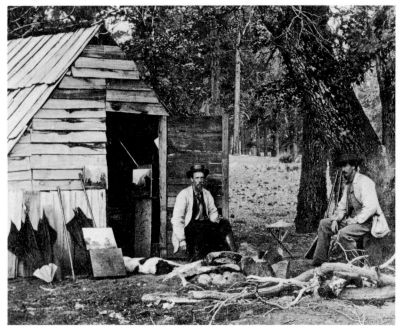

In Camp, Yosemite [Virgil Williams and Thomas Hill in Yosemite],
albumen silver print, stereo half, c. 1865. Yosemite National Park.

Landscape painters Virgil Williams and Thomas Hill were close friends with
Watkins. In 1865 Yosemite commissioner Frederick Law Olmsted asked the
three men for their opinion concerning the best uses of the region.

June 1864; by September the first Yosemite commissioners
had been appointed. The chairman was Frederick Law Olm-
sted (1822–1903), who had been chief architect for New
York's Central Park. Olmsted immediately wrote a letter solic-
iting Watkins's opinion as to the best way to preserve and
enhance the beauty of the valley. Although the request prom-
ised no financial reward, the implied honor was unmistakable.[50]

The Yosemite photographs had clearly summoned broad,
popular support for the preservation of the American wilder-
ness far beyond the simple documentation of geological struc-
tures. Edward L. Wilson, editor of the *Philadelphia Photogra-
pher*, must have had this in mind when he wrote: "It has been
said that 'the pen is mightier than the sword,' but who shall
not say that in *this* instance, at least, *the camera is mightier than
the pen?*"[51]

Watkins's Yosemite images were influential both as art
and as sources of information. In an effort to define his land-
scape aesthetic, art scholars have observed that his mammoth
photographs made their appearance at about the same time
as large landscape painting in California. In a sense Watkins
competed with landscape painters. Although he could sell un-
limited copies of his prints, there were some limitations:

> Unlike a painter, he could not move mountains and elim-
> inate the trees, rocks and debris which obstructed his
> view. Also his control of tonality was severely limited by
> the requirements of his chemicals. Skies, which were
> often the painter's vehicle for dramatic effect were impos-
> sible to achieve in a negative.[52]

In recent years considerable interest has emerged as to
the influence of landscape photographers on landscape paint-
ers. Albert Bierstadt, for example, is known to have purchased
a large body of Watkins's Yosemite work, and both William
Keith and Thomas Hill were staunch admirers as well. Al-
though aesthetic exchange between painter and photographer
was widespread, not everyone approved of the practice; one
reviewer of Hill's Yosemite paintings was unreservedly sarcas-
tic about his reliance on photographs: "It must be a strain

50. Frederick Law Olmsted to Messrs. Williams, Hill, and Watkins, 8
August 1865, as quoted in Hans Huth, "Yosemite: The Story of an Idea,"
Sierra Club Bulletin 33, no. 3 (March 1948): 70.

51. Edward L. Wilson, ed., "Views in the Yosemite Valley," *The Phil-
adelphia Photographer* 3, no. 28 (April 1866): 106.
52. Sexton, "Watkins."

upon an artist to produce so many pictures from memory, but then we have known artists who essayed large Yosemite views from points which they have never visited, but which their friend the photographer had."[53]

Most critics agree that it is Watkins's masterful use of light that best distinguishes his Yosemite photographs from those of lesser artists. Patterns of light and dark areas forcefully emphasize the immensity of Yosemite's monolithic structures and give a dynamic quality to his scenes. (Plate 18)

> The brightest elements in Watkins' views of the valley are invariably the geological structures—equally they are the most lucidly described. But the strength of Watkins' photographs is not . . . in the heights, the vastness of the sweep of the valley, the mysteriousness of the giant sequoias, or even in the predictable responses to the melodramatic valley. Rather, it is within the finely honed balance of his dramaturgy. Each natural part of the valley claims to define itself and its sense of sweep, thrust, and energy, its feeling of upheaval. Watkins balances all these contradictory claims; he fits all the parts together so that nothing overwhelms. And by so doing he asserts his own artistry against man's generalized sense of awe of nature.[54]

Although Watkins gained considerable recognition for his 1861 Yosemite photographs, the reception was limited by

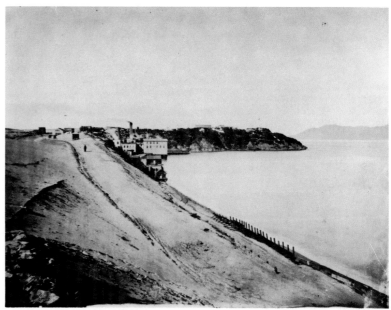

[*View of Black Point, San Francisco*],
albumen silver print, unmounted stereo half, c. 1864.
Collection of Western Americana,
Beinecke Rare Book and Manuscript Library, Yale University.

national preoccupation with the Civil War. His greatest potential market was in the East, where money remained tight throughout the period. California itself was little affected, however, and Watkins was able to pursue his career without interruption. These years were relatively productive for him; he made some fine stereographs of San Francisco which were taken serially to form panoramas of the growing metropolis. His favorite vantage points were the heights of Telegraph Hill and the observatory on Russian Hill (Plates 27, 28).

In 1863 he made two fine series of mammoth views. The first pictured mining and manufacturing facilities at the New Almaden quicksilver mines near San Jose (Plates 19, 21); one

53. "Art Jottings," *California Mail Bag* 7, no. 2 (June 1875): 116–117. A collection of Watkins's photographs, donated to the Oakland Museum History Department, was found in the attic of the home of Thomas Hill's grandson. The group includes Oregon and Yosemite images; many have tears and holes where tacks were used to fasten them to the wall—presumably for Hill's use as an aid to his painting. Information courtesy Pauline Grenbeaux.

54. John Coplans, "C. E. Watkins at Yosemite," *Art in America* 66, no. 6 (November/December 1978): 106.

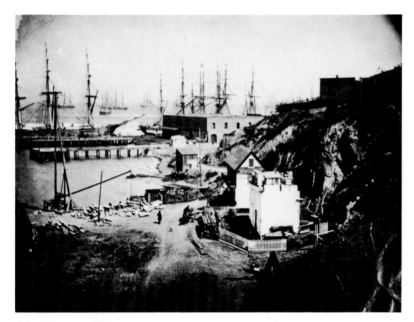

[San Francisco Waterfront],
albumen silver print, unmounted stereo half, c. 1864.
Collection of Western Americana, Beinecke Rare Book and Manuscript Library, Yale University.

Before 1870 Watkins traveled about the San Francisco region in an open wagon, setting up his portable darktent at each site to be photographed. His tent may be seen in the lower right foreground of this view.

of the finest images is *The Town on the Hill*. A larger, visually exceptional group features lumbering activities along the Mendocino Coast, north of San Francisco (Plates 22–25). Watkins reached Mendocino by steamer, then traveled to photographic sites with his equipment and darktent in an open wagon; he camped on the beaches. Most of the lumber mills were on the mouths of rivers at Albion, Noyo, and Big River. Watkins took more than fifty mammoth photographs and approximately one hundred stereographs. Among them were pictures of the Page Lumber Mill (at Big River), which burned

The Town on the Hill, New Almaden, albumen silver print, 1863.
The Huntington Library, San Marino, California.

to the ground on 17 October 1863; "before" and "after" photographs attest to Watkins's presence.[55]

Both the New Almaden and Mendocino negatives were excellent, unblemished by the streaking and unevenness that had flawed his work at Mariposa. The images are compositionally refreshing as well, an indication of self-assurance and growing competence with the giant camera. As in all his earlier work, the prints were dome-topped, or rounded, on the upper corners. In part this was done to eliminate darkened corners caused by the failure of the lens to cover the entire

55. Examples of Watkins's New Almaden photographs may be seen at the Huntington Library, San Marino, California. The Jerome B. Ford collection of Mendocino images is held by the Bancroft Library, Berkeley. Ford, a major mill owner in Mendocino, probably commissioned the latter series. Watkins also made stereographs in both locations.

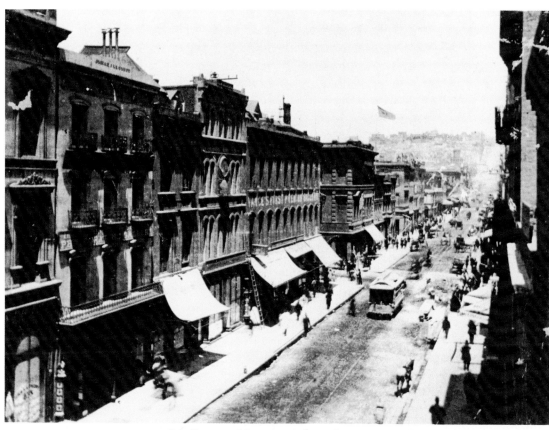

San Francisco Montgomery Street, Instantaneous, Corner California Street, Looking North, unknown photographer, albumen silver print, 1863–1864. Lester Silva Collection.

San Francisco's Montgomery Street was a prime location for photographers during the 1860s. Watkins's studio location at 415 Montgomery is in the extreme left of this scene. To the right are Hamilton & Shew at 417 Montgomery, William Shew at 421 and 423 Montgomery, and Bradley & Rulofson at 429 Montgomery. In 1865 Watkins relocated to 425 Montgomery Street.

plate evenly; the fault would have been particularly apparent in the sky area.[56]

While it is difficult to gauge Watkins's financial condition precisely for these early years, Nanette Sexton has compiled a listing of his sales for 1864 drawn from his "Daily Pocket Remembrancer" of that year. Her inventory reveals an income of $1,345 from mammoth-plate views and $464.25 from stereographs; his total income for 1864 was $2,926.22. "The income from the Yosemite photographs [from negatives made in 1861] was $1,223.53, Mendocino yielded $827.75 and New Almaden $185.74 . . . indefinite sources, copywork, portraits, etc., $880.75." Sexton concludes that Watkins was making the very good living of nearly fourteen dollars a day, "substantially more than his friend [W. H.] Brewer, who was making five dollars a day with the Geological Survey . . . if and when he was paid."[57] During this period he occupied a gallery on Montgomery Street.

At least one limitation to success existed, however: Watkins was not alone in the field of large-view production. His major challenger was Charles Leander Weed, the first to photograph Yosemite in 1859. Outmaneuvered by Watkins's 1861 Yosemite mammoths, Weed made a similar set in 1864; that fall the two men competed at the San Francisco Mechanics' Fair and Weed won. This was not to be the last of such confrontations between the two photographers, which produced a very unsettling milieu for Watkins. Another photographer, Nathan M. Klain, used a mammoth camera in 1864 for views of San Francisco, which also served to erode Watkins's commercial prospects at a time when he was just beginning to ex-

56. It may also have been a stylistic touch; many paintings and engravings of the period share this characteristic. After 1864 Watkins's prints are square cornered. In later years Watkins frequently masked his negatives to insure blank sky areas.

57. Sexton, "Watkins." Watkins's "1864 Daily Pocket Remembrancer" is a notebook in the Watkins Miscellaneous Papers, Bancroft Library, Berkeley.

perience some success in selling views directly to the public.[58]

In the spring of 1865 the Civil War finally ended. Few Americans had not suffered some loss in the agony of this conflict; for the survivors it was time to withdraw from all memory of the battlefields, a time of reflection, taking stock, and making plans for the future. Many turned westward. Not only did the West offer respite from the recent horrors but also the golden promise of spiritual and economic prosperity.

The federal government also took a great interest in the West, once again sponsoring the exploration and surveys abandoned during the war. The decade following 1867 was a particularly active one. Government patronage and talented wet-plate photographers, such as Alexander Gardner and Timothy O'Sullivan, associated during the war with Mathew Brady, led to one of landscape photography's finest eras.

Survey photographers generally were part of a closely knit team of scientists and trained observers. They worked hard and were often poorly paid for their efforts. Survey photographers were, however, insulated from a very harsh reality—the business of marketing landscape photographs. Inasmuch as the government was the primary customer, these photographers could concentrate on images that effectively documented an area, rather than concerning themselves with views that would sell. An extra bonus was the possibility that their images would survive to serve as a significant record of the fast-changing frontier.

Watkins did not become formally associated with the California State Geological Survey until 1865, but he had previously worked for individual members. J. D. Whitney, for instance, used Watkins's 1861 Yosemite images to illustrate *Report of Progress for 1860–1864*, which was published in 1865.[59] Also, from time to time he had copied maps for Charles F. Hoffman (1838–1913), the survey's talented topographer. Many of the survey members were, or would become, close friends.

Watkins's early association with members of the California State Geological Survey gave him several years head start in the principles of survey photography. If the Guadalupe, San Antonio Rancho, and Mariposa Estate images may be considered topographic survey commissions, then, this experience began as early as 1857. This fact is all too frequently overlooked in comparisons of Watkins's survey photographs with those of others working after 1867, in particular William Henry Jackson (1843–1942), John K. Hillers (1843–1925), Andrew J. Russell (1830–1920), Charles Roscoe Savage (1832–1909), and Timothy H. O'Sullivan (1840–82).

Unlike the early explorations, surveys of the 1860s emphasized systematic study of a region's geology and biology, and scientific mapmaking. Just as the survey leader had to select the best possible scientists, capable of working under hardship, it was also essential to have the best possible photographer; the survey's regard for Watkins was very high and without reservation.

58. Weed's mammoth images, as well as a large issue of stereographs, were marketed by the firm of Lawrence & Houseworth, a powerful competitor in photographic publishing. Details may be found in Peter E. Palmquist, *Lawrence & Houseworth/Thomas Houseworth & Co.: A Unique View of the West 1860–1886*. Watkins's field trips kept him away from San Francisco for extended periods, severely curtailing his efforts to market his landscape photographs; he even lacked a permanent business location until the late 1860s.

59. Whitney explains his selection of Watkins's images, rendered as woodcut engravings, in the following statement: "To make the peculiar features of the Yosemite more enjoyed, which is the next best thing itself . . . the admirable photographs of Mr. C. E. Watkins." Whitney confirms that there were thirty mammoth images taken in 1861, and notes that the glass stereographs "are in some respects even more effective than the [large] photographs." All of Watkins's views were used "by permission," which should be construed to mean that no fee was paid. Josiah Dwight Whitney, *Report of Progress for 1860–1864*, p. 408.

Clarence King wrote this tongue-in-cheek comment to W. H. Brewer in December 1863: "How kind it was of the Indians to shoot the other Watkins [no relation to Carleton] and let the immortal one go free . . . providence will take care of him I am sure till he has 'taken' Mt. Shasta and the Mono Lake region."[60] King and Watkins did actually make a trip in 1870 to photograph Mt. Shasta.

The California surveys differed from federal surveys in various ways. The most important, from Watkins's point of view, was the scarcity of funding. The survey paid him directly for photographic services, such as map copying, but not a regular stipend. Thus, while his two-year association with the survey was a time of great technical maturation, it was also an unfortunate digression from the important business of making money.

When Watkins joined the survey for the 1865 season, his goals were several: to provide photographs useful to the California State Geological Survey (and scientists generally); to capitalize on the international interest that had been generated by Yosemite's status as a national park; to gain new stock for his personal plan to publish sets of Yosemite photographs in albums; and to demonstrate his ability to produce landscape images that would surpass those of C. L. Weed.

Watkins was under way by early July on this trip that required "2000 lbs of baggage" and "enough glass plates for 100 big negatives." Turrill noted that it required "at least twelve mules . . . to pack the outfit of the indomitable photographer."[61] Even the writers for the *Gazette* of Mariposa, a jumping-off place for Yosemite, marveled at the entourage: "There will undoubtedly be some good pictures taken of the valley this season, on account of the great number of artists visiting it . . .

last week a party passed through here with their [photographic] machinery, and another left San Francisco [headed by one of Watkins's assistants], Friday the 28th of July."[62]

Work continued from July through August. On September 9 the *Gazette* observed that "Mr. Watkins the artist . . . and others came out of the Yo Semite Valley and voted in the election."[63] A week later it was announced that Watkins was returning to San Francisco: "He has completed his business in the Yo Semite and Big Trees for this season."[64]

Fieldwork for 1865 finished, Watkins and his assistants now turned to the immense task of printing the season's output of view negatives. Writing to Brewer in December, Whitney described the progress of this work:

> Watkins is now at work printing from his new set of Yos. photos some of which are perfectly beautiful. He took 30 large ones . . . [and] has also taken 30 smaller ones (13″ x 9½″) perfectly lovely, which he intends to use after taking a lot more and then selecting the best & making a book [albums for sale to the public] of them of which he does not want anything said, lest the plan be known [to a competitor].[65]

Early in 1866 Watkins sent six of his new mammoth Yosemite images to Edward L. Wilson at the *Philadelphia Photographer*. Wilson's enthusiasm was total: "At no time has our table been graced and favored with such a gorgeous contribution."[66] Meanwhile, the members of the survey made plans for

60. Clarence King to W. H. Brewer, 18 December 1863, in William Henry Brewer Papers, Yale University Library, New Haven. King joined the California State Geological Survey in 1863.

61. Turrill, "Watkins," p. 32.

62. "Artists in Yo-Semite Valley," *Mariposa Gazette*, 5 August 1865.

63. *Mariposa Gazette*, 9 September 1865.

64. Ibid., 16 September 1865.

65. Whitney to Brewer, 15 December 1865, Brewer-Whitney Correspondence.

66. Wilson, "Yosemite Valley," p. 107. Wilson continued with his praise: "We never saw trees that were more successfully photographed. There seems to have been no wind, and the very best kind of light."

the 1866 season. High on their list of priorities was a proposal that Watkins produce a set of photographs specifically for use in a publication to be called "The Yosemite Book." Inasmuch as Watkins's Globe lens made images that were far too large for this purpose, a new lens was needed. Whitney wrote to Brewer, who was now in the East, asking him to obtain one of the new Dallmeyer lenses that had just appeared on the market. During the exchange of correspondence a nasty little swindle came to light—Watkins's 1861 Yosemite photographs were being copied and sold at cut-rate prices in New York.[67]

> Do I understand that the Yosemite photographs sold by Appleton are copies and pirated from Watkins' pictures? —if this be so I will make it known surely. I have several times told enquiring persons that Appleton has Watkins' pictures for sale, as I saw sets there which I supposed were his. Why don't Watkins copyright his pictures and why don't he have an agency subscription where people can select the most beautiful & striking pictures. There would be a continual sale.[68]

The piracy was crippling Watkins financially. "He complains that all the photographers in the East are stealing his pictures and underselling him."[69] It was hard enough to sell landscape photographs without having to compete with his own outlets. By March Whitney wrote that: "Watkins has been as poor as poverty all winter . . . in the first three months after he returned from the Yos., he did not get $200 in orders."[70] By April the report was even gloomier: "Watkins is in poor health . . . I fear he may not be able to go to Yosemite [in 1866] after all."[71] Although Watkins did recover his health in time to rejoin the survey, his fiscal difficulties continued.

> When in Philadelphia I found a scoundrel copying Watkins' earlier pictures and selling the reduced copies at two dollars each—I went in and had the satisfaction of expressing myself very freely on the matter—but of course what good does it do—They were Germans, and they claimed that as the pictures were not copyrighted "anyone has a right to copy them." I found that any appeal to their honor had but little effect and left in disgust.[72]

Although pirating was morally outrageous, Watkins was in a bind legally; before 1865 copyright laws did not protect photographers. His 1861 Yosemite views were especially vulnerable in this regard. As a result of his experiences Watkins made it a point to rephotograph many of his earlier sites during 1866; however, he did not complete copyright procedures until 1867.

67. The Appleton forgery, described by Whitney, was a copy of an album of 1861 Yosemite views with an 1863 title page, which had been sent to New York. The Appleton version was issued as an album of thirty images, reduced from the original mammoth size to 6½ by 8½ inches, with a new title page: *Album of the Yosemite Valley, California*, D. Appleton & Company, 443 & 445 Broadway, New York. A copy of this forgery is held by the Huntington Library, San Marino, California. Because of the 1863 title page, many writers have credited Watkins with a trip to the valley in that year. The date is merely that of the album's assembly. More confusion was caused by the fact that Watkins photographically copied this title page for use in albums of various sizes over a period of years; some of these later editions contain images from his 1865–66 visit to Yosemite. See the listing of albums for additional examples.

68. Brewer to Whitney, 10 March 1866, Brewer-Whitney Correspondence.

69. Whitney to Brewer, 8 February 1866, Brewer-Whitney Correspondence.

70. Ibid., 19 March 1866, Brewer-Whitney Correspondence.

71. Ibid., 14 April 1866, Brewer-Whitney Correspondence.

72. Brewer to Whitney, 5 January 1867, Brewer-Whitney Correspondence.

The California state geological party of 1866 included Clarence King, James T. Gardner (or Gardiner), Henry N. Bolander, Charles Brinley, and two helpers. Packers, guides, and other assistants were also employed as needed. This was to be a big season for Watkins, and he may have had as many as six helpers; not all of them were in the field at once, as the work seems to have been done in stages. While King was the leader of the field survey party, Whitney also accompanied the survey during part of the June to October season. Whitney was especially interested in the progress of Watkins's photography. On May 6 Whitney advised Brewer that Watkins was ready to leave for Yosemite in about a fortnight: "he will take our views [for the proposed "Yosemite Book"] for us with our Dallmeyer [lens]. Then we can use them for making wood cuts from, or publish [them] as photographs in the book; or have the negatives reproduced as photolithographs, if the science [of photolithography] can get as far ahead as that."[73]

By July 5 Whitney was able to report substantial progress:

Watkins is on the spot, with a most wonderful camp, and has taken many fine pictures, some of these I think will surpass anything he has ever had—especially the trail views from the Mariposa trail & a spectacle from a spot two-thirds of the way down [the canyon wall] which we all think gives the best general view of the valley, and which Watkins thinks his best picture. He took views from high points—from Inspiration point, from Weed's point of view, I like as well as any of them. Watkins has finished in the valley and is going up to Sentinel dome and into the valley by the Mariposa trail [and to] Mono [and] back by the Pic-ak trail which will give him a marvelous set of scenes and views, I imagine. When he left the valley he went to Sentinel dome and blazed a trail [to

the edge of the precipice]. The view from this point I think the finest that can be made in or about the valley. [From this lookout point] he has the Yosemite and Nevada falls in full view, the grandest view of Half dome, the finest panorama of the High Sierra & specially the Merced river which it is possible to get in the region.[74]

This intense activity did not escape public notice, as the editor of the Mariposa *Gazette* observed: "Mr. Watkins, the artist, is engaged at the present time, with several assistants, on the outside of the Yo Semite Valley taking photographic views of the wild mountain scenery."[75] The mention of "several assistants" is hardly surprising, since in addition to his mammoth camera Watkins carried instruments that produced negatives in four different sizes: 18 by 22 inches for mammoth views; 9½ by 13 inches for landscape views to be published in albums; approximately 6½ by 8½ inches for the "Yosemite Book," and stereo. Efficient manipulation of this diverse equipment was a task requiring not only extra hands, but a large measure of skilled teamwork as well (Plates 29, 30, 31).

Photographing anywhere along the sheer valley rim was dangerous. Horace Greeley, who made the trip to Inspiration Point in 1859, wrote of his apprehension as he approached the brink: "My friends insisted that I should look over the brink into the profound abyss . . . but I, apprehending giddiness, and feeling the need of steady nerves, firmly declined."[76] Gla-

73. Whitney to Brewer, 6 May 1866, Brewer-Whitney Correspondence.

74. Ibid., 5 July 1866, Brewer-Whitney Correspondence.
75. *Mariposa Gazette*, 14 July 1866. One of these assistants may have been George Fiske who was also destined to become a well known photographer of Yosemite. Fiske later worked for Watkins at the Yosemite Art Gallery from about 1874–75. On August 1874, Fiske made an unmistakeable expression of his respect for Carleton Watkins by naming his firstborn in his honor—Carleton W. Fiske. Paul Hickman and Terrence Pitts, *George Fiske: Yosemite Photographer*, pp. 4–10.
76. Horace Greeley, *An Overland Journey from New York to San Francisco*, p. 302.

cier Point was even more awesome; in 1874, an English tourist described this view: "Mirror Lake appears only as a little silver speck [it is about fifteen hundred feet long], and splendid trees, some of them two hundred feet high, look like the trees in a child's toy farmyard. The Merced winds along like a silken thread, and the high mountains seem to narrow the valley [so] that from some points, you fancy you could almost jump over it."[77] In 1866 the trails were still in the process of being developed, and it was a far different ascent for Watkins than for an unencumbered tourist. During his work on Sentinel Dome he had to carry his water thirty-three hundred feet up the mountain.

The photographic fraternity was continually amazed at the high technical quality of Watkins's photographs. *Humphrey's Journal*, a prominent photographic publication of the day, marveled at his ability to "perform all the chemical and manipulatory details with [such] exceptional skill and success" in a wilderness setting.[78] In 1866, C. R. Savage, a highly regarded landscape photographer in his own right, sought out Watkins for an interview. He noted that Watkins was quite "agreeable" and "ever ready to communicate information to the ardent photographer." In a letter to the *Philadelphia Photographer* Savage revealed his primary motive for the visit:

> I was somewhat curious to learn [Watkins's] *modus operandi* for producing his large views in a climate so dry and difficult to work in. After so much attention to photographic ware, porcelain, rubber, and other materials for making [processing] baths, I found his to consist of pine wood coated heavily with shellac. In addition to this, he uses the water bath, by means of which he can take a greater number of pictures without losing his chances

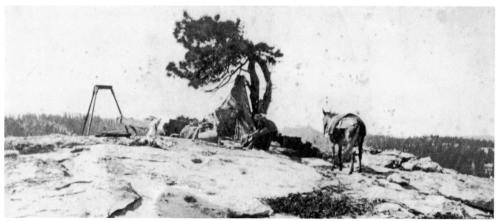

[*Watkins's Camp on Sentinel Rock, Yosemite*], albumen silver print, stereo half (detail), 1866. Yosemite National Park.

Working at an elevation of 8,000 feet was a difficult task in 1866, especially as mammoth-size glass plates had to be transported along narrow mountain trails. In this photograph Watkins's darktent is pitched in the only shady spot; the tripod for his mammoth camera is on the left.

> while the light is good. His negatives are taken, developed, and then placed in the water bath until he is ready to finish them. Just think of carrying such huge baths, glasses, Etc., on muleback, and you can form some idea of the difficulties in the way of producing such magnificent results.[79]

The water bath was an innovative idea to speed negative production and suggests, as well, close teamwork between Watkins and his staff. Because of the multiple cameras, with their different formats and purposes, it is probable that each assistant performed a particular task and that assembly-line coating, processing, and negative finishing was practiced. It

77. J. W. Boddam-Whetham, *Western Wanderings*, pp. 132–133.

78. "California Photographs," *Humphrey's Journal* 18, no. 2 (15 May 1866): 21.

79. Charles Roscoe Savage, "A Photographic Tour of Nearly 9000 Miles," *The Philadelphia Photographer* 4, no. 45 (September 1867): 289.

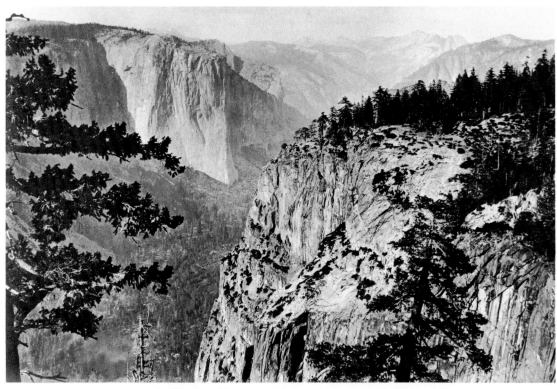

The First View of the Yosemite Valley from the Mariposa Trail in Yosemite Valley, albumen silver print, 1865–1866. California State Library.

This view was made for the California State Geological Survey.

may be that Watkins performed the more difficult tasks, but as his assistants gained experience they may have required little supervision. The result of their efforts was a large number of technically superb negatives, but at the expense of a reduced personal vision for Watkins.

In 1861 Watkins had confronted the valley's potential on a personal basis, image by image. His orchestration of the mass-survey photography of 1865 and 1866 got the job done, but it lacked the vivacity of the images of 1861 or of his later

work in Yosemite after 1878. In 1861 Watkins made several remarkable closeups of Yosemite's rock structures in stereo which revealed texture and design in great detail; in the mid-1860s there is not a single close photograph of the region's geologic features. Although Watkins could easily make a life-size copy of a survey map, he inexplicably failed to apply this valuable skill to field work. Whitney, however, was delighted with Watkins's work; for the first time the viewer could really see the vast inter-relationship of the valley to surrounding terrain. Moreover, the photographs were wonderfully sharp and detailed. On December 10 Whitney, in a letter to Brewer, announced the completion of the first prints for the "Yosemite Book." "Are not these last photos of Watkins superb?" Because no suitable way could be found to reproduce the photographs as half-tone images, Whitney went on to propose that original prints be used, with payment to Watkins as follows:

> All the arrangements are completed for the Yosemite Book; 250 copies and [each] to be illustrated with 20 of our Dallmeyer photographs, for which we pay Watkins $6 a set [of twenty views], 10 cents apiece in advance and 20 cents as the books are sold. I expect the price [of the book] will be above $10 and that the book will be something very handsome.[80]

Watkins had not yet visited the high country of the Tuolumne and Hetch-Hetchy valleys, so Whitney in 1867 dispatched another photographer, W. Harris, to photograph these

80. Whitney to Brewer, 10 December 1866, Brewer-Whitney Correspondence. Copies of Whitney's *Yosemite Book* are found in many rare-book libraries. We are fortunate to have details of the financial arrangements for the photographs used in this book. They may have been a typical publishing agreement of its kind. Although Whitney planned for twenty photographs, the final book had twenty-eight; twenty-four by Watkins and four by Harris.

areas.[81] Four views were selected from Harris's output to bring the total number of images for the *Yosemite Book* to twenty-eight. The task of printing 250 copies of each of the twenty-eight negatives, a total of 7,000 individual prints, was accomplished by Watkins and his staff in the winter of 1867–68. Assuming that Watkins received at least $6 per book, and that all the books were sold, he would have netted $1,500 for his work. Although not an extraordinary payment for the work involved, this would have been a considerable amount of money for the time. Also, he could hope to continue publishing his Yosemite negatives for public sale at a good profit.

The *Yosemite Book* was a great accomplishment for both Watkins and the geological survey. Nothing of its kind had been published before in America. In addition to his geological studies for the book, Watkins made a number of mammoth and stereo views documenting the major species of trees in the Yosemite region. These were greatly prized by such botanists as Professor Asa Gray of Harvard (Plate 10).[82] He was to add to this botanical series well into the 1880s.

Watkins was not to return to Yosemite until 1872. In grateful recognition of Watkins's work with the survey, Whitney and his crew named a Sierra peak after him. This designation was recognized from an early time, as we see in Edward Vischer's 1870 account:

[Mirror Lake] is frequently visited—and best early in the morning—for the purpose of getting the reflection from

81. According to Charles F. Hoffman, who headed the 1867 party, "the views are not the finest because our photographer was rather a dirty cuss." C. F. Hoffman to W. H. Brewer, 29 October 1867, Brewer Papers, Yale University Library.

82. Much of Gray's collection of Watkins's photographs may be found in the library of Gray Herbarium, Harvard University, Cambridge, Massachusetts. A photograph of Gray's office shows Watkins's images on the walls. "Most of the photographs bear inscriptions by [Brewer and Whitney] identifying the trees, their locations and the date they were photographed." Nanette Sexton to Peter Palmquist, 28 December 1980.

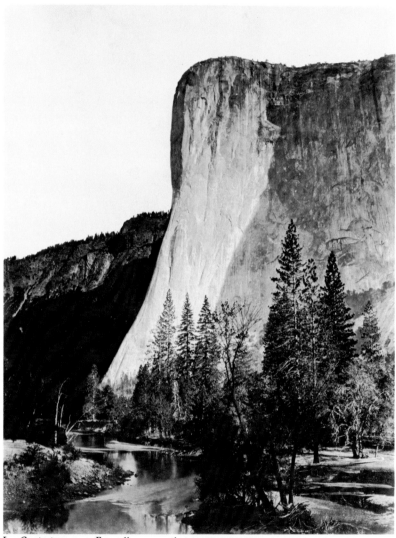

La Capitaine 3300 Feet, albumen silver print, c. 1865.
The Bancroft Library, University of California, Berkeley.

Watkins photographed some locations repeatedly. El Capitan, for example, was recorded at least once on each trip into the valley. Frequently the only differences between views are changes in vegetation or the time of day.

its unruffled surface of a noble overhanging mass of rocks, to which the name of Mount Watkins has been given, as a compliment to the photographer who has done so much to attract attention to this region.[83]

Watkins had become the toast of the scientific community and was revered by the photographic press, yet he was relatively little known in San Francisco. Although he operated a gallery in the city from at least 1861, it was not among the leaders in the trade. He did not remain at the same location from year to year nor did he advertise. Most of his assignments came to him through recommendations from clients; even when these commissions paid well, they failed to cover his expenses during lean periods.

It is unfortunate that Watkins was not able to mount and sustain a high-grade studio trade during the early 1860s. He had most of the finest landscape negatives available and needed only a viable means of marketing them. Because of his great technical skill and early entry into the stereoscopic market, Watkins should have been in a position to dominate this field. Instead, his efforts at photographic publishing remained erratic and suffered greatly from a lack of proper promotion. While it is true that the Civil War had depressed the market, others, such as the firm of Lawrence and Houseworth, did very well in this field. Watkins also avoided interacting with his peers, either from distaste for their commercialism or from simple lack of interest.

In 1866 the San Francisco Photographic Artists' Associa-tion was formed, "for the purpose of mutual protection, and for the improvement of the Art of Photography."[84] Membership rules required only that a photographer work in San Francisco or elsewhere on the Pacific Coast. Hidden in the by-laws was the principal objective of the organization: "To fix a scale of prices for the various descriptions of work in our art, so as to prevent that ruinous spirit of competition . . . [and] to regulate the business of photography in the city of San Francisco."[85] Characteristically Watkins would have nothing to do with this organization, which represented the most powerful galleries and photographers in the city, although it would have helped him market and receive a fair price for his work.

Behind his aloofness Watkins was involved in plans, or rather dreams: he wanted to become the foremost landscape photographer of the Pacific Coast. In 1867 he copyrighted his earlier images, and organized his stereo negatives by number. He also made plans to visit Oregon, where he would add to his selection of *Pacific Coast Views* as part of his goal to photograph all aspects of the developing West. His commercial task was formidable. Although there was a steady portrait market, landscape photography languished. Worse yet, because of the travel involved, Watkins's views were expensive in the absence of a means of mass-producing them. In addition Watkins needed a landmark gallery location with good public access and a qualified production and sales staff to place his photographs in the hands of the buying public, all of which demanded capital beyond his means.

At the close of the 1866 season, Watkins had a large inventory of view negatives, including at least 230 mammoth-size of which 110 pictured Yosemite. In addition, he had 65 imperial-sized negatives of Yosemite and approximately 1,400 stereo negatives (about 1,000 featured Yosemite and the Big

83. Edward Vischer, *Vischer's Pictorial of California*, p. 124. Other Western mountains have been named for photographers, including Jackson Butte of the Mesa Verde for W. H. Jackson, Mt. Hillers in the Henry Mountains of southeastern Utah for John K. Hillers of the Powell surveys of 1872, and Mt. Haynes in Yellowstone National Park for F. J. Haynes, the official photographer for the park from 1884 to 1916. Mt. Watkins first appears on a "Map of the Yosemite Valley" by Clarence King and J. T. Gardner dated 1865, California State Library collection.

84. *Constitution of the San Francisco Photographic Artists' Association*, p. xiii.

85. Ibid., pp. xiii–xix.

Trees).[86] Back in San Francisco, attempts to market his photographs were a dismal failure: "the times are horribly dull for Yosemite photographs now and Watkins has not sold any himself except to our boys in the survey since he came back. . . . He is badly hurting for money."[87]

The year 1867 was paradoxical for Watkins. That year he received his first European recognition at the Paris International Exposition; in January Whitney proudly informed Brewer that Watkins had sent a set of thirty Yosemite photographs to Paris, "all framed and they look so splendid."[88] On the commercial front, however, Whitney was greatly concerned for him: "Watkins is as poor as he can be of late. He told me that he had only received $2.50 in 20 days . . . he plans to go to Oregon this summer; but I do not see how he can, unless he sells more pictures."[89] Greatly alarmed by the extent of Watkins's poverty, Whitney entreated Brewer to seek ways of getting him money, adding, "Ashburner thinks he is a completely 'played out' man."[90]

It was not that Watkins was oblivious to the situation; his friends had repeatedly begged him to consider alternatives. Harriet Errington, the English governess for the children of Frederick Law Olmsted, wrote to a friend in 1865:

> One of my great objectives in writing to you again so soon is to ask you if any plan occurs to you to facilitate the introduction and sale of Watkins' photographs [of Yosemite] in England. He is here [in the valley] now taking new and beautiful views and seems so lukewarm

about pushing their sale that I am afraid it will be long before they are known there. It seems to me, they would be so thoroughly appreciated both for their intrinsic excellence and in the interest of the subject. He is about to make photographs of the pines and other trees of this region and I saw a negative of a Ponderosa [pine] which promises to be a beautiful picture. Could not [English botanist] Erwin Field be interested in such an object . . . ? Mr. Watkins has hitherto sold his Yosemite views, which are quite large, in a set of thirty, I think his price $150 for the set and well are they worth it.[91]

One hundred and fifty dollars was a large sum of money for the period, and it is clear that this inhibited wide sales of his work. In addition 1867 was the year in which Eadweard J. Muybridge (1830–1904), soon to be regarded as one of America's most influential photographers, began his earliest work in Yosemite.[92]

All was not well at the Paris Exposition, either. Following Watkins's lead the photographic publishing firm of Lawrence and Houseworth also sent a selection of views to Paris, among them C. L. Weed's 1864 Yosemite images. Once again Weed and Watkins stood in direct competition. Confusion began shortly before the Lawrence and Houseworth entry had been sent; when they announced their exhibition plans, the San Francisco *Alta California* sent a reporter who praised the photographs "as works of art beyond praise," but erroneously attributed them to Watkins.[93] Outraged, Lawrence and House-

86. Sexton, "Watkins."

87. Whitney to Brewer, 10 December 1866, Brewer-Whitney Correspondence.

88. Ibid., 18 January 1867, Brewer-Whitney Correspondence. William Ashburner was the survey's mineralogist.

89. Ibid., 8 February 1867, Brewer-Whitney Correspondence.

90. Ibid., 26 February 1867, Brewer-Whitney Correspondence.

91. Harriet Errington to Charlotte "Lottie" Field, 10 August 1865, Frederick Law Olmsted Papers.

92. For information on Muybridge see Robert Bartlett Haas, *Muybridge: Man in Motion.* Details of his Yosemite work are found in Mary V. Jessup Hood and Robert Bartlett Haas, "Eadweard Muybridge's Yosemite Valley Photographs, 1867–1872," *California Historical Quarterly* 42, no. 1 (March 1963): 5–26.

93. "California's Representation at the Paris Exhibition," San Francisco *Alta California*, 13 January 1867.

worth demanded a retraction, which led to an announcement that "the large views are not by Watkins as stated, but by C. L. Weed."[94]

As yet, only Watkins's pride had been hurt, but one can well imagine his dismay when Lawrence and Houseworth's display, with Weed's mammoth Yosemite images, was reported to have received a medal "for landscape photographs." This report was featured in many San Francisco newspapers and such foreign journals as the *Illustrated London News*, which gave considerable space to the notice.[95] Then William P. Blake, official commissioner to the fair from the state of California, published a review of the Paris Exhibition in which he listed both Lawrence and Houseworth and Watkins as participants, but only Watkins as having won an award.[96] Watkins naturally took the earlier reports to be false, and was rankled by the gross injustice and insult to his work. Thereafter his advertising cards carried the following claim: "The only medal awarded by the Paris Exposition for California photography."[97] In retrospect it appears that both Lawrence and Houseworth and Watkins received awards.

By June 1867 Watkins had not recovered from his finan-cial problems, and his proposed Oregon trip appeared to be in jeopardy. Whitney, determined that Watkins should proceed as planned, confided his strategy to Brewer: "Watkins goes [to Oregon] if I can lend him the money . . . [which is difficult] as I have already borrowed $7,000 on next years' [Geological Survey] apportions!"[98] His motives for backing Watkins were only partly altruistic; Whitney wished to obtain photographs of the geology of Oregon for comparison with similar terrain in California. In particular he wanted photographs of the long chain of extinct volcanic mountains which cap the Coast Range, such as Mt. Hood in Oregon and Mt. Shasta near the Oregon-California border.

Unlike most survey leaders, it is clear that Whitney had every respect for Watkins's ability to select appropriate subject matter for study. In part this was due to Watkins's long-term relationship with Whitney, but also important was the experience that Watkins had gained in showing geologic subjects in court, especially in the San Antonio Rancho case. As he prepared for his Oregon venture, Watkins had been doing western landscape photography for ten years, far longer than anyone else at that time.

On July 15 the Portland *Oregonian* announced Watkins's arrival there:

> Mr. C. E. Watkins, a gentleman who has been for some time engaged in taking photographic views of notable places in California, came passenger on the *Oriflamme* and goes up the Columbia [River] this morning for the purposes of taking observations from various points preparatory to photographing Mt. Hood. In the course of a brief call upon us yesterday, he informed us that he intends to take views wherever he may find the scenery remarkable. He ascended to the summits of two or three of

94. "California Photographs," San Francisco *Alta California*, 15 January 1867.

95. "America," *Illustrated London News*, 14 September 1867.

96. William P. Blake, ed., *Reports of the United States Commissioners to the Paris Exposition, 1867*. Blake records that Watkins entered "28 large photographic views of Yosemite Valley, and two of the Big Trees of the Mariposa Grove . . . sent by the exhibitor framed in 'passe partout' [mats] and ready to hang." An article "On the Origins of Yo-Semite Valley," the *Mining and Scientific Press* (9 November 1867), p. 289, reported that Blake had recently addressed the Academy of Sciences, and that he had shown some of Watkins's photographs, "which appear in the Paris Universal Exhibition."

97. The artist William Keith made the pen-and-ink sketch of the Paris Medal, which was then printed on the verso of Watkins's stereographs and used in advertising. The sketch is dated 1868, probably because Watkins did not physically receive the medal until that year.

98. Whitney to Brewer, 9 June 1867, Brewer-Whitney Correspondence.

the hills west of this city yesterday, and says that the view from the summit of Robinson's Hill is the most variedly picturesque that he ever saw—combining as it does, in one view, the city, many miles of both the Willamette and Columbia rivers, with their confluence and the majestic flow of the Columbia, thence, oceanward, forests, plains, the dark blue range of the Cascades, with every snow peak in full view from Diamond peak in Southern Oregon, to Mt. Baker, near the British Columbian border. Mr. Watkins will return from the Cascades this evening and enter immediately upon his preparations for the prosecution of his work. There are several of his pictures of California scenery on exhibition and for sale in this city. Mr. Shanahan has some of them framed and hung against the walls of his art gallery, corner of Front and Morrison Streets.[99]

Whitney made the journey with Watkins, for in his next letter to Brewer he mentions that: "I have returned from our northern trip." He was deeply chagrined to report that Watkins's initial experience with Oregon's rainy climate had proved exceedingly unpleasant: "It has been raining ten days in Portland & [Watkins] was [busy] watching his toes to see the webs that started [to grow] between them," and concluded that "Oregon [equals] webfeet."[100] Even the *Oregonian* was

moved to commiserate with Watkins's plight in a piece headlined "Waiting to Take a Picture":

> Mr. Watkins, the celebrated photographist of scenery, has his instrument in readiness on the summit of the hill adjoining Robinson's Hill, on the south, to take a view of Mt. Hood and the surrounding scenery, whenever the weather will permit. Ever since his arrival here we have had almost continuous bad weather for the taking of such pictures.[101]

Watkins's disappointment with the bad weather is understandable. Whereas his plates were disproportionately overexposed in sky areas during clear weather, they were made far worse by overcast conditions. Weather worries were almost habitual for the landscape photographer; the 1872 edition of the *Photographer's Friend Almanac*, for instance, gives hints on how to read the sky, the season, the sunset, the barometer, and "the puffs of wind between the quiet times."

Finally completing his Portland panorama, Watkins went to Oregon City, on the Willamette River. Then he moved to Vancouver, on the Washington Territory side of the river. After pausing there to capture a distant view of Mt. Hood, Watkins traveled up the Columbia River itself. His route almost exactly paralleled that of the Oregon Steam Navigation Company's trade route, suggesting strong cooperation between Watkins and the company.

Watkins made at least fifty-nine mammoth negatives and more than one hundred stereo images during his Oregon visit. His views of Mt. Hood, of special interest to Whitney, were distant, and Whitney later suggested that Watkins try to enlarge the central part of his negatives to reveal the mountain

99. "Visit from an Artist," Portland *Morning Oregonian*, 15 July 1867. The *Oriflamme* docked in Portland on 12 July 1867, after a four-day journey from San Francisco.

100. Whitney to Brewer, 29 July 1867, Brewer-Whitney Correspondence. Whitney spent only a little of his time in Oregon with Watkins. His trip up the Columbia River, thence north into Washington Territory as far as Victoria, British Columbia, took thirty-two days. He returned to California overland by way of Jacksonville, Oregon. He passed near Mt. Shasta shortly after crossing the border. When Watkins returned by the same route later in the fall, he photographed both Mt. Shasta and Mt. Lassen. J. D. Whitney to W. D. Whitney, 26 July 1867, in W. D. Whitney Family Papers.

101. "Waiting to Take a Picture," Portland *Morning Oregonian*, 20 July 1867.

more clearly.[102] Most of the photographs were of local landmarks such as Rooster Rock, Multnomah Falls (Plates 32–35), and Castle Rock, along the river. Many views show the wild beauty of the Columbia itself, especially where the river ran swiftly over rocky outcrops, forming immense "cascades." He also documented human development in the region's small towns and outposts, the Oregon Iron Company Works and the Oregon Steam Navigation Company facilities, and residences and school houses along the route.

The unifying theme was the river, followed along its length by steamboat or railroad. Like the river itself, the Oregon Steam Navigation Company's railroad tracks often form a dramatic element in these photographs. One image in particular, *Cape Horn near Celilo* (Plate 34), owes much of its composition to the congruence of the railroad tracks with the natural environment; elementally simple, its total effect is that of a tightly controlled interaction of light and dark. This is an example of Watkins's vision at its most exciting, and it is not surprising that some modern writers have praised this image as "the single most beautiful photograph made in the 19th century."[103]

Watkins left Oregon around November 1 and traveled overland to California, where he stopped at Mt. Shasta and Lassen's Butte. While at Lassen an early winter's snow caught the party; Watkins produced several stereo negatives of their campsite, including *Camping in the Snow on Lassen's Butte, Sis-*

kiyou County, Cal. Another, *Camp Bed on Lassen's Butte* shows how the campers contrived an impromptu shelter of branches and logs.[104]

On November 28, Whitney announced Watkins's safe return to San Francisco: "[He] has just returned from Oregon, complains much of the weather there and says he has few pictures." Despite Watkins's pessimism, however, Whitney assured Brewer that he saw "some [photographs] which seem very interesting."[105] One month later his letter to Brewer was even more enthusiastic: "One [view] is taken of Mt. Hood and lovely to print . . . magnificent." Unfortunately, "he has not got anything ready yet, as the weather has been atrocious for a month."[106]

The views were not finished until mid-April 1868, when a set was dispatched to Shanahan's Art Gallery; by May 7 they were on public display:

A splendid set of views. We think nobody can enter Shanahan's Art Gallery without admiring the sets of views of Columbia river scenery which grace the walls and show windows. Mr. Shanahan now has fifty views— large size—of the most notable places along the Columbia and Willamette rivers, and one hundred and twenty stereoscopic views. These are all accurate representations of localities which are well known to travelers on those rivers and adjacent mountains, and which have, thousands of times awakened the wonder and unbounded admiration of the beholder.[107]

102. Whitney to Brewer, 30 December 1867, Brewer-Whitney Correspondence. "The mountain of course occupies only a small place in the picture; but [Watkins] is going to try to enlarge that portion & print it separately to try to bring out the snow by . . . [photographic manipulation]." This interesting proposal is accompanied by a sketch showing the original photograph and the central portion to be enlarged. Such examples of technique in practice are seldom found in the literature of survey photography.

103. Russ Anderson, "Watkins on the Columbia River: An Ascendency of Abstraction," in James Alinder, ed., *Carleton E. Watkins: Photographs of the Columbia River and Oregon*, p. 27.

104. "Weather," *Yreka Union*, 9 November 1867, remarks on the unusually large snowfall and bad weather which had occurred over the preceding week.

105. Whitney to Brewer, 28 November 1867, Brewer-Whitney Correspondence.

106. Ibid., 30 December 1867, Brewer-Whitney Correspondence.

107. "A Splendid Set of Views," Portland *Morning Oregonian*, 7 May 1868.

In the eight years after his Oregon trip, Watkins made scores of new negatives, fulfilling his plan for a comprehensive set of photographs of the Pacific frontier. These new images, together with his previous inventory, formed the basis of *Watkins' Pacific Coast Views*.[108] He mass-produced these views in various sizes from mammoth down to stereo; he sold most of his larger views in albums, while he sold stereographs singly or by the dozen to tourists and other casual customers.

Beginning in 1865 Watkins began calling his rented rooms at 425 Montgomery Street the "Yo Semite Gallery." His studio was on the top floor of the Austin Building, where he had convenient access to the roof for sun-printing his view negatives. Although this space served his basic needs, it was inconvenient to the public. It may well have been this inaccessibility that caused Watkins to market his large views in albums through retail stores or agents, rather than on his premises as single prints. This procedure entailed additional expense to Watkins for their fees and limited his sales to all but a select group of clients.

As his reputation grew so did his desire to exert greater control over his professional situation. He especially wanted his own gallery, a place easily reached by the public, where he could display his large landscape photographs. Since he was still financially limited, Watkins continued to wait for the proper combination of opportunity and good fortune to come his way. The opportunity was abundantly provided by the completion of the Transcontinental Railroad in 1869; this event almost guaranteed a tourist rush to San Francisco and many new clients for Watkins. His good fortune probably took the form of enough "seed money" to fund wholly or in part a new gallery operation, and could have come as a loan either from William C. Ralston, president of the Bank of California, or from Watkins's friend Collis P. Huntington.[109]

Whatever the means, by 1869 Watkins had rented space at 429 Montgomery Street, adjacent to the facilities formerly operated by R. H. Vance, but at this time occupied by Bradley and Rulofson, the largest and oldest portrait establishment in San Francisco. For the first time Watkins enjoyed the many benefits of a prestigious business location, and he had room to display his best landscape photographs. He was to remain at this location only until 1871, however.

To foster his new image as a gallery entrepreneur, Watkins had already begun to increase his participation in local exhibitions and fairs. He entered some of his latest work in the San Francisco Mechanics' Fair in 1865, still rankled by his 1864 loss to C. L. Weed's Yosemite views. Although he won the coveted premium for "Mountain Views," it was a hollow

108. Watkins produced his *Pacific Coast Views* until about 1876, when he lost many of his view negatives to a creditor; thereafter he issued his landscape images as *Watkins New Series*. Besides the mammoth and stereo images, Watkins offered photographs in an eight-by-twelve-inch format as well. In addition to publishing his own negatives, Watkins published as his own the stereo negatives of Alfred A. Hart (1816–1908) of the Central Pacific Railroad and the negatives taken by Louis Herman Heller (1839–1928) of the Modoc Indian War of 1873. For details concerning these matters, see the following articles by Peter E. Palmquist: "Watkins—The Photographer as Publisher," *California History* 57, no. 3 (Fall 1978): 252–257; "Alfred A. Hart and the Illustrated Traveler's Map of the Central Pacific Railroad," *Stereo World* 6, no. 6 (January/February 1980): 14–18; and "Imagemakers of the Modoc War: Louis Heller and Eadweard Muybridge," *Journal of California Anthropology* 4, no. 2 (Winter 1977): 206–241.

109. Ralston was noted for his generosity towards the arts. Huntington, on the other hand, was considered conservative with his money, but he was very close to Watkins, despite their great differences of personality and station in life. Before locating at 425 Montgomery Street in 1865, Watkins had worked at the following San Francisco addresses: 1861, with J. M. Ford at 425 Montgomery Street; 1862–63, 649 Clay Street (same location as photographer George H. Johnson), dwelling on Calhoun between Green and Union Streets; 1863, 227 Russ Block; 1863–64, 415 Montgomery Street.

At the Mechanics' Institute, albumen silver print, stereo #3785, 1869.
The Bancroft Library, University of California, Berkeley.

San Francisco's Mechanics' Institute was an important showplace for California artists and photographers. Watkins was a regular participant from 1864 through at least 1872.

In that portion of the [Mechanics'] Art Gallery allotted to the display of photographs is a magnificent selection from the gallery of Mr. Watkins, the talented photographer, which embrace a variety of subjects . . . they justly deserve the encomiums passed upon them. For clearness, strength, and softness of tone, these picturesque views are unexcelled; and while they present truthful representations of the scene chosen, they are an earnest of the artistic skill of the photographer.[112]

In 1870 Watkins displayed his mammoth photographs at the Cleveland Exhibition; in 1871 he won the only award given—a silver medal for the "best views of California scenery and photographic landscapes at the Eighth Industrial Exhibition of the Mechanics' Institute."[113]

Watkins built up his *Pacific Coast Views* whenever possible. Besides taking numerous cityscapes, he was also alert to newsworthy events. In 1861, for example, he captured the crowds that had gathered to support California's joining the Union in the impending Civil War. Another early photograph shows the various stages involved in rebuilding and launching

victory, as Weed had left California and did not compete; Nathan M. Klain won the award for "City Views."[110] In 1868 he exhibited sixty-two *Pacific Coast Views* in the newly built "Picture Hall," a facility described as "205 feet long and 30 feet wide."[111] Although critical impressions of this display were not recorded, the following report of a similar exhibition in 1869 shows the esteem in which his work was regarded:

110. "Card Photographs," *Mining and Scientific Press,* 6 January 1866. Weed departed for Hawaii in the spring of 1865 and did not return to California until 1870. Klain was another of Watkins's competitors in large-format photography.
111. "The Mechanics' Fair," Sonora *Union Democrat,* 22 August 1868. See also, "General Review of Exhibitions," *Mining and Scientific Press,* 5 September 1868, pp. 146 and 163.

112. "Mechanics' Industrial Fair," *Illustrated San Francisco News,* 9 October 1869, p. 107. A complete listing of Watkins's entry is found in "Official Classified Catalogue," *Mining and Scientific Press,* 16 October 1869, p. 252. His studio address is given as 429 Montgomery Street.
113. "Industry Rewarded," *California Mail Bag* 1, no. 4 (October/November 1871): xxix. For information regarding the Cleveland Convention, see John Waldsmith, "The Cleveland Convention of 1870," *Stereo World* 5, no. 1 (March/April 1978): 4–5; Watkins's exhibit is pictured on the cover of this issue, taken from E. and H. T. Anthony's stereo view #6792—*Exposition of the National Photographic Association, Cleveland Bank, 1870.* In 1873, Watkins, Muybridge, and Houseworth each received the "Medal of Progress" for a joint entry of thirty-four mammoth prints assembled by the American Geographical Society of New York. In 1876 Watkins exhibited at the Centennial Exposition in Philadelphia and the Chilean Exposition, where his entry won a first premium. "The Chilean Exposition," *California Mail Bag* 9, no. 2 (June 1876): 54.

the iron-hulled warship *Comanche* in San Francisco harbor. In April 1866 Watkins documented the aftermath of a nitroglycerine explosion that had devastated a large area of San Francisco's business district. In 1868 he recorded the effects of a major earthquake and made his superb maritime image, *Wreck of the Viscata* (Plate 37). There were many other on-the-spot pictures, as well.

Other *Pacific Coast Views* were taken of the bubbling geysers of Sonoma County (Plate 39) and the murre rookeries on the Farallon Islands, thirty miles west of San Francisco (Plate 40). By the mid-1880s the Farallones had become the "egg basket" of San Francisco, thanks to the great productivity of the island's predominant bird species, the common murre. Watkins used his mammoth camera to record the islands' rugged geology (probably for Whitney) and his stereoscopic instrument to show the birds, their nests, and the typical egg-gathering techniques employed by the men who made their living supplying San Francisco with eggs. One close-up view of a bird on its nest, stereograph #2065, *Young Gull Presenting His Bill*, shows a play on words typical of Watkins's sometimes whimsical sense of humor.[114]

In 1870 Watkins fulfilled Clarence King's prophecy that he would take Mt. Shasta. The two men had been friends since 1863, when King joined the state geological survey; in 1866 King had been Whitney's field leader in Yosemite. The following year, at age twenty-five, King was appointed chief of the United States Geological Explorations of the 40th Parallel. Presumably King hoped to appoint Watkins the expedition's photographer, since he thought him "the most skilled operator in America," yet the job fell to Timothy O'Sullivan.[115] It may have been the impending Oregon trip of 1867 (including his loyalty to Whitney?) which prevented Watkins's participation

114. For an excellent description of the Farralones, see Charles Nordhoff, *California: For Health, Pleasure, and Residence*, pp. 63–76.

115. Thurman Wilkins, *Clarence King: A Biography*, p. 135.

[*Pro-Union Street Gathering at Corner of Post and Market Streets, San Francisco*], albumen silver print, 1861. Collection Robert B. Fisher, M.D.

at that time. By 1870, however, O'Sullivan was occupied by the Darien Survey of Panama, and King sought out Watkins for the long-awaited trip to Mt. Shasta. The geologist S. F. Emmons described their preparations:

We left on August 27 [1870] by steamer for Sacramento, and thence by rail to Chico the N[orthern] Terminus of

the Calif. & Oregon R.R. Here we got together our out-
fits, Clarke having to get 18 Govt. Mules from [Nevada].
We had our army wagon, and Watkins' photographic
wagon; our party consisted of King, Munger, Watkins,
the two Clarkes . . . Palmer, who gave us trouble all the
way until we got him into camp [near] Charlie Staples, a
good natured miner-trader, who enlisted as teamster and
packer, knowing nothing of either business, and a camp
meeting cook, who was of no account.[116]

The mention of Watkins's "photographic wagon" is the
first reference to this useful device. Before 1870 Watkins used
an open wagon and relied solely on his darktent for field pho-
tography. His ambitions concerning the *Pacific Coast Views*,
however, demanded a more efficient means of transporting his
photographic kit, as well as an all-weather home-away-from-
home.[117]

Watkins traveled with at least two different vans. The
first, used on this trip, was light colored and without any visi-
ble advertisement. Although sturdy looking, it was probably
clumsy and overweight for use in the mountains. In 1871 he
purchased a replacement, trimly built, painted a dark color,

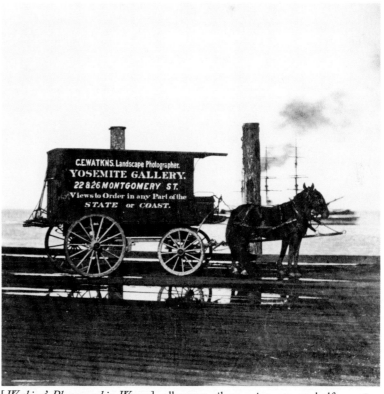

[*Watkins' Photographic Wagon*], albumen silver print, stereo half, c. 1871.
The Bancroft Library, University of California, Berkeley.

116. S. F. Emmons to Arthur Emmons, 14 November 1870, in Sam-
uel Franklin Emmons Papers.

117. Portable darkrooms date from the earliest days of photography
and were frequently used in the rural West after the Civil War. Timothy
O'Sullivan used a converted Civil War ambulance as his traveling wagon.
With this device, drawn by two or four mules (depending on terrain),
O'Sullivan was able to traverse hundreds of miles of the West in his role as
photographer for King's Fortieth Parallel Survey. The firm of Lawrence
and Houseworth also used a makeshift van for their work along the Sierra
foothills during the 1860s. Such vehicles are occasionally visible in a cor-
ner of a photograph. Eadweard Muybridge referred to his van as the "Fly-
ing Studio," while Oregon photographer Peter Britt (1819–1905) may
have had good reason to dub his "The Pain," in a tongue-in-cheek refer-
ence to the wagon's manufacturer's name, Bain. Richard H. Engeman to
Peter Palmquist, 21 September 1982.

and bearing an advertisement for his Yosemite Art Gallery. He
used this van well into the 1880s; it is the one most frequently
observed in surviving photographs made in Utah, Nevada, and
Arizona. During the summer Watkins's van was covered with
white canvas to reflect the sun.[118]

118. It is possible that Watkins had owned other traveling wagons as
well. The following account explains the final deposition of at least one of
them: "[One of Watkins's wagons] was owned and used by a bricklayer as
a place to reside while he was working on the construction of the Court

As the Shasta party headed northward their anticipation grew, until:

> At last, through a notch to the northward, rose the coni-
> cal summit of Shasta, its pale rosy lavas enamelled with
> ice. Body and base of the great peak were hidden by in-
> tervening hills, over whose smooth rolls of forest green
> the bright blue sky and the brilliant Shasta summit were
> sharp and strong. From that moment the peak became
> the centre of our life.[119]

As soon as camp was established, they commenced their work. "Munger [the survey's landscape painter, Gilbert Mun-ger] though disappointed as to the small amount of snow . . . got to work steadily, and soon had a fine picture of the mountain on his easel."[120] King reported:

> When our tents were pitched at Sisson's, while a pictur-
> esque haze floated up from southward, we enjoyed the

[*Camp at Mt. Shasta*], albumen silver print, stereo half, 1870.
"Amy" album, Photograph Collection, Special Collections,
Stanford University Libraries.

Watkins made many views from the top of his traveling wagon in order to gain a better vantage point and escape foreground obstructions. The land-scape painter Gilbert Munger is seated by the tent.

House at Martinez. Afterward it was acquired by the Wightman family and moved to their ranch by the river near Antioch. The body [of the van] made a handy storage place for feed for the farm animals. Wightman, after a few years removed the outside paint that covered the lettering and clearly exposed was the sign of C. E. Watkins. In the early 1900s all the ranch buildings were destroyed by fire including the remains of the wagon." Eugene Compton, "Notes re Carleton E. Watkins and His Family," Compton Papers. It should be mentioned that Watkins often set his camera atop the wagon, perhaps fifteen feet above the ground, to gain a better vantage point.

119. Clarence King, "Shasta," *Atlantic Monthly* 28, no. 170 (December 1871): 712.

120. S. F. Emmons to Arthur Emmons, 14 November 1870, Emmons Papers. Samuel Franklin Emmons (1841–1911) was a professional geologist who accompanied King on several expeditions. Gilbert Davis Munger (1837–1903) took up painting as a career in 1866; he apparently joined the Shasta trip as a volunteer, or "guest painter." Emmons makes several references to Watkins's activities in camp; i.e., killing two rabbits for dinner, fishing, etc.

grand uncertain form of Shasta with its heaven-piercing crest of white . . . but we liked to sit at evening near Munger's easel, watching the great lava cone glow with light almost as wild and lurid as if the crater still steamed . . . Watkins [however] thought it "photographic luck," that the mountain should so have draped itself with mist as to defy his camera.[121]

On September 11, the little band began the ascent, each member burdened with the "traps" of his profession. "Watkins' traps were about four times the amount O'Sullivan used to carry, and took up most of the load upon the pack mules, so there was very little room left for grub," grumbled Emmons.[122] King described the climb:

As we climbed on, the footing became more and more insecure, piles of rock giving way under our weight. Before long we came to a region of circular, funnel-shaped craters, where evidently the underlying glacier had melted out and a whole freight of boulders had fallen in with a rush. Around the edges of these horrible traps we threaded our way with extreme caution, now and then a boulder, dislodged under our feet, rolling down into these pits, and many tons would settle out of sight. Altogether it was the most dangerous kind of climbing I have ever seen.[123]

Elsewhere King wrote:

We clambered along the edge toward Shasta, and came to a place where for a thousand feet it was a mere blade of ice, sharpened by the snow into a thin, trail edge, upon which we walked in cautious balance, a misstep likely to hurl us down into the chaos of lava blocks within the crater . . . while Watkins was making his photographic views, I climbed about, going to the edges of some crevasses and looking over into their blue vaults, where icicles overhang and a whispered sound of waterflow comes up faintly from beneath.[124]

Emmons described their final push as "alternations of simple slippery ice and debris slopes." But, on the summit:

Here such a wind was blowing it was ticklish work getting over the highest point, which was a rather loosely fastened mass of rock with only room for one person to stand, and from which one could look down over debris slope and cliffs almost to the bottom . . . you may well imagine what an extended view, when you considered that within at least 100 miles there was no mountain within 5,000 feet of our height . . . here we remained till sunset which was the finest I ever saw in my life![125]

Wet-plate photography at fourteen thousand feet was tricky indeed. Slippery and unstable surroundings made all movement hazardous, even without the cumbersome photographic equipment. One of Watkins's most difficult tasks was the camera documentation of Whitney Glacier, a slow-moving mass of ice half a mile wide and perhaps seven miles long. In the process, Watkins pitched his darktent directly on the ice, with an unusual result:

Leaving our perch above the lower crater, we crawl down the ledge toward this gorge, and cross a small pond of smooth blue ice at its base. It was on this level spot that Watkins pitched his field-tent for photographic work, and

121. King, "Shasta," p. 713. King wrote a number of essays about his Mt. Shasta visit. The *Atlantic Monthly* article was later incorporated into his book, *Mountaineering in the Sierra Nevada*.

122. S. F. Emmons to Arthur Emmons, 14 November 1870, Emmons Papers. Inasmuch as Emmons had recently worked with O'Sullivan in Nevada, he was in a good position to judge the differences between the two photographers.

123. King, *Mountaineering*, p. 253.

124. King, "Shasta," p. 714.

125. S. F. Emmons to Arthur Emmons, 14 November 1870, Emmons Papers.

when he thought he had the light all shut off, found that enough still came through the ice-floor to spoil his negatives, obliging him to cover that also.[126]

The King party spent nearly six weeks in the vicinity of the mountain. From time to time the team climbed nearby cinder cones, enabling Watkins to get a clear view of Shasta from several distant points. Their main camp was located at Sheep Rock, about a day's march from the mountain. Emmons recalled this bivouac favorably: "We had a pretty camp here, also stayed over a day to get Watkins up on an outlying peak from which he could photograph the mountain . . . this King superintended, [with] both he and W[atkins] getting thrown in the ascent, and one pack mule rolling down the hill, while I geologized afoot."[127] Watkins photographed Mt. Shasta systematically, from all sides, with many views contrasting the grass-carpeted slopes of the adjacent valleys with the ragged remains of old lava flows, and with Shasta looming over all. The images taken on the mountain itself are remarkable for their sense of immediacy, revealing the massiveness of Whitney Glacier and the ageless process of nature at work. Many of these views appear strikingly modern, as though they had been taken from an airplane. While Watkins was neither the first to make high alpine photographs nor the first to capture a glacier on glass, he may well have been the first to produce close views of a living glacier in America (Plate 45).[128]

Upon his return to San Francisco, Watkins found that his finances were on the upswing. His gallery was fast becoming a landmark and "must see" for tourists arriving on the transcontinental railroad. Eastern visitors who could afford long periods away from homes and businesses could also easily justify photographic souvenirs of their California sojourn. Increased business, however, placed a strain on the facilities at 429 Montgomery Street, and he decided to leave this location to open his long-awaited landscape gallery. Besides relocating, he took this occasion to add a portrait studio, which would ensure a steady source of income. The final result was Watkins's Yosemite Art Gallery, at 22 and 26 Montgomery Street, directly across the street from the famous Lick House. With this move Watkins became the proprietor (on borrowed money) of the most notable gallery of landscape photography in the West, if not in all of America.

His new enterprise was grandly planned: "The walls are adorned with one hundred and twenty-five of those superb views of Pacific Coast scenery (in size 18 x 22 inches) which have given Watkins a reputation world-wide . . . views of almost everything curious, grand or instructive."[129] His portrait accommodations were equally sumptuous:

Blanc's glaciers were recorded on paper negatives no later than 1855, and in July 1861 Auguste Bisson made wet-plate views from its summit, nearly 16,000 feet above sea level. In America, Solomon Carvalho is thought to have made a daguerreotype panorama from Cochetopa Pass, on the Continental Divide of the Rocky Mountains, in December 1853. King tried unsuccessfully to obtain Watkins's services for his 1872 field season, as O'Sullivan was already involved with Lt. George Wheeler. King wrote: "There is no photographer in the country whom I can trust and obtain except Mr. Watkins of San Francisco. He will do my work, furnishing his own instruments, wagon, chemicals, animals, and men, charging me $3,000 for the summer's work. This is very high in price but he is by far the most skillful operator in America." Clarence King to A. A. Humphreys, 18 December 1871, in Correspondence Regarding Wheeler, King, O'Sullivan, and Watkins. Citation courtesy Jonathan Heller.

126. Benjamin P. Avery, "Ascent on Mount Shasta," *Overland Monthly* 12, no. 5 (May 1874): 472.

127. S. F. Emmons to Arthur Emmons, 14 November 1870, Emmons Papers.

128. Mountain photographs had been made in Europe for many years. The Matterhorn, for example, was daguerreotyped in 1849. Mont

129. *Buyers' Manual and Business Guide*, pp. 153–154. A fine advertisement for Watkins's new address is found in Langley's San Francisco *Directory* for 1873, p. xcii.

[*Korean Nobleman*], albumen silver print, c. 1873–1875.
California Historical Society, San Francisco.

A pleasant gathering took place yesterday at C. E. Watkins' new galleries, opposite the Lick House—the occasion being an opening to members of the press. The accommodations for portrait-taking—to which Watkins intends to devote himself in addition to his labors in landscape art—are of the most complete and elegant nature. The operating room—56 x 30 feet—is the largest in the city. There are all the usual arrangements and a great number of new specialties, recently imported, in use in that department. The reception rooms, parlors, dressing rooms, etc., are splendidly frescoed and elegantly furnished. There is also, as in his old gallery, a chamber specially set aside for the exhibition of his well known Yosemite, Columbia River, and other views. This, to the stranger, is the point of special attraction. Stereoscopes are placed at intervals round the room, and views to be obtained range from the smallest card to the largest mounted picture. Some of the portraits recently made by Watkins are life-like and very artistically posed, with very appropriate backgrounds and accessories. An appetizing French lunch was provided in one of the lower chambers, to which the Bohemians did full justice. A more public reception will take place shortly. Mr. Watkins has gone to great expense in fitting up his establishment.[130]

Great expense, indeed; where did Watkins get the money for such a major investment? As recently as 28 February 1870 Whitney had noted Watkins's shortage of funds: "He has not taken in over $2 at his place since Christmas [a two-month period]."[131] It was not that Watkins was undeserving, as we see in writer Abby Sage Richardson's succinct observation: "The fruits of twenty years of zealous, untiring work, which was in-

130. "Watkins' Yosemite Art Gallery," San Francisco *Alta California*, 13 April 1872.
131. Whitney to Brewer, 28 February 1870, Brewer-Whitney Correspondence.

John Jay Cook (1837–1904), Isaiah West Taber, American (1830–1912), gelatin silver print, c. 1894, print later. Yosemite National Park.

The most likely investor would have been John Jay Cook (1837–1904). Worth at least $150,000 at the time of his arrival in California, Cook settled in Mariposa about 1862. There he opened a drugstore and entered into a partnership in a local livery business. By 1872 he also owned a drugstore in Merced, and by 1875 another in San Francisco.[133] He was especially interested in business ventures tied to Yosemite; eventually he became a well-known hotel proprietor in the valley. While Cook's financial backing of Watkins's Yosemite Art Gallery remains conjectural, it is obvious that he would have been an ideal partner. Moreover, his close association with the gallery, together with subsequent events, almost guarantee such a connection.

Part of Watkins's goal in the new gallery was to enhance his role as an artist. To this end he became a charter member of the newly formed San Francisco Art Association in March 1871.[134] This was an astute move for Watkins, in that it practically assured a steady clientele for his portrait business; it also provided social access to those individuals most likely to patro-

spired by the love of art, not lucre . . . now that his hair is growing gray [Watkins was forty-two], he ought to reap more substantial rewards."[132]

132. Abby Sage Richardson, ed., *Garnered Sheaves from the Writings of Albert D. Richardson*, p. 297.

133. Shirley Sargent to Peter Palmquist, 9 June 1980. Other useful mentions are found in her book *Yosemite's Historic Wawona*. Cook frequently described himself as a "capitalist." In 1878 and 1879 Cook sold Watkins's views from the gallery at 26 Montgomery Street. In later years he was financially involved with I. W. Taber and for a time served as vice-president of Taber's photographic company.

134. San Francisco Art Association, *Constitution, By-Laws, and List of Members*. "Members shall be chosen by ballot . . . admission fee two dollars and monthly dues of one dollar." Many of the portrait clients at Watkins's Yosemite Art Gallery were drawn from the ranks of this organization. In addition, nearly every San Francisco-based painter—active between 1871 and 1875—posed at Watkins's establishment, as did the majority of local scientists and business leaders of the period. Watkins was also a member of the Bohemian Club, active from 1872–76. "A Roster of Former Members of the Bohemian Club From the Date of Its Founding in 1872 until 1945," California Historical Society; citation courtesy Waverly Lowell.

nize artists. Gala events were a basic part of this organization:

> The hall of the Art Association was prettily decked for the Holiday Reception . . . the attendance was large, comprising a goodly portion of our artists, connoisseurs in art and others of cultivated tastes . . . [here] the visitor is brought into contact with refined and cultivated people whose conversation is entertaining and instructive; there is an artistic freedom from the conventionalities and restraints of the society *omnium gatherium* which is affected by the fashionable element, and the atmosphere, freed from the unpleasant odors of shop and business, brings a delightful relief from the cares and anxieties of everyday life.[135]

Many of the founding members of the Art Association, were, or soon would be, important patrons of Watkins's photography. William C. Ralston, president of the Bank of California, was one of these; in 1874 he commissioned a group portrait of all the officers and employees of the bank's San Francisco branch. It was a substantial photographic task, as each person was individually photographed and the likenesses then incorporated into a large montage (Plate 49). Turrill described the process:

> I would state that one of the noted pieces of Watkins' portrait work was the celebrated portrait group showing William C. Ralston and the employees of the Bank of California . . . this large picture is remarkable for its system of construction. Each figure in the group was carefully posed (with the pre-arranged plan of its being placed in a larger picture) as a portrait study in Watkins' studio, at 26 Montgomery Street. Prints of these portraits were made and carefully trimmed around the margins

and then mounted on a large sheet of Wrathman drawing paper. Then Burgess, the writing and drawing teacher, carefully drew, in India ink the entire background for these pictures, representing a room in the Bank. The large [composite] was afterward photographically copied by Watkins.[136]

A substantial part of Watkins's gallery income was generated by photographically copying local paintings and other art works. A typical example is mentioned in the San Francisco *News Letter and California Advertiser* on 18 October 1873: "[Thomas Hill's] grand picture of the 'Eagle's Home,' [recently purchased by an art patron] . . . has been photographed by Watkins, and the effect and tone of the picture is well preserved." William Keith had nearly all of his artistic output documented by Watkins. Virgil Williams did likewise, and it is probable that it was Watkins who prepared the photographic portfolio (mammoth size) of Williams's drawings now held by the California Historical Society.

Watkins as a gallery entrepreneur was concerned with matters far different than ones he dealt with as a rugged outdoorsman. At the gallery he was just another businessman with personnel and cash-flow problems. Although the exact number of gallery employees is unknown, their ranks included clerks, receptionists, photographic printers, and finishers. William White Dames (born in Canada in 1842, of English parents) was Watkins's principal portrait operator. Edwin M. Dutcher, who had been Watkins's photographic printer at 429 Montgomery Street, may have continued at the new location as well; by 1872, however, Policarpo (spelling varies) Bagnasco had assumed the role of Watkins's chief printer. Another darkroom assistant was Albert Henry Wulzen (born c. 1845). During times of peak production Watkins hired part-time

135. "Holiday Reception," San Francisco *Illustrated Press* 1, no. 1 (January 1873): n.p.

136. Turrill, "Watkins," p. 35.

help, usually women or Chinese, to do photographic finishing, mounting, labeling, and other assembly-line tasks.[137]

Unquestionably, the greatest single drawing card for the Yosemite Art Gallery was Watkins himself, and like many small businesses, the gallery prospered in direct proportion to his actual presence there. When he was away his assistants had a tendency to avoid making decisions which led to inefficiency. Visitors described Watkins as a "genial" host, who often spent hours in his landscape gallery showing off his views. He also had a reputation for kindness, well supported by such stories as this one, written by an out-of-town traveler in March 1872:

> Then I went to see Mr. Watkins, the celebrated photographer of Yosemite valley, to whom I had a letter from the C's of Colorado Springs. His photographs and his description of the valley made me wish more than ever that our time had been long enough in California to allow us to get [to Yosemite]; but at this time of year it is impossible as there are forty feet of snow in the valley. However, if anything could give one an idea of its grandeur, these photographs would; and when next morning I found a collection of six dozen [stereographs] on my table, which, with Californian generosity, Mr. Watkins had sent me, simply from my being a friend of his friends, I was quite content to wait till some future day to see Yo-Semite.[138]

With the opening of his Yosemite Art Gallery, Watkins stood at the apex of his career. He was widely known and admired for his work and had gained many friends and admirers among the foremost artists of the time. Most unusual, he had even become a patron of the arts by making several charitable donations.[139] Moreover, he had finally proven himself as the "finest photographer of the Pacific Coast."

The first half of the 1870s was an especially busy period for Watkins, in the field as well as at his gallery. In the early fall of 1871 he accepted a commission to photograph facilities at the North Bloomfield Gravel Mines in Nevada County (Plates 42, 43). Like the Mariposa views, these images were to be used in an effort to attract foreign investment. He apparently made several trips to the region and took more than forty different mammoth photographs of various sites in the Nevada, Yuba, and Placer County areas. The only specific contemporary mention of this work is found in *Mining & Scientific Press*, 4 November 1871, where twenty of these views are discussed:

> We had the pleasure, a few days since, of examining some twenty photographic views recently taken of the North Bloomfield Gravel Mines. The pictures, which were taken by C. E. Watkins, of this city, are really masterpieces of the photographic art, and present the most perfect and life-like representations of hydraulic mining which we have ever seen depicted on paper. The mines are shown from several different points, and distant views are given of the line of the company's [water supply] ditches, their dams, reservoirs, etc. . . . The accurate distinctness with which they are shown, in connection with the topography of the country, timber, etc., is really remarkable, and affords another instance of the value of the photographic art in aiding the engineer to describe the progress and condition of his work.[140]

137. San Francisco business directories, for example, list Watkins as employing six permanent assistants in 1872, three in 1873, ten in 1874, and six in 1875.

138. Rose G. Kingsley, *South by West*, p. 173.

139. For a typical example see the *Catalogue of the Arriola Relief Collection*. In this instance Watkins contributed two mammoth photographs, "nos. 70 and 71, Farralones [*sic*]."

140. "Photographic Mining Views," *Mining and Scientific Press*, 4 November 1871, p. 281.

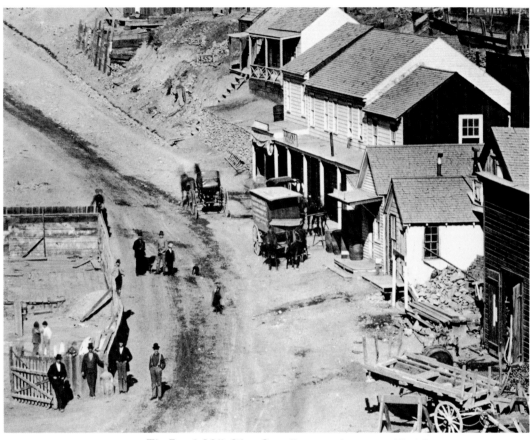

The French Mill, Silver City, albumen silver print (detail), c. 1876.
The Bancroft Library, University of California, Berkeley.

This view typifies Watkins's traveling technique during the 1870s. He put
his wagon and horses on a special flat car, off-loading at a railhead and
then completing his work with his wagon.

Watkins's mastery of mining photography did not go un-
noticed, and led ultimately to a series of extensive assignments
in Nevada's fabulously rich Comstock Lode. Mining projects
would eventually take him as far afield as Tombstone, Ari-
zona, and even into the depths of the Montana copper mines at
Anaconda and Butte.

Yet another important business connection was provided
by the immense agricultural and industrial development that
had accompanied the completion of the railroad. For Watkins
the railroad meant easier access to hitherto remote regions
where he could gather new and unique *Pacific Coast Views*. He
began a close relationship with the railroad shortly after the
completion of the transcontinental railroad at Promontory
Point, Utah, on 10 May 1869, as corroborated by this news-
paper account:

> Mr. C. E. Watkins, the distinguished landscape pho-
> tographer, is now engaged in taking views along the line
> of the Pacific Railroad, and will doubtless return with a
> portfolio of choice illustrations. Most of these scenes . . .
> will be re-produced in the pages of the *Illustrated San
> Francisco News*; when our patrons will have an oppor-
> tunity of studying some of the remarkable pictures which
> are presented on that great highway of the West.[141]

The overall tone of this account suggests that Watkins
had been commissioned to produce a series of images directly
for use in the *News*. It was probably at this time also that
Watkins obtained the important railroad negatives of Alfred A.
Hart (see n. 108). Finally, it may have been on this trip that
Watkins became officially linked with the Central Pacific Rail-
road through his friend Collis P. Huntington. Turrill describes
this relationship as an exchange of favors:

141. *Illustrated San Francisco News*, 14 August 1869, p. 15.

During the construction and the early days of the Central Pacific Railroad, Watkins did a large amount of photographic work for the company, though for some reason this did not begin until after the making of the Hart series [of negatives about 1869] . . . Watkins [also] made photographic reproductions of a great many plans and drawings for the engineering department and for other departments on the road. . . . Owing to the close friendship between Watkins and Huntington the making of bills for this work was a secondary consideration. Much of the work done was purely on the grounds of friendship, and no bills were ever presented. Watkins [however] always traveled [at Huntington's expense], and his [photographic] outfit was transported free. During the entire time that Collis P. Huntington was connected with the road Watkins was the recipient of annual passes.[142]

In the 1870s Watkins used the railroad to make several trips from San Francisco to Donner Summit. It was a quick way to reach the High Sierra in winter as well as in summer; from an elevation of fifty-six feet at San Francisco, the route rose to more than 7,000 feet at mile 105, the summit. In early spring the trip was especially striking because of the sharp contrast between the lush greenness of the lower country and the arctic pallor of the region above snowline. From the summit Watkins was able to take "bird's-eye" views of Lake Tahoe, and from nearby photographed Soda Springs, a popular camping area. The area was rugged and inspiring; from the top he was able to observe a vast sweep of northeastern California. Nearly 3,000 feet below the promontory wound the American River, "a ribbon of silver in a concavity of somber green, seen at intervals only in starry flashes, like diamonds set in emerald."[143]

Perhaps the most interesting (and adventurous) railroad journey made by Watkins was in the company of the landscape painter William Keith, in the winter of 1873/74. The two men set out in November, traveling eastward along the route of the Central Pacific as far as Salt Lake City. Apart from his visit to Oregon in 1867, the Utah excursion was one of the first photographic trips Watkins had made outside of California. The trip was novel in at least two other ways: the journey was made in midwinter, and Watkins took his traveling wagon with him on the train. A Boston newspaper describes the technique: "They chartered two railroad cars . . . one of which contained [their] horses, wagon, hay, and feed, while the other was supplied with all the appointments requisite for domestic life."[144] This "piggy back" system worked so successfully that Watkins used it for most of his subsequent railroad trips.

The technique was not well suited for winter travel, however, as the *Overland Monthly* for February 1874 reported: "William Keith has returned from a trip along the Pacific railroad as far as Echo Canon [Utah] where he made studies in color when the thermometer stood at 26 degrees below zero."[145] Under these conditions it is difficult to imagine how Watkins was able to make photographs by the wet-plate process, and yet he did (Plates 46, 47). The Utah negatives were of three sizes, mammoth, 9½ by 13 inches, and stereo. Several views

142. Turrill, "Watkins," p. 36. Watkins's rail passes from 1884 through 1900 are in the Watkins Pioneer File, Society of California Pioneers, San Francisco. Several describe him as "Company Photographer." Most list "C. E. Watkins and Assistant," and two are endorsed by C. P. Huntington as president of the Southern Pacific Railroad Company.

143. Benjamin P. Avery, "Summering in the Sierra," *Overland Monthly* 12, no. 2 (February 1874): 179.

144. Quoted in Brother Cornelius, *Keith: Old Master of California*, p. 78. See also "Art Notes," *San Francisco News Letter and California Advertiser*, 22 November 1873, p. 12.

145. "Art Notes," *Overland Monthly* 12, no. 2 (February 1874): 192. A Boston newspaper noted that William Keith "is sick at San Francisco, his illness having been caused by over-exertion and exposure to the weather." As quoted in Cornelius, *Keith*, p. 78.

The Devil's War Club, albumen silver print, stereo #2760, c. 1873–1874. California State Library.

show his traveling wagon, one alongside a mountain road and in another, in the foreground with Salt Lake City beyond.

After Watkins's return to San Francisco, Whitney described the new Utah images in a letter to Brewer: "Watkins has some fine photographs of scenery in Echo Canon, Webber [*sic*] Canon, Devil's Slide & Sentinel Rock . . . one is the best picture I've seen." However, "his printer broke 8 of the best negatives (biggest size) in one fell swoop."[146] The unfortunate accident must have been a bitter blow for Watkins, since eight mammoth-size negatives would have formed a major portion of the output from his Utah visit.

In 1873 he also received a commission to photograph the Carson and Tahoe Fluming Company's works at Glenbrook, on the shores of Lake Tahoe. This mill supplied lumber and timbers for the mines at Virginia City, Nevada, as well as for the railroad (Plate 41).[147] There, the changeable beauty of

146. Whitney to Brewer, 26 January 1874, Brewer-Whitney Correspondence.

147. The Reno *Nevada State Journal*, 31 July 1874, reported that the

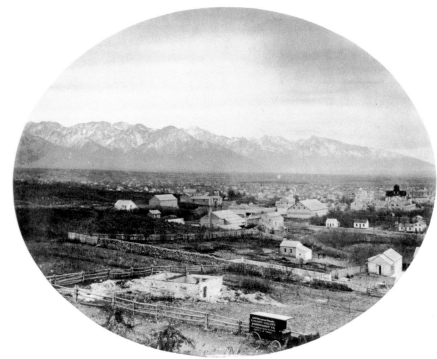

[*Salt Lake City, Utah*], albumen silver print, c. 1873–1874. Department of Special Collections, University Research Library, University of California, Los Angeles.

Lake Tahoe attracted Watkins, and he began the first of a long series of views of the high mountain lake tucked between California and Nevada. Tahoe was well known for its scenic magnificence: "No painter would ever dare to put upon canvas the variegated colors of Tahoe's waters in a summer sunset . . . here stretches out a shadow like the mother of pearl, or the breast of a beautiful pigeon; there a deep band of crimson; again, further on, a deep purple, shaded at the edges with blue

Glenbrook mills employed about sixty men and cut one hundred thousand feet of lumber daily, or nearly nineteen million feet during the 1873–74 season.

and green."[148] At one point Watkins succeeded in capturing the forbidding clouds of *A Storm on Lake Tahoe* (Plate 54). Several years later he made a valiant attempt to grasp the "sublimity" of a Lake Tahoe sunset (Plate 69).

During the 1870s Watkins benefited greatly from access to California's well-to-do in mining, railroads, banking, and growing industry of all types. Sometimes the money was used by these people to purchase culture; more often it provided only crass opulence and incredible extravagance:

> San Francisco's new millionaires (particularly the wives of San Francisco's new millionaires) wanted to spend their enormous fortunes. This was more difficult than it seemed. How could one be extravagant in a town where the hotel clerks wore diamonds and the prostitutes wore Parisian gowns? The most visible thing one could do was to own a large house where everyone could see it. This realization set off an architectural orgy unrivaled in the West.[149]

William Ralston, for example, had been a clerk on a Mississippi steamboat before he entered the bullion business in Nevada. After making his fortune he moved to California, where he invested his Comstock wealth in railroads, real estate, vineyards, a woolen mill, and a clock factory; he even became president of his own bank. Ralston also built the Palace Hotel, the city's most expensive; at Belmont, twenty miles south of the city, he constructed the most extraordinary country mansion in California.

The Belmont railroad station, on the main route between San Francisco and San Jose, was built especially to serve the lavish estates of Ralston and others. In a sense the railroad

helped launch the peninsula as a showplace of the wealthy. Here the princes of commerce and industry built their architectural monuments, and the dictates of local ostentation condemned each new builder to erect a facade more flamboyant than those of his neighbors. Part of this display involved commissioning Watkins to record the finished spectacle with his camera. Most of these images were then mounted in lavish albums for the owner's elegant library.

In addition to Ralston's Belmont estate, Watkins photographed the country homes of W. E. Barron and James C. Flood (mining tycoons) at Menlo Park, of Thomas H. Selby (mayor of San Francisco) at Fair Oaks, and of John Parrott (banker) at San Mateo. One of the most impressive commissions, however, was that of documenting Milton S. Latham's (1827–82) monumental Thurlow Lodge in 1874. There were parlors and sitting rooms, magnificent library, billiard room, art gallery, and a lavish dining room. The grounds had been transformed into a park. "There were ornamental iron aviaries, bronze and marble statuary, park benches, a rockery topped by a redwood gazebo, and a trout pond . . . gatehouse, Islamic Temple (tea-house), stable, carriage house, greenhouses, and a grapery."[150]

Watkins photographed everything—the *Charter Oak, Milty's* [Milton's] *Summer House*, the *Trout Pond, Mollie's* [Latham's wife] *Private Garden*, the *Deer Park*, the *Music Room*, the *Palms* growing outdoors, the hall statuary of *Cupid & Daphne*, standing near the art gallery, the *Rookery*, the *View from the Tower*, and the exotic *Century Plant*. A total of sixty-three of Watkins's choicest mammoth prints were mounted in two magnificent albums, each imprinted with *Views of Thurlow*

148. Benjamin C. Truman, *Tourists' Illustrated Guide to the Celebrated Summer and Winter Resorts of California*, p. 97.

149. Frances Moffat, *Dancing on the Brink of the World*, p. 48.

150. Sewall Bogart, "Four Turn-of-the-Century South Country 'Gentleman's Farms,'" *La Peninsula* 19, no. 2 (Fall 1977): 4–13. The author wishes to thank Herbert Garcia, of the San Mateo County Historical Association, for his help in locating information on Thurlow Lodge.

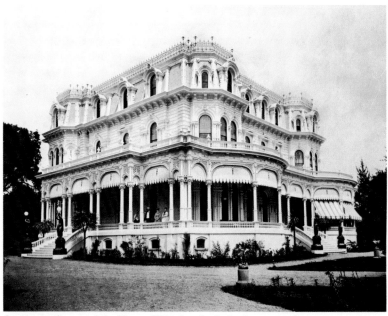

Southwest Corner of the House [Thurlow Lodge], albumen silver print, 1874. Collection Centre Canadien de Architecture/ Canadian Centre for Architecture, Montréal.

Lodge, Mollie Latham, Photographs by Watkins (Plates 50, 51, 52). These two albums joined three others—*Photographs of the Columbia River and Oregon* (fifty-one views), *Photographs of the Pacific Coast* (fifty-two views), and *Photographs of the Yosemite Valley* (fifty-three views)—in the Lathams' sumptuous library. Taken as a group these albums form the finest known collection of Watkins's mammoth images.[151]

Watkins's Thurlow Lodge photographs are superb architectural studies, sophisticated even by today's standards of "house and garden" photography. By the mid-1870s Watkins

151. The three "Pacific Coast" albums are in the Bender Library, Stanford University. In 1980 the two Thurlow Lodge albums were sold at auction for $75,000 (New York, Christie's East, Sale 137 "Basilisk," lot 144). They are held by the Canadian Centre for Architecture, Montreal.

had also photographed many of the finer residences in San Francisco, Oakland, and San Jose. He photographed the majority of San Francisco's Nob Hill mansions as they were completed, beginning in 1873 with James B. Haggin's residence. This rather modest home had only sixty-one rooms, some as large as thirty-four by twenty-seven feet. Leland Stanford's town house, on the other hand, cost at least $2,000,000, but was shortly overshadowed by Mark Hopkins's $3,000,000 castellated palace. Today Watkins's surviving photographs form one of our finest records of the wealth and glamor of those illustrious times.

All was not success, however. In 1875/76 Watkins lost the majority of his *Pacific Coast Views* negatives to Isaiah West Taber (1830–1912). Although the loss occurred partly as the result of treachery and intrigue on the part of Watkins's financial partner, J. J. Cook, other factors also led to this unfortunate outcome. A business panic in 1874, resulting in the failure of the Bank of California, marked the bottom of a recession that had been under way for some time. This collapse, together with changes in the way photographs were distributed and sold, contributed largely to Watkins's debacle. The final result was the loss of his Yosemite Art Gallery, and of his inventory of hard-earned view negatives. Although he started anew, the loss hung over Watkins for the remainder of his life. Turrill described the takeover in these words:

At one time advantage was taken of [Watkins's] absence from [San Francisco] and through the dishonorable treatment of a man [Cook] who had advanced money to him a sale was made of his entire property at his studio, 26 Montgomery Street. At that sale the negatives and photographic equipment were purchased in the interest of I. W. Taber. Prior to that time Mr. Taber had been known as a portrait photographer, though in those days the lines were not so closely drawn between portrait and view men. Watkins's earlier work [as published by Taber]

Isaiah West Taber (1830–1912), unknown photographer, gelatin silver copy print, c. 1890, print later. Peter Palmquist, Arcata, California.

formed the basis [for] and the greater part of the well known Taber collection of scenic negatives. After losing his property Watkins started his photographic life anew, and with the knowledge of what were the most saleable subjects retook these on the various sizes of negatives which he used, giving to the new work the title of "Watkins New Series."[152]

In fairness to Cook it is likely that Watkins had repeatedly promised to repay him by a certain date and that this promise was oral. Cook would have had legal claim to the business, making it possible for him to foreclose when the money was not forthcoming. Faced with the business slump of 1874, which also affected his other investments, he was probably unable to meet obligations due to Watkins's tardiness.[153]

Watkins was not a good businessman. He habitually failed to concentrate on producing a steady source of income to smooth out the periods between major sales; moreover, he was unwilling to compromise. Turrill may have described it best:

> [Watkins] was a man of strong likes and dislikes. He had been helped financially and socially by some of the most prominent people of San Francisco and California. Naturally, he made some enemies. For these he had no charity, and never forgave those who injured him, and of whom he spoke in the harshest terms. He was always

152. Turrill, "Watkins," p. 29.

153. In 1874–75 Cook assumed clerking responsibilities for the gallery. While this may have been an economy measure, it is far more likely that he was trying to protect or salvage his investment. In January 1876 George B. Rieman, secretary of the Photographic Art Society of the Pacific, wrote to *The Philadelphia Photographer* 13, no. 146 (February 1876): 46, saying that money was very scarce: "First, the death of the lamented William C. Ralston [president of the Bank of California, which failed in August 1875], a kind patron to our art, then the Bank of California disaster, inducing everyone to economize their means during the threatened financial panic."

generous to a fault, but more of an artist than a business-man, which accounts for his lack of financial success . . . he made enormous amounts of money from his photographic work, but through friends lost it all.[154]

Part of the problem was not Watkins's fault. Photographic competition had risen to a surprising level. By 1870 the stereo-photographer John James Reilly had left his studio at Niagara Falls to try his hand in Yosemite. He made hundreds of new views of the valley and even established the first photographic gallery in Yosemite. He also sold many of his negatives to John Payson Soule, of Boston, who published them in great volume, flooding the Eastern stereo market. Thomas C. Roche did much the same for the New York firm of E. & H. T. Anthony in 1871; Charles Bierstadt, C. L. Pond, and others were also active at this time. In California Thomas House-worth & Company (successor to Lawrence & Houseworth) already controlled a large portion of the Western sales, and in turn was pushed hard by Muybridge's stereographs, published by Bradley & Rulofson.

The commercial rivalry was intensified by the overall weakness of the stereoscopic market itself. Severe competition, mass-production technology, pirating, and a trend towards cards of poor quality forced prices down sharply. This was especially damaging to Watkins, particularly when even an advocate had noted that "in one thing only will the stranger be disappointed [during a visit to Watkins's Yosemite Art Gallery] . . . receiving first-class work produced by first-class artists, aided by first-class mechanical appliances; [the customer] may expect to pay exorbitant prices."[155] During the 1860s Watkins had easily sold his stereoscopic views for $5 per dozen, yet by 1873 these same views listed at $1.50. J. J. Reilly experienced a similar loss:

Fine work is not appreciated by the public in stereo-scopic views. The man who can furnish the cheapest sells most without regard to quality . . . I used to get $24 per gross for stereoscopic views some eight years ago at Niagara, and two years ago $24 per gross for views of the Yosemite valley, and today I can get barely half that. It is not because my views are poorer, for they are at least fifty percent better, but the men who handle them say, "I can buy views from Mr. A at $12 per gross, and why do you ask more?" Why? Because my views are better, "Yes, but the public don't see any difference."[156]

Watkins nonetheless persevered. His "old" negatives gone, he immediately began the slow and painful process of rebuilding his stock. He rephotographed many of his most popular subjects, especially San Francisco and Yosemite. In an effort to broaden his selection of subject matter, he spent much of the next ten years traveling widely throughout California, Oregon, Washington Territory (going as far north as Vancouver, B.C.), and along the route of the Southern Pacific Railroad, deep into Arizona. He also spent additional time in Nevada, and made a northeastern journey that carried him into Idaho and finally into Wyoming. Watkins's renewed undertaking was made on the grand scale the public had come to expect of him.

Watkins was unsettled during the two years following his bankruptcy. He spent long periods in the field, including most of the summer of 1878 in Yosemite, allowing time to ease the pain of his losses. By the end of 1878, however, he was ready to begin his business life anew. He opened a new gallery at 427 Montgomery Street, advertising himself as the "leading landscape photographer . . . from Alaska to Mexico." While

154. Turrill, "Watkins," p. 37.
155. *Buyers' Manual*, p. 154.

156. John James Reilly, "Outdoor Work on the Pacific Coast," *The Philadelphia Photographer* 11, no. 127 (July 1874): 211.

Photograph from C. E. Watkins' Yosemite Art Gallery, 22 & 26 Montg'y St. opp. Lick House Entrance.

Francis Sneed Watkins (1856–1945), albumen silver print, c. 1875.
The Bancroft Library, University of California, Berkeley.

Watkins appeared to be adhering to his previous patterns, there was one definite difference—he was in love.

The object of Watkins's affections was the twenty-two-year-old Frances Henrietta Sneed (sometimes spelled Snead or Sneade).[157] Frances (Watkins called her "Frankie") had been raised in Virginia City, Nevada; she met Watkins about 1875, during a visit to San Francisco. A surviving photographic portrait shows her to be attractive, even stylish, though hardly a beauty. They were married on Watkins's fiftieth birthday, 11 November 1879, in the First Presbyterian Church of San Francisco.[158]

The romantic ideal of bliss in matrimony often eluded them. While Watkins was a patient and loving husband and father, Frankie was never satisfied. Many years later their daughter Julia often remarked on the unevenness of the match: "She [behaved] twenty years older than he was, and he [acted] twenty years younger . . . they weren't anything alike."[159] Watkins enjoyed visitors immensely, "but he didn't entertain very much because [my mother] didn't care to entertain." "My father was happiness, he was full of fun . . . he took us to the park and to Chinatown, to lunch at Jax's [Watkins's favorite restaurant in San Francisco]."[160] Whenever Watkins was away Frankie complained constantly, and his letters home often reveal his vexation at her attitude: "[Your letter] is full of

157. The 1875 Nevada *State Census* for Storey County lists Frances Henrietta Sneed, born 1856 in New York, and Hiram H. Snead (Frances's brother, born 1861) both residing in Virginia City, Nevada. Judith M. Rippetoe to Peter Palmquist, 4 February 1980. Julia Watkins spoke of her mother as being of French extraction.

158. Despite a considerable search, the author was unable to locate any primary source to support this date, which is derived from various interviews with Julia.

159. William and Karen Current, "Interview with Miss Julia C. Watkins, February 12, 1975," p. 2.

160. Ibid., p. 4.

the blues, and you must try to get over them, 'keep a stiff upper lip,' find something to busy yourself about and try to be merry as a lark, and the old man will be around before you know it."[161]

Despite his obvious frustration with Frankie's complaining, Watkins frequently went out of his way to provide her with emotional support during his absences:

> If things are as bad as you say . . . I am sure you ought to feel thankful, instead of blue, that you have got an old man that thinks you are awful nice . . . you must try to make the best of that which cannot be helped. If the old man should stay at home all the time there would soon be nothing to make the pot boil, and there is devilish little at any time. Try to look at the cheerful side Frankie . . . I have not got so old yet that I cannot find a bright side, and every day I live in the hope that there are to be happy times for the old man yet. So cheer up, give the devil your blues, and one of these days we will have some good *harness* [clothing].[162]

Perhaps the most succinct and revealing summary of Frankie's personality is that by Ralph Anderson, written following an interview with Julia Watkins, in 1949: "Watkins' wife had an incurable disease—she felt sorry for herself!"[163]

Business demands preoccupied the couple from the very beginning of their relationship. Re-opening the Yosemite Gallery was especially troublesome to the couple, and Frankie was needed to assist on a regular basis. Whenever Watkins was away Frankie served as the gallery's business manager—a role she hated. Technical matters were usually handled by Bagnasco, "Number one man around the gallery," and a Chinese assistant named Ah Fue.[164]

In the field Watkins was assisted by his long-time friend Charley Staples, who doubled as teamster and cook. Two other important members of the operation were William H. Lawrence and Sallie L. Dutcher. Lawrence was billed in the San Francisco *Directory* as the "proprietor" of Watkins's Yosemite Gallery; it is probable that he provided the capital that enabled Watkins to reopen his gallery.[165] Dutcher had been associated with Watkins for many years; during the late 1870s she operated a branch sales outlet at 8 Montgomery Street, "Parlor 1, over the Hibernia Bank."[166]

Yosemite National Park ["Watkins Summary"]. In addition, there are a number of hand-written notes.

161. C. E. Watkins to Frances Watkins, 6 April 1880, Watkins Letters. Remonstrations concerning Frankie's griping were frequent, including this one made about 1890: "I am going to stick to [my work] and do the best I can . . . I *wish* you would do the same and try to get along without so much growling . . . I don't think it makes either of us any happier, and I am sure it don't me." Watkins to Frances Watkins, [27 September 1890], Watkins Letters.

162. Watkins to Frances Watkins, 18 May 1880, Watkins Letters.

163. Ralph H. Anderson, "Carleton E. Watkins," one-page typescript summary of interview with Julia Watkins, 1949, Research Library,

164. Ah Fue became adept at photographic printing. Besides Frankie, Myra Waddell served as a sales assistant, and Jessie Miller helped Watkins in the field and as a "man Friday" around the gallery. A one-armed man, known as Mr. Voy, ran errands. Information from various sources, primarily Ralph Anderson, "Watkins Summary" and Compton Papers.

165. William H. Lawrence had been employed as a foreman by the firm of Pool & Harris, Oriental Warehouse, San Francisco. It is probable that Lawrence invested in Watkins's new studio venture but left Watkins to do his own management (with possible constraints in fiscal matters). By 1883 Lawrence had become general superintendent for the Spring Valley Water Works. Lawrence is listed in the San Francisco business directories as proprietor of the Watkins gallery from 1881–85. Other evidence suggests an involvement lasting from about 1879 to at least 1890.

166. The Hibernia Bank outlet was only one of several sales outlets used by Watkins; Woodward's Gardens was another. A trade card for Miss Dutcher's operation is in the Photograph Collection, Library, California

Sallie Dutcher, unknown photographer,
gelatin silver copy print, c. 1870s, print later. Yosemite National Park.

Dutcher was frequently referred to as the "tall lady." She seems to have been a captivating, self-assured, and aggressive individual, who was widely admired by men, if not by women. She is credited with being the first woman to scale Yosemite's Half Dome. Watkins may have had a romantic interest in Dutcher, inasmuch as Frankie was upset by the mere mention of her name. Watkins was often required to allay her fears in

Historical Society, San Francisco. The card reads: "The NEW SERIES comprise Yosemite, Big Trees, Orange Groves and Vineyards of Southern California, Old Missions, Mills and Mines of Virginia City and Carson River, Lake Tahoe, San Francisco, Overland R.R., in all sizes mounted or unmounted . . . the NEW SERIES of Yosemite embraces views made accessible by the opening of new trails, and are included in NO OTHER collection." Watkins also offered wholesale rates to dealers, tourist concessionaires, and the like.

this regard: "you are thinking altogether too much about the tall woman, and you are making yourself nervous and *fidgety* about matters and things that you can't help."[167]

Although this gallery was far less elegant than the one he had lost, it was well attended by tourists and San Francisco regulars alike. He added new negatives to his *Watkins' New Series* whenever possible, including some negatives that had not passed to Taber. During the mid-1870s he made at least two rail trips to Nevada where he photographed the Comstock mines and nearby towns. A number of these views show the stamping and reduction mills on the Carson River. Among the more remarkable are interior views in both mammoth and stereoscopic formats (Plate 56). One of his stereographs, #4154—*Interior Ophir Hoisting Works, the Cages*, shows miners preparing for descent (Plate 57). Another, #4156—*Interior Ophir Hoisting Works, Incline Hoisting Works*, is stunningly three-dimensional when placed in a stereo viewer (Plate 58).

In Nevada he photographed the opera house, International Hotel, orphan asylum, U.S. Mint, and the Nevada State Prison as well as the State Capital. His travels took him to Carson City, Reno, Virginia City, Empire City, and Gold Hill, as well as sparsely populated areas. He made several impressive panoramas: one, *Panorama of Virginia City, Nevada, View from the Combination Shaft*, is a three-part series, dated 26 October 1876 (Plate 55). There are Nevada stereographs of interest as set pieces such as #4137, *Chinese Chair Mender* or #4127, *A Quiet Poker Game*.

About 1876 Watkins also made a photographic tour of the newly built rail route into southern California. This trip may have marked the start of Watkins's *Mission Views* (Plates 70 through 73).

On his first southern California trip Watkins returned in

167. Watkins to Frances Watkins, 11 May 1880, Watkins Letters.

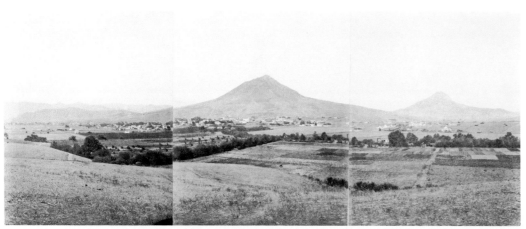

[*Mission San Luis Obispo*], albumen silver print, three-part panorama, c. 1876–1878. The Huntington Library, San Marino, California.
Watkins was one of the earliest photographers to record southern California scenes systematically. He succeeded in documenting all of the California missions, including this overview taken in sections. Watkins frequently made multiple panoramic images to show vistas, some composed of as many as twenty overlapping negatives.

his wagon from San Diego, following the old overland stage road the greater part of the way, and visiting most of the Franciscan Missions . . . this collection of mission views is the earliest general photographic collection of California Missions made. They are extremely valuable in showing details of construction which the hand of time has swept away.[168]

It was on this journey that Watkins made photographs of the famed Tehachapi Loop of the Southern Pacific Railroad. Railroad designers were faced with the problem of raising the railroad 2,734 feet from the floor of the San Joaquin Valley, at

Caliente, to the top of Tehachapi Pass, a total rise of 4,025 feet in sixteen miles as the crow flies. This feat was accomplished by swerving twenty-eight miles of tracks in serpentine fashion around many gradual curves of 2.2 percent grade, through eighteen tunnels. At the Tehachapi Loop the track crossed over itself in a remarkable stroke of engineering. Watkins made a grand overview of this scene, later reinforcing the position of the tracks by marking them with a dotted line directly on the mammoth photograph. Reduced copies of this image remained in demand for many years (Plate 61).

Among Watkins's first priorities following the foreclosure was the immediate replacement of his Yosemite negatives; he made an extended visit to the valley in the summer of 1878. By this time Yosemite Valley had become a vast beehive of tourist activity, with hotels, a post office, a local police constable, and many other refinements typical of a small community. On May 8 a visitor noted that Watkins was already at work in the valley: "The great Watkins . . . is here with a large photographic waggon [*sic*]."[169]

That Watkins could take his traveling wagon into the valley was itself a clear indication of change. No longer was a trip to Yosemite confined to the hardy. New roads, together with an active program of tourist promotion, had garnered such surprising results as this: "The great revivalist and preacher, Mrs. Van Cott, of New York, preached here last Sunday night, at the Yosemite Hall [in the valley itself], which was well filled."[170] The year's major happening, however, was a gala Fourth of July:

We learn through a correspondent who resides in Yosemite Valley that the fourth of July was celebrated there

168. Turrill, "Watkins," p. 34.

169. Constance F. Gordon-Cumming, *Granite Crags of California*, p. 129.

170. "Letter from Yosemite," *Mariposa Gazette*, 10 August 1878.

in the customary manner. The thundering of cannon in different portions of the Valley, and the echo and reverberations from the lofty crags and peaks, together with the sky-rockets shooting heaven-ward from some of the loftiest domes, made it one of the grandest and most sublime scenes that can be imagined.[171]

Watkins must have been sorely amazed by the changing milieu; gone were the remoteness and isolation that had characterized his first visit to Yosemite in 1861. He must have been saddened by much of what he now observed. The original inhabitants of the valley had been labeled savages and worse, but they were not nearly as barbaric as a horde of noisy tourists. It is little wonder that Watkins preferred his own rustic camp beside his photographic wagon. Here, at least, he could visit quietly with fellow artists and his circle of Yosemite friends.

By 1878 Watkins was a legendary figure in the valley. Many people sought him out, not only to inquire of his work, but to share his wisdom. Not surprisingly, his photography from this period shows a keen and greatly renewed interest in the artistic potentials of Yosemite. He began a series of cabinet-size images at this time; using a smaller camera with a very wide angle of view, he emphasized foreground areas in an effort to force perspective. Rock forms and shimmering water areas predominate as subject matter. To support the increased feelings of space, he deliberately cropped (masked) these deep-space images into oval, round, or dome-topped prints (Plates 62, 63).

Many of these new views, while far smaller than his mammoth images, are compositionally pleasing in ways unusual for Watkins. For the first time in many years he seems to have taken the time needed to experiment with his subject matter. Between 1878 and 1881 Watkins made a fine new se-

171. "From Yosemite Valley," *Mariposa Gazette*, 13 July 1878.

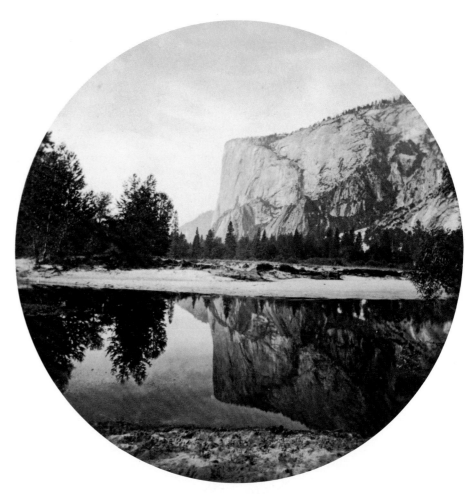

[*Mirror View, Yosemite*], albumen silver print, 1878.
The Bancroft Library, University of California, Berkeley.

In 1878 Watkins spent most of the summer in Yosemite. His work showed his continued preoccupation with water, but there were changes in his vision. Working with cabinet and boudoir-size images, he greatly emphasized the foreground similar to his work in stereo. He reinforced the spaciousness of his images by printing round and dome-topped photographs designed for commercially available portrait albums and tourists' scrapbooks.

ries of mammoth views of the valley; these too reveal a new vitality and a searching interest in the valley's geologic elements (Plates 64–67). Once again a feeling of pride and workmanship, which had been subverted during his geological survey period, is evident in his photographs. Watkins knew it as well, as we see in this letter to a friend: "Everybody says they are better, softer, more artistic, etc."[172]

Several of Watkins's later mammoth views show evidence that he manipulated the environment to accommodate visual needs. Here and there one can observe a freshly cut stump, or places where a clump of obscuring brush was carefully removed. Branches that interfered with the view were trimmed, and one view shows an ax in the foreground; not that this was a precedent-setting technique:

> The foreground being one of the main points in a picture . . . if not naturally [attractive, can be made so] by a little labor in the way of rolling up an old log or stump in an effective position . . . and let me advise you here to always have with you on your photographic trips, a spade and a good axe; the latter particularly will often be found "a friend in need," when it is desirable to cut a small tree or remove a branch that would otherwise obscure some important point of your view.[173]

Much of Watkins's renewal may have been the result of his interest in Frankie. Shortly after his return from Yosemite in 1878 he prepared an album of his best cabinet views, and inscribed it to Frankie, "Compliments of C. E. Watkins— Christmas 1878" (Plate 63).[174]

The best record of Watkins's personality has come to us through several interviews with his daughter, Julia Caroline Watkins (1881–1976). A persistent rumor suggests that Frances and Watkins were forced into marriage by an unplanned pregnancy; even if this allegation is untrue, Julia herself was unsure of her own birthday, claiming that her mother would not tell her whether it was accurate or not. Whatever the facts, it is abundantly clear that Watkins adored his "Juju" (as Julia was known). Julia, in turn, was never happier than in the company of her father. From childhood, she hated her mother, and later her brother Collis (whom she thought was much like her mother) as well. Watkins and a Catholic priest named Father Varsi were the dominant influences on young Julia's life. Even as an adult "Julia could get along with men, but did not know how to deal with women."[175]

It may have been her mother's negative attitude that led Julia to idolize her father. Years later, when Julia was nearly seventy, an interviewer reported that "When [Frankie] spanked daughter, it was a long time before they were friendly again . . . [yet] when Carleton E. spanked daughter, they were playing together again in 15 minutes."[176] Her most prized possession was a cameo likeness that Watkins had had made for his mother. Julia said that he "looked exactly like this cameo . . . he was always neat and clean" (Frontispiece). Her intense pride in her father's character is clearly apparent as she continued: "This cameo was made by an Italian; my father had it

172. Watkins to George Davidson, 2 September 1878, Davidson Correspondence and Papers.

173. James Mullens, "Landscape Photography," *The Philadelphia Photographer* 10, no. 117 (September 1873): 466.

174. The album contains thirty-eight views and is in the Research Library, Yosemite National Park. The gift of this album to Frances is men-

tioned in a memo from Ralph H. Anderson to the Superintendent of Yosemite National Park, 16 September 1949, Research Library, Yosemite National Park.

175. Alma Compton to Peter Palmquist, 13 July 1981. The author is indebted to Mrs. Compton for many first-hand details concerning both Julia and Collis Watkins.

176. Anderson, "Watkins Summary."

made and gave him money so he could go back to Italy . . . it's a wonderful likeness [and] it speaks to me."[177]

Although Julia remembered her father as a large man—"heavy and had large shoulders . . . large strong hands and used to terrify [his] wife by holding babies on his hand and raising them high over head"—it should be observed that she was thinking of him when he was in his late fifties and older.[178] At the time of his commitment to the California State Insane Asylum in 1910, he was noted to be "5′-6″ tall, weight 130 lbs."[179] In his prime, he was probably five feet, seven inches, and perhaps one hundred and fifty pounds.

Julia's earliest memories were of watching him at work in the room adjacent to her nursery, at 427 Montgomery Street. A treasured picture shows this workroom, with her and her younger brother Collis (1883–1965) peering through the doorway between the two rooms. A closer look reveals that the workroom had become overrun with the trappings of domesticity, including a child's highchair and the clutter of family living. Nearby, we see Julia's favorite doll—"Araminta Clementina Josephina Watkins." It was a homey scene, and one that fits very closely what she described during an interview made in 1949:

> Julia vividly remembers those early days in the top floor of that building on Montgomery Street. The reception room and the studio, with its elaborate props, were downstairs. Her father would sometimes call up to the stairway that he would soon bring a distinguished visitor up to their living quarters . . . [she also] remembers

[*Watkins' Workroom at 427 Montgomery, Collis and Julia in the Doorway*], gelatin silver copy print, c. 1884, print later. Yosemite National Park.

going to bed in the room adjoining the living room and watching through a crack in the doorway the shadow profile of her jovial father as he chuckled over the cartoons and jokes in his favorite magazine, *Puck*, or wiped tears from his eyes after reading a sad story in the *Overland Monthly*, another of his magazines. He was evidently a man of deep feelings, quick to respond to humor or pathos.[180]

Another of Watkins's special interests was *The Poetical Works of Thomas Moore* (1829), and he was an avid reader of *The Century* magazine as well. He also enjoyed novels, history,

177. Current and Current, "Watkins Interview," p. 2.

178. Anderson, "Watkins Summary." Frances was physically short; as adults both Julia and Collis were under five feet, two inches.

179. As noted by Eugene Compton: "Health was good, totally blind, quiet and [withdrawn?] . . . committed from old age and unable to work," Compton Papers.

180. Ralph H. Anderson, "Carleton E. Watkins, Pioneer Photographer of the Pacific Coast," *Yosemite Nature Notes* 32, no. 4 (April 1953): 36.

and travel accounts. Because Frankie disliked reading and had no time for intellectual discussion, Watkins welcomed any opportunity to share his feelings with visitors, especially Thomas Hill, William Keith, John Muir, and others who had traveled widely and who also loved nature. Although Julia liked to run her fingers through Keith's curly dark hair, she was much less enthusiastic about John Muir: "One of the dearest friends [my father] ever had was that dirty old man John Muir. He didn't like me, he didn't like children. He wouldn't have anything to do with me. He was a dirty old man and I was so afraid he'd get Poppa dirty. Oh, but he loved John Muir. He was a Scotchman too."[181]

Although Julia did not accompany her father on his journeys, she enjoyed hearing him speak of his adventures. Many of these memories stayed with her all her life:

> [Watkins] had a deep appreciation of nature, his many accounts to his children of the beauties of Mirror Lake in the moonlight, songs of the lark in the valley, camping near Mirror Lake and Folsom Ferry [on the way to Yosemite]. Liked to fish, enjoyed eating fish, but never hunted. Once just for fun he aimed a gun at a humming bird never thinking he would hit it, when the shot shattered the bird he felt very badly, would never again shoot a living thing. Loved wildflowers of the [Yosemite] Valley . . . was an early riser. Took many of his best pictures at daybreak, told often of the beauty of Yosemite when the sun first touched the cliff walls . . . described often to children how he packed into the mountains with Mary and Frank, two of the mules. Frank was very stubborn (like C. E. Watkins!) and according to Julia C. Watkins, her father used to use other words in front of their names . . . wife had no interest in Yosemite. Galen Clark often asked him to bring family to Yosemite, he would take

them all over the park! Collis [however] poked fun at [his] father's stories about Yosemite. Pointed out how father went straight up the Bridalveil Falls and down the Yosemite Falls![182]

When Julia was asked whether her father could paint or draw, she responded that "he couldn't draw anything. . . . I heard him say that . . . he just couldn't, isn't that funny?" Also, "he didn't like to have his own picture taken . . . the picture of Watkins as a gold miner was made for us children . . . we wanted a picture of Poppa so he had a picture made . . . but did you ever see a miner with a white shirt?" (Plate 87).[183]

Julia frequently said her father was "jolly" and that his stories were great fun. She loved to retell Watkins's story of "The Englishman with the Squirrrreeeellll":

> [An] Englishman at the hotel [in Yosemite] saw a little animal running over the porch. He ran after him saying, "Oh, there is a little squirrel, I wonder if he'll play with me?" The skunk gave him a full blast on his long beard, and the poor fellow had to leave his party. It was terrible. He had to have his beard shaved and when [Watkins] saw him 6 months later in [San Francisco] the Englishman said . . . "had to give up my beard, and *I* fawncy I can smell him yet."[184]

It should be remembered that Julia's reminiscences were gleaned from events scattered over many years, mainly during her childhood. When Julia became a teenager and would have welcomed her father's steadying influence, he was unfortunately already an old man, full of disappointments and suffering from arthritis and diminished eyesight.

Young Collis Potter Watkins, named after C. P. Hunt-

181. Current and Current, "Watkins Interview," p. 4.

182. Anderson, "Watkins Summary."
183. Current and Current, "Watkins Interview," p. 2.
184. Anderson, "Watkins Summary."

ington, was to suffer most of all. As a teenager he tried to assist his ailing father in the photography business, but was rebuffed: "Collis was a good man in the darkroom but Watkins would not give him any credit when he helped . . . when they were [particularly] hard up (in the 1890s) and Collis was able to earn money for the family, Watkins would not accept it and told him to leave."[185] It has been remarked by those who knew them that both Collis and Julia inherited some measure of their father's artistic ability and that "Julia designed and sewed all her own clothes and both loved classical music and particularly the opera."[186] Collis also learned to play the piano when he worked for a music company as a young man.

Watkins's first years as a family man were happy ones; they were also busy ones for him professionally. In the year of his marriage Watkins accepted an assignment which took him to the heights of the Sierra Nevada for the Geodetic Survey. A year later, in 1880, he made an extended rail trip to the developing fruit orchards of southern California, and on as far as Tombstone, Arizona (Plates 74–82).

The scientific curiosity of the period led to surveys of various kinds. One of the most important surveying organizations in the West was the United States Coast and Geodetic Survey, under the leadership of George Davidson (1825–1911). In 1879 Davidson was hard at work to establish a series of geodetic stations along the mountain backbone of California: he wanted Watkins to photograph the process.

By the summer of 1879 Davidson had secured a survey base on Mt. Shasta and another on Mt. Lola (9,200 ft.), near the California-Nevada border, not far from Lake Tahoe. Although it was already June, Davidson's official report reveals the difficulty of work at high elevations:

Much hardship was incurred in reaching Mount Lola, on account of snow and cold air. Officers, men, and animals sank in the snow to their knees, and all were severely tried in the ascent, which of necessity was done afoot in a rare atmosphere . . . [on the summit] the earth was found to be frozen to the depth of two feet and a half. Bad weather delayed arrangements for observing, but ceased on the 12th of June, after sixty consecutive hours of snow, sleet, rain and wind. The nights were intensely cold, and ice formed frequently to the thickness of an inch.[187]

On July 2, Watkins wrote to Davidson asking when he would be wanted at Mt. Lola: "If you *want* me, don't let any uncertain conditions or *approximations* interfere."[188] On July 14 Watkins again queried: "From what point do you pack [in to the summit], and can I haul my waggon [*sic*] to that place with two horses? Give me full directions as you can, and the *latest* moment I can report myself with plenty of time to do the work."[189] Although Davidson's reply is not known, it probably told him to take the train to Summit Station, and from there a fourteen-mile drive for his wagon. The last five and one-half miles, however, involved a twenty-eight-hundred-foot climb by "packing and sledding."[190]

Watkins was now fifty years of age and normally spent most of his time at or near sea level. He would have had to ascend the final five and one-half miles on foot, with his outfit physically carried to the summit. At the top there would be no shelter from the glaring days and freezing nights; nor would there be a convenient place from which to take his pictures. To

185. Alma Compton to Peter Palmquist, 13 July 1981.
186. Ibid.

187. United States Coast and Geodetic Survey [USCGS], *Report of the Superintendent* (1879), p. 55. Mt. Lola was named after the actress Lola Montez.
188. Watkins to Davidson, 2 [July] 1879, Davidson Papers.
189. Ibid., 14 July 1879, Davidson Papers.
190. USCGS, *Report of the Superintendent* (1880), p. 37.

photograph the surveying party at work on the summit required that he move away from the summit and take his pictures uphill, with all the attendant problems of perspective distortion, lack of appropriate vantage point, and a slippery, unstable surface on which to place his tripod. On July 19 Watkins signaled his imminent departure: "expect wagon daily will come immediately on its arrival."[191]

Davidson recorded the photographer's arrival in his notes for Friday, July 25: "Watkins came up P.M. . . . Weather intensely smoky; clouds over Shasta." Since Watkins hoped to photograph all the peaks to be seen from Mt. Lola, including Mt. Shasta, nearly two hundred miles away, clear visibility was essential. The following morning, however, Davidson noted "Watkins at photos," although Shasta was still obscured. The following day was even worse, and by Monday he lamented: "At sunrise smokier than ever, hid Mt. Shasta until 9½ A.M. . . . Watkins bound to [North] head P.M. at sunset waiting for Shasta and could see nothing." Yet Watkins persevered, and by late on July 29 he had finished the needed views. Davidson noted this fact with obvious relief, and indicated that Watkins had gone back down the mountain.[192]

All the necessary photographs of an adjacent observation point had not been made, however. On July 31 Davidson's notebook records the arrival of a hired packer with three mules to help carry Watkins's outfit to a nearby mountain, Round Top, 10,600 feet above sea level and troublesome to reach: "The station is on a sharp backbone lying east and west [of the main ridge] . . . to the south is the deep transverse canon [which is] the headwaters of the Mokelumne River."[193]

Conditions on the ragged summit (the name was reportedly chosen as being directly contrary to the actual physical characteristics) were exceedingly difficult; there were virtually no flat surfaces, and everything—lumber, camp equipment, instruments, water, and provisions—had to be carried. "The little wooden observatory, eight feet square, was protected from blowing away by a heavy dry wall of rocks."[194]

In what must be regarded an understatement, Davidson's official report for the Round Top project noted: "Many difficulties were overcome in securing photographic views."[195] Perched on the most precarious of footings, Watkins used his large camera to capture the magnitude of the vistas that surrounded him on all sides; the images are superbly clear and detailed. When the weather was clearest the deep azure sky was sufficiently dark to produce cloud effects without manipulation, particularly when they were tinged red, as in the early morning hours. At incredible personal risk Watkins recorded Davidson's observatory, with Davidson and his team posed with their instruments. At least forty different large views were taken of Mt. Lola and Round Top, as well as several distant views of these peaks from nearby Independence Lake (Plate 68). Negatives of other sizes were taken as well. The series was titled *Summits of the Sierra*.[196]

Watkins did other survey work for Davidson as well. In 1881 he was a participant in Davidson's Yolo Base Line project, near Davis; the Yolo Base Line was another step in precision measurement of the so-called Davidson Quadrilaterals and was followed a few years later by the Los Angeles Base Line. Watkins's photographs show the measuring process, including its unique sheltering cover fifty feet long, twelve feet

191. Watkins to Davidson, 19 July 1879, Davidson Papers.

192. All entries from George Davidson, "Mount Lola Sierra Nevada, Daily Journal, Occupation Commencing May 19/79 ending July 31/79: Round Top Commencing Aug. 1st, ending Aug. 22/79," Notebook 64, Davidson Papers.

193. USCGS, *Report of the Superintendent* (1880), p. 40.

194. Ibid., p. 39.

195. Ibid.

196. The best collections of these unusual photographs are in the Bancroft Library and the Huntington Library. Other collections are known, but consist mainly of boudoir or stereoscopic images.

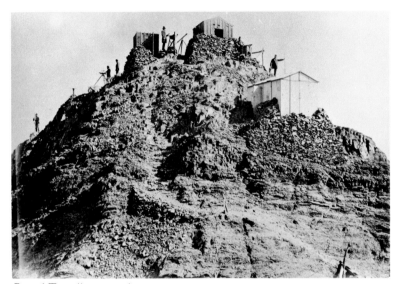

Round Top, albumen silver print, 1879.
The Huntington Library, San Marino, California.

Looking South from Round Top—Sierra Nevadas, albumen silver print, 1879.
The Bancroft Library, University of California, Berkeley.

Watkins's High Sierra photographs often seem timeless, as though taken only recently from a modern aircraft. Today, in the age of small-format cameras, it is difficult to fully appreciate the great hardship which accompanied such work more than one hundred years ago.

wide, and nine feet high, which had come to be known as the "Yolo Buggy" (Plate 83).[197]

In the spring of 1880 Watkins made his extended journey along the route of the Southern Pacific Railroad. It proved to be a long and tiring experience for him, often under the difficult conditions of glaring sun, driving desert sand, and almost continual travel. During the course of his trip Watkins wrote regularly to Frankie (who was minding the gallery in San Francisco); eighteen of these letters survive today. In them we gain a unique glimpse of Watkins involved in his daily tasks. In particular we have an unprecedented opportunity to observe his anxieties as he struggled to meet his professional responsibilities and overcome the multitude of uncertainties that hampered him along the way. In many ways, these letters from southern California and Arizona serve as a classic primer

197. USCGS, "Report of the Measurement of the Yolo Base [Line], Yolo County, Cal.," p. 144. Watkins also made a number of copy photographs of documents and maps for Davidson. The Bancroft Library has at least twenty examples, including a photographic copy of a "Spanish" map copied in June 1888. Davidson Papers, Manuscript File c-b 490 (oversize). It appears that Watkins made the Yolo Base Line negatives in cooperation with the Survey's "mechancian [*sic*]," Werner Suess, who later borrowed the negatives in order to produce a set of prints under his own name. See Werner Suess to George Davidson, 19 January 1882, Davidson Papers.

of the problems confronting commercial photography in California during the 1880s.

His first letter, of 27 March 1880, announced his safe arrival "at the city of the Angels," Los Angeles.[198] The letter reveals that this was not his first stop since leaving San Francisco; he had already photographed the exhibits of the Pasadena Citrus Fair on March 24. He returned to Pasadena briefly on March 26. On the thirtieth he wrote: "Why have you not written to me? . . . I shall be glad to hear that you have been so busy taking in cash that you have not had time. . . . I am doing a little work everyday, but the wind blows so much that it is very little."[199] Also on March 30 Watkins shipped his negatives, with special instructions for their printing, to Bagnasco, in San Francisco. This list is the only surviving document which shows a direct interaction between Watkins and his photographic printer, and as such merits full reproduction here:

The first four negatives in the box are the master ones. Print 2 strips [proofs] of the *entire lot* [19 negatives] *full size* of the negative[s] and give one to Carter [Watkins's client and publisher of the *Semi-tropical California and Southern California Horticulturist*] and send one [set] to me. *Nurse* the intense [dark and contrasty] ones so they will print as good as possible. Spot [retouch dust spots] the 3 negatives marked for cabinets, and print [them] as nicely as you can. Print the set for Carter and myself the day after you get the negatives, *sure*. I hope Frankie will have got some money by that time. If you have got any [albuminized] plates prepared for transparencies [projection positives, often used to make duplicate negatives of important views], you had better print from the *best* one of the Fruit negative 3 or 4 copies before you print the pa-

per [prints; the copy transparency needed to be made first, before the original negative became too dirty from handling]. I made a 10 x 14 view of that fruit piece which I will send up [to San Francisco] in a few days with some other larger prints. Carter will pick these up, and he wants the prints immediately.[200]

This note reveals that Watkins was printing both stereo pairs and cabinet-size prints from the same negative. Turrill describes this clever innovation:

Watkins had constructed a camera which would work a plate 5½″ x 14.″ Thus, he made at each exposure two negatives [a stereo pair] approximately 5½″ x 7.″ From these ends of his stereoscopic plate he made prints, approximately 5 x 7, which he published as his "Boudoir Series," [and] using the same plates for stereoscopic views he employed [printing] mats, properly cut out. He printed a certain portion from each negative for stereo . . . In my research in regard to photographs and photographic methods, I believe that this system of Watkins was never used by any one except himself.[201]

Watkins's letter to Bagnasco also contains cryptic instructions for printing each of the four master negatives. The fourth one, for example, required Bagnasco to: "Mat for stereo and print 200 as soon as you can . . . have printed on the bottom of the stereo mounts the enclosed slip—*Pasadena's First Citrus Fruit Fair, March 24th 1880.*" Watkins closed his letter by

198. Watkins to Frances Watkins, 27 [March] 1880, Watkins Letters.
199. Ibid., 30 March 1880, Watkins Letters.

200. Watkins to P. Bagnasco, [30 March 1880], Watkins Letters. Although this is the only specific note from Watkins to his photographic printer, he sometimes conveyed messages to Bagnasco in his letters to Frankie.
201. Turrill, "Watkins," p. 32. By selecting different portions of a negative Watkins sometimes made as many as three slightly different stereographs from the same master negative.

Pasadena's First Citrus Fruit Fair, Mar. 24, 1880,
albumen silver print, stereo #4782, 1880. California State Library.

apologizing for the low quality of the negatives, explaining: "I hope you will [be able to print them adequately] as it is very much more smoky down here than I expected to find it." To this, he added a further difficulty: "I am having the rhumatis [*sic*] like the devil in my shoulders and neck, and the weight in the [equipment] case don't help me much."[202]

He next wrote on April 3; he had been held up in Pasadena by several days of rain and had just returned to his railroad car only to find that his packer, Charley Staples, had locked it and gone away. Depressed by the rain and the unfortunate lockout, Watkins was also very worried about his dwindling money supply: "Should be awful glad to hear that you have struck a good customer or two, and have something to jingle in your pockets . . . I may slap mine ever so hard and no

202. Watkins to Bagnasco, [30 March 1880], Watkins Letters.

sound comes forth but an empty one."[203] On April 6 he wrote to apologize for his "scolding letter," happily announcing a bonanza gift of five letters from Frankie. At the same time he lamented: "I have lost the whole week on account of the rain, and it is safe to say that I am *dam* mad."[204] The following morning Watkins received a visit from Carter, who brought him thirty dollars—"a pretty small capital to start for Arizona with."[205]

By April 15 Watkins had reached Tucson, Arizona, but was again delayed:

> Dear Frankie—to my infinite disgust I date this letter from this mad city [of Tucson] instead of Tombstone where I expected to have been three days ago. "Man proposes and God disposes." My horses are not worth a cuss. And you may tell Mr. Lawrence, when he comes in, that if I ever wish him Evil it will be that he has to come to Arizona and drive this d---n team for three weeks. The first days drive from this place to water is nearly 40 miles and the team never would stand it. And I do not know just yet what I am going to do, "Trust to Luck," I suppose.[206]

Despite this continued pessimism his closing words were reassuring: "Say something good to everybody that enquires of me, and don't get blue. When I get back you shall have

203. Watkins to Frances Watkins, 3 April 1880, Watkins Letters.
204. Ibid., 6 April 1880, first letter, Watkins Letters.
205. Ibid., 6 April 1880, second letter, Watkins Letters.
206. Ibid., 15 April 1880, Watkins Letters. The Arizona *Weekly Star*, 22 April 1880, noted his activities: "Mr. C. E. Watkins, the pioneer photographer of San Francisco, has been in this place about a week taking views. He has made several large views from Sentinel Peak of this city, and also several street views. He has also made seven views of San Xavier church. Mr. Watkins travels with two cars, and is prepared to do any kind of photography work. He will visit Tombstone and the mining camps in a few days."

something else but mutton . . . I am afraid [that the constant diet of mutton at Hoy's boarding house] does not make you lamb like." By April 27 he had reached his destination:

> At last I am in Tombstone, and have received and read all your letters . . . you mention having sent me $30, but it has not come to hand. I suppose you sent it by express . . . and it is now at Los Angeles, 700 miles from here. Never mind, don't worry. I shall get along somehow . . . I told you that I had a bad face but that it was getting better. I had no sooner sent off that letter than my damned face got worse, and I had *such* a time. For three days I could only eat with a spoon, and I never slept a wink for two nights. At a place called Charleston [in Arizona, between Tombstone and the Mexican border], I went into a little place where they sold drugs to see if I could get it lanced, and before I could get my mouth open far enough to talk, *it broke*, and Oh Lordy in about 2 minutes I felt like *some other feller*, and I have since had some peace in my life. This is a nasty country to travel in. Last night we slept in a hay mow and tonight we have not half so good a place. I am writing this in my waggon about half a mile outside of Tombstone, and Jessie [Miller, Watkins's young assistant] is waiting to take it to town to mail. I am too tired to go.[207]

Despite his grumbling Watkins had succeeded in making photographs all along his route. At Tombstone he made several large overviews of the town from a nearby hill; he then turned his camera on local mining facilities, such as the Contention Mill and others located in the San Pedro Valley and at Millville (Plate 81). Some of his finest Arizona views, however, are those taken of the San Xavier del Bac Mission, near Tucson (Plate 78), and those of the pre-Columbian Indian ruins, near Casa Grande. "As the traveler approaches Casa

207. Watkins to Frances Watkins, 27 April [1880], Watkins Letters.

View from the Palace Hotel, Tucson, Arizona,
albumen silver print, stereo #4889, 1880. California State Library.

Grande he cannot fail to be somewhat disappointed . . . instead of the stately edifice he has pictured in his imagination, he beholds only a huge dun colored, almost shapeless mass, looming up strangely from the desolate plain."[208] In Watkins's photographs, taken almost exactly a year later, this shapeless mass has been transformed into a striking sculpture, vigorous and remarkably monumental (Plates 79, 80).[209]

As they returned to Yuma Watkins began to suffer severely from the hot climate. "This is the place [a man] comes back to for his blankets after he has been in [hell] . . . it is so

208. Henry G. Hanks, "Casa Grande," *The Californian* 2, no. 8 (August 1880): 104.

209. Watkins commenced by taking a distant view of the ruins; in the foreground are the tracks of wagon wheels which lead the eye directly to the distant structures. He then moved closer with three successive views, until the ruins loomed massively, filling the frame. This effect was made even more dramatic by taking the first view from the top of his traveling wagon and the others from ground level. Examples may be seen at the Huntington Library, San Marino, California.

Round House, Yuma, albumen silver print, 1880.
The Huntington Library, San Marino, California.

hot and dry, that it is very difficult to work the chemicals . . . I expect to be here for three or four days yet, as I can only work in the morning."[210] On May 13 he wrote:

> This infernal climate finds me the best possible ex-
> cuse to get mad, for not a stroke of work have I done
> since I wrote you last. It has been blowing sand night and
> day . . . I am *getting* anxious to be out of this country. Not
> only do I want to be at home, but the d--- sand head of
> a place is *getting* too uncomfortable. Jess and I think
> Charley too is getting homesick, and so is the old man in
> truth. The Colorado River is rising fast. The only dif-
> ference between the land and the water is that one is dry
> and the other wet . . . it looks like rolling mud.[211]

210. Watkins to Frances Watkins, 11 May 1880, Watkins Letters.
211. Ibid., 13 May [1880], Watkins Letters.

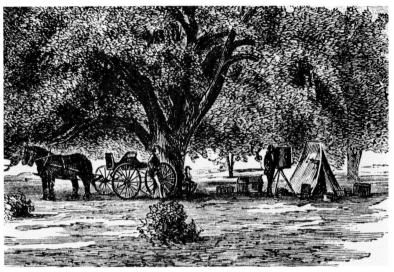

[*Watkins in Southern California*], unknown artist, woodcut engraving (Major Ben C. Truman, *Tourists' Illustrated Guide to the Celebrated Summer and Winter Resorts of California* . . . San Francisco: H. S. Crocker & Co., 1884, page 75), 1884. Peter Palmquist, Arcata, California.

Although this engraving does not name Watkins, it is clear that he is the photographer shown. During his work in southern California he frequently traveled short distances in wagons borrowed from local landowners and reserved his traveling wagon for longer trips. Charlie Staples (packer and cook) and Jessie Miller (photographic assistant) are also pictured.

By May 18 he had returned to southern California, where he produced an exciting array of new material. He took street scenes of Los Angeles, San Bernardino, San Diego, Santa Barbara, and Santa Monica. He also took the majority of the recently built civic buildings along the way. He had succeeded in photographing every mission in California. This in itself was no small task, inasmuch as the twenty-one missions were scattered approximately a day's journey apart, over a large part of the state (Plates 70–73). As representative examples of agricultural and farm development Watkins's images are unex-

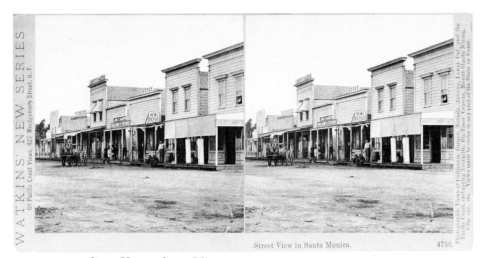

Street View in Santa Monica,
albumen silver print, stereo #4756, 1880. California State Library.

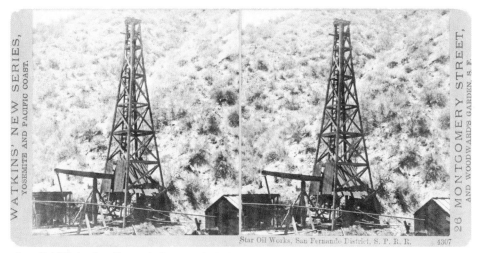

Star Oil Works, San Fernando District, S. P. R. R.,
albumen silver print, stereo #4307, 1880. California State Library.

celled; they include orange groves and walnut orchards, vineyards, a bee ranch, and a host of farmsteads up and down the San Gabriel Valley (Plates 74, 75, 76). Nor did he neglect more peculiar subjects, such as unusual trees planted by the settlers—palm, cork, and banana trees, and a castor bean tree. He also made some of the first photographs of an oil well in operation; his pictures of the headlands and rock sculptures at San Fermin were also among the earliest of that kind. At Santa Monica he succeeded in making "instantaneous" photographs of sea bathers and tourist facilities. His efforts resulted in a magnificent collection of fresh negatives for his *New Series* offerings.

Over the next two years Watkins completed his series of coastline views, extending his southern California views to include images showing the coast all the way to San Francisco (Plates 88–91). In January 1883 he made a special journey to Monterey to document the lavish Del Monte Hotel. Many of these photographs were reproduced as woodcuts in Ben C. Truman's *Tourists' Illustrated Guide to the Celebrated Summer and*

Winter Resorts of California Adjacent to and upon the Lines of the Central and Southern Pacific Railroads (1884). It is probable that Watkins made these images with the book in mind or even as a direct commission for the project. He visited other tourist spas as well, particularly those at Felton, Glenwood, and Capitola. Many of these coastal photographs will be instantly familiar to anyone who has traveled the famous "Seventeen Mile Drive," between Pacific Grove and Carmel, California; Watkins's photographs of Cypress Point and other promontories are the precursors of the multitude of postcards available today (Plate 86).

During this period of intense travel (1880–85) he also traveled northward to Oregon, Washington Territory, and British Columbia. In between he had covered the entire coastline of California, from San Diego to San Francisco (the better part of one thousand miles). All of this would have been an incredible feat for a man half his age, yet Watkins even had time to father two children. Frankie, however, must have had

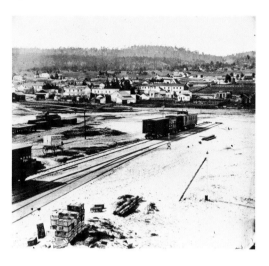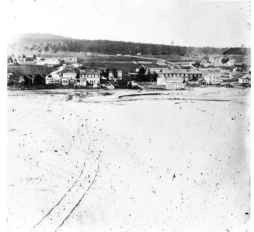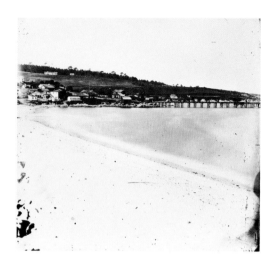

[*Panorama with Watkins's Wagon*],
albumen silver print, four-part panorama, c. 1882. California State Library.

This photographic panorama serves as a classic illustration of Watkins's travel by rail. The rail flat-car and enclosed living quarters designed for Watkins are visible as is his traveling wagon. The wagon advertisement lists W. H. Lawrence as proprietor of Watkins's gallery. Lawrence assisted Watkins financially from 1878 until about 1890.

very mixed feelings, as her husband often wrote: "Keep up your courage . . . the old man will be home as soon as he can, and we will 'take a walk' . . . that's poor folks luxury. God bless."[212]

Because of the scarcity of documentation, Watkins's field activities are often hard to track; he seems to have been riding his traveling wagon in southern California at one moment, at the next to have been using his camera to capture the fumaroles of Yellowstone. What happened in between is often shadowy and unclear. Roughly speaking, however, Watkins was in southern California and Arizona in 1880; Monterey, Oregon, Washington, and Victoria, B.C., in 1882; Monterey and

212. Ibid., 24 June 1880, Watkins Letters.

[*Pacific Grove, Monterey*], albumen silver print, 1883.
California State Library.

[*Collis, Julia and Frances Watkins*], gelatin silver copy print, c. 1887, print later. The Bancroft Library, University of California, Berkeley.

WATKINS' NEW GEMS OF
Pacific Coast Scenery.

City of San Francisco and Suburbs, Yosemite, Big Trees, Geysers, Shasta, Lake Tahoe, Central Pacific Railroad, Nevada, Arizona, Southern Pacific Railroad, Southern California, Monterey, Santa Cruz, Hotel del Monte, Cypress Groves, Placer, Quartz and Hydraulic Mining.

The New Northwest, Oregon, Washington Territory, British Columbia, embracing

TACOMA, SEATTLE, PUGET SOUND, VICTORIA, COLUMBIA RIVER, NORTHERN PACIFIC R. R., MONTANA, IDAHO, and the great YELLOWSTONE NATIONAL PARK.

THESE VIEWS ARE TO BE OBTAINED IN ALL SIZES, FROM STEREOSCOPIC TO IMPERIAL.

Tourists and all others are respectfully invited to call.

427 MONTGOMERY STREET,
SAN FRANCISCO, - - CAL.

Watkins' New Gems of Pacific Coast Scenery, Overland Monthly, c. 1885. Peter Palmquist, Arcata, California.

Oregon in 1883; and Oregon, Idaho, Montana, and the Yellowstone in the fall and winter of 1884/85.

Julia was born in the spring following his 1880 trip to southern California. Her arrival meant a number of changes in the gallery, due in part to Frankie's confinement, as well as additional marketing responsibilities. It may have been at this time that Myra Waddell joined the gallery as a sales assistant; the arrival of Frankie's sister Helena also helped. A more serious change was the defection of Watkins's finest photographic printer, Bagnasco, to his arch rival, I. W. Taber.[213] By

213. After spending nearly ten years with Watkins, Bagnasco went on to spend his next ten years with I. W. Taber. Bagnasco's desertion must have been a bitter blow to Watkins, but at least the move ensured that

Port Blakeley, Puget Sound, W. T., albumen silver print, 1882.
Historical Photography Collection, University of Washington Libraries.

Watkins's darktent may be seen along the railroad track. It was on this trip
that the tent was set afire by a spark from a locomotive.

the fall of 1882 Watkins was hard at work in the Pacific North-
west. Writing to Frankie from Portland he remarked on an-
other type of photographic hazard:

> I have never had the time seem so long to me on any trip
> that I ever made from home, and I am not half done with

prints made from Watkins's negatives now in Taber's hands would have the
same high print quality as before. There is fairly strong evidence to sup-
port the idea that few if any of Watkins's large negatives were printed by
Taber before Bagnasco's arrival. See also, Peter E. Palmquist, "Taber Re-
prints of Watkins Mammoth Plates," *The Photographic Collector* 3, no. 2
(Summer 1982): 12–20.

my work, in fact barely commenced. It drags along awful
slow, between the smoke and the rain and the wind, and
as if the elements were not enough to worry me, a spark
from an engine set fire to my [dark]tent last week and
burned it half up, and it was the merest chance that it did
not ruin the whole outfit. I was where I could not see it
but some men working near called out to me, and I got to
it in time to prevent it doing any damage except to the
tent. It took a couple of days to repair damages, and of
course money, talking about money.[214]

His letter closed tersely: "Its late, I had a bad night last
night and I have to get up at ½ past four in the morning . . .
God bless you all, Carleton." Confirmation of his arrival and
work in Seattle was noted by the *Seattle Post Intelligencer* on
September 22:

> Mr. Watkins of the Watkins' Photographic Gallery of San
> Francisco, took some very fine views of the city from
> Denny's Hill in the northern end of town and from the
> Coal Wharf in the south end. By erecting a platform
> twenty feet high on Denny's Hill he got a very good
> view of Lake Union on one side, and Puget Sound with
> the Coast range in the background on the other. We were
> shown some of Mr. Watkins' work, which we consider
> very good. He goes to Olympia tomorrow to take views
> in and about the Capital city.

The images from Denny's Hill form an eight-part pan-
orama, published in both stereo and boudoir sizes; he made
another eight-part view from the Coal Wharf. In addition
there are images of Mt. Rainier and many points along the wa-
terfront at Port Blakely, Port Gamble, Port Ludlow, and Port
Madison, some in mammoth size (Plate 84). The historical

214. Watkins to Frances Watkins, 19 September 1882, Watkins
Letters.

Castle Rock, Columbia River, Oregon,
albumen silver print, stereo #E10, 1883–1885. California State Library.

[*Watkins's Traveling Wagon on the Train, Oregon*],
albumen silver print, 1883. Joan Perkal-Books.

consequence of this work today cannot be overestimated; in many cases it has become "the standard and most reproduced images for the period."[215]

From Seattle Watkins traveled across Puget Sound to Victoria, on the Canadian side of the border. Here he concentrated on overviews of the city, including two striking panoramas: a thirteen-view series from the roof of a government building and a seventeen-view series from the heights of Christ Church, another prominent vantage point. He then returned to Portland and sailed for San Francisco on the *California* on October 11.

215. Dennis Anderson to Peter Palmquist, 6 December 1979. Anderson points out that one of the views picturing the Hall Brothers Shipyard provides an inference for dating the series: "It depicts the barks *Hesper* and *William Benton* on their keels under construction. The *Hesper* was launched with ceremonies on October 12, 1882." Examples of Watkins's northern images may be found in Special Collections, University of Washington, Seattle, and in the Oregon Historical Society, Portland.

A year later he returned to Oregon (Plate 93). Watkins's son, Collis, had been born on 4 October 1883, yet by November 18 an observer wrote of seeing Watkins at work near The Dalles: "Watkins the photographer who took my Yosemite views is here. He has a sleeping car to himself and is put onto a siding wherever he wishes."[216]

Photographs, including two albums, are the only surviving evidence of Watkins's 1884–85 visit to Oregon. One is entitled *Clearing the Track of the O.R. & N.R.R., from Rooster Rock to Oneonta Falls—Great Storm of the Winter of 1884–5, Columbia River.* Both albums illustrate the effects of an unusually heavy

216. C. F. Newcombe to his wife, Marion Newcombe, 18 November 1883, in Provincial Archives, Victoria, B.C., as quoted in Jean F. Low to Peter Palmquist, 11 November 1980.

Livingston, Montana,
albumen silver print, c. 1884–1885. Joan Perkal-Books.

snow that occurred in late December, which apparently blocked the railroad for a ten-mile stretch between Rooster Rock and Oneonta Falls (Plate 94). Most of the photographs show train crews at work clearing the tracks; the rest are scenic views of the snow-covered Columbia River landscape.[217]

Also related to this series are eleven mammoth photographs and several dozen different stereographs of Yellowstone (Plate 95). The most probable reason for Watkins's trip may have had to do with the completion of the Oregon Short Line Railroad, on 25 November 1884.[218] Surviving photographs suggest that Watkins traveled from Portland at least as

far as Livingston, Montana. Since Livingston was the northern rail terminus, Watkins would have entered Yellowstone from the north. The Yellowstone views are not unlike those produced by W. H. Jackson and covered many of the same subjects—hot springs and geysers, including Old Faithful. The Oregon winter scenes are especially interesting in that Watkins had time to complete a "picture story" sequence of events involving the snow-bound travelers; his scenic views of the frozen Multnomah Falls form an interesting contrast to his 1867 photographs of the same site. All these photographs deserve closer study.

As a result of these northern trips, Watkins had greatly expanded his inventory of *Pacific Views* (New Series). Purely in terms of variety of subject matter, Watkins was far ahead of other view-photographers on the Pacific seaboard, and he attempted to promote this fact to the public. In 1885 he began advertising his Northwest photographs in such journals as the *Overland Monthly*: "*The New North-West, Oregon, Washington Territory, British Columbia,* embracing Tacoma, Seattle, Puget Sound, Victoria, Columbia River, Northern Pacific R.R., Montana, Idaho, and the great Yellowstone National Park."[219] He

217. One album is held by the Oregon Historical Society Library, and the other by the International Museum of Photography, George Eastman House, Rochester, New York. The images are nine by seven inches, from dry-plate negatives.

218. The Northern Pacific Railroad was completed in September 1883. Watkins could have taken the Northern Pacific—through Moscow, Idaho, Spokane, Washington Territory, and thence eastward through Mon-

tana as far as Cinnabar (a jumping-off point for Yellowstone)—or directly eastward by way of the Union Pacific (also known as the Oregon Short Line), to Baker City, Oregon, Caldwell, Idaho, and the Yellowstone entrance near Pocatello. Or he may have undertaken the entire loop, traversing Yellowstone from Cinnabar to Pocatello in his traveling wagon. (The author has seen a photograph from a private collection which depicts Watkins's wagon in Cinnabar.) Information courtesy of Glenn Mason. For a concise account of Yellowstone's growing importance as a Western attraction around 1883, see Richard A. Bartlett, "Will Anyone Come Here for Pleasure?" *The American West* 6, no. 5 (September 1969): 10–16. The mammoth Yellowstone photographs are held by the History Department, Oakland Museum; examples of Watkins's Yellowstone stereographs may be seen in the Picture Collection, California State Library, Sacramento.

219. Several versions of this advertisement are found in the *Overland Monthly* and tourist guides between 1885 and 1886.

had come very close to fulfilling his boast of having photographs from "Alaska to Mexico."

In the fall of 1887 Watkins completed a series of views of Sonoma County ranch and farm lands at El Verano, emphasizing the lush agriculture in California's valleys. He then traveled to Kern County, where he did an extensive survey of irrigated farms for promotional purposes. This was not his first visit to the region, nor his first job for James Ben Ali Haggin (1827–1914), an investor who at one time had interests in more than one hundred gold, silver, and copper mines, from Alaska to South America. Between 1861 and 1881 a complex irrigation system had been established along the Kern River by draining swamps that bordered the river and using the water to irrigate land that once had been desert. The result was the greatest irrigated farm in the world. From the beginning there were enormous financial stakes, and two large partnerships—Haggin and Carr and Miller and Lux—bought up smaller holdings on every hand. Eventually the two giant landholders met in court to decide who controlled the water from the Kern River, its drainages, and its tributaries. In January 1881 Watkins photographed the contested sites for use in court.

As in his San Antonio Rancho case of twenty years earlier, Watkins was required to describe and defend his photographs in the courtroom: "I have taken [these photographs] . . . about Buena Vista Slough, at Tracy's Crossing; [and] some at the bridge on Kern River . . . they were made on the 9th and 10th and 11th of January 1881."[220] As his testimony continued, however, the court became increasingly interested in whether Watkins's images could be made to reveal the true scale of the objects therein:

220. *Lux, Charles, et al., v. Haggin, James B., et al.*, pp. 577–581. The case was essentially a contest between riparian rights and the use of water by appropriation.

Haying at Buena Vista Farm, Kern County, Cal.,
albumen silver print, c. 1887–1888. Kern County Museum.

Watkins made nearly 1,000 8-by-10 inch dry-plate negatives of Kern County in 1887–1888. They are the finest collection of such views of pioneer agriculture in the region.

Q—Can you tell anything about how wide this sheet of water [the Kern River] is from water's edge to water's edge? Is there any way you can tell [or account for] how much it is distorted or exaggerated by the perspective [of the single lens] or otherwise?

A—Yes, sir. Here is the engineer [a tall man of about six feet], and there is [also] a man on horseback on the other side [of the river].

Q—How can you make any calculation from that?

A—The man on horseback you can measure, and then measure this one on the opposite side, and tell the perspective.[221]

221. Ibid., p. 579.

Mouth of Kern Canyon, Kern County, Cal., albumen silver print, 1881.
The Huntington Library, San Marino, California.

In 1881 many of Watkins's Kern County images were introduced as evidence in a California land case involving the ownership of the region's water resources.

The debate continued at some length, growing in intensity until Watkins finally retorted: "I am not a mathematical sharp . . . there are given objects . . . I think it could be done." The last witness was heard on 2 June 1881, and the total testimony made a stack of paper four feet high; Haggin won the case. Although Watkins did not succeed in convincing the court that his photographs could reveal "scale," his efforts were unusual in the history of photographic jurisprudence.

In 1888 Watkins returned to the Bakersfield area to complete his task of "taking a series of photographic representations of the waterways, canals, and headgates that constitute

Late George Cling Peaches, albumen silver print, 1888.
The Huntington Library, San Marino, California.

the great irrigation system of the Kern Valley . . . it is said that these photographs will be issued by Haggin and Carr in pamphlets containing statistical and other valuable descriptive matter for general distribution."[222] Although his primary responsibility was to promote the Kern County Land Company, Watkins made himself available to any interested party:

> Mr. C. E. Watkins, the eminent photographer of San Francisco, is in Kern County taking views of various ranches and picturesque scenes. This is an unusual opportunity for those who want photographs of their property to have them taken. Mr. Watkins will visit any place

222. Bakersfield *Kern County Californian*, 7 July 1888.

*Kern County Exhibit. Twenty-Fourth Industrial Fair
of the Mechanics' Institute, 1889*, albumen silver print, 1889.
The Huntington Library, San Marino, California.

Watkins's large Kern County photographs may be seen on the walls of
this exhibit. These images were widely used as illustrations in publications
that promoted Southern California's bountiful harvests and agricultural
richness.

desired. His charge is only $6 per dozen for the 8 x 10
size, and others in proportion.[223]

Watkins's Kern County photographs made use of several
new photographic techniques. He was using an eight-by-ten-
inch dry-plate negative, which enabled him to take many pho-
tographs without the need to coat or process his negatives in
the field. This, in turn, improved his chances of making many

223. Ibid., 21 July 1888.

[*Kern County*], albumen silver print, c. 1888–1889. Kern County Museum.

images in a short period of time. In Kern County he made
dozens of photographs of a single farm—a distant view or
two, followed by closer images of barns and houses, and fi-
nally a close look at the details of a piece of machinery or spe-
cific farming activity (Plates 97, 98). He was well organized, as
we see in a photograph of the entire working stock of a farm;
not only were the various animals carefully arranged and
grouped as to function, but the appropriate teamster or farm
worker was posed as well. Almost all of the views were made
with his camera located atop the traveling wagon. From this
perch, fifteen feet above the ground, Watkins could picture ag-
ricultural scenes without including overwhelming foreground
areas; flooded fields without getting his feet wet; and herds
of livestock without having foreground animals obscure those
behind. Although Watkins was nearly sixty years old, the vol-
ume of his Kern County output is staggering:

Seven hundred and twenty-six splendid photographic views [by Watkins] of all the principal places of interest in Kern County can be had at the stationery store of A. C. Maude, Bakersfield, at the price of fifty cents each, considerable less than the actual cost. A complete description of each picture is printed on them. A few of these pictures sent to your friends will tell them more of the beauty and resources of this county than can be written. Call at the store for them. They are all bound in albums for convenience of inspection.[224]

A later advertisement claimed that the total number of different photographs had risen to "nearly one thousand splendid photographic views."[225] Although both notices appeared in the fall of 1888, Watkins is known to have used only the month of July in taking the negatives; more time, of course, was needed for printing and mounting them. Even so, the total project—taking, processing, and printing the negatives, and mounting the prints (many with elaborate captions) in albums—would have been a major task for any photographic finisher. While Watkins's picture-taking days were surely long and tiresome, he still retained his gregarious ways and his sense of humor:

One evening when he returned from a hard day of pho-

tography, he found the property owners were having an elaborate dinner party. They invited him to join them. Watkins had only his old work clothes and his one white shirt was dirty. Nevertheless they insisted he join the gay party, and promised that they would dress him up. Whereupon Watkins washed his shirt and his hosts produced a linen duster, nattily cut in the shape of a swallowtail coat. While everyone else at the affair was in full dress, Watkins was the life of the party dressed in the improvised suit.[226]

In 1890 Watkins was in Montana; his task was to document J. B. Haggin's holdings in the copper mines of Butte and Anaconda. Once again our best source of information is a series of letters from Watkins to Frankie. They are often sad, with agonizing details of the life of a man who has spent too many years working under the strain of financial uncertainty, inconsistent meals and lodging, and little medical care. His first letter was written on July 5, from Anaconda; it was raining and Watkins was very worried about the amount of work to be done underground. His arthritis was acting up as well: "I am in constant pain with my hip and have a limp in walking . . . sometimes it seems as if I could not stand it but I have to."[227]

He had recently worked in the mines at Butte: "Went up to Butte last week and tried making views in the mine with a combination of electric and flash light [flashpowder]. And it did not work worth a dam, but I [finally] *got it* 'all the same.' Telegraphed to New York for three more lights . . . when they come *that* part of the work won't be much of a picnic. I am getting thin and no wonder."[228] Turrill later amplified some of the reasons for Watkins's problems in the mine:

224. Ibid., 6 October 1888. Watkins's photographs were also used in the Kern County exhibit at the San Francisco Mechanics' Fair in 1889, as well as at a local fair in Bakersfield; see the *Californian*, 1 September 1888. The railroad had begun to promote immigration to Southern California in the early 1880s. In 1883, for instance, Watkins's Southern California views of agriculture were displayed at the Illinois State Fair as part of the exhibit of the California Immigration Commission (Central Pacific Railroad). The title of the book which accompanied the exhibit is a study in itself: *California, the Cornucopia of the World—Room for Millions of Immigrants—43,795,000 Acres of Government Lands Untaken, Railroads and Private Lands for a Million Farmers, a Climate for Health and Wealth Without Cyclones or Blizzards.*
225. Bakersfield *Kern County Californian*, 10 November 1888.

226. Anderson, "Carleton E. Watkins," p. 36.
227. Watkins to Frances Watkins, 5 July [1890], Watkins Letters.
228. Ibid.

It is interesting to recall that a part of the 8 x 10 photographic work on this trip, unfortunately, was a failure. Watkins visited the lower levels of the mines for the purpose of making 8 x 10 flash lights of the workings. He spent an entire day on this work. Part of his negatives were ruined through the inquisitiveness of some unknown parties drawing the slide of his plateholders, which he had left in the superintendent's office while he went to dinner. Other interesting views showing the workings proved failures, owing to a condensation of moisture on the lens.[229]

Conditions in the mines were exceedingly difficult, not only for technical reasons, but also because the mines were so dangerous. On July 22 Watkins was preparing to enter a mine where five men had recently died in an accident:

This morning they are preparing to take out the other two [bodies] that were found last night. The mine is full of bad air and as it is the one that they want the most work done in I shall have to put it off until the last. I started in when I came up to do mine work with the flash lamps, and in making preparations got hot . . . [then I] caught cold in a wet room, and yesterday I was so "bunged up" that I could scarcely move . . . the job is going to be interminably long, but I *must* wait and do good work.[230]

229. Turrill, "Watkins," p. 34.
230. Watkins to Frances Watkins, 22 July [1890], Watkins Letters. Although no example of Watkins's mine interiors has been located, the Montana Historical Society has eight mammoth photographs in the Giegerich Family Collection which depict flume building near Anaconda. These images are probably by Watkins even though they are not identified as such; one of the men shown has been identified as George Davidson which strengthens this contention. Lory Morrow to Peter Palmquist, 4 October 1982.

Watkins's letters during August and September 1890 are equally depressing: "I am in no mood for writing. . . . Yesterday I was taken with one of my vertigo fits, and while I manage to get about it has upset me completely. I was in hopes to get through with the infernal job before it got after me, but it was not to be. I hope it will not [prove to] be a bad attack, if it should, the Lord save us."[231] October 2 found him

boxed up in the [railroad] car and a snow storm raging outside . . . if you don't think *I wish* I was home you are mistaken. . . . Kiss the children big and little and give them fat hugs, as you are the only one in the family that deals in that healthy commodity . . . the wind is howling outside and it just goes through my rickety old bones, but never mind. We'll get fat again, I hope, all of us. God bless you. Papa.[232]

On November 11 Watkins was still tied up with the job, but he was the recipient of a wonderful surprise—letters from his children wishing him happy birthday. Six-year-old Collis wrote that Frankie's father "sent us two chickens and two ducks, nice big ones . . . hope you will soon come home . . . love and hugs, from your chap, Collis."[233] Julia's letter is longer and filled with youthful, eight-year-old dignity:

My dear Papa—Grandpa made a mistake, he thought your birthday was Sunday and so we got the ducks and chickens Saturday. Mama cooked the chickens Saturday and had Uncle Ray and Mrs. Fish to dinner. We had a very nice time and talked about you. I wish you could

231. Watkins to Frances Watkins, 27 [September 1890], Watkins Letters.
232. Ibid., 2 October [1890], Watkins Letters.
233. Collis Watkins to C. E. Watkins, 11 November 1890, Watkins Miscellaneous.

have been here. We had the giblets Sunday. Monday we had the ducks. Helene's [Frankie's sister] Aunt Gennie was here to help us eat them, and today we are going to finish them up. I wish you were here with with us. I must close, wishing you a happy birthday, lots of love and kisses. From your daughter, Juju.[234]

By the close of 1890 Watkins was fast nearing the end of his ability to work in the field; only two groups of his photographs are known after this time. The first is represented by an album, *Views of the Church and College of St. Ignatius, of the Society of Jesus, Cor. of Van Ness Ave., and Hayes St. San Francisco, California*, containing fifty eight-by-ten-inch dry-plate views of the academic facilities (Plates 99, 100). Collis would later attend high school here, but it was probably Watkins's friend Father Varsi who made the arrangements of the photographs.[235]

The last commercial project Watkins is known to have completed pictured the construction of dams and waterways at the Golden Gate and Golden Feather Mining Company's works on the Feather River, in Butte County.[236] At least twenty-eight different images are known, most dating from 19–21 November 1891. In what might be regarded as a fitting climax, the Golden Gate–Golden Feather views are mammoth size and apparently from wet-plate negatives. Technically superb, as always, these images still reveal the masterful hand of their

Golden Gate Dam. Feather River, Butte County, Cal., albumen silver print, 1891. The Bancroft Library, University of California, Berkeley.

The Golden Gate/Golden Feather mining views are thought to be the last commercial venture completed by Watkins before ill health forced him into semi-retirement.

234. Julia Watkins to C. E. Watkins, 11 November 1890, Watkins Miscellaneous.

235. Three copies of this album are thought to exist. Two are in the Rare Book Room, San Francisco University Library, and a number of unmounted copies are held by the Library, Society of California Pioneers, San Francisco. It is possible that the St. Ignatius images could have been made as early as 1885, but 1890 is more likely.

236. See Clarence F. McIntosh, "The Carleton E. Watkins Photographs of the Golden Gate and Golden Feather Mining Claims," *The Diggin's* 8, no. 1 (Spring 1964): 3–21.

maker (Plates 101, 102). One view, in particular, stands out as a symbol of the intrepid Watkins at his best: in the foreground of the view, silhouetted by the bright sun behind his back, is the shadow of Watkins himself in a self-portrait with his giant camera.

Nothing in this view foretells Watkins's incipient decline after so many years behind the camera, but the decline was already underway in 1891. During the early part of the year Frankie and the children were away, leaving Watkins in San Francisco. His arthritis was especially bad; it affected his back and required the attention of a doctor. Once again, his finances

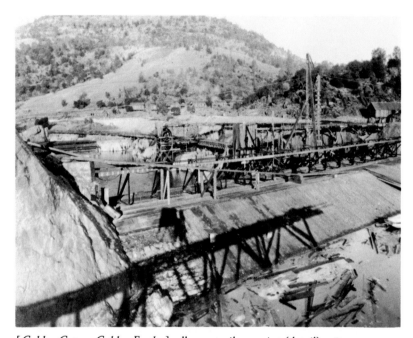

[*Golden Gate—Golden Feather*], albumen silver print (detail), 1891.
The Bancroft Library, University of California, Berkeley.

The bright, slanting sunlight creates a silhouetted portrait of Watkins at work.

were in a dismal state: "Got the rent paid at last . . . wore one shirt 17 days. There's economy for you. Had this one all the week, and of course the other has *not* gone to the wash. There is one consolation [however]. The shirt *suits* the *suit*. There is only 2 buttons left on the vest, and the wind plays Yankee Doodle through the place I set down on."[237]

Photograph sales were meager, and he did little (if any) new negative work. At one point during the 1890s he started a series of views of Phoebe Hearst's Hacienda Del Pozo de Ve-

rona, near Livermore; failing eyesight interfered and he had to abandon the project.[238] Watkins was forced by diminishing income to change his business (and living) location several times during the 1890s; at the lowest point the entire Watkins "family lived in the R[ail] R[oad] car at 7th & Grove St., in Oakland for 18 months prior to going to the ranch at Capay in 1896."[239] The ranch in Yolo County was a gift from C. P. Huntington.

During one of his trips to California Collis P. Huntington arranged to have a small ranch in the Capay Valley deeded to Watkins by the Railroad Company, as a partial recompense for the man's fidelity and unpaid-for labors. The last few years prior to 1906 Watkins lived in his studio on the top floor of the building on the southeast corner of Ninth and Market Streets. Part of the time his wife, daughter, and son lived with him. The greater portion of the time, however, the wife and son and daughter were away, most of this time at the Capay Valley ranch. The son attempted to help his blind father in his photographic work by making prints from negatives but was not very successful. A photographer [Turrill himself] in the city volunteered to make these prints and assist the old gentleman in many ways where possible, making sales of his wares and cataloging and arranging his stock.[240]

By 1903 Watkins was almost totally blind. With the aid of

237. Watkins to Frances Watkins, [January-February 1891], Watkins Letters.

238. Turrill, "Watkins," p. 35.
239. Compton, "Notes," Compton Papers.
240. Turrill, "Watkins," p. 37.
241. C. B. Turrill to George C. Pardee, 29 September 1903, Pardee Correspondence and Papers. In an effort to gain Pardee's favor, Watkins—with the aid of his son and Charles Turrill—made a set of mammoth glass transparencies for the governor. Six Yosemite images from this group were used in preparing a six-sided lighting fixture which is presently in the main hall of the Pardee House, Oakland.

his son and Turrill, Watkins entreated the World's Fair Commission to include his photographs in the St. Louis Exposition. After months of delay Turrill wrote directly to the governor of California, George C. Pardee, reminding him that he had promised to look into the matter personally, adding: "[Poor Watkins] has been sitting in darkness, hoping that you might get some word from the World's Fair Commissioners . . . last night I saw him again and he had not had dinner as he had been without the purchasing price."[241]

Despite Pardee's avowed interest the St. Louis exhibit failed to include Watkins's photographs. Negotiations and entreaties continued for many more months, with Turrill doing all he could to interest the state in purchasing views from Watkins. Finally it was agreed that a selection of Watkins's images would be purchased for inclusion in the Lewis & Clark Exposition in Portland, Oregon, which featured a historical theme. Elation soon turned to dismay, however, when the state failed to pay Watkins for the prints; by February 1906 Watkins was again forced to seek redress directly from Pardee.[242] Turrill also wrote and reminded the governor that "Watkins needs speedy help if he is to receive the benefit personally!"[243]

In the meantime Turrill increased his attempts to interest the state in buying Watkins's "historically significant" photographs. Finally, on Sunday, 15 April 1906, H. C. Peterson, curator of Sutter's Fort Historical Museum, was persuaded to visit Watkins. He fully agreed that Watkins's works were in need of immediate preservation; especially important was a trunk "filled with dozens of rare daguerreotypes, including

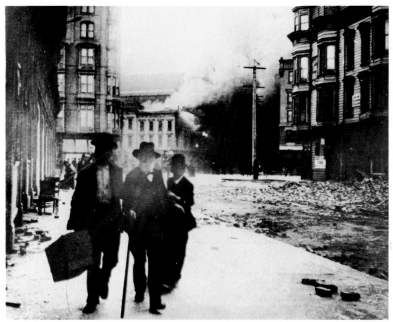

[*Watkins after the Earthquake*], unknown photographer, gelatin silver print, 1906. The Bancroft Library, University of California, Berkeley.

Watkins is escorted from his gallery after the San Francisco earthquake. Like many others, Watkins lost his prize photographs and negatives in the insatiable fires which erupted after the earthquake rather than in the quake itself.

that of [John] Sutter of Sutter's Mill."[244] Peterson promised to begin moving the most precious items the following Sunday, but this was not to be. On Wednesday, April 18, the San Francisco earthquake "wrecked his place . . . and the subsequent fire consumed everything"; dazed and bitterly disappointed at the loss of his life's work, Watkins was led forcibly from his burning studio. "He lost everything but the clothes on his back," wrote Turrill to Pardee. "He was left at my place and

242. Watkins to George C. Pardee, 2 February 1906, Pardee Correspondence and Papers.

243. Turrill to Pardee, 11 February 1905, Pardee Correspondence and Papers. Variations of this plea for assistance are frequent in the Turrill-Pardee correspondence.

244. H. C. Peterson to Robert Taft, 1 June 1933, as quoted in Robert Taft, *Photography and the American Scene*, pp. 255–256.

left the day of the earthquake . . . he has slept on the hillside with me for two nights, but that is too rough for him."[245]

Watkins eventually retired to his Capay ranch, but his health continued to deteriorate. In 1909 he was declared incompetent and Julia became his guardian.[246] He proved too much of a burden, however, and the family had him committed in 1910 to the Napa State Hospital for the Insane, at Imola. "We put him in Napa because it was convenient."[247] Frankie immediately began calling herself a widow. Watkins lived in darkness and despair at the hospital until his death on 23 June 1916, at the age of eighty-seven. He is thought to have been buried in the hospital graveyard, but no tombstone marks his grave.

In a sense we know far too much concerning the decline of Watkins's final years. It would be better to remember him in his prime, struggling to produce the truly remarkable views that form this exhibition. Moreover, at a time when photographs have become as plentiful as bricks, the intense discipline and clear vision necessary to make memorable images of the wilderness remain unchanged. Dr. Hermann Vogel (1834–1898), an esteemed critic and friend of photography, may have had this in mind when he wrote: "Landscape photography and hunting resemble each other . . . we have [had] many holiday hunters amongst landscape photographers, who waste their ammunition on every sparrow, but never succeed in killing nobler game."[248] Watkins was surely one of the finest photographic hunters of any era.

245. Turrill to Pardee, 21 April 1906 and 4 June 1906, Pardee Correspondence and Papers.

246. Julia C. Watkins, "Petition for Guardianship of C. E. Watkins, an Incompetent," in the Superior Court Records, Yolo County Courthouse, Woodland, California. The petition was approved 29 June 1909.

247. Mary Pauline Grenbeaux, "Interview with Julia Watkins, Winter 1976," recording tape and typescript summary held by Grenbeaux, Sacramento.

248. Dr. Hermann Vogel, "German Correspondence, October 1, 1867," *The Philadelphia Photographer* 4, no. 47 (November 1867): 362.

Notes on the Plates

WATKINS' OLD SERIES

Watkins photographs printed or published before 1876 are called "Watkins' Old Series." In 1876 Watkins lost his Yosemite Art Gallery and most of his view negatives to I. W. Taber who subsequently printed them as his own.

All of Watkins's early negatives were made by the wet-plate process. The large prints were printed on salt paper until 1862, and after that date on albumen paper. Mammoth and imperial size prints made before 1864 were dome-topped. Stereographs were printed on albumenized glass or on paper, paper predominating after 1865.

Titles published on the photograph mounts or supplied in a contemporary hand are listed here as confirmed titles. Titles added later or attributed by the exhibition curators are in brackets.

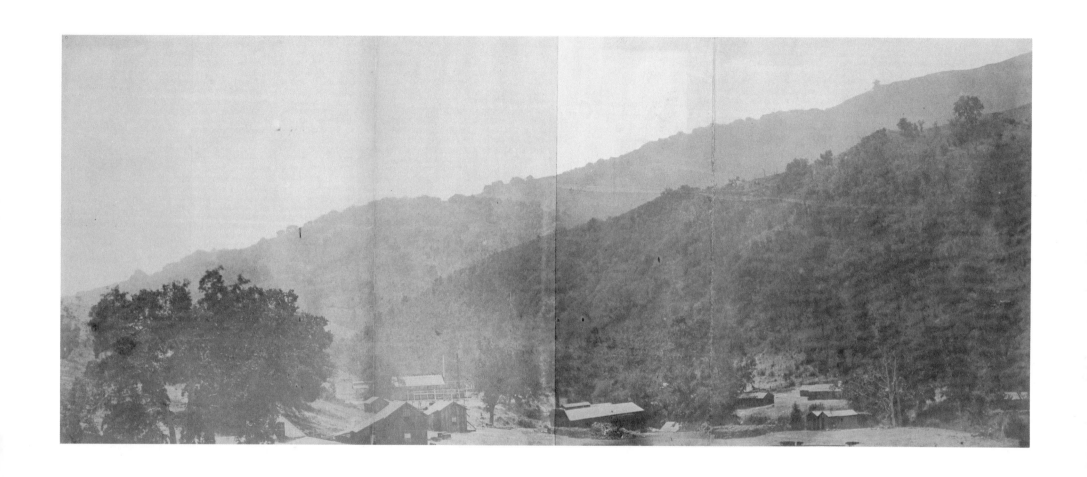

1. [*Panorama of Guadalupe Quicksilver Mine*],
salt print, 10 × 24¼″, 1858. National Archives.

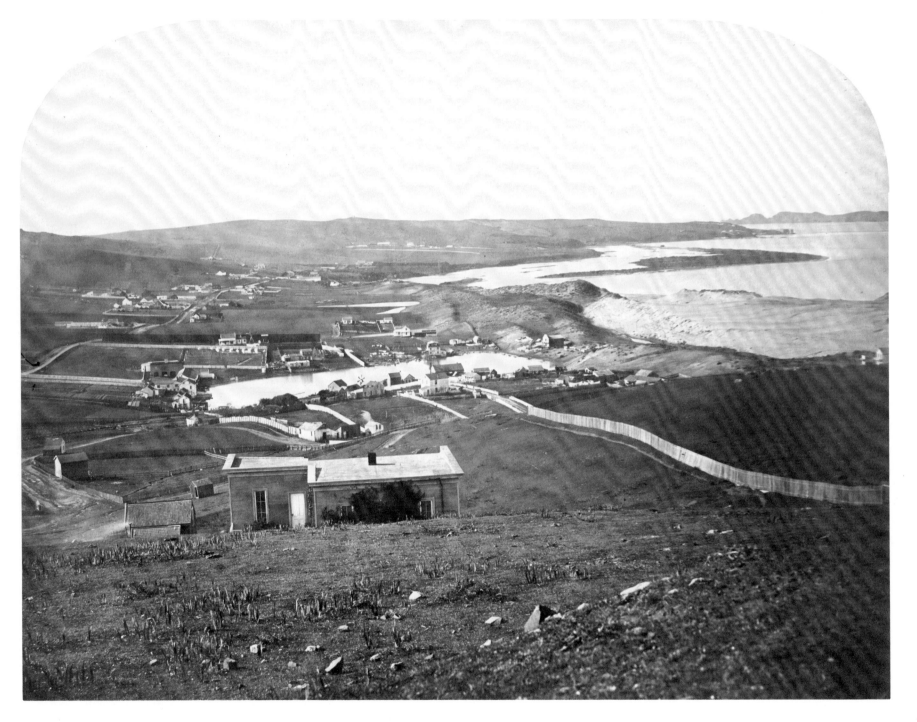

2. *Washerwoman's Bay, 1858*, salt print, 12¼ × 16⅛″ (dome-topped), 1858.
The Bancroft Library, University of California, Berkeley.

3. *Pine Tree*, salt print, 12¼ × 16⅜″ (dome-topped), c. 1860.
Collection of The Park-McCullough House, North Bennington, Vermont.

4. *Guadaloupe*, salt print, 12¼ × 16⅜″ (dome-topped), c. 1860.
Collection of The Park-McCullough House, North Bennington, Vermont.

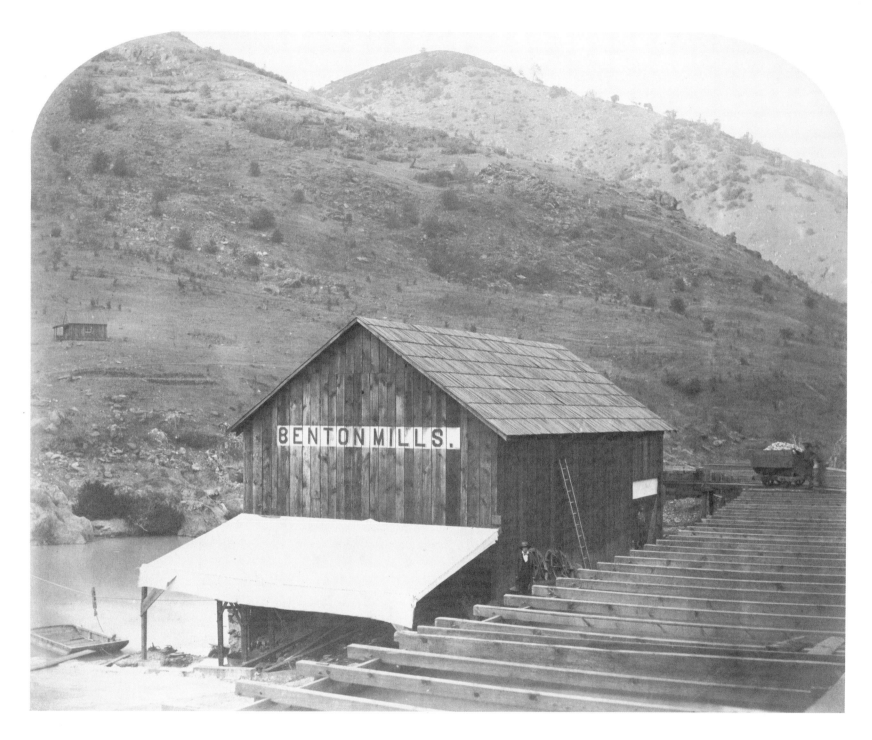

5. [*Benton Mills*], salt print, 12¼ × 16⅜″ (dome-topped), c. 1860.
Collection of The Park-McCullough House, North Bennington, Vermont.

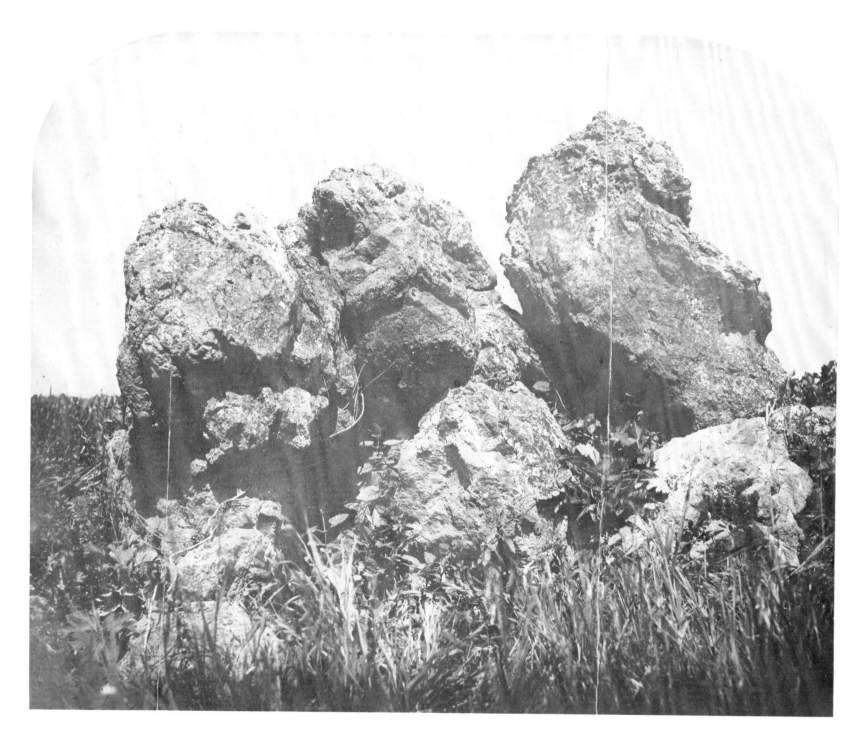

6. [*Rock Formation, San Antonio Rancho*], salt print, 13½ × 16½″ (dome-topped), 1861. The Bancroft Library, University of California, Berkeley.

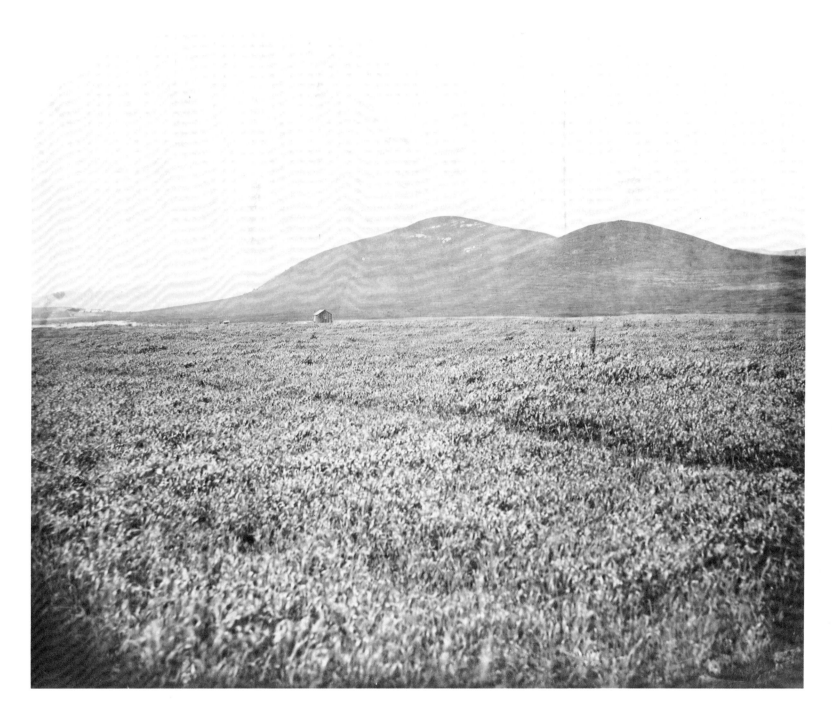

7. [*View West towards El Cerrito, San Antonio Rancho*],
salt print, 13⅛ × 16⅜″ (dome-topped), 1861.
The Bancroft Library, University of California, Berkeley.

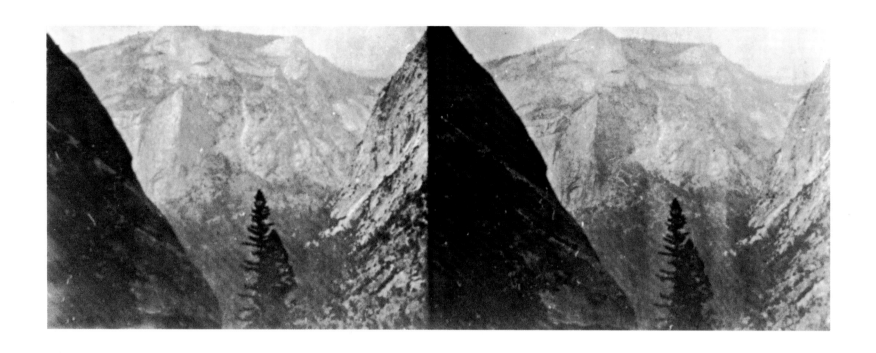

8. *North Dome from the South Fork*, glass stereo, 3¼ × 8½″, 1861.
National Park Service, Yosemite Collection.

9. *Over the Vernal Fall*, glass stereo, 3¼ × 8½″, 1861.
National Park Service, Yosemite Collection.

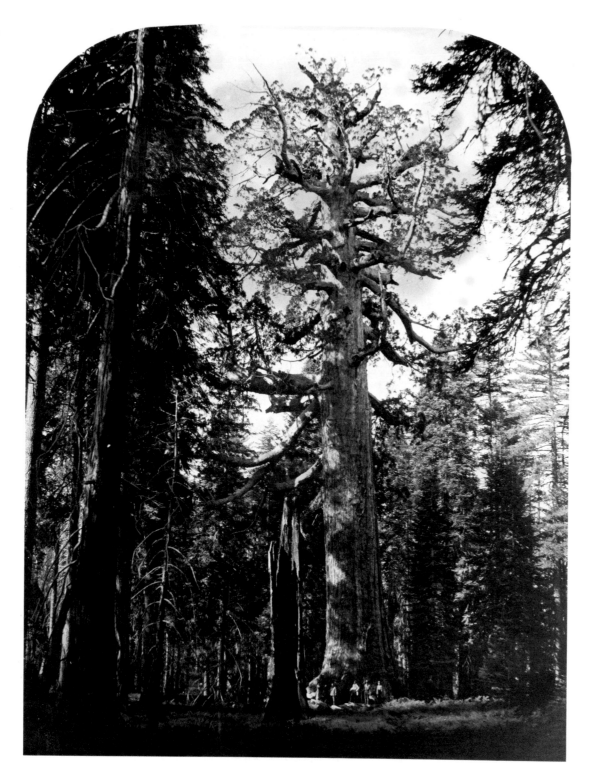

10. [*Grisly Giant 86 Feet in Circumference 225 Feet High Mariposa Grove California*],
albumen silver print, 21 ½ × 16″ (dome-topped),
1861.
Gray Herbarium of Harvard University.

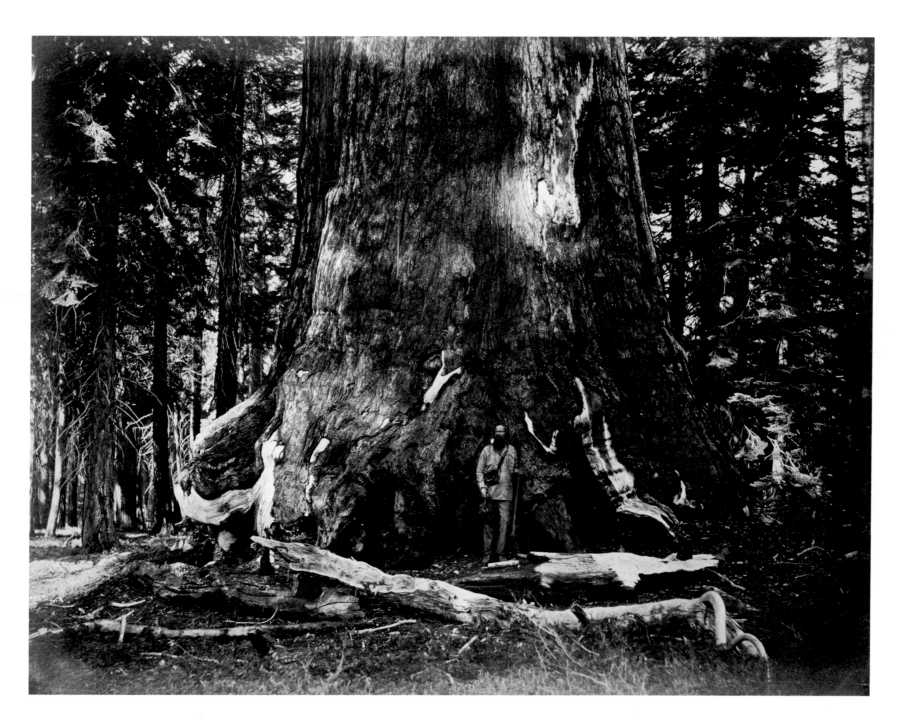

11. *Part of the Trunk of the "Grizzly Giant" [with] Clark, Mariposa Grove 33 Feet Diameter*,
albumen silver print, 15¾ × 20¾", negative 1861, print later.
Courtesy Daniel Wolf, Inc., New York.

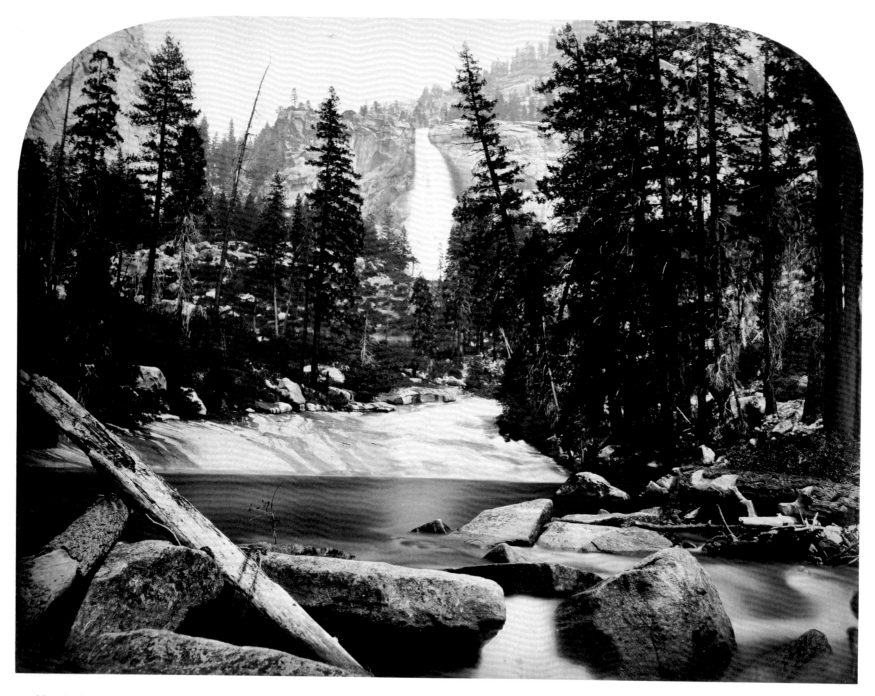

12. *Nevada Fall, 700 Feet, Yosemite,*
albumen silver print, 15¾ × 20¾″ (dome-topped), 1861.
California Historical Society, San Francisco; Carleton Watkins Collection.

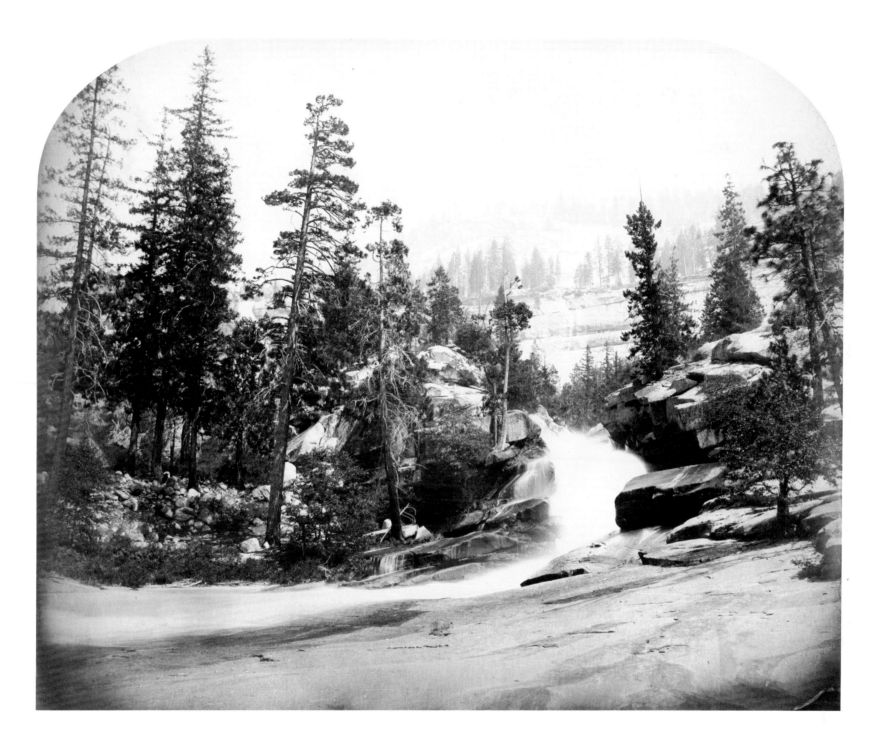

13. *Cascade, Nevada Falls*, albumen silver print, 16¾ × 20¼″ (dome-topped), 1861. Jonathan Stein, New York City.

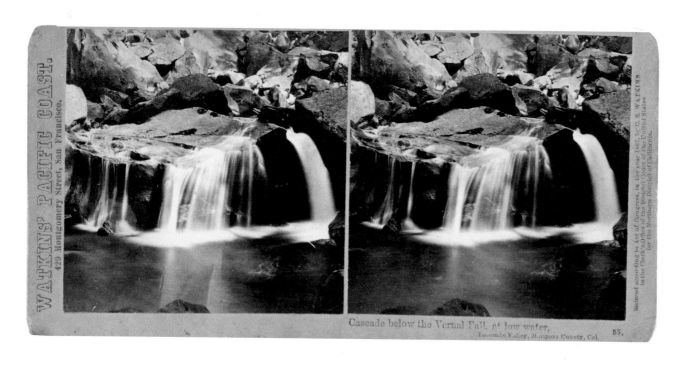

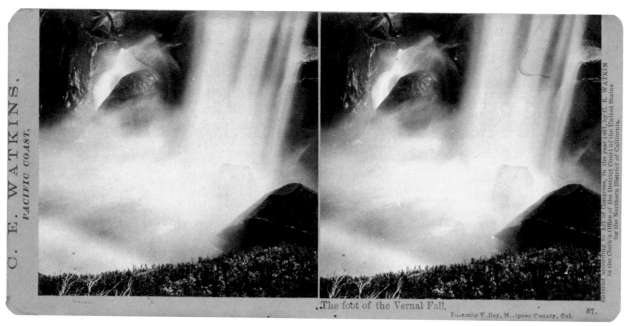

14. *Cascade Below the Vernal Fall, at Low Water. Yosemite Valley, Mariposa County, Cal.*, albumen silver print, 3⅛ × 6¼″, Old Series stereo #55, negative 1861, print c. 1869. Peter Palmquist.

15. *The Foot of the Vernal Fall. Yosemite Valley, Mariposa County, Cal.*, albumen silver print, 3⅛ × 6¼″, Old Series stereo #67, negative 1861, print 1867. Peter Palmquist.

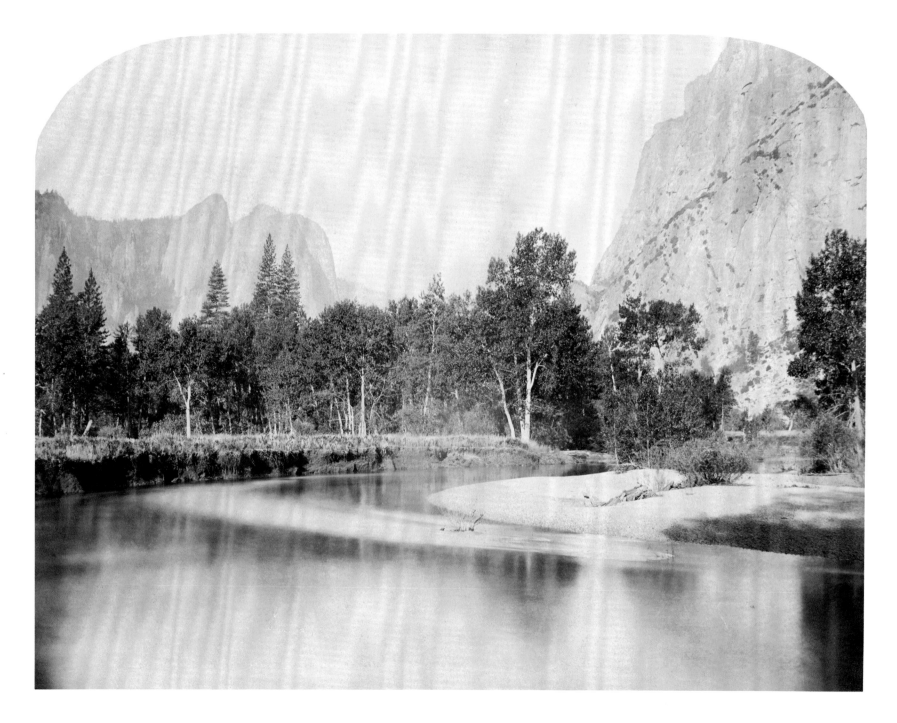

16. [*River View, Yosemite*],
albumen silver print, 15⅜ × 20¾″ (dome-topped), 1861.
California Historical Society, San Francisco; Carleton Watkins Collection.

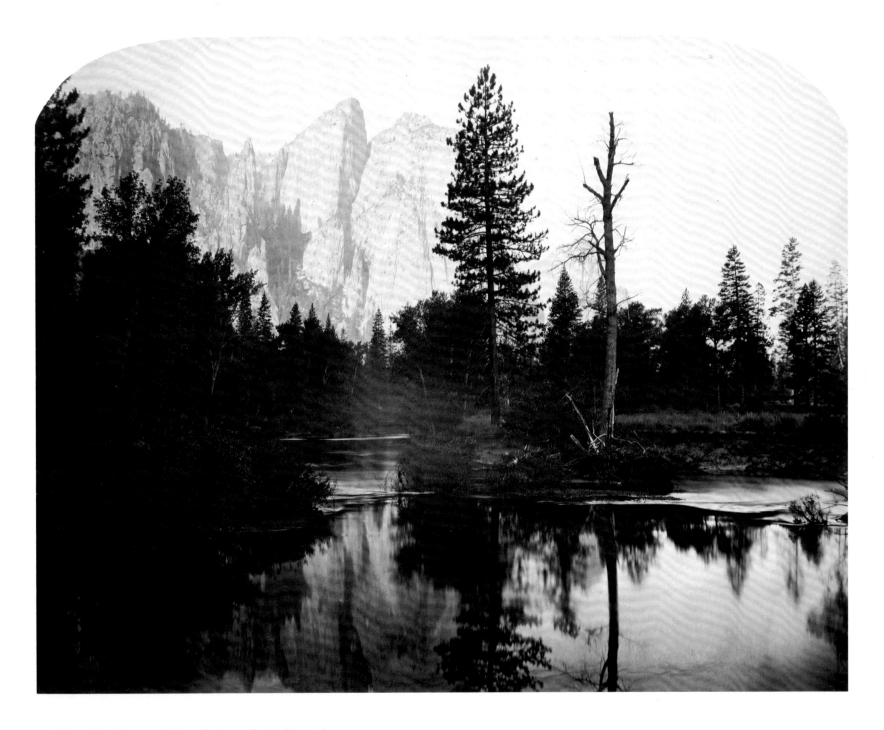

17. [*River View Down the Valley (Cathedral Rock), Yosemite*],
albumen silver print, 15½ × 20¾″ (dome-topped), 1861.
California Historical Society, San Francisco; Carleton Watkins Collection.

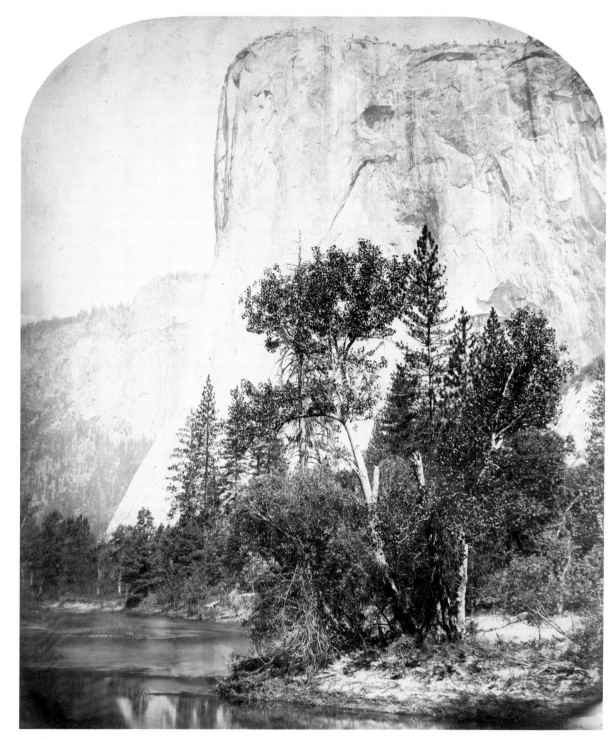

18. *Tutucanula—El Capitan*, albumen silver print, 20¼ × 16¾" (dome-topped), 1861. Collection of The Park-McCullough House, North Bennington, Vermont.

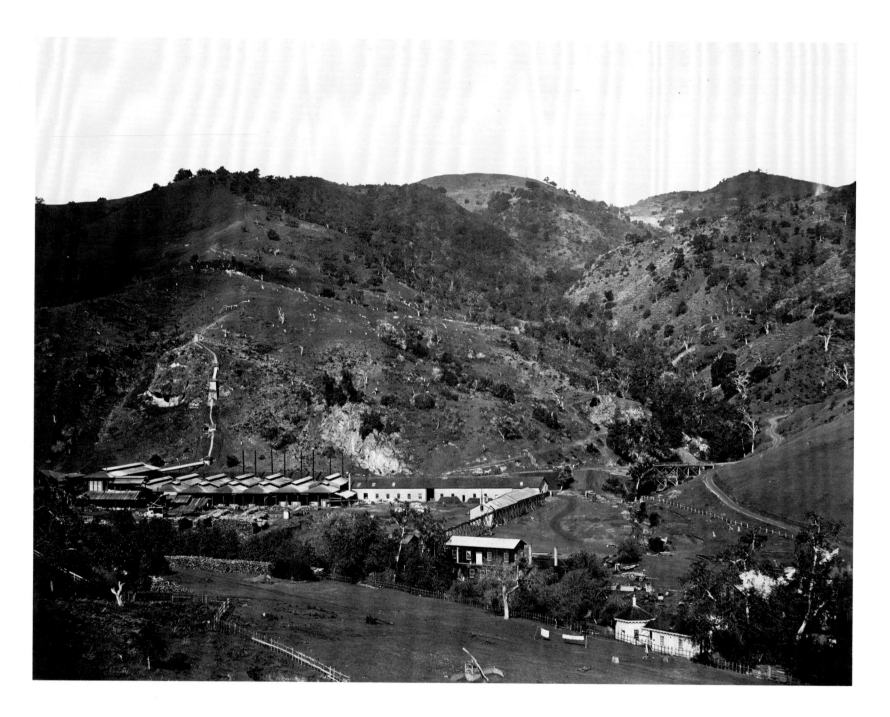

19. *The Works and the Mine, New Almaden, Santa Clara, Cal.*,
albumen silver print, 15¾ × 20⅝″, negative 1863, print later.
From the American Geographical Society Collection of the University of
Wisconsin-Milwaukee.

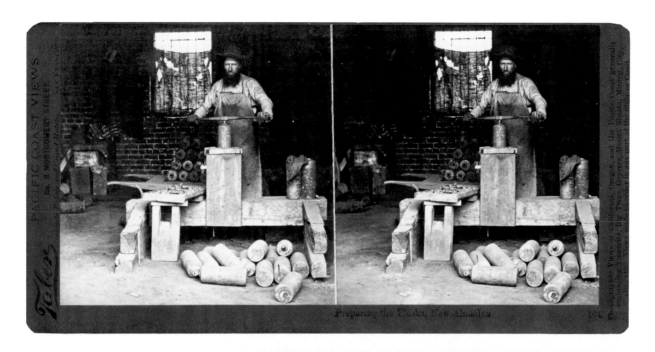

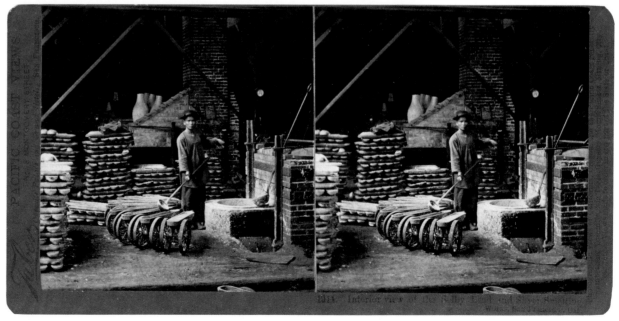

20. *Preparing the Flasks, New Almaden*, albumen silver print, 3 1/16 × 6 1/8″, Old Series stereo negative; Taber stereograph #164, negative 1863, print by I. W. Taber c. 1880. California State Library.

21. *Interior View of the Selby Lead and Silver Smelting Works, San Francisco, Cal.*, albumen silver print, 3 1/8 × 6 1/4″, Old Series stereo negative; Taber stereograph #1944, negative c. 1867, print by I. W. Taber c. 1880. California State Library.

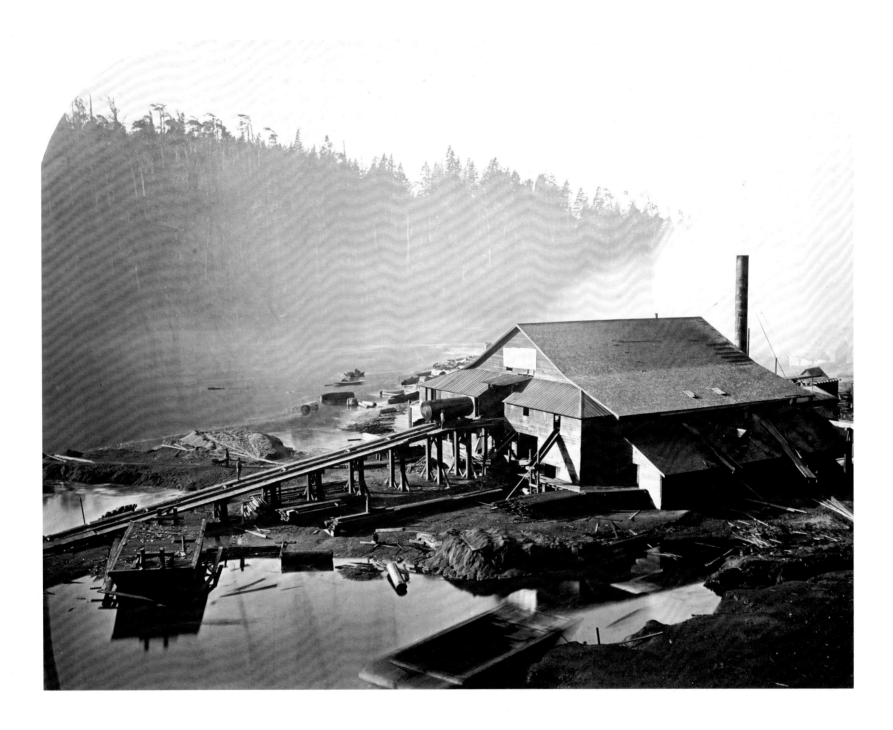

22. [*Big River Lumber Mill*],
albumen silver print, 15⅜ × 19⅞″ (dome-topped), 1863.
The Bancroft Library, University of California, Berkeley.

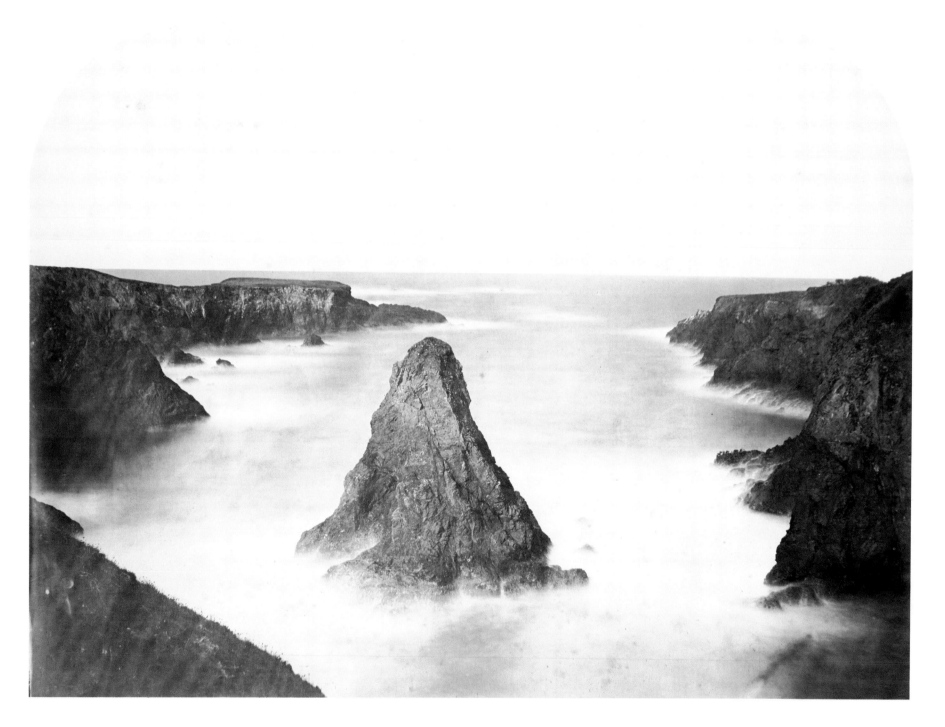

23. [*Coast View* #1], albumen silver print, 15⅜ × 20½″ (dome-topped), 1863. The Bancroft Library, University of California, Berkeley.

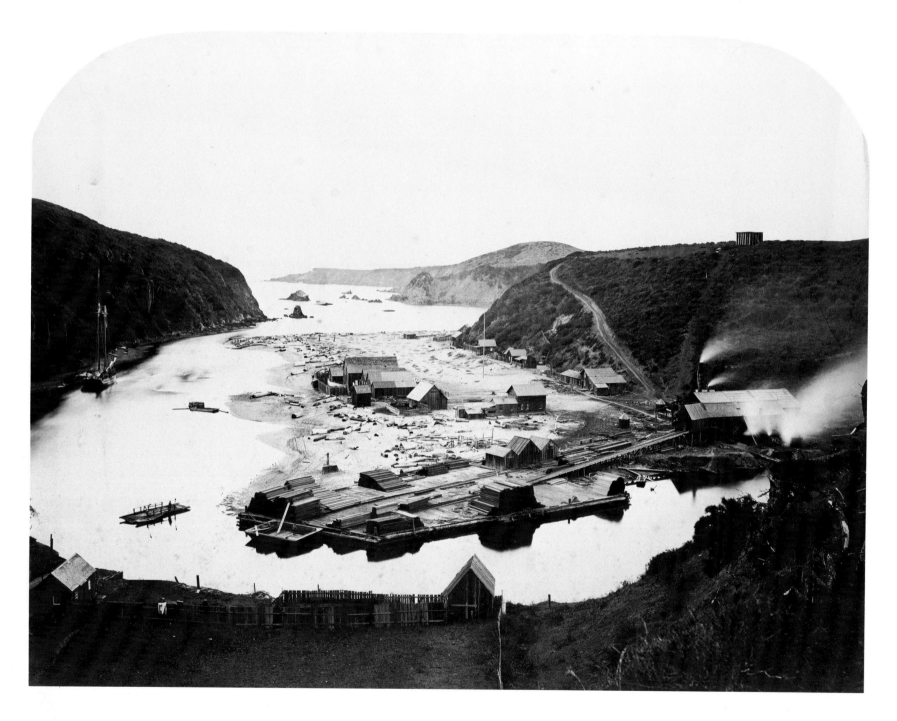

24. [*Albion Mill from above Ferry*],
albumen silver print, 15⅜ × 20⅝″ (dome-topped), 1863.
The Bancroft Library, University of California, Berkeley.

25. [*Mendocino City from South*], albumen silver print, 15⅜ × 20½″ (dome-topped), 1863. The Bancroft Library, University of California, Berkeley.

26. [*Starr King's Church, San Francisco*],
albumen silver print, 17⅝ × 20½″ (dome-topped), c. 1864.
The Bancroft Library, University of California, Berkeley.

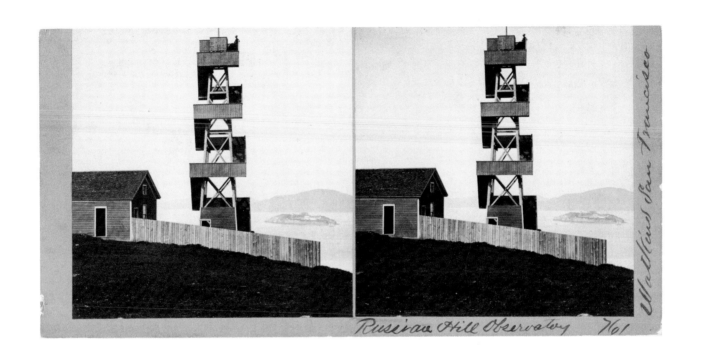

Russian Hill Observatory 761

Watkins' San Francisco

27. *Russian Hill Observatory*, albumen silver print, 3 × 6″,
Old Series stereo #761, c. 1865. Courtesy Daniel Wolf, Inc., New York.

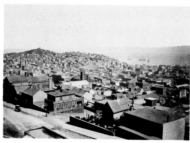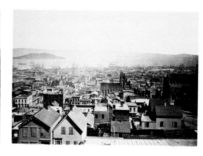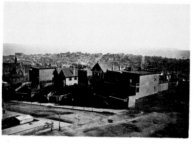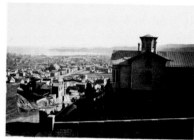

28. [*San Francisco Panorama*], albumen silver prints,
five-part panorama, each plate 14½ × 20½", 1864.
California Historical Society, San Francisco; Carleton Watkins Collection.

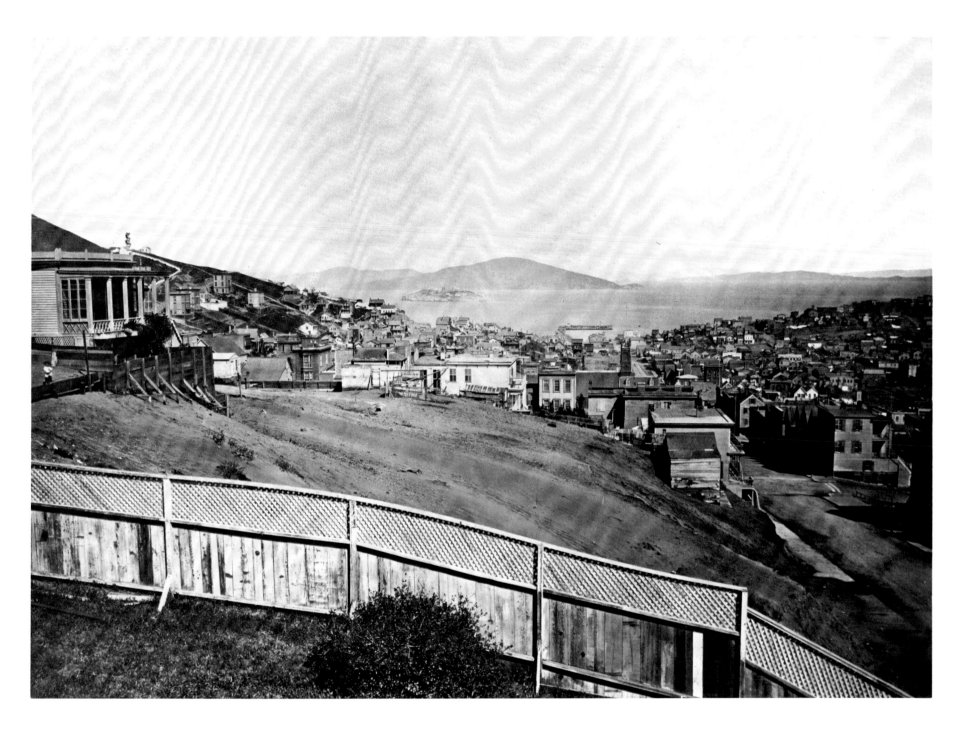

28A. [*San Francisco Panorama*],
albumen silver print, five-part panorama, plate A: 14½ × 20½″, 1864.
California Historical Society, San Francisco; Carleton Watkins Collection.

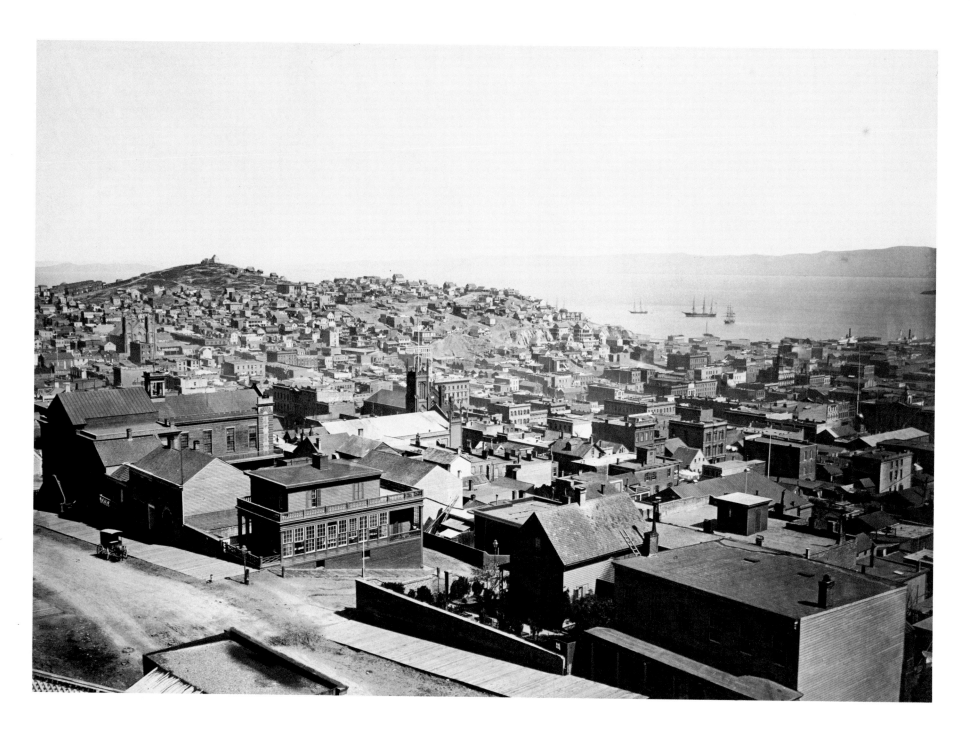

28B. [*San Francisco Panorama*],
albumen silver print, five-part panorama, plate B: 14½ × 20½″, 1864.
California Historical Society, San Francisco; Carleton Watkins Collection.

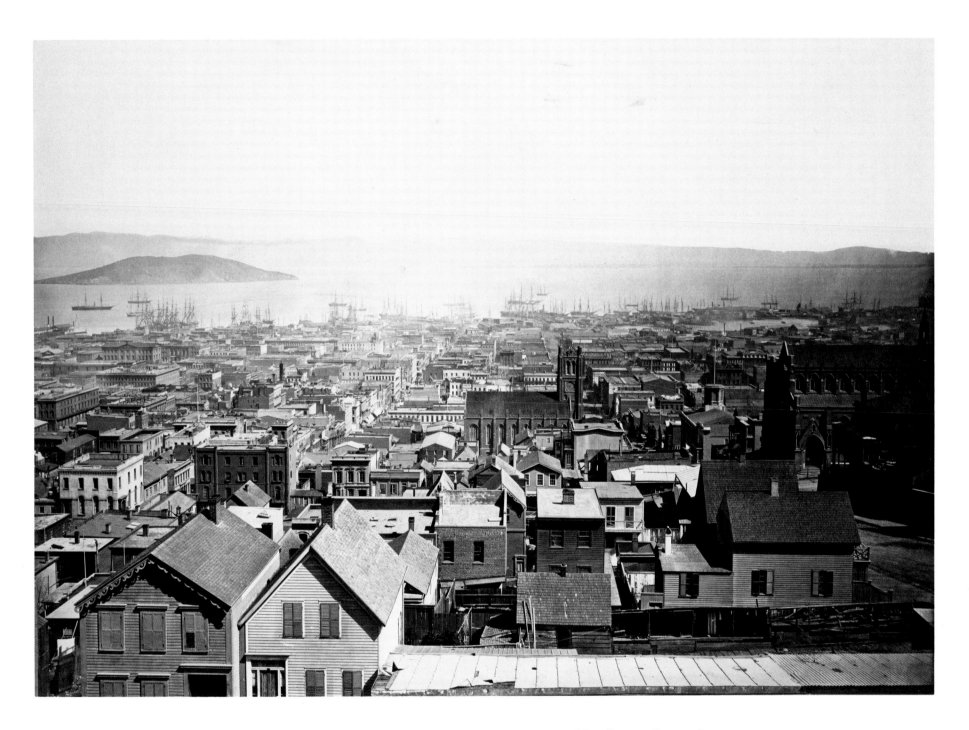

28C. [*San Francisco Panorama*],
albumen silver print, five-part panorama, plate C: 14½ × 20½″, 1864.
California Historical Society, San Francisco; Carleton Watkins Collection.

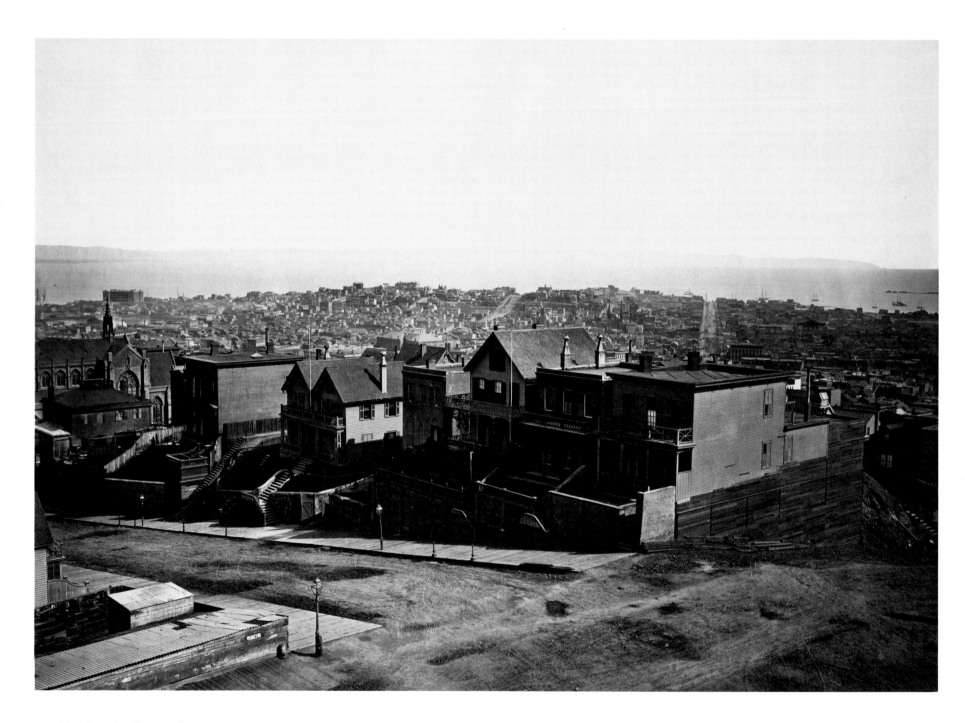

28D. [*San Francisco Panorama*],
albumen silver print, five-part panorama, plate D: 14½ × 20½", 1864.
California Historical Society, San Francisco; Carleton Watkins Collection.

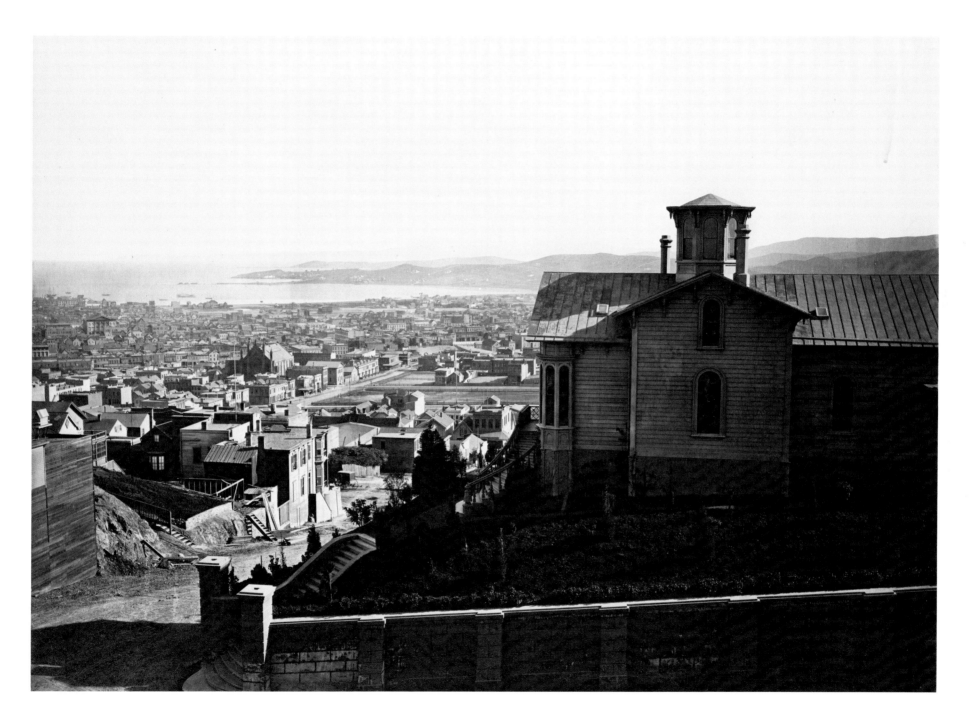

28E. [*San Francisco Panorama*],
albumen silver print, five-part panorama, plate E: 14½ × 20½", 1864.
California Historical Society, San Francisco; Carleton Watkins Collection.

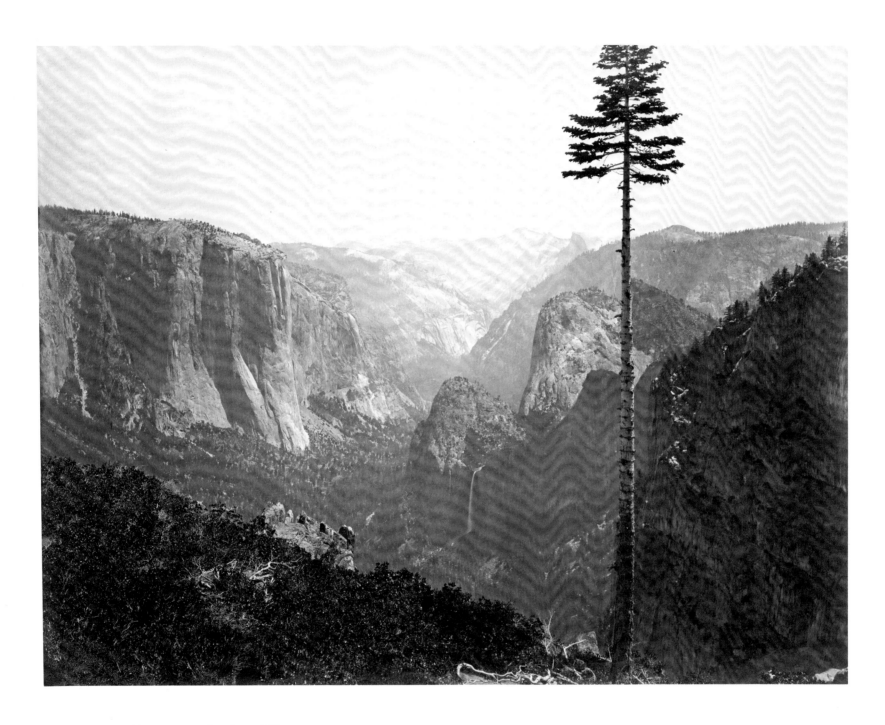

29. *The Yosemite Valley from the Best General View,*
albumen silver print, 15¾ × 20⅝″, c. 1865.
From the American Geographical Society Collection of the University of
Wisconsin-Milwaukee.

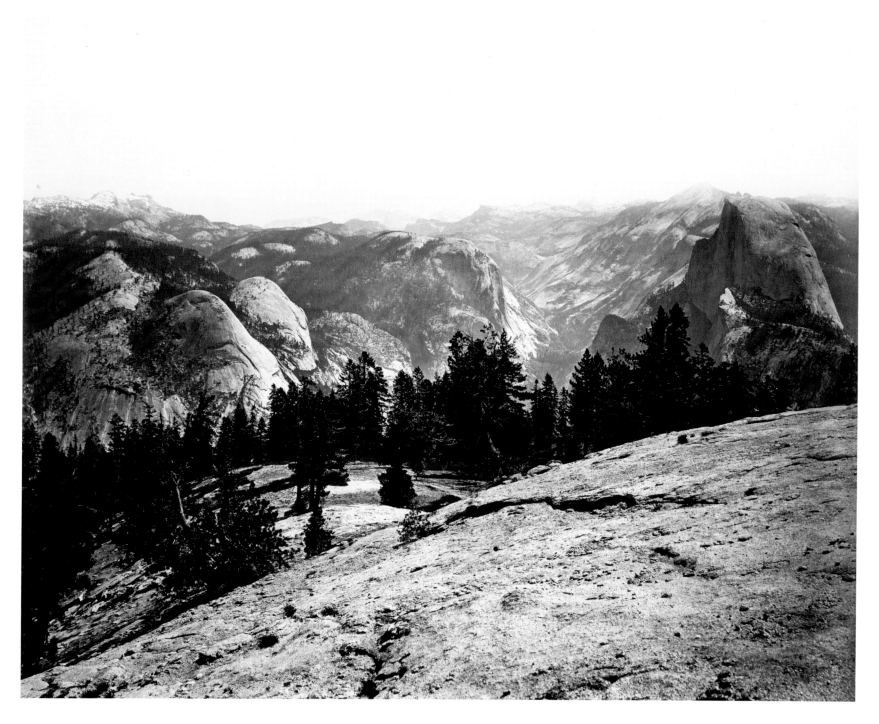

30. [*The Domes from Sentinel Dome*], albumen silver print,
16⅜ × 20⅝″, 1866. Gilman Paper Company Collection.

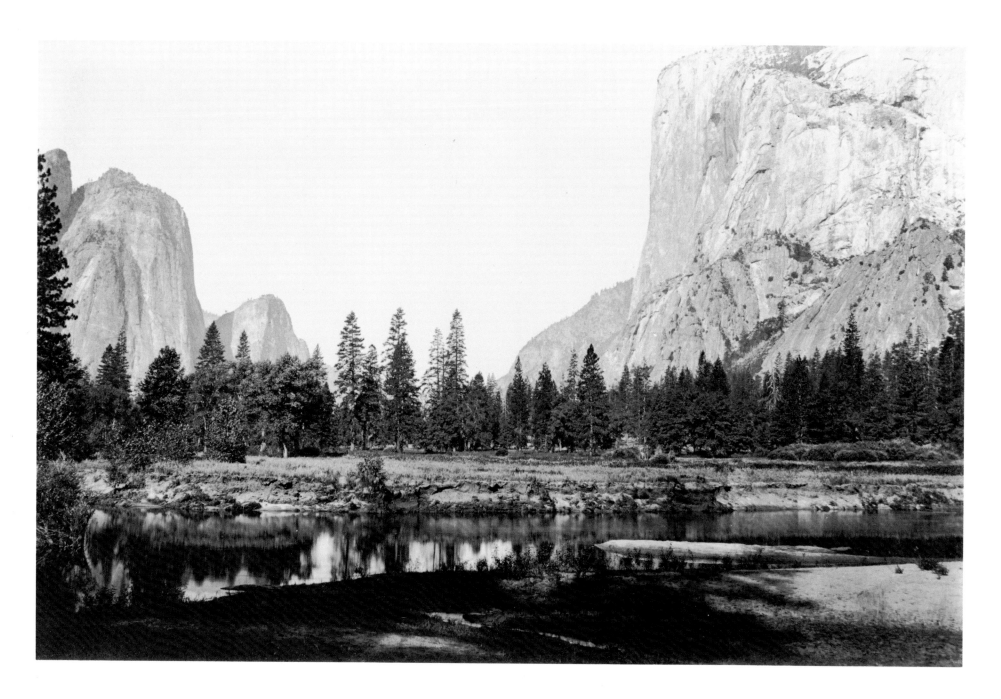

31. *View down the Valley from near the Ferry* [from the album *Yo-semite Valley: Photographic Views of the Falls and Valleys of Yo-semite in Mariposa County, California*], albumen silver print, 7⅝ × 11⅝", negative c. 1865–1866, album published c. 1867–1869.
San Francisco Museum of Modern Art; Gift of Dwight V. Strong.

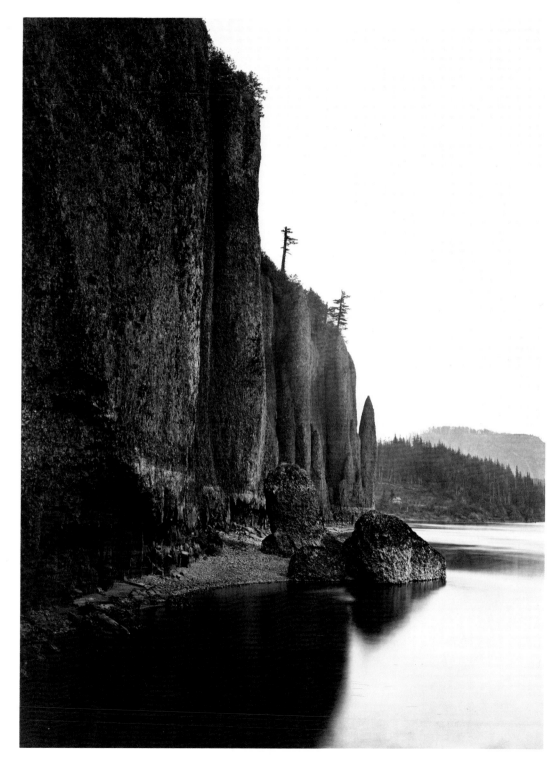

32. [*Sheer Cliffs*],
albumen silver print, 20½ × 15¼″, 1867.
Gilman Paper Company Collection.

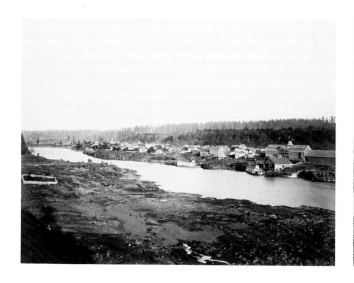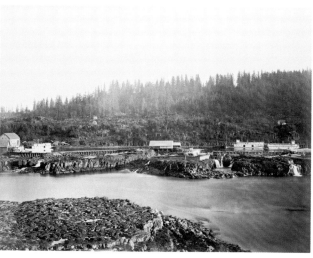

33. [*Oregon City and Willamette Falls*], albumen silver prints, three-part pan-
orama, plate A: 15 ¹¹/₁₆ × 20⅝″; plates B and C: 15 ¾ × 20⅝″, 1867.
Collection Centre Canadien d'Architecture/
Canadian Centre for Architecture, Montréal.

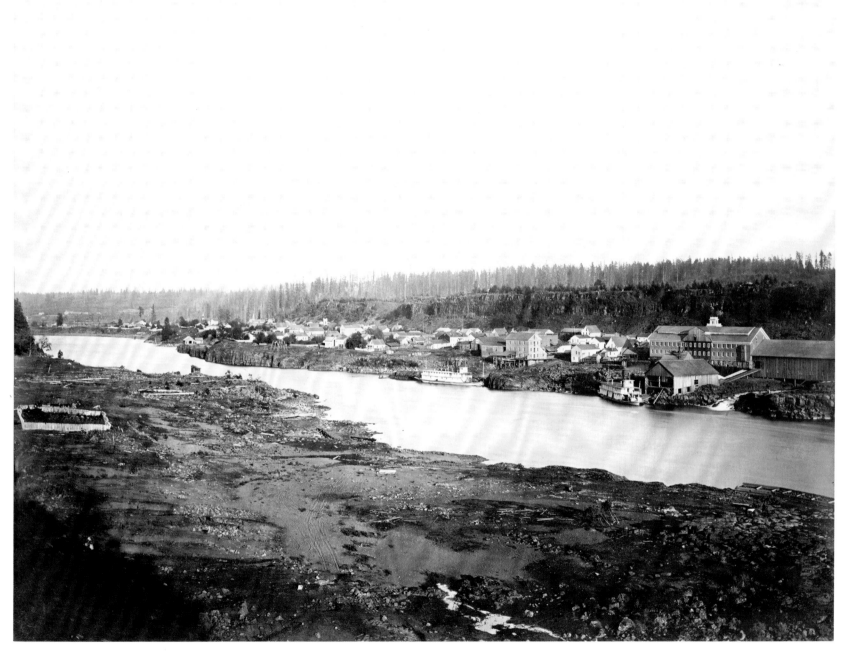

33A. [*Oregon City and Willamette Falls*],
albumen silver print, three-part panorama, plate A: 15¹¹⁄₁₆ × 20⅝″, 1867.
Collection Centre Canadien d'Architecture/
Canadian Centre for Architecture, Montréal.

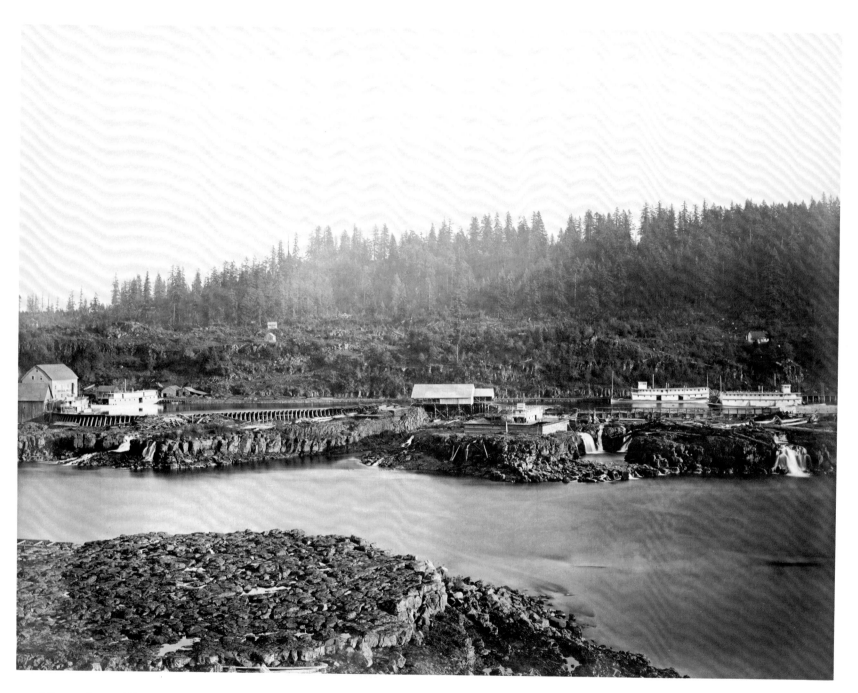

33B. [*Oregon City and Willamette Falls*],
albumen silver print, three-part panorama, plate B: 15 ¾ × 20 ⅝″, 1867.
Collection Centre Canadien d'Architecture/
Canadian Centre for Architecture, Montréal.

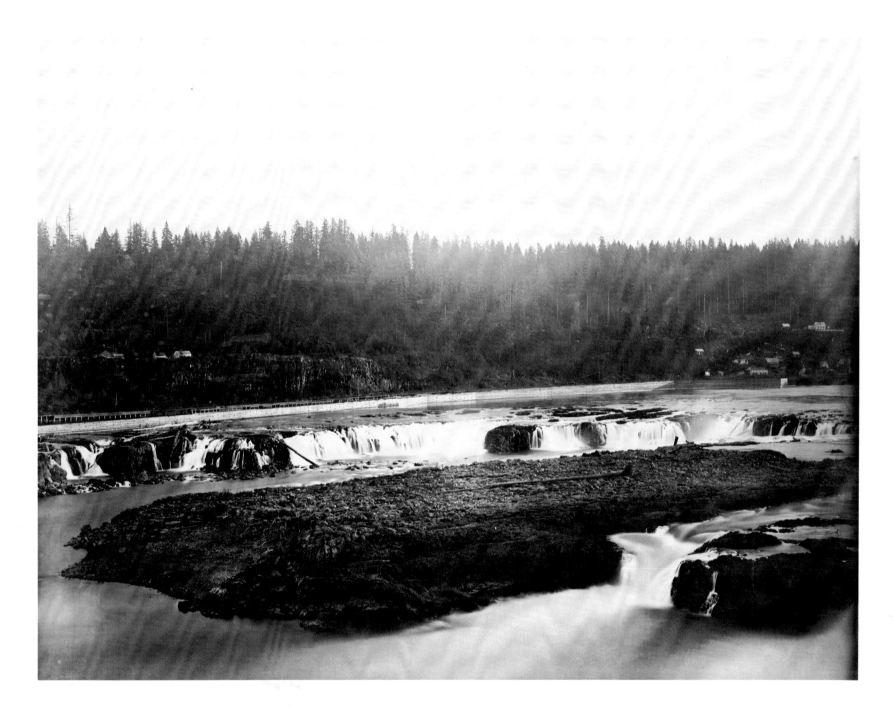

33C. [*Oregon City and Willamette Falls*],
albumen silver print, three-part panorama, plate C: 15¾ × 20⅝″, 1867.
Collection Centre Canadien d'Architecture/
Canadian Centre for Architecture, Montréal.

34. *Cape Horn near Celilo*, albumen silver print, 20¾ × 15¾″, 1867.
Gilman Paper Company Collection.

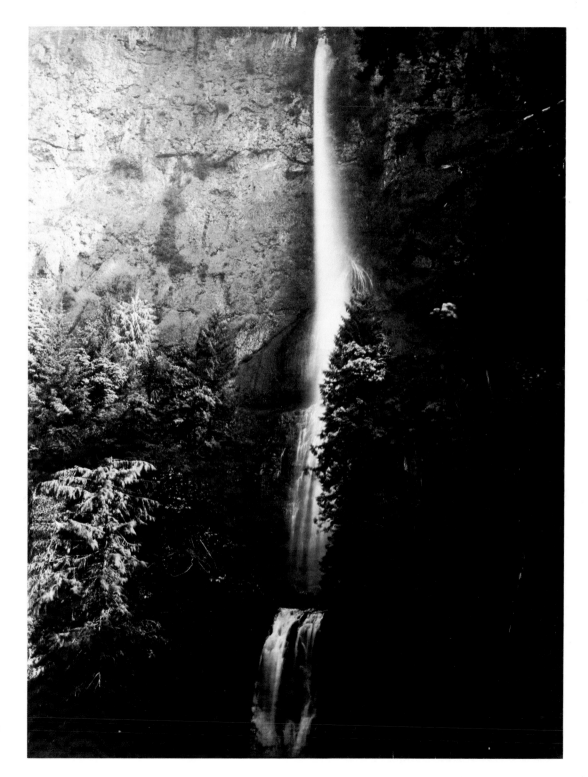

35. *Multnomah Fall Cascade, Columbia River,*
albumen silver print, 20½ × 15⅝″, 1867.
Gilman Paper Company Collection.

36. *Alcatraz from North Point*, albumen silver print,
15¾ × 20¾″, c. 1866. Fraenkel Gallery, San Francisco.

37. *The Wreck of the Viscata*,
albumen silver print, 15½ × 20½″, 1868. Amon Carter Museum.

38. *Sugar Loaf Islands, Farallons*, albumen silver print,
15¾ × 20⅝", c. 1868–1869. Gilman Paper Company Collection.

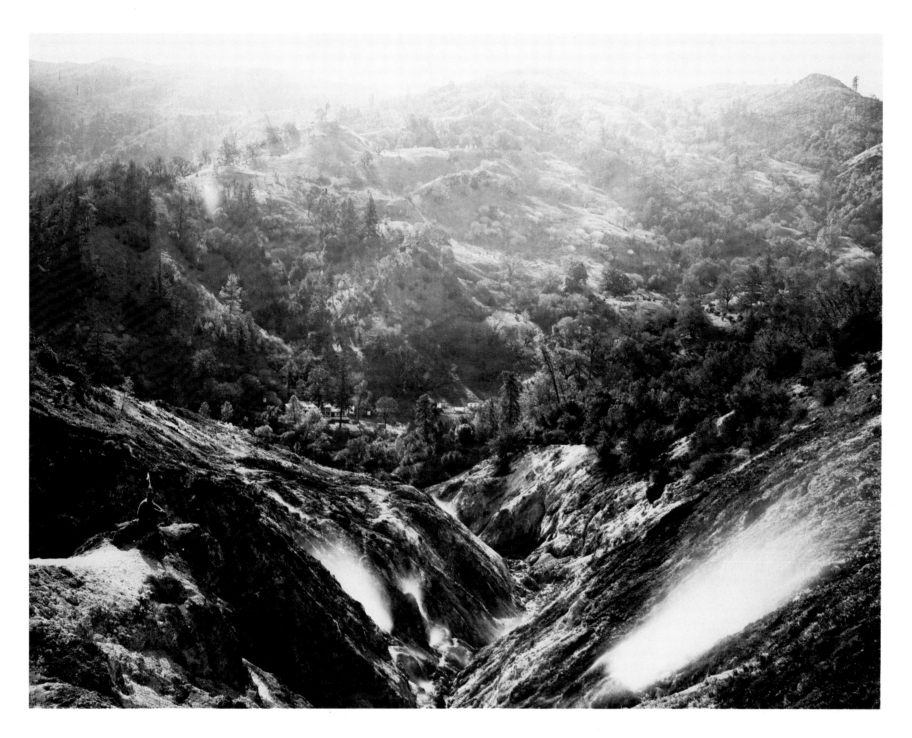

39. [*California Geysers*],
albumen silver print, 15⅝ × 20½″, c. 1868–1870. Library of Congress.

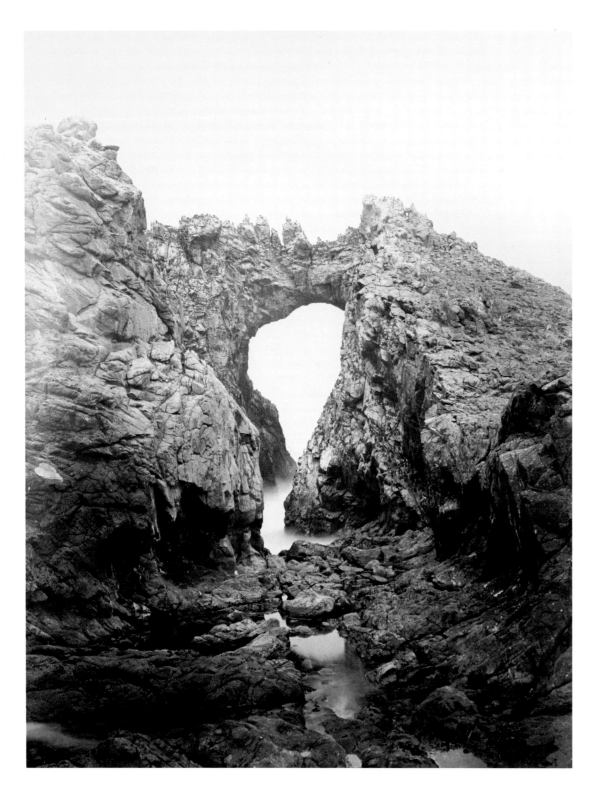

40. *Arch at the West End, Farallons,*
albumen silver print, 20⅝ × 15¾", c. 1869.
Fraenkel Gallery, San Francisco.

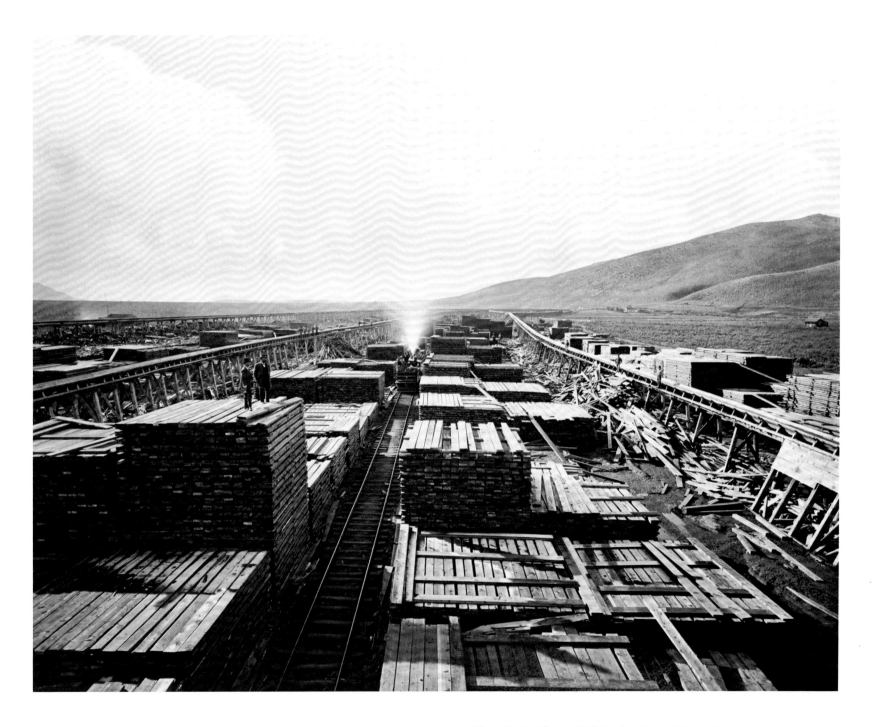

41. *Upper End of Carson & Tahoe Lumber and Flume Co. Lumber & Wood Yard near Carson City*, albumen silver print, 16⅛ × 21½″, c. 1873. Nevada State Museum.

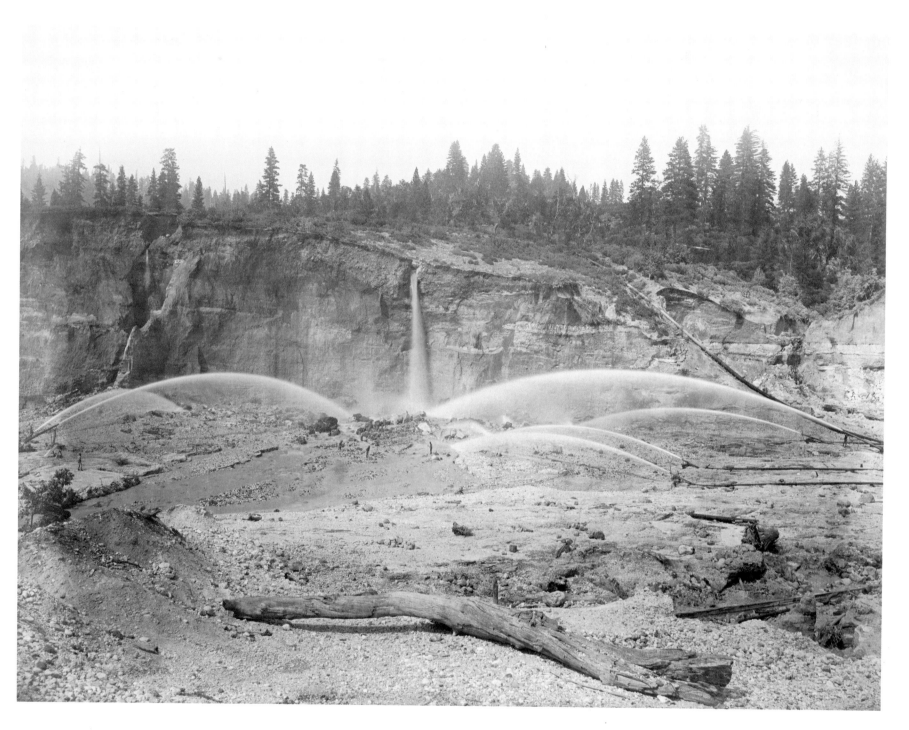

42. *Malakoff Diggins North Bloomfield, Nevada Co., Cal.*, albumen silver print,
15 1/8 × 20 5/8″, c. 1869–1871. Fraenkel Gallery, San Francisco.

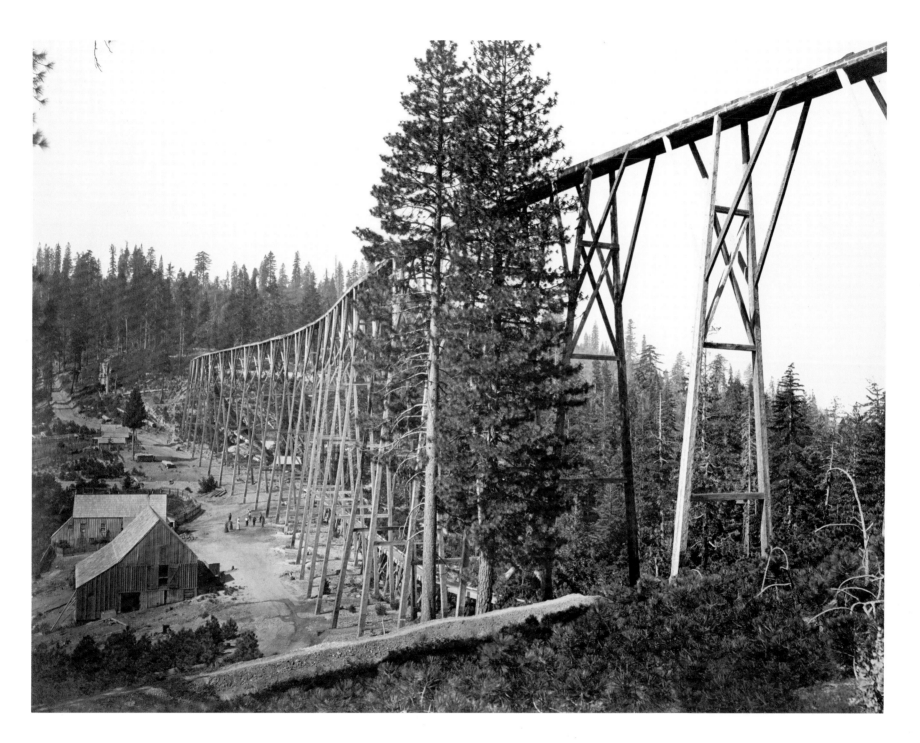

43. *Magenta Flume Nevada Co., Cal.*, albumen silver print,
15¾ × 20¹¹⁄₁₆″, c. 1869–1871. G. H. Dalsheimer Gallery, Ltd.

44. *The Summit of Lassen's Butte,*
albumen silver print, 8⅛ × 12⁵⁄₁₆″, 1870. Amon Carter Museum.

45. *Commencement of the Whitney Glacier, Summit of Mount Shasta,*
albumen silver print, 8¼ × 12¼", 1870. Amon Carter Museum.

46. *The Devil's Gate C. P. R. R. [Utah]*, albumen silver print,
4 15/₁₆ × 6⅜″ (oval), c. 1873–1874. Amon Carter Museum.

47. [*Watkins' Photographic Wagon along the C. P. R. R. Tracks, Utah*], albumen silver print, 4¹⁵⁄₁₆ × 6³⁄₈″ (oval), c. 1873–1874. Amon Carter Museum.

48. [*Professor Louis Agassiz*],
albumen silver print, 5⅞ × 4″, cabinet card, c. 1875.
California Historical Society, San Francisco; Carleton
Watkins Collection.

49. [*Composite Group Portrait of W. C. Ralston and the Directors of the Bank of California*], albumen silver print, copy of drawing by George H. Burgess and photo composite by Watkins, 10¼ × 22¼″, 1874.
California Historical Society, San Francisco; Carleton Watkins Collection.

50. *Trout Pond* [*Thurlow Lodge*], albumen silver print, 15 11/16 × 20 3/4″, 1874.
Collection Centre Canadien d'Architecture/
Canadian Centre for Architecture, Montréal.

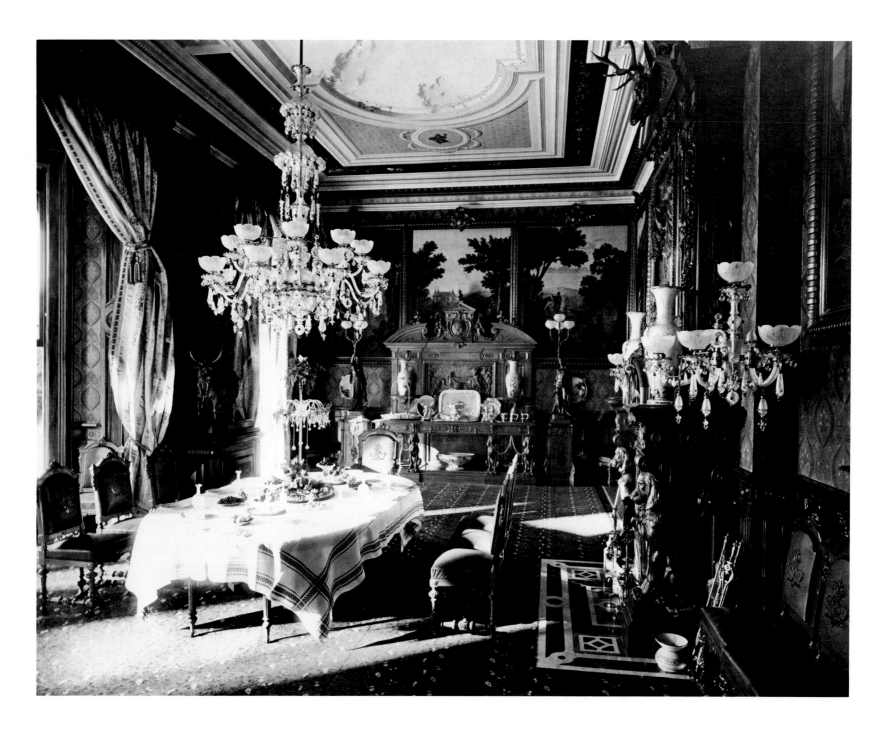

51. *Dining Room* [*Thurlow Lodge*], albumen silver print, 15⁹⁄₁₆ × 20⅝″, 1874.
Collection Centre Canadien d'Architecture/
Canadian Centre for Architecture, Montréal.

52. *Acacia Arbor* [*Thurlow Lodge*],
albumen silver print, 14^{15}/$_{16}$ × 20^{1}/$_{8}$″, 1874.
Collection Centre Canadien d'Architecture/
Canadian Centre for Architecture, Montréal.

53. [*River Cascade*], albumen silver print, 15⅜ × 20⅝″, c. 1872.
Bailey/Howe Library, University of Vermont.

54. [*A Storm on the Lake, Lake Tahoe*],
albumen silver print, 15 × 21⅛″, c. 1873–1878. California State Library.

Notes on the Plates

WATKINS' NEW SERIES

Watkins photographs printed or published after 1876 are called "Watkins' New Series." In some instances, negatives made before 1876 were published under the New Series designation. Negatives made up to c. 1883 were produced by the wet-plate process. After 1883 Watkins used factory-prepared dry-plate negatives, especially for commissions involving a large output of views, although he continued to use wet-plate negatives intermittently until 1891. Most of the New Series prints were made on albumen paper; however, examples of cyanotypes and large glass transparent positives exist.

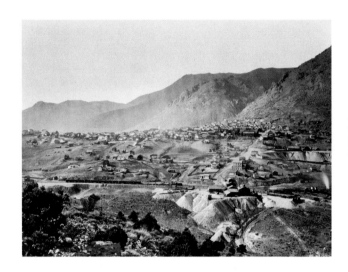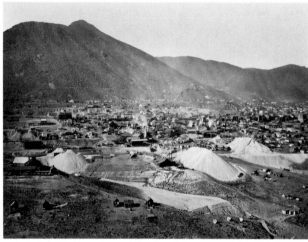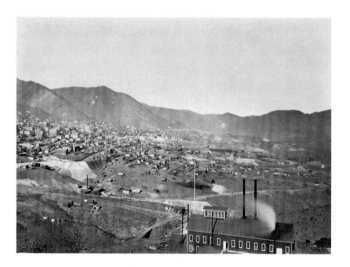

55. *Panorama of Virginia City, Nevada. View from the Combination Shaft,*
albumen silver print, three-part panorama, each plate 15 ½ × 21 ⅛″, 1876.
The Bancroft Library, University of California, Berkeley.

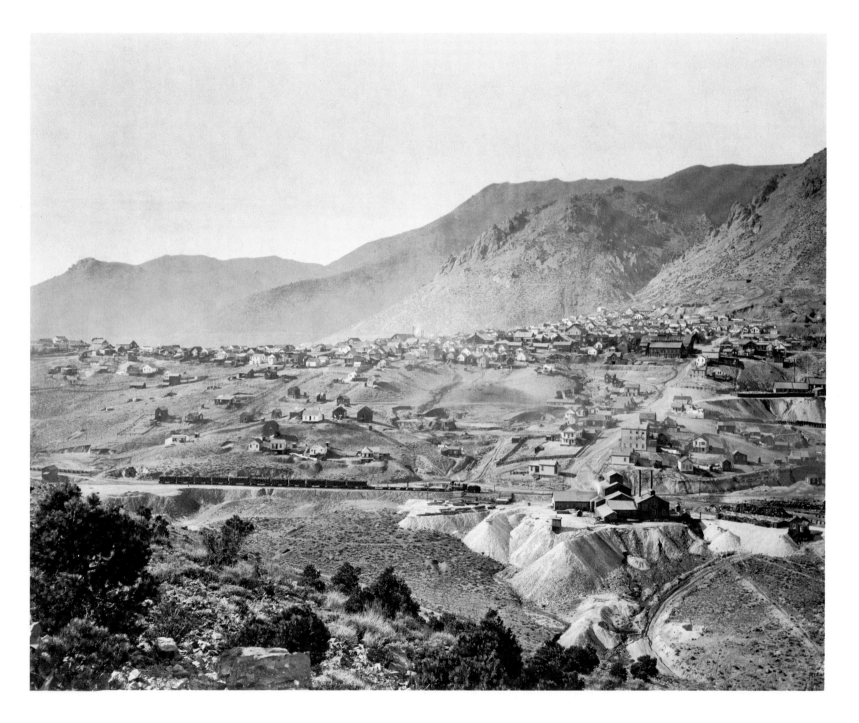

55A. *Panorama of Virginia City, Nevada. View from the Combination Shaft*,
albumen silver print, three-part panorama, plate A: 15½ × 21⅛″, 1876,
The Bancroft Library, University of California, Berkeley.

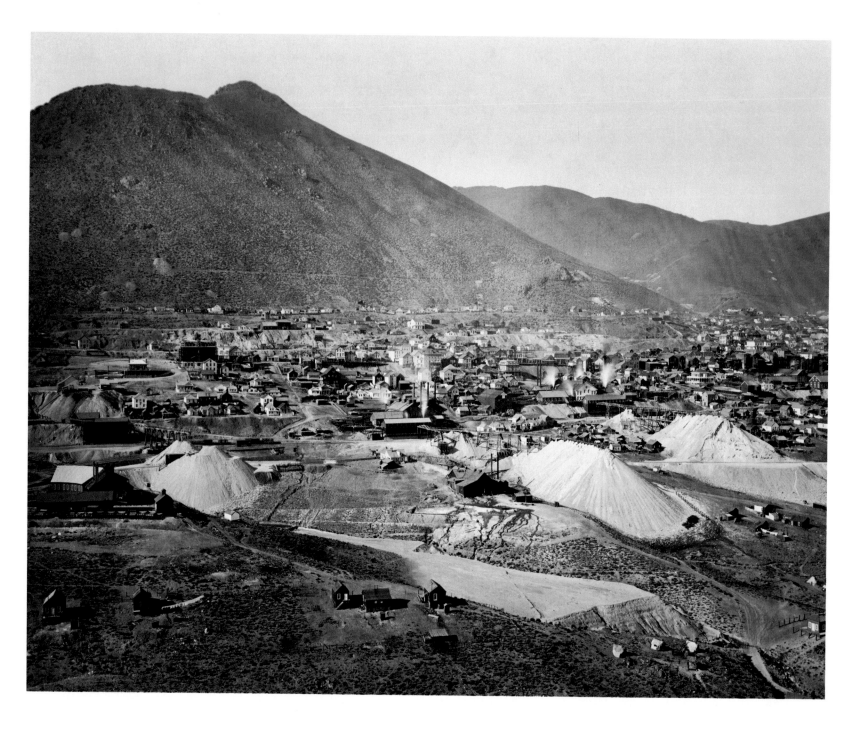

55B. *Panorama of Virginia City, Nevada. View from the Combination Shaft*,
albumen silver print, three-part panorama, plate B: 15½ × 21⅛″, 1876.
The Bancroft Library, University of California, Berkeley.

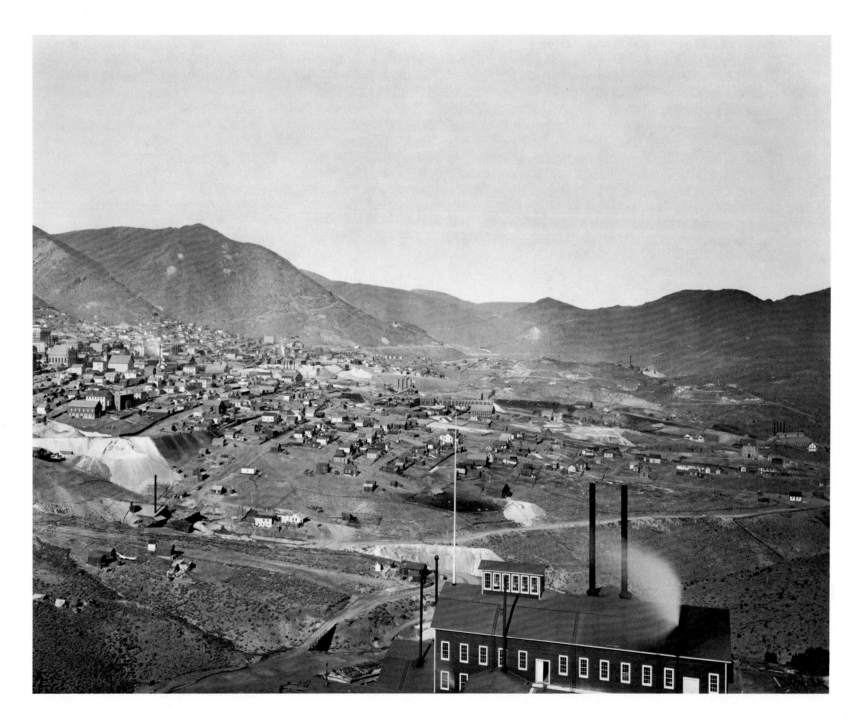

55C. *Panorama of Virginia City, Nevada. View from the Combination Shaft*, albumen silver print, three-part panorama, plate C: 15 ½ × 21 ⅛″, 1876. The Bancroft Library, University of California, Berkeley.

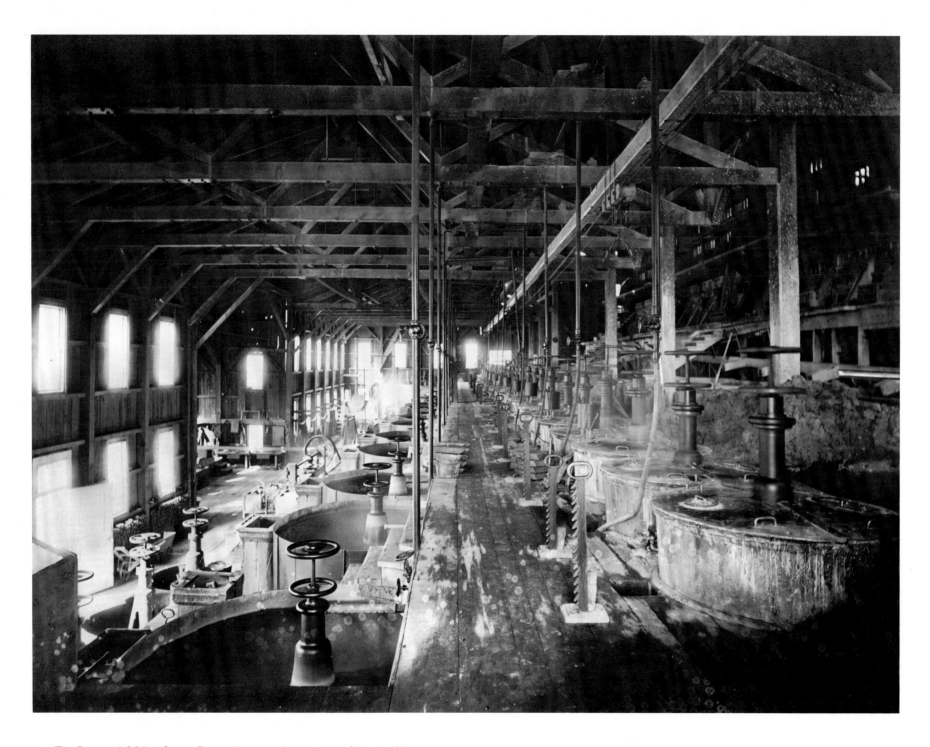

56. *The Brunswick Mill—Carson River*, albumen silver print, 15½ × 21⅛",
c. 1876. The Bancroft Library, University of California, Berkeley.

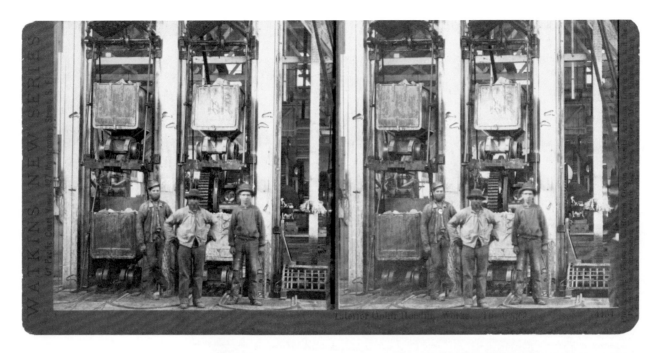

57. *Interior Ophir Hoisting Works. The Cages*,
albumen silver print, 3⅛ × 6¼″, New Series stereo #4154, c. 1876.
The Bancroft Library, University of California, Berkeley.

58. *Interior Ophir Hoisting Works. Incline Hoisting Works*, albumen silver print,
4⅛ × 8¼″, New Series stereo #4156, c. 1876. California State Library.

59. *Artillery Practice, Presidio, San Francisco,*
albumen silver print, 7 × 8½", c. 1876.
California Historical Society, San Francisco; Carleton Watkins Collection.

60. [*Centennial Train*], albumen silver print, 14⅞ × 21″, 1876.
The Bancroft Library, University of California, Berkeley.

61. *View of Loop. Tehachapi Pass on Line of Southern Pacific Railroad,*
albumen silver print, 15 1/4 × 20 15/16", c. 1876. California State Library.

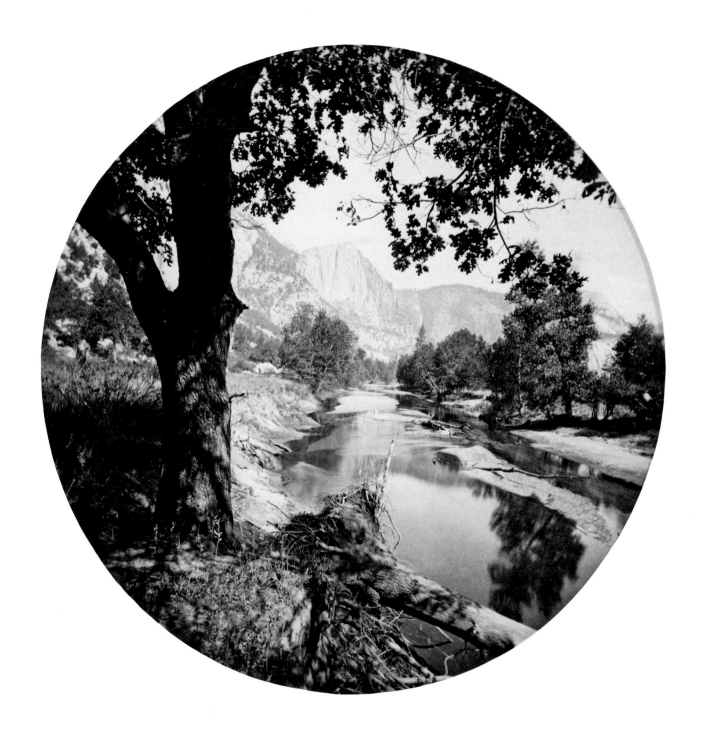

62. [*View on the Merced*], albumen silver print, 5″ diameter (round), 1878.
William Keith Collection, The Bancroft Library, University of California,
Berkeley.

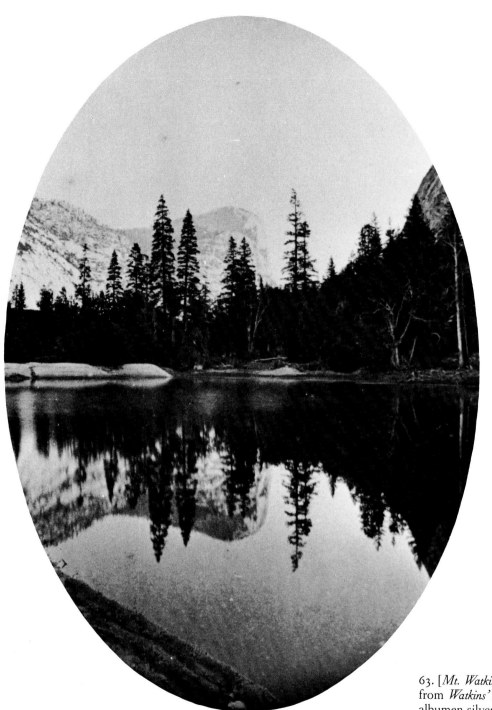

63. [*Mt. Watkins Reflected in Mirror Lake*],
from *Watkins' New Series Yosemite Valley Album*,
albumen silver print, 5 13/16 × 3 3/16″ (oval), 1878.
National Park Service, Yosemite Collection.

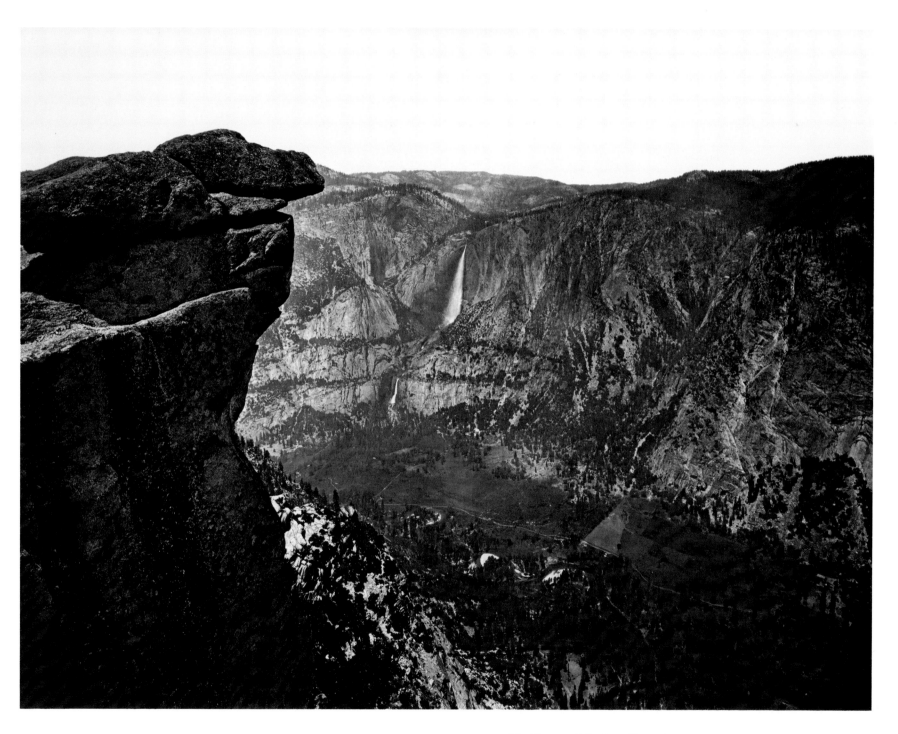

64. *The Yosemite Falls, from Glacier Point*, albumen silver print, 15 ¼ × 21 ¼″, c. 1878–1881. Lent by Gordon L. Bennett, Kentfield, California.

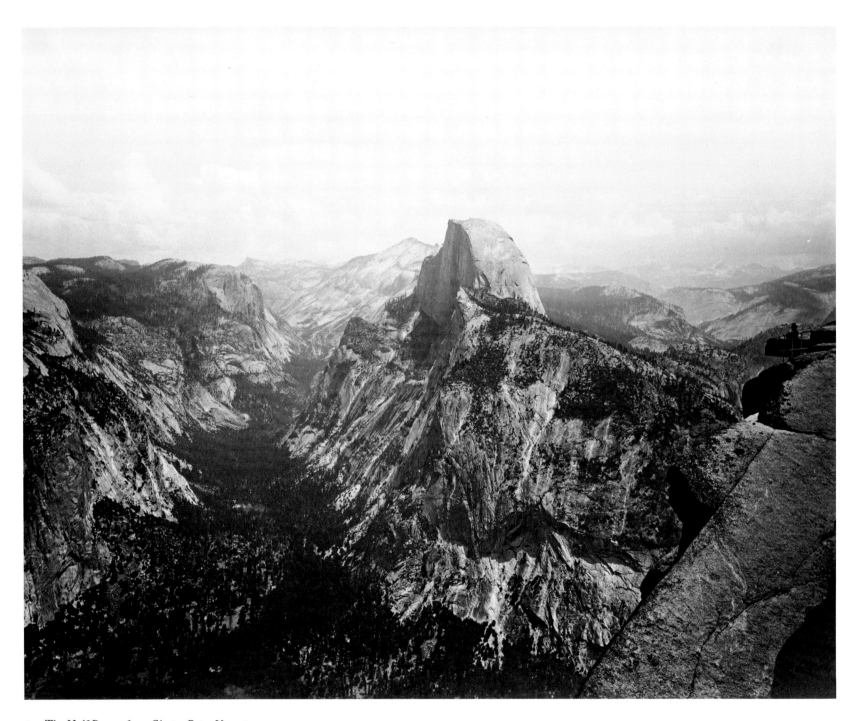

65. *The Half Dome, from Glacier Point Yosemite,*
albumen silver print, 15 ⅜ × 21 ¼″, c. 1878–1881.
Lent by Gordon L. Bennett, Kentfield, California.

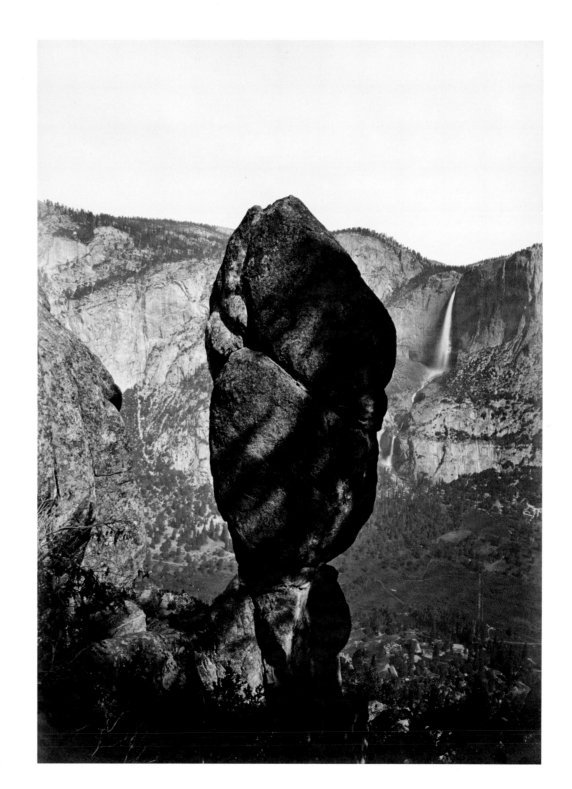

66. *Agassiz Rock and the Yosemite Falls,*
from Union Point, albumen silver print,
21⅜ × 15⅜″, c. 1878–1881.
Lent by Gordon L. Bennett, Kentfield, California.

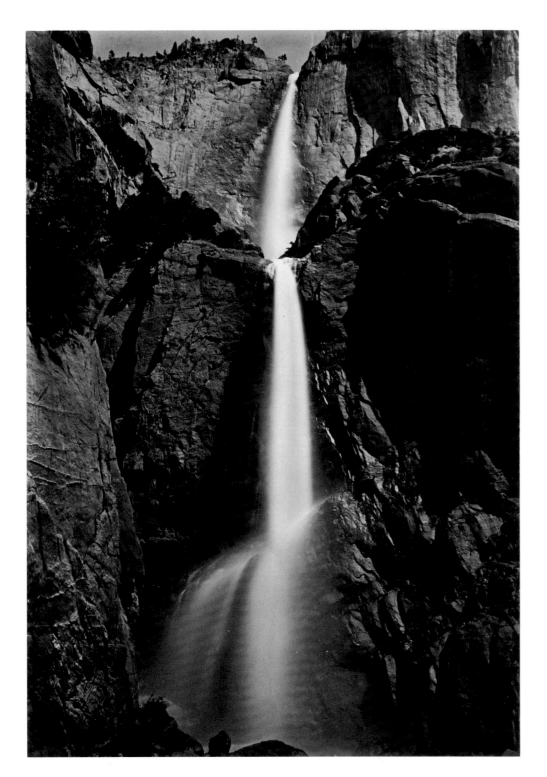

67. *Yosemite Falls, View from the Bottom,*
albumen silver print, 21½ × 15″, c. 1878–1881.
Lent by Gordon L. Bennett, Kentfield, California.

68. *Lake Independence, Foot of Trail to Mt. Lola,*
albumen silver print, 15½ × 21⅛″, 1879.
The Bancroft Library, University of California, Berkeley.

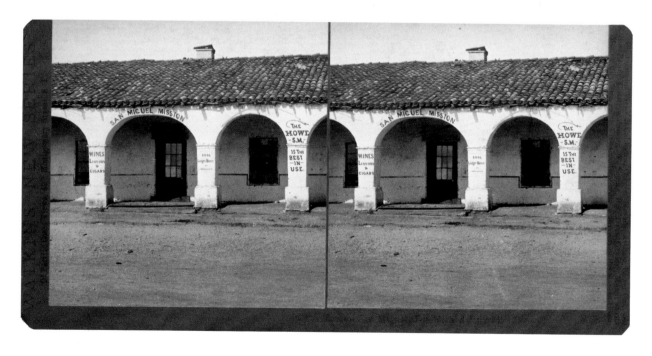

69. *Lake Tahoe, from the Warm Springs,* albumen silver print, 3⅛ × 6¼″, New Series stereo #4026, negative c. 1878, print c. 1882. Peter Palmquist.

70. *Mission San Miguel, Established July 25, 1797,* albumen silver print, 3⅛ × 6¼″, New Series stereo #4658, c. 1880. Peter Palmquist.

71. [*California Mission*], albumen silver print, 4¼ × 7⅝″, c. 1880.
Collection Centre Canadien d'Architecture/
Canadian Centre for Architecture, Montréal.

72. *Mission, San Carlos del Carmelo,*
albumen silver print, 14 15/16 × 21 1/4″, c. 1880–1881.
Department of Special Collections, University Research Library,
University of California, Los Angeles.

73. *Mission, San Juan Capistrano. View from the West,*
albumen silver print, 14^{15}/$_{16}$ × 21¼″, c. 1880–1881.
Department of Special Collections, University Research Library,
University of California, Los Angeles.

74. *Sunny Slope Wine Buildings*, albumen silver print,
3⅛ × 6¼″, New Series stereo #4813, c. 1880. California State Library.

75. *Sunny Slope Wine Buildings*, albumen silver print,
3⅛ × 6¼″, New Series stereo #4812, c. 1880. California State Library.

76. [*Indiana Colony, Pasadena*],
albumen silver print, 15 1/16 × 21 1/16″, c. 1880. California State Library.

77. [*Pacific Coast Steamship Company Building and Wharf, San Diego*],
albumen silver print, 15 1/16 × 21 1/16″, 1880. California State Library.

78. *San Xavier Mission, Near Tucson. "Facade"*,
albumen silver print, 21 ¼ × 15 ¼″, 1880.
The Bancroft Library, University of California,
Berkeley.

79. [*Casa Grande, Arizona*], albumen silver print, 15⅞16 × 21¼″, 1880.
Department of Special Collections,
University Research Library, University of California, Los Angeles.

80. [*Casa Grande, Arizona*], albumen silver print, 15⅝ × 21¼″, 1880.
Department of Special Collections,
University Research Library, University of California, Los Angeles.

81. *Contention Hoisting Works and Ore Dump, from Below, Arizona,*
albumen silver print, 15 ½ × 21 ⅛″, 1880.
The Bancroft Library, University of California, Berkeley.

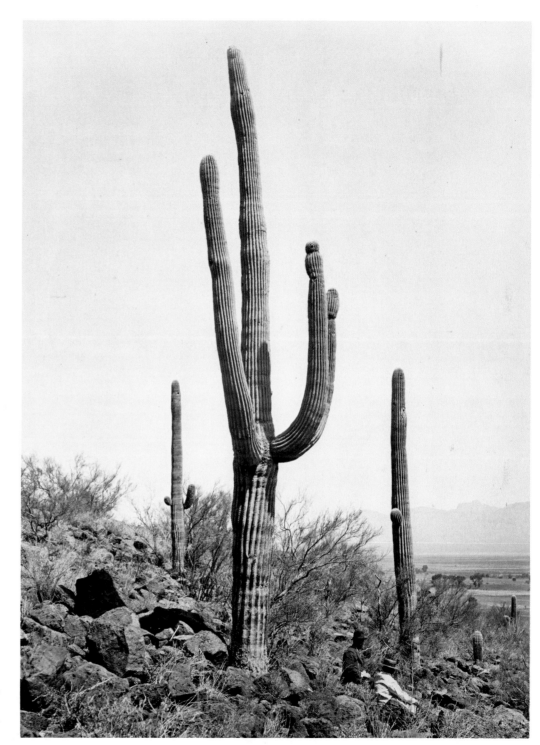

82. *Cereus Giganteus, Arizona,*
albumen silver print, 21⅜ × 16⅛″, 1880.
The Bancroft Library, University of California,
Berkeley.

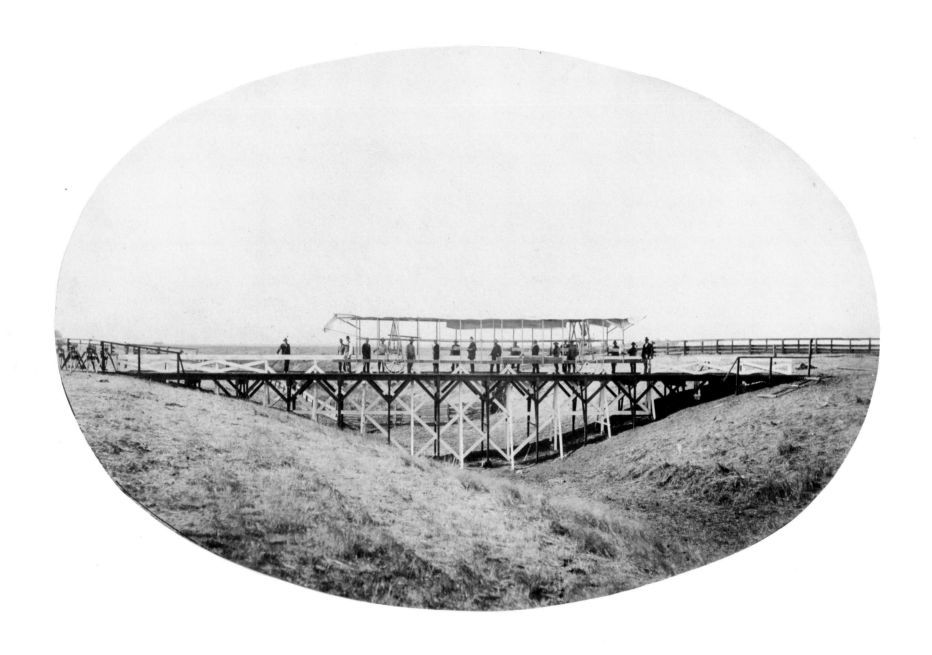

83. *Yolo Base Line. Measuring Across One of the Sloughs.*
"Dry Trough" Trestle, 115 Feet Long, 22 Feet High at Footpath, 25 Feet at Rail,
albumen silver print, 7⅞ × 11⅞″ (oval), 1881.
The Bancroft Library, University of California, Berkeley.

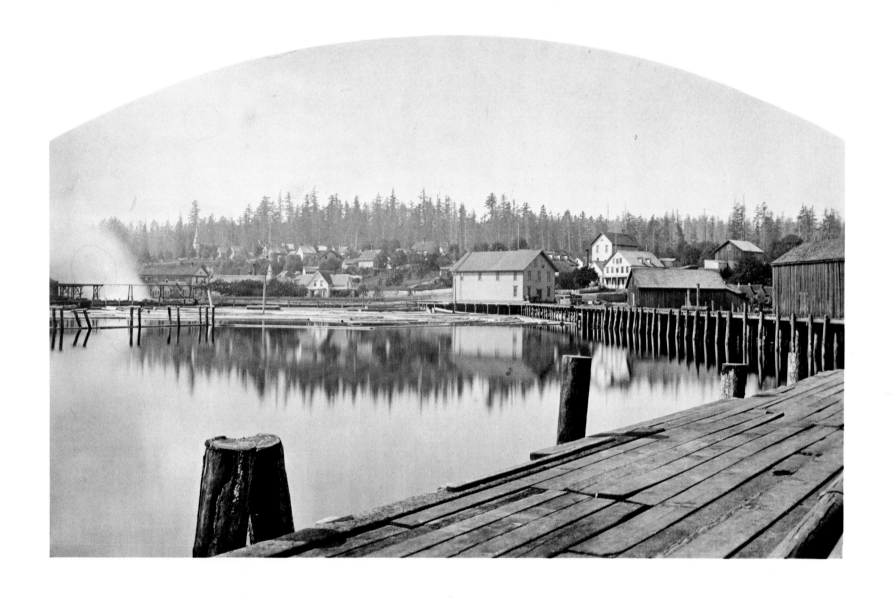

84. *Port Gamble, Puget Sound, W. T.,*
albumen silver print, 5⁵/₁₆ × 8⁷/₁₆″, New Boudoir Series #B 5253, 1882.
Historical Photography Collection, University of Washington Libraries.

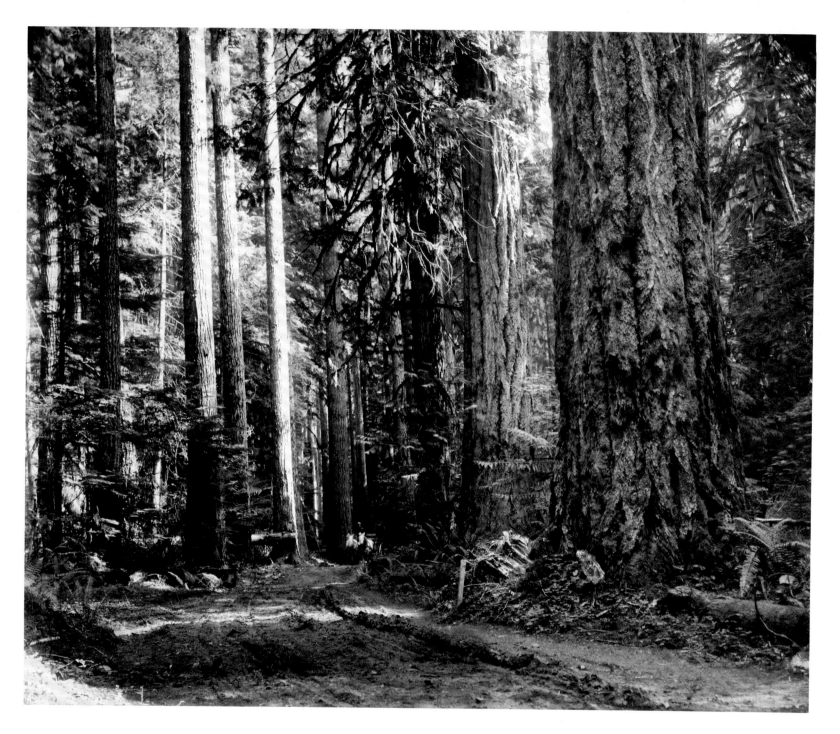

85. [*Rainier Forest Reserve*], albumen silver print, 17¾ × 21½″, 1882.
Bailey/Howe Library, University of Vermont.

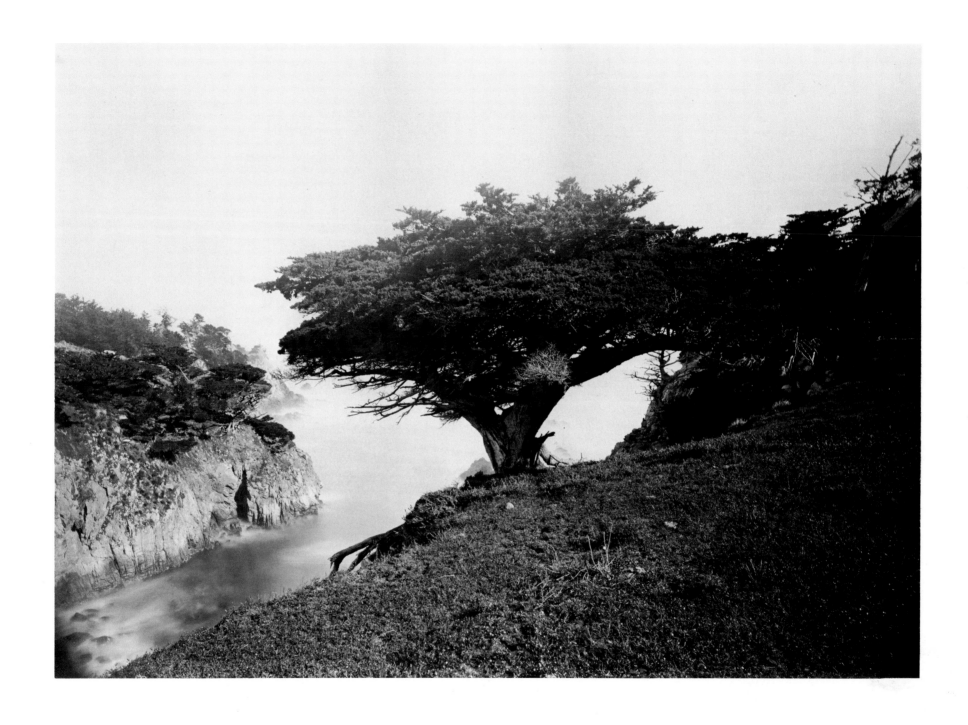

86. [*Cupressus Macrocarpe (Monterey Cypress) Cypress Point: Monterey
California San Francisco April 1885*], albumen silver print, 15 × 21½″, 1885.
Gray Herbarium of Harvard University.

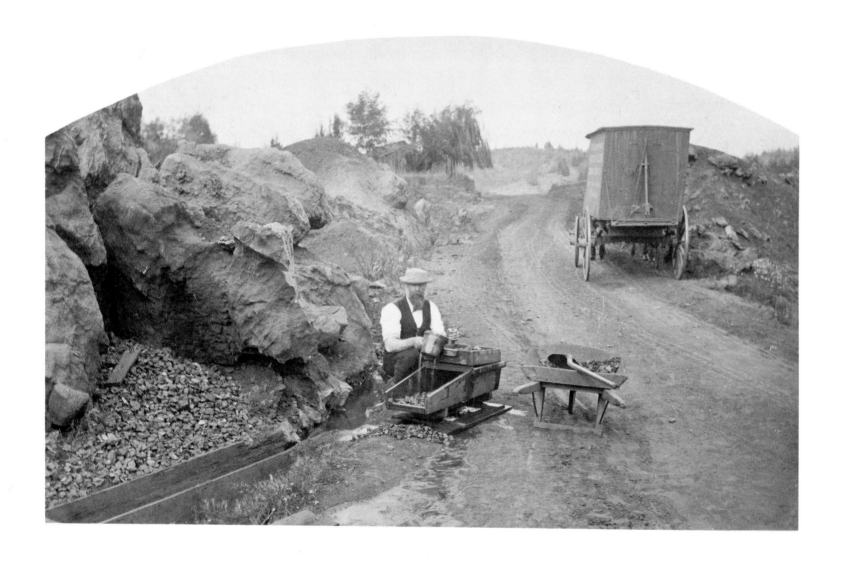

87. *Primitive Mining; The Rocker Calaveras Co., Cal.*, albumen silver print, 4⅜ × 6¹⁵⁄₁₆″, New Boudoir Series #B 3542, c. 1883. California State Library.

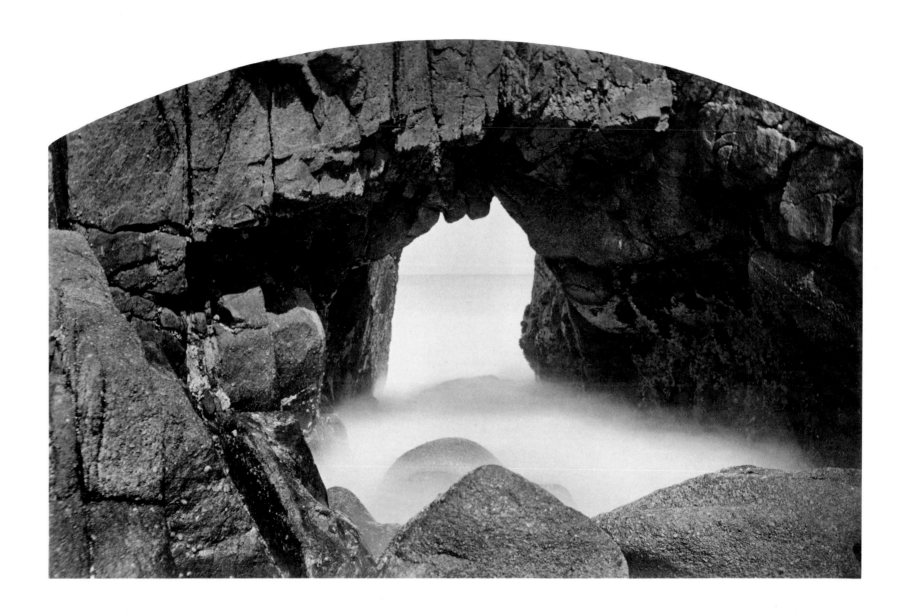

88. *Arch Rock, near Pacific Grove, Monterey* [from *Bentley's Handbook*, 1884], albumen silver print, 5⁵⁄₁₆ × 8⁷⁄₁₆″, New Boudoir Series #B 3864, negative 1881, print 1884. Peter Palmquist.

89. *On the Cliff Road, Santa Cruz, Cal.*, albumen silver print, 3⅛ × 6¼″, New
Series stereo #5030, c. 1883. California State Library.

90. *On the Cliff Road, Santa Cruz Co., Cal.*, albumen silver print, 4⅜ × 6¹⁵⁄₁₆″,
New Boudoir Series #5040, c. 1883. California State Library.

91. *Monterey, California. Pebble Beach, Carmel Bay. 18 Mile Drive,* albumen
silver print, 15⅜ × 21¼″, c. 1880–1885. Private Collection, New York.

92. *Chinese Family, Monterey, California,*
albumen silver print, 7 × 8½″, c. 1883.
California Historical Society, San Francisco; Carleton Watkins Collection.

93. *Oneonta Gorge, Oregon*,
albumen silver print, 8½ × 7″, c. 1883–1885.
California Historical Society, San Francisco;
Carleton Watkins Collection.

94. *Clearing the Track—Winter of 1884–5, Columbia River, Or.*,
albumen silver print, 4¾ × 8″, New Boudoir Series #D 101, 1884–1885.
Oregon Historical Society.

95. *Minerva Terrace, Mammoth Hot Springs, National Park*, albumen silver
print, 15⅝ × 21¼", c. 1884–1885. Oakland Museum History Department.

96. *Cat-Tail and Tules*, albumen silver print, 7 × 8½″, c. 1887.
California Historical Society, San Francisco; Carleton Watkins Collection.

97. *Cotton Ranch Dairy. The Milk Room, Kern Co.*,
albumen silver print, 6½ × 8½″, c. 1888.
Library of Congress.

98. *The Managing Owner, Superintendent, Engineer, Tenant, Clerk, and Cook, Poso Ranch, Kern Co.*, albumen silver print, 6½ × 8½″, c. 1888. Library of Congress.

99. [*Museum (Mineralogy, Ornithology), St. Ignatius College, San Francisco*],
albumen silver print, 6⅞ × 8⅞″, c. 1890. Society of California Pioneers.

100. [*Physical Cabinet (Mechanics, Thermodynamics, Acoustics),*
San Francisco, St. Ignatius College], albumen silver print, 6⅞ × 8⅞″, c. 1890.
Society of California Pioneers.

101. *Golden Gate Mining Claim. Feather River, Butte County, Cal.*,
albumen silver print, 15 × 21⅜″, 1891.
The Bancroft Library, University of California, Berkeley.

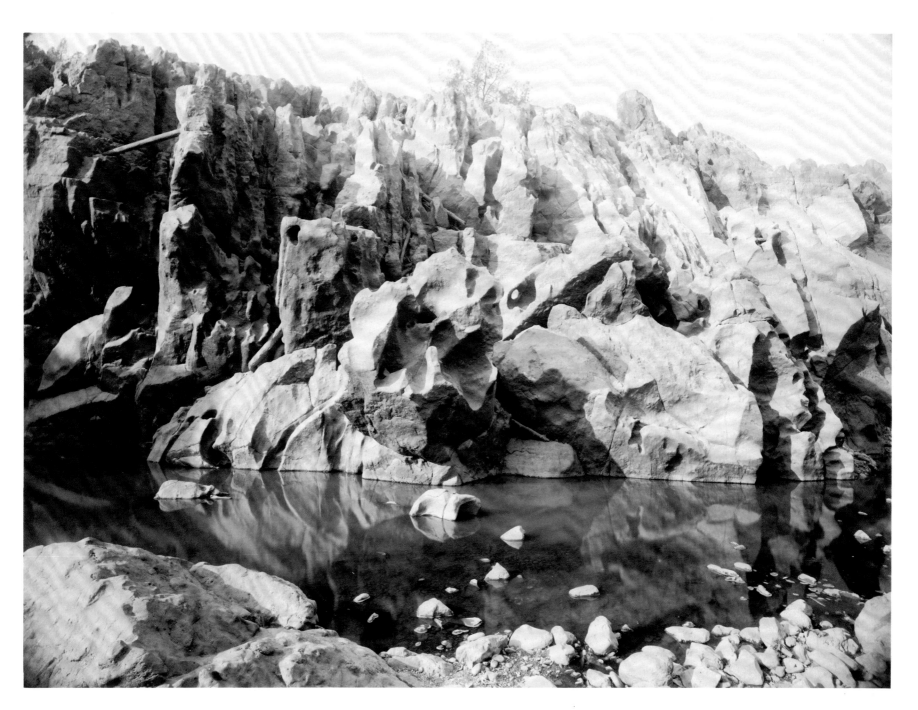

102. *Eroded Rock, Golden Gate Claim,*
albumen silver print, 15½ × 21⅛″, 1891.
The Bancroft Library, University of California, Berkeley.

APPENDICES,
BIBLIOGRAPHY,
AND INDEX

CARLETON E. WATKINS
CHRONOLOGY

1829 Watkins born in Oneonta, New York, November 11th.

1851 Arrives in San Francisco; employed by Collis P. Huntington in Sacramento store.

1852 Huntington's store destroyed by fire; Watkins works as carpenter.

1853 Employed as clerk in George Murray's bookstore in San Francisco.

1854 Works as photographer in the studio of Robert H. Vance, possibly in Marysville, California branch; uses the daguerreotype process.

1856 Works as portrait photographer for James M. Ford in San Jose; uses collodion process to make ambrotypes and wet-plate negatives. May have made earliest outdoor photograph on paper at this time.

1858 Accepts commission to document the Guadalupe quicksilver mine for use as courtroom evidence (U.S. v. Fossat).

Makes early photographs of San Francisco.

1860 Receives commission to photograph John C. Frémont's Mariposa estate.

Makes first stereographs.

Begins ad hoc association with California State Geological Survey.

Shares studio located at 425 Montgomery St., San Francisco with James M. Ford.

1861 Accepts commission to photograph San Antonio Rancho for courtroom evidence (U.S. v. D. & V. Peralta).

Visits Yosemite and uses mammoth-plate camera for the first time.

1862 Oliver Wendell Holmes and Ralph Waldo Emerson request Yosemite stereographs.

Mammoth-plate views of Yosemite on display at Goupil's Gallery, New York.

Mariposa mining photographs exhibited at London Exposition.

1863 Yosemite views praised in *North Pacific Review* and *Atlantic Monthly*.

Photographs New Almaden mines and Mendocino lumber mills.

Uses studio at 649 Clay St., San Francisco, possibly with G. H. Johnson.

1864 Photographs around San Francisco and makes numerous panoramas of the city in both mammoth-plate and stereo formats.

Yosemite views influential in persuading United States Congress to pass legislation to preserve Yosemite Valley.

Watkins loses landscape photography competition to Charles Leander Weed at San Francisco Mechanics' Fair.

Relocates to studio at 415 Montgomery St., San Francisco.

1865 Josiah Dwight Whitney's *Geology I* published with woodcut illustrations based on Watkins's 1861 Yosemite views.

Joins California State Geological Survey in Yosemite.

Yosemite Commissioner Frederick Law Olmsted consults Watkins on preservation and use of Yosemite.

Mt. Watkins, in Yosemite, named in honor of
Watkins.

Opens Yosemite Gallery at 425 Montgomery St., San
Francisco.

1866 Returns to Yosemite with the California State Geo-
logical Survey and begins work on negatives for
J. D. Whitney's proposed *Yosemite Book*.

Edward L. Wilson reviews Watkins's Yosemite pho-
tographs in the *Philadelphia Photographer*.

Yosemite images from 1861 pirated by D. Appleton
& Company in New York.

1867 Copyrights photographs.

Wins bronze medal at Paris International Exposition.

Photographs Oregon and the Columbia River re-
turning by way of Mts. Shasta and Lassen.

William P. Blake shows Watkins's photographs at a
meeting of the California Academy of Sciences.

1868 Through reviews in the foreign press, Watkins gains
an international reputation for his landscape
photography.

Wins award at Mechanics' Fair, San Francisco.

Photographs Lime Point for United States Topo-
graphic Engineers.

J. D. Whitney's *Yosemite Book* issued in 250 copies,
each with twenty-eight vintage prints by Watkins.

1869 Moves Yosemite Gallery to 429 Montgomery St. and
greatly expands inventory of landscape views to in-
clude images of geysers, the Farallon Islands, hy-
draulic mining, and towns adjacent to San Francisco.
Begins production of *Yosemite Gallery* albums.

Obtains A. A. Hart's Central Pacific Railroad
negatives.

Undertakes an ambitious program of stereograph
production.

Begins making views for the *Illustrated San Francisco
News*.

1870 Travels to Mt. Shasta with Clarence King; ascends to
14,400 ft. summit and photographs Whitney Glacier.

Begins to use an enclosed wagon for field work.

Exhibits at the Cleveland Exposition.

1871 Becomes charter member of the San Francisco Art
Association.

Opens lavish Yosemite Art Gallery at 22 and 26
Montgomery St. that includes a portrait-taking facil-
ity. Expands view inventory to include scenes of en-
tire Pacific Coast.

Photographs North Bloomfield gravel mines.

Wins silver medal for photography at Mechanics'
Fair, San Francisco.

1872 Becomes increasingly involved in San Francisco art
circles and photographs the estates of many of San
Francisco's most wealthy families.

Joins Bohemian Club.

Revisits Yosemite.

1873 Publishes the Modoc War negatives of Louis Heller.

Accepts a commission to photograph the Carson and
Tahoe Fluming Company.

Begins making series of views for the *California Hor-
ticulturalist and Floral Magazine*.

Travels with painter William Keith along the Central
Pacific Railroad as far as Utah and, for the first time,
uses a railroad flatcar to carry his photographic
wagon.

Receives Medal of Progress award at the Vienna
Exposition.

1874 Undertakes commission to photograph the Milton
Latham estate at Thurlow Lodge.

Local business depression hampers gallery sales.

1875 Begins extensive series on Nevada's Comstock region.

Returns to Yosemite.

Joins Photographers' Art Society of the Pacific Coast.

1875–76 Continuing economic slump leads to loss of Yosemite Art Gallery and most Old Series negatives to J. J. Cook who becomes owner of the gallery in association with I. W. Taber.

1876 Begins New Series of view negatives.

Continues Comstock series, including panoramas of Virginia City.

Photographs Centennial celebrations.

Exhibits at the Centennial Exposition in Philadelphia and wins major award at the Chilean Exposition.

1876–77 Travels by rail to Southern California where he begins a series of photographs of Mission architecture and documents Tehachapi Loop on the Southern Pacific route.

1878 Spends summer in Yosemite.

1879 Returns to Yosemite.

Opens new gallery at 427 Montgomery Street with William H. Lawrence as a financial partner. Establishes exhibit and sales outlet at Woodward Gardens and at 8 Montgomery Street.

Completes Mt. Lola and Round Top photographs for the United States Geodetic Survey.

Marries Frances Sneed, November 11th.

1880 Takes major trip along the route of the Southern Pacific railroad and makes numerous photographs of Southern California agriculture. Travels as far as Tombstone, Arizona, where he photographs mining and railroad development as well as the Casa Grande ruins. Completes Mission series and records the developing oil industry and harbor facilities in the San Diego region.

1881 Daughter Julia born April 18th.

Completes Yolo Base Line photographs for United States Coast and Geodetic Survey.

Visits Yosemite.

1882 Travels north to Portland, Washington Territory and Victoria, British Columbia where he photographs Port Blakely and the Puget Sound area, as well as Victoria.

1883 Photographs Hotel Del Monte and other resorts in the Monterey district.

Travels to Oregon to photograph the Cascade Locks on the Columbia River.

Exhibits at the Illinois State Fair on behalf of the California Immigration Commission.

Son Collis born October 4th.

1884 *Bentley's Handbook* and Ben Truman's *Illustrated Guide* published with photographic illustrations by Watkins.

Returns to Oregon then travels eastward into Idaho and Montana where he photographs Yellowstone.

Begins to use 8x10 inch dry-plate negatives for field work.

1885 Exhibits at New Orleans Exposition.

Advertises landscape photographs from Mexico to Alaska.

1887 Begins Kern County series of agricultural views.

Completes El Verano (Sonoma County) commission.

Adds salesroom at 26 New Montgomery Street.

1888 Completes Kern County series.

1889 Exhibits Kern County photographs at Mechanics' Fair in San Francisco.

1890 Photographs Montana copper mines using electric light and flashpowder underground.

Health begins to fail.

Photographs St. Ignatius College, San Francisco.

1891 Photographs Golden Gate and Golden Feather mines.

Relocates studio to 425 Montgomery Street.

1892 Suffers from severe arthritis and failing eyesight.

1894 Attempts to photograph Phoebe Hearst's Hacienda del Pozo de Verona, but is unable to complete project after nearly a year on site.

Relocates to 417 Montgomery Street.

1895–96 Unable to pay rent, Watkins lives with his family in a railroad car for eighteen months.

Collis P. Huntington deeds Capay Ranch to Watkins.

Rents photographic rooms at 1249 Market Street.

1897–1900 Almost totally blind, Watkins is assisted in his pho-tographic work by his son Collis and by fellow pho-tographer Charles Turrill.

1903 Seeks photographic commissions directly from Cali-fornia Governor George C. Pardee.

Desperately poor, Watkins accepts financial aid from Turrill.

1904 Exhibits at Lewis and Clark Exposition, but fails to receive financial compensation for his work from the State of California.

1905 Turrill encourages California State Library to pur-chase Watkins's historic photographs.

1906 Loses everything in April 18th earthquake and fire.

1909 Watkins is declared incompetent and placed under the custody of his daughter Julia.

1910 Committed to Napa State Hospital for the Insane.

1916 Watkins dies June 23rd.

Appendix 1

COLLECTIONS OF

WATKINS MATERIALS

Amon Carter Museum, Fort Worth, Texas. Collection of one hundred Watkins photographs, of which fifty-five are stereographs and the rest mammoth or smaller landscape views. Includes the album *California Views 1876*. California scenes predominate.

Andrew Johnson Historic Site, United States Department of the Interior, Greenville, Tennessee. Four mammoth Yosemite views, reportedly presented to Andrew Johnson by Watkins.

Arizona Historical Society, Tucson, Arizona. Approximately seventy-five Watkins stereographs of Arizona.

Bancroft Library, University of California, Berkeley. This collection is probably the finest and most comprehensive gathering of Watkins's photographs and related manuscript collections. The following description has been provided by the library staff (William Roberts, personal communication, 13 May 1982): "The Bancroft Library's holdings of Watkins photographs amount to nearly 1,000 items, with some 750 prints of various sizes and 250 stereographs. The largest single collection is the Hearst Collection, a gift to the University in 1909 by Phoebe Apperson Hearst, which consists of 138 mammoth-plate views of Comstock Lode mining in Nevada, North Bloomfield hydraulic mining in Nevada County, and of mining claims along the Feather River above Oroville—the Golden Gate and Golden Feather claims.

"There are several smaller sets of mammoth plates including the Mendocino coast photographs of 1863 (fifty-three prints) as well as some of the earliest views of logging mills in the area. The forty mammoth prints in the Arizona series were taken in 1880, mainly along the railroad line, and show mining companies, long-forgotten towns, and some fascinating studies of desert vegetation. Two other sets contain a total of seventy mammoth plates, many of Yosemite, but also including many other locales from the famous Columbia River views to those of the Southern

California missions. The seventeen mammoth plates which form the Mt. Lola—Lake Independence set, formerly in the possession of George Davidson of the U.S. Coast and Geodetic Survey, provide an unusual glimpse of Watkins's interest in mountain photography. A panorama of San Francisco from Nob Hill, probably from 1872, in four mammoth plates, is also of considerable interest. Another valuable set is the thirteen large-format salt prints prepared by Watkins for presentation in the U.S. District Court in 1861 in the case of the Rancho San Antonio, one of the Mexican Land Grants. Watkins's set of thirty-two prints of John C. Frémont's Mariposa Estate provides documentation of mining and towns in the area.

"Important Watkins albums include: *Sun Sketches of San Mateo*, mainly the residence and estate of John Parrott (twenty-five prints); the *Franciscan Missions of California* (thirty-five prints); and an unusual commercial endeavor, *Photographic Views of El Verano and Vicinity, Sonoma County, California*, which consists of 133 photographs taken about 1887 for the Sonoma Valley Improvement Company.

"The library has a number of photographic copies of maps by Watkins, many in mammoth size. In addition, the library owns nearly one hundred Watkins's *New Boudoir Series* views of various topics. The stereographs cover an equally wide range of subjects. There are interesting panoramas of San Francisco from Nob Hill, Telegraph Hill, and Russian Hill. Nevada is well represented with at least twenty-two stereo views of Virginia City, Nevada, in 1876 which both complement and supplement the Hearst Collection previously mentioned. Another useful source of Watkins's imagery is found in the Wyland Stanley Collection, a large set of *copy* photographs of outstanding views of nineteenth-century San Francisco; many not available elsewhere.

"Bancroft also owns some of Watkins's manuscripts: a set of letters, mainly to his wife, describing his experiences while photographing in Arizona, Oregon, and Montana between 1880 and 1890; a notebook recording picture-taking and financial transactions from 1864; some letters to George Davidson in 1878–1879 and to Governor George C. Pardee in 1903–1906. While these collections are not large they are uniquely valuable to the study of Watkins's life and activities. The library also has collections of notes on Watkins's life and work, assembled by Joe Johnson and by Eugene Compton. Finally, the Bancroft has the single best collection of pictures showing Watkins and his family at various points in their life."

Beale Memorial Library, Bakersfield, California. Literature illustrated by Watkins relating to Kern County agriculture; two Kern County albums by Watkins.

Boston Public Library, Boston, Massachusetts. Print Department. Collection of thirty-eight mammoth Yosemite photographs.

Buffalo and Erie County Public Library, Buffalo, New York. Album, *Views of the Yosemite Valley*, with twenty-nine mammoth photographs.

California Historical Society Library, San Francisco, California. A significant Watkins collection, consisting of nearly 1,000 original images: 117 mammoth size; 234 smaller landscape and outdoor images; 404 stereographs; 223 prints in albums and books; ten portraits by Watkins's Yosemite Art Gallery; as well as twelve mammoth prints published by Taber, but attributable to Watkins. Items of note include: forty-six Mariposa salt prints (1860); nine early glass stereographs (c. 1860); two copies of the Bank of California photographic composite (1874); a five-panel, mammoth panorama of San Francisco (1864); also a fine selection of portraits from Watkins's Yosemite Art Gallery, taken c. 1871–75. Albums include: *Views of Thurlow Lodge, Yo-Semite Valley Photographic Views* . . . with fifty prints and a photographically reproduced title page, *Pacific Coast Views*, a unique album of western imagery assembled c. 1890. Also a copy of J. D. Whitney's *The Yosemite Book* (1868).

California State Library, Sacramento, California. A significant Watkins collection of nearly 2,000 original photographs: 194 mammoth size, approximately 1,500 stereographs, 170 images in albums and books, and more than fifty boudoir and cabinet photographs. Important items include: five albums, of which *Photographic Views of One Hundred and Twelve of the Principal and Most Picturesque Places of California* (1886) is especially significant; a boudoir view of Watkins as a miner; and the periodical *The California Horticulturist and Floral Magazine*, which contains tipped-in Watkins photographs. Also a copy of J. D. Whitney's *The Yosemite Book* (1868). The California State Library's collection of Watkins stereographs is the most comprehensive of its kind.

Centre Canadien d'Architecture/Canadian Centre for Architecture, Montréal. This collection has been recently assembled and features a fine selection of quality Watkins photographs. The finest acquisition is the two-volume *Thurlow Lodge* album of sixty-three mammoth images (1874).

Crocker Art Gallery, Sacramento, California. Approximately twenty-four mammoth photographs, primarily Yosemite and mining. Some images not seen elsewhere.

Gilman Paper Company, New York City. A representative collection of approximately twenty-five images, mainly California and Oregon scenery.

Gray Herbarium Library, Harvard University, Cambridge, Massachusetts. Approximately twenty-five mammoth images of botanical interest. Watkins made many of these photographs with Professor Asa Gray and his scientific colleagues in mind.

Huntington Library, San Marino, California. A superb collection of Watkins materials. There are 315 mammoth photographs, mostly in albums. The most important are: *Yo-Semite Valley Photographic Views of the Falls and Valley of Yo-Semite in Mariposa County* . . . (1863) with the Fulgencio Seraqui title page; and the Appleton forgery, *Album of the Yo-Semite Valley, California* . . . (c. 1865). Also significant are the five albums made for Collis P. Huntington: *The Central Pacific and Views Adjacent, Summits of the Sierra, Arizona and Views Adjacent to the Southern Pacific R.R., Photographic Views of Kern County*, and a large album containing 605 cabinet photographs of railroad and Southern California subjects. The collection also contains 222 stereos, nine cabinet portraits, and fifty-five views from the *New Boudoir* series. In addition there are 371 I. W. Taber views, most of which may have been made from Watkins negatives. Also interesting are six nine-by-thirteen-inch cyanotypes of

Professor Davidson's Yolo Base Line Survey of 1881. The Huntington has a copy of Edward Vischer's *Pictorial of California* (1870), with fourteen views of the 1864 Mechanics' Industrial Fair.

International Museum of Photography, George Eastman House, Rochester, New York. Collection includes twenty images from the King Survey, and twenty-four mammoth views of western scenery. Also some stereo and boudoir photographs, as well as the album *Clearing the Track of the O.R. & N.R.R. . . .* (1884/85).

Library of Congress, Washington, D.C. Collection of the Prints and Photographs Division includes twenty-one mammoth prints of Yosemite and a fine selection of 415 six-by-eight-inch views of Kern County, California (1887–89). The Collis P. Huntington, S. F. Emmons, and Frederick Law Olmsted papers are found in the Manuscript Division.

Metropolitan Museum of Art, New York City. Prints and Photographs Department. A small but representative selection of Watkins's photographs, including the album titled "Presented to Ambroise Bernard by his brother Charles, his sister Clarisse, and his nieces Clarisse and Helena H., 1877."

Montana Historical Society, Helena, Montana. The society has a number of unidentified mammoth views of copper mining at Butte and Anaconda in Montana, which may have been taken by Watkins.

The National Archives and Records Services, Washington, D.C. This collection has the earliest known Watkins photograph—a view of the Guadalupe quicksilver mine, taken in 1858. The Bellinger collection contains twenty-four mammoth prints: Yosemite, geysers, Mt. Shasta, Hotel Del Monte (Monterey), and a view of a horde of people on the beach near the Cliff House, San Francisco. In addition, there are four mammoth images of Lime Point (San Francisco) taken by Watkins for the United States Topographical Engineers on 27 July 1868. Likewise a number of Modoc War stereographs photographed by Louis Heller and published by Watkins. Manuscripts include the King Survey papers and records of the Office of Topographic Engineers relative to geological surveys.

Nevada State Museum, Carson City, Nevada. The museum holds a small but important group of Watkins's mammoth images of the Glenbrook-Lake Tahoe area (c. 1873).

The Newberry Library, Chicago, Illinois. Collection includes *Vischer's Pictorial* (1870) and a copy of Whitney's *Yosemite Book* (1868).

New York Public Library, New York City. Collection includes forty-five mammoth photographs of Yosemite, some with I. W. Taber's imprint. The Library also has thirty Yosemite mammoths by C. L. Weed taken in 1864. Whitney's *Yosemite Book* and *Bentley's Handbook* (1884) are located here as well.

Oakland Museum, Oakland, California. The Art Department has an outstanding album of cabinet views of Lake Tahoe and Yosemite, a total of 101 images. Also a fine mammoth album published by Taber, presumably including images from Watkins negatives. The History Department has a mixed collection of mammoth views, including thirteen from Yellowstone and a collection once owned by landscape painter Thomas Hill. A large number of Watkins stereographs are also available.

Oregon Historical Society, Portland, Oregon. The society has a comprehensive collection of Watkins's photographs from 1867 through the winter of 1884/85. There are 72 mammoth prints, 254 stereographs, 26 boudoir prints, and two albums—*Sun Sketches of Columbia River Scenery* and *The Great Storm of the Winter of 1884–5, Columbia River, Oregon*. A Watkins checklist is available.

Oregon State Library, Salem, Oregon. An album, *Photographs of the Columbia River and Oregon . . . ,* containing thirty-five mammoth views, 1867.

Park-McCullough House, North Bennington, Vermont. The Trenor Park collection of early Watkins images includes forty-eight of Mariposa (1860) and twenty-three of Yosemite (1861). Park was largely responsible for commissioning the Mariposa images and may also have helped Watkins in Yosemite. The Trenor Park manuscript collection is located here as well.

Pioneer Museum, Bakersfield, California. Useful collection of materials relative to Kern County; also a Kern County album.

Provincial Archives, Victoria, British Columbia. The home of a magnificent (and heavy) mammoth-plate album of ninety-eight Watkins views.

San Francisco Museum of Modern Art, San Francisco, California. A small collection, including an excellent example of the "Yosemite Gallery" album, with fifty-one images.

Society of California Pioneers, San Francisco, California. Collection

includes the Charles B. Turrill assemblage of pioneer photographs. Biographic file contains only examples of Watkins's rare stereograph listings known to be published. There are an estimated 600 Watkins images in this collection, many of San Francisco and environs. Also a nearly complete series of A. A. Hart stereo prints, as published by Watkins. The collection also has glass negatives attributed to Watkins, primarily copies of paintings. Finally there is useful information in the letters of Thomas Starr King and Ralph Waldo Emerson.

Stanford University Library, Palo Alto, California. Collection has three superb albums: *Photographs of the Columbia River and Oregon . . .*, *Photographs of the Pacific Coast . . .*, and *Photographs of the Yosemite Valley. . . .* All three albums belonged to the Latham estate, as did the two Thurlow Lodge albums now held by the Canadian Centre for Architecture. During the 1870s, when all five of these albums were together in the Latham Library, they probably formed the finest assembly of Watkins's work in one location.

Syracuse University Library, Syracuse, New York. Album of sixty-five Yosemite views.

University of Arizona, Tucson, Arizona. Center for Creative Photography. Album of fifty Yosemite views, plus three additional images and 145 stereographs by Watkins.

University of California Library, Los Angeles, California. This collection has a fine selection of Yosemite photographs, including thirty-three mammoth views given to the Library by Martin R. Huberty. Another fine series of thirty-six mammoth views shows the California missions, c. 1876–80. Also a copy of *Bentley's Handbook* (1884) and an example of J. D. Whitney's *The Yosemite Book* (1868), which is on loan for an extended period.

University of Nevada, Reno, Nevada. Special Collections Library. A small collection of Watkins's photographs, mainly of Nevada mining.

University of the Pacific, Stockton, California. Pacific Center. An interesting and varied collection of Watkins's boudoir cards and stereographs. They also have the manuscripts and papers of naturalist John Muir.

University of San Francisco, San Francisco, California. Two "St. Ignatius" albums of fifty prints each.

University of Texas, Austin, Texas. Photography Collection, Humanities Research Center. A small collection of boudoir cards and one album, *American Scenery*, with twenty-five mammoth views.

University of Vermont, Burlington, Vermont. An interesting collection of twenty-eight mammoth photographs, primarily of botanical interest. Several views not seen elsewhere.

University of Washington Library, Seattle, Washington. A representative collection of Watkins's views of the Puget Sound and Vancouver areas; mainly boudoir cards. One shows Watkins's tent pitched alongside the railroad. Also, a *Bentley's Handbook*.

University of Wisconsin Library, Milwaukee, Wisconsin. An excellent collection of about eighty mammoth prints of Yosemite, Oregon, geysers, mining, and other subjects. These views came to the Library from the American Geographical Society.

United States Geological Survey Library, Denver, Colorado. The most comprehensive collection of Watkins's photographs from Clarence King's survey of the Mt. Shasta and Mt. Lassen areas in 1870.

Wells Fargo Bank History Room, San Francisco, California. A small collection, mainly stereographs.

Yale University, New Haven, Connecticut. Beinecke Library. A representative collection of Yosemite and Mt. Shasta mammoth photographs, also a fine selection of King Survey views on 40th Parallel mounts. There are thirty-five glass stereographs c. 1860–61, mainly of Mariposa and San Francisco, as well as additional stereo examples on paper. A copy of Whitney's *Yosemite Book* (1868) is found here. The manuscript collection contains useful Watkins references in the William H. Brewer, W. D. Whitney, and Brush Family Papers.

Yosemite National Park Library, Yosemite, California. This excellent collection has numerous Watkins items. In addition to a strong, Yosemite-related selection of mammoth and stereo photographs, the library has a useful manuscript collection, including typescripts of interviews with Julia Watkins. The Baird Collection of glass stereographs (taken by Watkins in 1861) are here, as is the special album that Watkins gave his fiancée, Frances, on Christmas, 1878. The collection also includes a surviving Watkins mammoth-plate negative.

Appendix 2

ALBUMS AND FOLIOS
OF WATKINS PHOTOGRAPHS

The following compilation of Watkins's surviving albums spans the period from 1863 to 1890. The albums vary generally in terms of their image makeup, titles, use of captions, and binding. They feature a wide range of image formats from mammoth to as small as a single stereo photograph. Many of the albums listed have become disbound at some point in their history. The listing has been arranged loosely by subject content, and albums with similar characteristics have been grouped together. There are sixty-five albums in this list; others doubtless exist.

CALIFORNIA MISSIONS

Franciscan Missions of California, photographed by Watkins, San Francisco. Thirty-three photographs about eight by twelve inches, from negatives taken c. 1876–82. Bancroft Library, Berkeley.

Missions of California, presently disbound in folio. Original album consisted of thirty-six mammoth images of California missions, c. 1876–82, and were titled and numbered as *Watkins' New Series.* Special Collections, Library, University of California, Los Angeles.

CENTRAL PACIFIC RAILROAD

Central Pacific Railroad and Views Adjacent, C. E. Watkins, photo., San Francisco, Cal. Forty-eight photographs, about fourteen by seventeen inches. Album specially prepared for C. P. Huntington, c. 1880. Huntington Library, San Marino, California.

COPIES OF PAINTINGS

Folio inscribed "To Mr. Josiah Hasbrooke with regards of the artist." A total of twelve mammoth photographic copies of paintings and drawings by Virgil Williams, San Francisco, c. 1871. Library, California Historical Society, San Francisco.

KERN COUNTY

Kern County. Collection of 420 images represents three albums now disbound. Each image is about 2¾ x 8⅝ inches. They are titled and numbered as *Watkins' New Series,* c. 1887–89. Library of Congress, Washington, D.C.

Kern County, California, C. E. Watkins, photo., San Francisco, Cal. Contains thirty-nine photographs, about fourteen by seventeen inches. Album probably made for C. P. Huntington in the 1880s. Huntington Library, San Marino, California.

Photographic Views of Kern County, Cal., photographed by Watkins, 427 Montgomery Street, San Francisco. Many examples of this title are known, all with images about 6¾ x 8⅝ inches, of Kern County agriculture, c. 1887–89. (A) Sixty-three photographs, and (B) 140 photographs, presently disbound because the album was stolen and the cover discarded, both in the Beale Memorial Library, Bakersfield, California; (C) 116 photographs, Pioneer Museum, Bakersfield, California. Finally, at least five albums are known to be in a private collection, but not examined by me. These albums vary in image makeup to a large extent, and it is thought that Watkins may have made as many as 1,000 negatives of Kern County. Many of the albums have extensive captions.

MENDOCINO COAST

Mendocino Coast, presently disbound and in folio. Contains fifty-three mammoth photographs, from negatives made in the fall of 1863. These images were originally in two albums, a gift of Mrs. Lewis Pierce in memory of her grandfather Jerome B. Ford, who is thought to have commissioned Watkins to make these photographs. Bancroft Library, Berkeley.

MULTIPLE SUBJECTS

Album. Contains three views of Yosemite, about eight by twelve inches, and 101 cabinet views of Yosemite and Lake Tahoe. The album and views are of exceptional quality and condition, from negatives taken c. 1878. Art Department, Oakland Museum.

American Scenery. Has twenty-five mammoth photographs of Yosemite, Oregon, Mt. Shasta, etc. Humanities Research Center, University of Texas, Austin.

"Amy White from her Brother Howard, Christmas, 1871." Made-up scrapbook of Watkins's stereo halves. Many are panoramic views of San Francisco and environs. This album also contains a view of Watkins's traveling wagon and mammoth camera at Mt. Shasta, in 1870. Library, Stanford University, Palo Alto.

California Tourists Association, San Francisco. Approximately seventy photographs, about seven by nine inches, subjects from Oregon, California, and Arizona. Bound in the 1880s. Private ownership.

California Views 1876. Contains fifty-three views, about eight by twelve inches. Photographs of Yosemite, Mt. Shasta, Mt. Lassen, and San Francisco. Amon Carter Museum, Fort Worth, Texas.

New Almaden Quicksilver Mine and Mendocino Coast. Twenty mammoth photographs—eight New Almaden and twelve Mendocino, negatives taken in 1863. Huntington Library, San Marino, California.

Pacific Coast Views. Album contains eighty-three images, but missing pages suggest that there may have been 102 images. Subjects include Oregon, California, and Utah. Each photograph is about seven by nine inches, from eight-by-ten-inch dry-plate negatives. Probably assembled about 1890, and includes a few images by

W. H. Jackson in addition to those by Watkins. Library, California Historical Society, San Francisco.

Photographs of the Pacific Coast by C. E. Watkins, nos. 22 and 26 Montgomery Street, San Francisco. Two albums known: (A) Fifty-two mammoth photographs of San Francisco, mining, coastal views, and seven images of the Thurlow Lodge library. The negatives date from 1864–74, Library, Stanford University; (B) Forty-nine images. This album was part of the San Francisco Mercantile Library, sold at auction in 1979 for $98,000. The album was subsequently disbound, placed on display, and individual prints sold by the Fraenkel Gallery, San Francisco.

Photographic Views of One Hundred and Twelve of the Principle and Most Picturesque Places of California. Has 112 photographs in three volumes. Contains a wide variety of subjects, from negatives dating from 1858 to the 1870s. Each print about 8 x 12⅜ inches. California State Library, Sacramento.

"Presented to Ambroise Bernard by his brother Charles, his sister Clarisse, and his nieces Clarisse and Helena H., 1877." Presentation album with 101 images, some approximately eight by twelve inches, and the remainder about ten by thirteen inches. Subjects include San Francisco, southern California, geysers, Nevada, Oregon, and Yosemite. Album contains many views not previously seen, such as the Sutro Tunnel area of Nevada. Prints and Photographs Department, Metropolitan Museum of Art, New York City.

Souvenir of the Pacific Coast, San Francisco, California, 1883. Inscribed to "Doctor Paolo de Vecchi," doctor-surgeon, St. Joseph's Hospital, San Francisco. Contains nearly sixty photographs by Watkins of Yosemite, San Francisco, North Bloomfield mines, and Oregon. Remainder of album has thirty-two images of Yosemite by Fiske and thirty-two views of Arizona and New Mexico Indians by E. A. Bonine. See also Robert Koch, *19th and 20th Century Photographs*, 1981–82 catalogue, Berkeley.

Souvenirs d'une tournée à travers la Californie et l'Oregon, 1871. This incredible album holds a total of ninety-eight mammoth prints. It was apparently bound by the London firm of "Jenner & Knewstub, to the Queen Makers, 33 St. James's St. & 66 Jermyn St." Presumably the album was prepared in connection with an official visitation of some kind, possibly by a French Canadian gov-

ernment figure. Provincial Archives, Victoria, British Columbia.

Watkins's New Series. Approximately forty-five photographs, mainly San Francisco, Monterey, and environs, with some Yosemite and Mt. Shasta as well. Private ownership.

Yosemite, California & Oregon. Two mammoth photograph albums: Vol. 1 has nineteen views of Yosemite; Vol. 2 has fifteen views of San Francisco, Mendocino, geysers, Oregon, etc. California State Library, Sacramento.

OREGON

Clearing the Track of the O.R. & N.R.R., from Rooster Rock to Oneonta Falls. Great Storm of the Winter of 1884–5, Columbia River, Ore. Thirty photographs about nine by seven inches, showing snow removal from the railroad tracks and snow-bound scenery. International Museum of Photography, Rochester, New York.

Great Storm of the Winter of 1884–85. Thirty-one views of Oregon in the snow, each about nine by seven inches, from dry-plate negatives taken in 1884–85. Library, Oregon Historical Society, Portland.

Photographs of the Columbia River and Oregon by C. E. Watkins, nos. 22 and 26 Montgomery Street, San Francisco. There are a total of three albums which bear this title, and all contain mammoth images taken in 1867. (A) Fifty-one photographs, Library, Stanford University. (B) Album nearly identical to Stanford example. Originally owned by San Francisco Mercantile Library, this album was sold at auction in 1979 for $100,000. Subsequently disbound, the individual images were displayed and sold at the Lowinsky Gallery, San Francisco. The views from this album were also used to prepare the book *Carleton E. Watkins: Photographs of the Columbia River and Oregon*, published by the Friends of Photography and Weston Gallery, in 1979. (C) Similar to previous albums but with only thirty-five images. It was presented by the Oregon Steam Navigation Company to Jay Cooke. Oregon State Library, Salem.

Sun Sketches of Columbia River Scenery, New Series, 427 Montgomery Street, San Francisco. Forty-five photographs of Oregon, 8¼ x 12 inches in size, presumably assembled in the 1880s. Library, Oregon Historical Society, Portland.

PARROTT ESTATE

Sun Sketches of San Mateo, by Watkins. Twenty photographs, approximately eight by twelve inches, showing the John Parrott estate in San Mateo in the late 1870s. Private ownership.

ST. IGNATIUS

Views of the Church and College of St. Ignatius of the Society of Jesus, Cor., of Van Ness Ave., and Hayes St., San Francisco, California. Albums of fifty-nine photographs, each about nine by seven inches, from dry-plate negatives, c. 1890. Views show the facilities and classrooms of the school. It is thought that three examples of this work exist; however, only two have been confirmed. Both copies, Library, University of San Francisco.

SONOMA AGRICULTURE

Photographic Views of El Verano and Vicinity, Sonoma Valley, California, Photographed by Watkins, 427 Montgomery Street, and under the Palace Hotel, San Francisco. Has 133 views, 7½ x 9½ inches, from dry-plate negatives. This album was prepared for the Sonoma Valley Improvement Company, about 1887. Bancroft Library, Berkeley.

SOUTHERN PACIFIC RAILROAD

Arizona and Views Adjacent to the Southern Pacific Railroad, C. E. Watkins, photo., San Francisco, Cal. Forty-six photographs, about fourteen by seventeen inches. Album probably prepared for C. P. Huntington, c. 1882. Huntington Library, San Marino, California.

SUMMITS OF THE SIERRA

Summits of the Sierra, C. E. Watkins, photo., San Francisco, Cal. Forty-one photographs, about fourteen by seventeen inches. Album probably made for C. P. Huntington, features railroad views. Huntington Library, San Marino, California.

THURLOW LODGE

Views of Thurlow Lodge, Volume I [and] *Volume II, Mollie Latham, Photographs by Watkins.* Two albums with a total of sixty-three mammoth photographs of Thurlow Lodge, exterior and interior, 1874, Canadian Centre for Architecture, Montreal. At least two smaller albums exist. These contain images cut down to about fourteen by seventeen inches from the mammoth format: (A) *Views of Thurlow Lodge,* inscribed to "John J. Thurlow, from Mollie Latham, Christmas 1874," a total of fifty-seven images, California Historical Society, San Francisco; (B) Thought to be similar to preceding example, but not examined by me, private ownership.

YOSEMITE

Album of the Yo-Semite Valley, California, D. Appleton & Company, 443 & 445 Broadway, New York. Forgery of Watkins's 1863 Yosemite album, negatives taken in 1861. Consists of thirty dome-topped images reduced from mammoth to 6½ x 8½ inches. This piracy occurred in about 1865–66. Huntington Library, San Marino, California.

Photographs of the Yosemite Valley by C. E. Watkins, nos. 22 and 26 Montgomery Street, San Francisco. Fifty-three mammoth views. Library, Stanford University, Palo Alto.

Views of the Yosemite Valley. Twenty-nine mammoth photographs of Yosemite. Buffalo and Erie County Public Library, Buffalo, New York.

Watkins's New Series Yosemite Valley, 1878. A standard cabinet album with thirty-eight cabinet photographs of Yosemite, 1878. A Christmas, 1878, gift to Watkins's fiancée. Library, Yosemite National Park.

Yosemite. Gift album similar to the one Watkins made for Frankie. Contains a total of thirty-seven of a possible fifty-two cabinet images of Yosemite, 1878. Bancroft Library, Berkeley.

Yosemite. Album of thirteen images, each about twelve by eight inches. See Swann Galleries, *Photographica,* auction catalogue, sale 1218, April 23, 1981, item 384.

Yosemite, New Series. Album presently disbound, in folio. A total of forty mammoth photographs of Yosemite, c. 1878–81. Important collection of later images in superb condition. Private ownership.

Yosemite Valley. Album of twenty-eight mammoth views, presented to the Bancroft Library by Mr. & Mrs. Francis B. Farquhar. Presently disbound in folio. Includes photographically copied map of the valley. Bancroft Library, Berkeley. It should be noted that the Bancroft also holds numerous Yosemite photographs which have been part of other albums.

Yosemite Valley and Mariposa Grove, Photographs by C. E. Watkins. Twenty-one mammoth photographs. Library, Gray Herbarium, Harvard University, Cambridge, Massachusetts.

Yo-Semite Valley; Photographic Views of the Falls and Valley of Yo-Semite in Mariposa County, California; Executed by C. E. Watkins, San Francisco, California, 1863. Contains thirty mammoth photographs of Yosemite and Mariposa Big Trees, taken by Watkins in 1861. The title page was designed and drawn by the San Francisco writing master Fulgencio Seraqui, in 1863; it was this album which was pirated by Appleton and Company. One of the more important examples of Watkins's photography surviving today. Huntington Library, San Marino, California.

Yo-Semite Valley: Photographic Views of the Falls and Valley of Yo-Semite in Mariposa County, California; Executed by C. E. Watkins, San Francisco, California, 1863. See previous entry. The following examples are distinguished by *not* having images from the 1861 Yosemite negatives, and by having a photographically copied title page from the foregoing album: (A) Thirty-eight mammoth photographs, c. 1865–66; presently disbound, in folio, Boston Public Library; (B) Fifty-one images, about 7⅝ x 11⅝ inches, from negatives c. 1865–66, Library, California Historical Society, San Francisco; (C) Similar to previous album, but with sixty-five prints, Library, Syracuse University, Syracuse, New York; (D) As before, with fifty-one prints, Museum of Modern Art, San Francisco; (E) Fifty prints, Center for Creative Photography, University of Arizona, Tucson. As far as is known, these albums were assembled about 1869.

Appendix 3

BOOKS AND PERIODICALS
ILLUSTRATED WITH
WATKINS PHOTOGRAPHS

The following listing contains only those works produced in Watkins's lifetime. Examples include tipped-in vintage photographs, woodcut engravings after Watkins's images, and images reproduced by various photomechanical means. At best this listing should be regarded as a sampling of such works, rather than a comprehensive compilation.

Bentley, William R. *Bentley's Handbook of the Pacific Coast; Containing a Complete List of the Prominent Seaside and Mountain Resorts . . . and other Places of Interest on the Pacific Coast.* Oakland: Pacific Press, 1884. This work contains numerous woodcut engravings after Watkins's photographs of southern California. It is of exceptional importance to Watkins's works in that an unknown number of these rare books have nine original tipped-in photographs (UCLA); others have thirty-one vintage prints (New York Public Library).

[Cape Horn]. *Illustrated Press* (January 1873). Engraving after Watkins's image, c. 1870. This particular journal is known to have used additional examples of Watkins's photographs as illustrations, including some after stereographs taken by A. A. Hart but published by Watkins.

Denison, E. S. *Pacific Coast Souvenir.* Oakland: privately published, 1888. Contains a wide selection of Watkins's images, reproduced by photomechanical means; an unusual work.

————. *Yosemite and the Big Trees of California.* San Francisco: privately published, 1881. Many reproductions based on Watkins's images; others by George Fiske.

Greene, Charles S. "Phil Sheridan's First Fight." *Overland Monthly* 14, no. 82 (October 1889): 337–352. Illustrated with Watkins's views of Oregon.

[Hutchings' Hotel]. *Yosemite Almanac.* San Francisco: J. M. Hutchings, 1867. Woodcut after Watkins photograph.

"Kern County Canals." (Bakersfield) *Californian,* 9 April 1892. Comprehensive, descriptive look at Kern County irrigation and farming, illustrated by Watkins. A special edition of this newspaper, date unknown, called the "Homeseekers' and Development Number," also utilized Watkins's Kern County photography. An example of these papers may be seen in the clipping file, Beale Memorial Library, Bakersfield.

"Kern County Land Company." *The Traveler* (January 1893). A promotional feature, illustrated by Watkins. This periodical may be seen in the clipping file, Beale Memorial Library, Bakersfield.

[Modoc War]. *Frank Leslie's Illustrated Newspaper,* 12 July 1873. One-page feature of Modoc captives, photographed by Louis Heller and published by Watkins.

[Modoc War]. *Harper's Weekly,* 14 June 1873. An important, two-page feature of woodcut engravings based on Louis Heller's photographs, as published by Watkins.

[Mt. Shasta]. *Crofutt's Western World* (November 1873). Woodcut of the mountain from Watkins's photograph; probably taken in 1870.

Palache, Charles. "The Forest Trees of the Sierra Nevada." *Overland Monthly* 21, no. 131 (April 1893): 337–347. Includes several views taken by Watkins, but credited to I. W. Taber.

[Rural Homes]. *The California Horticulturist and Floral Magazine* (1873–80). Beginning with the February 1873 issue, this journal announced a series of descriptive articles on "the rural homes of California . . . each paper will be accompanied by a full-page photographic view [tipped in] in Watkins' best style." These images were primarily of the country estates of the well-to-do, such

as R. B. Woodward's Oak Knoll, at Napa, and Thomas H. Selby's Fair Oaks, in San Mateo County.

Scott, Irving M. "Hydraulic Mining Illustrated—II." *Overland Monthly* 13, no. 73 (January 1889): 1–12. Illustrated with Watkins's photographs from North Bloomfield and elsewhere in Nevada County, c. 1871.

Shinn, Charles Howard. "Artesian Belt of the Upper San Joaquin." *Overland Monthly* 12, no. 68 (August 1888): 113–128. Features Watkins's Kern County photographs.

————. "The California Lakes." *Overland Monthly* 18, no. 103 (July 1891): 1–19. Includes photographic views by Watkins of Lake Tahoe and mountain scenes at Mt. Lola and Round Top, c. 1879.

Stocking, Fred M. "Up the Columbia in 1857." *Overland Monthly* (February 1894): 186–194. Illustrated with Watkins's Oregon images, one or two from 1867 and the rest from 1883.

Suess, Werner. *Photographs of the Yolo Base Line, California, 1881.* Folio of ten photographs, with title page, from negatives taken by Watkins but printed (published?) by Suess. An example may be seen at the Bancroft Library, Berkeley.

Taber, Isaiah West. *The "Monarch" Souvenir of Sunset City and Sunset Scenes; Being Views of California Midwinter Fair and Famous Scenes of the Golden State . . .* San Francisco: H. S. Crocker, 1894. Includes many images printed from Watkins's negatives.

Truman, Ben C. *Homes and Happiness in California.* San Francisco: H. S. Crocker, 1883. Contains woodcut engravings after Watkins's photographs, particularly views of Monterey and vicinity.

————. *Tourists' Illustrated Guide to the Celebrated Summer and Winter Resorts of California Adjacent to and upon the Lines of the Central and Southern Pacific Railroad.* San Francisco: H. S. Crocker, 1883. An important source of Watkins's images from the resort areas of California, all rendered as woodcut engravings. Includes an illustration of Watkins with his darktent and mammoth camera.

Victor, Frances Fuller. "Studies of the California Missions—I [and] II." *The Californian* 5, no. 29 (May 1882): 389–405; 514–526. Illustrated with Watkins's views of California missions.

Views of Kern County. [New York: Moss Engraving, n.d.]. Features thirty of Watkins's Kern County photographs. The views are heavily cropped and retouched and were probably copied directly from a Watkins album, captions and all. Beale Memorial Library, Bakersfield.

Vischer, Edward. *Vischer's Pictorial of California.* San Francisco: published for the author by J. Winterburn, 1870. Picture make-up varies, but this work usually contains twenty-one of Watkins's images including rare 1864 views of the San Francisco Mechanics' Fair.

[Waterfall]. "La Belle Cascade." *Mining and Scientific Press,* 17 August 1878. Engraving of a San Gabriel Valley scene after a Watkins photograph. Also, proof that Watkins was active in southern California before 1880.

Whitney, Josiah Dwight. *Contributions to American Geology.* Cambridge, England: University Press, John Wilson & Son, 1880. Vol. 1. Several "heliotype" reproductions of Watkins's photographs of the North Bloomfield Mines, 1871.

————. *Report of Progress for 1860–1864.* Vol. I of *Geologic Survey of California.* Philadelphia: Caxton Press of Sherman and Co., 1865. Illustrated with woodcut engravings after Watkins's 1861 photographs of Yosemite, especially his stereographs.

————. *The Yosemite Book: A Description of the Yosemite Valley and the Adjacent Region of the Sierra Nevada, and of the Big Trees of California.* New York: J. Bien, 1868. An important work for Watkins. Issued in 250 copies, each book has twenty-eight vintage prints, twenty-four taken by Watkins in 1866, and four by W. Harris, made in 1867.

[Yosemite Falls]. *The Illustrated San Francisco News,* 2 October 1869. Woodcut engraving after Watkins's 1866 photograph.

BIBLIOGRAPHY

SINCE 1918 there have been numerous articles, books, and cata- logues which discuss Carleton E. Watkins and his work. For the most part, they have concentrated narrowly on a specific segment of his life. This problem has been caused, or at least greatly aggra- vated, by the shortage of primary source materials, particularly those records destroyed by the San Francisco earthquake and fire of 18 April 1906.

Watkins's earliest biographer was Charles Beebe Turrill (1854– 1927), a San Francisco photographer who befriended Watkins in his old age. His essay, "An Early California Photographer: C. E. Wat- kins" (1918), was based on the elderly Watkins's faulty reminis- cences. Many of the dates in this account are inaccurate and Turrill offers only an incomplete overview of Watkins's activities. Nonethe- less, this essay contains useful information not found elsewhere— for example, the account of how Watkins came to photography in the first place—and has provided the basic framework for most sub- sequent studies of Watkins. Robert Taft drew heavily on Turrill's ac- count and on the comments of such Watkins contemporaries as Oliver Wendell Holmes for his account of Watkins in his monu- mental *Photography and the American Scene* in 1938. Beaumont New- hall's *The History of Photography*, a standard text in the field, makes no mention of Watkins in either the original 1939 edition or in the 1978 revision of the work, and makes only a passing reference in the new 1982 edition. This despite the fact that Watkins pioneered in the use of the mammoth-plate camera for landscape photography in 1861, years before the other great landscape photographers such as William Henry Jackson, Timothy O'Sullivan or John K. Hillers (all cited by Newhall) ever took their cameras west.

In 1949, Ralph H. Anderson, an employee at Yosemite, sought out Julia Watkins for an interview concerning her father's life which is immensely useful today. Similarly, in the mid-1960s, Eugene Compton gathered the Watkins family correspondence and con- ducted a number of interviews with Watkins family friends. His notes are at the Bancroft Library, University of California, Berkeley.

In recent years, Watkins's career has come under more schol- arly scrutiny. In 1960, Joe William Johnson, Professor of Hydraulic Engineering, University of California, Berkeley, assembled a fine catalogue of collections of Watkins's photographs, with a particular emphasis on his mining views. *The Early Pacific Coast Photographs of Carleton E. Watkins* contained little new in the way of biographical information and included no reproductions, but it laid the ground- work for further research into Watkins's career. Weston Naef's essay in *Era of Exploration* (1975) finally brought Watkins to a point of emi- nence among American photographers. Naef focused primarily on Watkins's Yosemite photographs of the 1860s, to the exclusion of the numerous city views and industrial photographs made during that decade and the cool, elegant landscapes of Watkins's later years. He portrayed Watkins as a brilliant photographer whose major con- cern of the 1860s was with presenting an illusory view of a virgin landscape unsullied by civilization, and whose later more commer- cial work represented a decline from the high ideals and standards of pure landscape photography. During the mid-1870s, after losing most of his negatives to his competitor Isaiah W. Taber, Watkins "was forced into the artistic stagnation of repeating himself," Naef wrote. And by the early 1880s, he "was in the autumn of his career and could not radically change his work or his vision."

In a special issue of *California History* in Fall, 1978, Pauline Grenbeaux, Peter Palmquist, and Nanette Sexton presented a more careful survey of Watkins's work and career in the years before his apparent bankruptcy in the mid-1870s. Both Grenbeaux and Sexton challenged Naef's notion that Watkins's 1861 Yosemite work was in- formed mainly by his exposure to East Coast and European stereo- graphs, by discussing Watkins's early work for Robert Vance and reviewing a previously unpublished set of views made in 1859 (now established to be 1860) at John C. Frémont's Mariposa estate. Gren- beaux also challenged Naef's characterization of the "elementary picturesqueness" of Watkins's Yosemite work of 1861 by calling at- tention to the extraordinary abstract qualities of Watkins's stereo views of Yosemite. In his essay on Watkins as a businessman, Palm- quist suggested the incessant business pressures and financial prob- lems that drove Watkins to wander the West in search of new pic- torial material for his customers. In a closing essay, the editors of

this volume called for further research into Watkins's career and his "neglected mature work" with its increasing emphasis on abstraction of form.

David Featherstone's essay in *C. E. Watkins: Photographs of the Columbia River and Oregon* (1979), a book reproducing the 51 mammoth plates from a recently recovered album of Watkins's 1867 Oregon work with its numerous images of industrial sites along the Columbia River, reiterated that Watkins was not merely a photographer of the pure, untrampled landscape. He was, wrote Featherstone, a photographer "as concerned with the interaction between man and the environment as he was with wilderness landscape."

In 1980, Naef again wrote about Watkins, this time placing him in the context of American Luminism—a mid-nineteenth century painting style that emphasized the absolute clarity of atmospheric light—for the catalogue accompanying the National Gallery of Art exhibition, "American Light." Working mainly with the same images he had used before in *Era of Exploration*, Naef again cast Watkins as a photographer of pure wilderness who reached the peak of his aesthetic development with his 1864–66 photographs of Yosemite and later settled into the role of "failed genius." Despite this focus on a narrow body of Watkins's work, Naef did provide an interesting new artistic and cultural context for the consideration of Watkins's formal style and imagery.

The most complete assessment of Watkins's photographic style, particularly that of his early years, is in Nanette Sexton, "Carleton E. Watkins: Pioneer California Photographer (1829–1916): A Study in the Evolution of Photographic Style During the First Decade of Wet Plate Photography" (Ph.D. dissertation, Harvard University, 1982).

This study of Watkins's life and work has been drawn from widely scattered sources. The best account of Watkins's childhood is in Willard V. Huntington's unpublished notes at the Susquehanna Historical Society in Oneonta, New York. Material which reflects Watkins's personal outlook is scarce, but useful information can be found in the Bancroft Library's manuscript collection, especially in Carleton E. Watkins, "Letters, approximately 1880–1890," and "Miscellaneous Papers, approximately 1864–1890;" Eugene Compton's "Notes re Carleton E. Watkins;" George Cooper Pardee,

"Correspondence and Papers 1890–1941;" and, to a lesser extent, in the correspondence between William Henry Brewer and Josiah Dwight Whitney. Also significant are interviews conducted with Julia Watkins by Ralph H. Anderson (1949), William and Karen Current (1975), and Pauline Grenbeaux (1976); and three surviving court depositions by Watkins that provide a rare insight into his working routine: *U.S. v. Charles Fossat* (1858), *U.S. v. D. and V. Peralta* (1861), and *Lux v. Haggin* (1881). The best collection of Watkins family photographs is in the Bancroft Library, with others to be found in the Research Library at Yosemite National Park.

Details of Watkins's career as a photographer are even more scattered than the references to his personal life, with brief newspaper mentions often providing the best evidence of Watkins's whereabouts or professional activities. A close examination of Watkins's photographs can also yield circumstantial evidence as to his movements and activities. Numerous specific references, however, are found in the California State Geological Survey Papers in the Bancroft Library, especially in the correspondence of Brewer and Whitney. Other pertinent information can be found in the Bancroft Library in the papers of William Ashburner, George Davidson, Francis P. Farquhar, Charles Frederick Hoffman, and Joe William Johnson. The King Survey Papers at the National Archives are useful and the Samuel Franklin Emmons Papers at the Library of Congress also contain important information about Watkins's activities with Clarence King.

At the Yale University Library, the papers of William Dwight Whitney, George Jarvis Brush, and William Henry Brewer shed light on the ways in which Watkins's photographs were used by scientists. The Trenor W. Park papers at the Park-McCullough House discuss Watkins's work in Mariposa in 1860 and his Yosemite trip of 1861. The papers of Collis P. Huntington and Frederick Law Olmsted, both at the Library of Congress, reveal Watkins's connections to these two key figures in the development and preservation of the West.

Although the following bibliography is lengthy and wide-ranging, it cannot be considered comprehensive. If nothing else, it clearly illustrates the difficulty of documenting the life and creative output of Carleton E. Watkins.

UNPUBLISHED SOURCES

Alexander, William Dewitt. Papers. Schubert Hall Library, California Historical Society, San Francisco.

Anderson, Ralph H. "Carleton E. Watkins." Typescript summary of notes from interview with Julia Watkins, 1949. Research Library, Yosemite National Park, California.

_____. "Report to Superintendent, Yosemite National Park, concerning Julia C. Watkins, September 16, 1949." Typescript. Research Library, Yosemite National Park, California.

Ashburner, William. Letters to William H. Brewer, 1864–1882. Bancroft Library, University of California, Berkeley.

"Bancroft Scraps." Scrapbooks. Bancroft Library, University of California, Berkeley.

Beardsley, Wallace R. "Watkins—Oregon and Columbia River Stereos, 1867," and "Watkins—Oregon Stereos, Winter 1884–1885." Typescript listing of stereograph titles held by Wallace R. Beardsley, Newark, California.

Brewer, William Henry. Correspondence, 1864–1882. Bancroft Library, University of California, Berkeley.

_____. Correspondence with Josiah Dwight Whitney, 1860–1885. Bancroft Library, University of California, Berkeley.

_____. Diaries and Journals, 1860–1864. Bancroft Library, University of California, Berkeley.

_____. Fieldbooks, 1861–1864. Bancroft Library, University of California, Berkeley.

_____. Letters Written to Him, 1862–1909. Bancroft Library, University of California, Berkeley.

_____. Notebooks and Miscellaneous Papers, 1860–1865. Bancroft Library, University of California, Berkeley.

_____. Papers. Historical Manuscripts Collection, Yale University Library, New Haven, Connecticut.

Brush, George Jarvis. Family Papers. Historical Manuscripts Collection, Yale University Library, New Haven, Connecticut.

California Geological Survey. Papers and Maps, 1844–1873; Letters, 1861–1866. Bancroft Library, University of California, Berkeley.

California State Department of Vital Statistics, Sacramento.

Compton, Eugene. Papers. Bancroft Library, University of California, Berkeley. "Notes re Carleton E. Watkins and his Family."

Correspondence Regarding Wheeler, King, O'Sullivan, and Watkins. Records of the Chief of Engineers, Record group 77, National Archives, Washington, D.C.

"Cosmopolitan House Grand Register, 1873." Bancroft Library, University of California, Berkeley.

Current, William, and Karen Current. "Interview with Miss Julia C. Watkins, February 12, 1975." Typescript summary of notes. Research Library, Yosemite National Park, Yosemite.

Davidson, George. Correspondence and Papers, c. 1845–1916. Bancroft Library, University of California, Berkeley.

Emerson, Ralph Waldo. Correspondence. Library, Society of California Pioneers, San Francisco.

Emmons, Samuel Franklin. Papers. Manuscripts Division, Library of Congress, Washington, D.C.

Farquhar, Francis Peloubet. Correspondence and Papers, 1912–1968. Bancroft Library, University of California, Berkeley.

Franklin, Jane. Journals, 1861–1865. Research Library, Scott Polar Research Institute, Cambridge, England.

Gillett, Marion N. "Carleton E. Watkins' Photographs of Yosemite Valley 1861–66, and the Development of the Western Landscape Motifs." Art Department, Arizona State University, Tempe, 1977.

Gilman, Daniel Coit. Correspondence, 1871–1875. Bancroft Library, University of California, Berkeley.

Grenbeaux, Mary Pauline. "The Early Yosemite Photographs of Carleton E. Watkins." Master's thesis, University of California, Davis, 1977.

_____. "Interview with Julia Watkins, Winter 1976." Typescript of taped interview, held by Mary Pauline Grenbeaux, Sacramento, California.

Hague, James Duncan. Papers. Huntington Library. San Marino, California.

Harris, David Jack. "The Painters, Photographers, and Writers of the Yosemite: 1850–1900." Master's thesis, San Francisco State University, San Francisco, 1974.

Hoffman, Charles Frederick. Letters to Josiah D. Whitney and William H. Brewer, 1862–1910. Bancroft Library, University of California, Berkeley.

Huntington, Collis Potter. "The Collis P. Huntington Papers, 1856–1901." Microfilm edition. Glen Rock, N.J.: Microfilming Corporation of America, 1978.

Huntington, Willard V. Papers. Upper Susquehanna Historical Society, Oneonta, New York. "Old Time Notes concerning the Pioneers and Progress of Oneonta, New York, before 1915."

Johnson, Joe William. Correspondence and Papers, 1962–1966. Bancroft Library, University of California, Berkeley.

Jutzi, Alan. "Notes re Watkins-Lummis." Summary of notes concerning photography lecture, Los Angeles County Museum of Art, 1981. Typescript held by Alan Jutzi, Los Angeles, California.

King, Thomas Starr. Correspondence. Library, Society of California Pioneers, San Francisco.

_____. Letters and Papers, 1839–1863. Bancroft Library, University of California, Berkeley.

Latham, Milton Slocum. Papers, 1848–1869, 1890, and 1921. Schubert Hall Library, California Historical Society, San Francisco.

Marsh, Othniel Charles. Papers. Historical Manuscripts Collection, Yale University Library, New Haven, Connecticut.

Muir, John. Papers. Research Library, Holt-Atherton History Center, University of the Pacific, Stockton, California.

Muybridge, Eadweard. Papers. 1868. Schubert Hall Library, California Historical Society, San Francisco.

Natural Science Manuscript Group. Historical Manuscripts Collection, Yale University Library, New Haven, Connecticut.

Olmsted, Frederick Law. Papers. Manuscripts Division, Library of Congress, Washington, D.C.

Palmquist, John F. "Notes on the Watkins Family of Oneonta, New York." Typescript held by Peter Palmquist, Arcata, California.

_____. "Watkins Family Plot." Typescript, 29 October 1979, held by Peter Palmquist, Arcata, California.

Palmquist, Peter E. "Robert H. Vance's Influence on Western Landscape Photographers—Carleton Watkins and Charles Weed." Typescript held by Peter Palmquist, Arcata, California.

Pardee, George Cooper. Correspondence and Papers, 1890–1941.

Bancroft Library, University of California, Berkeley.

Park, Trenor W. Papers. Manuscript Collection, Park-McCullough House, North Bennington, Vermont.

"Peregoy Hotel Register, 1869–74." Research Library, Yosemite National Park, California.

Pioneer File. California State Library, Sacramento.

Pioneer File. Library, Society of California Pioneers, San Francisco.

Pond, Elizabeth Keith, comp. "The William Keith Miscellanea." Bancroft Library, University of California, Berkeley.

Rapaport, Neil. "Carleton E. Watkins: Resolution of Forces in Early Photography. Photography Think-Piece #6, November 1981." Typescript held by Neil Rapaport, Bennington, Vermont.

Records of the California Geological Survey, 1860–1884. Bancroft Library, University of California, Berkeley.

Records of the Geological Exploration of the Fortieth Parallel (the "King Survey"), 1867–1881. Record Group 57, National Archives, Washington, D.C.

Records of the United States Supreme Court. Record Group 267, National Archives, Washington, D.C.

Records of the United States District Court for the Northern District of California. Bancroft Library, University of California, Berkeley.

Records of the United States Public Land Office. Record Group 49, National Archives, Washington, D.C.

Rosenbloom, Jean. "Some 19th Century California Photographers." Typescript held by Jean Rosenbloom, Sherman Oaks, California.

"A Roster of Former Members of the Bohemian Club From the Date of Its Founding in 1872 until 1945." Typescript in Schubert Hall Library. California Historical Society, San Francisco.

Ross, Pinkie P. "Mr. J. J. Cook and Family." Research Library, Yosemite National Park, California.

San Francisco Art Association. Records, c. 1871, 1936–1940. Schubert Hall Library, California Historical Society, San Francisco.

San Francisco Artists Union. Records, 1868. Schubert Hall Library, California Historical Society, San Francisco.

Sexton, Nanette Margaret. "Carleton E. Watkins: Pioneer California Photographer (1829–1916): A Study in the Evolution of Photographic Style, During the First Decade of Wet Plate Photogra-

phy." Ph.D. dissertation, Harvard University, Cambridge, Massachusetts, 1982.

————. "Towards a Definition of Process: The Yosemite Paintings of Albert Bierstadt." Master's thesis, Harvard University, Cambridge, Massachusetts, 1972.

Seyl, Susan. "Carleton E. Watkins Holdings at the Oregon Historical Society." Library, Oregon Historical Society, Portland.

Silliman, Benjamin. Family Papers. Historical Manuscripts Collection, Yale University Library, New Haven, Connecticut.

Slawson, Alma F. "John and Julia (McDonald) Watkins." Typescript of notes, 9 October 1965, held by Alma F. Slawson, Oneonta, New York.

Street, Richard Steven. "Carleton E. Watkins' Kern County Photography: An Unknown Phase of His Career." Typescript held by Richard Steven Street, San Rafael, California.

Superior Court Records. Yolo County Courthouse, Woodland, California.

Terry, Richard. "Carleton E. Watkins—Preliminary Checklist of Photographs." California State Library, Sacramento.

Turrill, Charles B. "Catalogue of Watkins' Stereoscopic Views, New Series." California Section, California State Library, Sacramento.

————. "List of Alfred A. Hart Stereos—C.P.R.R." California Section, California State Library, Sacramento.

————. Papers, 1888–1890, Schubert Hall Library, California Historical Society, San Francisco.

————. Papers. Library, Society of California Pioneers, San Francisco, California.

United States Census. "San Francisco: 1850 through 1900." United States Government Federal Records Center, San Bruno, California.

"United States Geological Exploration of the Fortieth Parallel." Listing of photographs taken during the Clarence King surveys, n.d. United States Geological Survey Library, Denver, Colorado.

Watkins, Carleton E. Letters, approximately 1880–1890. Bancroft Library, University of California, Berkeley.

————. Miscellaneous Papers, approximately 1864–1890. Bancroft Library, University of California, Berkeley.

Weinstein, Robert A., and Robert Haas. "Notes Toward a Time Chart on Carleton E. Watkins, Photographer." Typescript held by Robert A. Weinstein, Los Angeles, California.

Whitehead, Margaret. "Carleton E. Watkins—the Dynamic Response: Wet Plate and the Landscape Photograph." Typescript, n.d. Research Library, Yosemite National Park, California.

Whitney, Josiah Dwight. Correspondence, 1860–1884. Bancroft Library, University of California, Berkeley.

————. Notes and Manuscripts, Geological Survey in California. Bancroft Library, University of California, Berkeley.

Whitney, William Dwight. Family Papers. Historical Manuscripts Collection, Yale University Library, New Haven, Connecticut.

Yolo County Recorder's Office. Records. Woodland, California.

NEWSPAPERS AND PERIODICALS CONSULTED
All newspapers published in California unless otherwise indicated.

Alameda News (1882–1883)
American Journal of Science (1860–1880)
American Philosophical Society Proceedings (1860–1870)
Anaconda Standard (1890). Montana
Anaconda *Weekly Review* (1886–1890). Montana
Anthony's Photographic Bulletin (1870–1880)
Atlantic Monthly (1857–1885)
Auburn *Placer Herald* (1857–1860)
Auburn *Union Advocate* (1862–1863)
Bakersfield *Kern County Californian* (1888–1890)
Bakersfield *Kern County Gazette* (1880)
Belmont Courier (1876–1880)
Bidwell *Weekly Butte Record* (1853–1856)
Benicia *Solano County Herald* (1855–1858, 1863–1865)
Boston Evening Transcript (1860–1861). Massachusetts
Butte *Daily Inter-Mountain* (1887–1891). Montana
Butte Miner (1890). Montana
Butte *Mining Journal* (1890). Montana
California Historical Quarterly (1922–1982)
The California Horticulturist and Floral Magazine (1873–1880)

California Mail Bag (1871–1875)
Californian Magazine (1880–1882)
Calistoga Tribune (1871–1874)
Carson City *Appeal-News* (1876–1878). Nevada
Carson City *Daily Appeal* (1873–1876). Nevada
Carson City *Daily Evening Herald* (1875). Nevada
Carson City *Nevada Tribune* (1873–1875). Nevada
Century Illustrated Monthly Magazine (1870–1885)
Chico Weekly Courant (1865–1868)
Chico *Northern Enterprise* (1869–1872)
Chico *Weekly Butte Record* (1874–1887)
Cloverdale Bee (1872–1873)
Cloverdale News (1878–1879)
Cloverdale Reveille (1874–1882)
Columbia Citizen (1866–1867)
Columbia Gazette (1853–1854)
Colusa *Weekly Sun* (1869–1872)
Dalles Times-Mountaineer (1884–1885). Oregon
Dalles *Weekly Mountaineer* (1865–1880). Oregon
Dutch Flat Enquirer (1864–1868)
Eureka *Humboldt Times* (1854–1900)
Genoa *Carson Valley News* (1874–1879). Nevada
Georgetown News (1854–1856). Nevada
Gold Hill Daily News (1874–1879)
Grass Valley Intelligencer (1856)
Grass Valley Telegraph (1856–1858)
Harper's Magazine (1850–1900)
Healdsburg *Democrat Standard* (1865–1868)
Humphreys' Journal (1865–1867)
Hutchings' California Magazine (1856–1861)
Ione *Amadore Times* (1878–1879)
Jacksonville *Oregon Sentinel* (1856–1886)
Lakeport *Clear Lake Courier* (1866–1871)
Leslie's Illustrated Weekly Newspaper (1855–1885). New York
Los Angeles Daily Herald (1878–1881)
Los Angeles Express (1878–1879)
Los Angeles *Star* (1851–1864)
Los Angeles Star (1878–1879)

Mariposa Free Press (1866, 1870–1871)
Mariposa Gazette (1855–1880)
Mariposa Mail (1866–1869)
Marysville Daily Appeal (1866–1869)
Marysville *Daily California Express* (1858–1865)
Marysville *Daily Evening Herald* (1850–1853)
Marysville Herald (1850–1858)
Mendocino Beacon (1878–1879)
Merced County Sun (1890–1923)
Merced Express (1875–1881)
Merced People (1872)
Merced *San Joaquin Valley Argus* (1873–1880)
Merced Tribune (1872–1875)
Mining and Scientific Press (1864–1880)
Monterey Sentinel (1855–1856)
Napa County Reporter (1857–1860)
Napa *Pacific Echo* (1862–1863)
Nevada City Daily Transcript (1861–1880)
Nevada City *Nevada Journal* (1851–1863)
Oroville *Butte Democrat* (1859–1862)
Oroville *Butte Record* (1857–1858)
Oroville Union Record (1864–1866)
Overland Monthly (1868–1900)
Petaluma *Sonoma County Journal* (1856–1864)
The Philadelphia Photographer (1864–1880)
Placerville *Mountain Democrat* (1857–1865)
Portland *Daily Oregonian* (1882). Oregon
Portland *Morning Oregonian* (1867–1868). Oregon
Portland *Oregon Herald* (1867–1868). Oregon
Portland *Weekly Oregonian* (1854–1862). Oregon
Quincy *Plumas Standard* (1859–1863)
Quincy Union (1864–1868)
Red Bluff *Beacon* (1857–1864)
Red Bluff *Independent* (1860–1872)
Red Bluff *Republican* (1878–1881)
Red Bluff Sentinel (1878–1881)
Red Bluff *Tehama County People's Cause* (1860–1870)
Redwood City *San Mateo County Gazette* (1859–1864)

Reno Crescent (1868–1875). Nevada
Reno Evening Gazette (1877–1878). Nevada
Reno *Nevada State Journal* (1874–1878). Nevada
Sacramento Bee (1857–1880)
Sacramento Daily Union (1851–1857)
Sacramento *Placer Times* (1849–1850)
San Bernardino Times (1880)
San Diego Herald (1851–1860)
San Diego Union (1880)
San Francisco *Alta California* (1851–1891)
San Francisco *Call Bulletin* (1863–1867)
San Francisco Chronicle (1865–)
San Francisco *Daily Evening Bulletin* (1855–1858, 1869)
San Francisco Daily Herald (1854–1862)
San Francisco Daily Times (1858–1860)
San Francisco *Illustrated California News* (1850)
San Francisco *Illustrated Press* (1873)
San Francisco *Illustrated San Francisco News* (1869)
San Francisco *Journal of Commerce* (1880)
San Francisco *Mirror of the Times* (1857)
San Francisco News Letter and California Advertiser (1869–1873)
San Jose *Mercury* (1856–1860)
San Jose *Tribune* (1856–1860)
Santa Cruz Courier-Item (1880–1885)
Santa Cruz *Local Item* (1875–1880)
Santa Cruz *Pacific Sentinel* (1856–1862)
Santa Cruz Sentinel (1880–1885)
Santa Cruz Surf (1884)
Seattle Post-Intelligencer (1882). Washington
Shasta Courier (1853–1900)
Shasta Republican (1856–1861)
Silver City *Reporter* (1876). Nevada
Silver City *Times* (1874–1876). Nevada
Snelling *Merced Herald* (1865–1869)
Snelling *San Joaquin Valley Argus* (1869–1873)
Sonoma Democrat (1857–1875)
Sonora *Union Democrat* (1854–1870)
Stockton Daily Independent (1861–1875)

Susanville *Lassen Advocate* (1868–1880)
Sutro Independent (1875–1880). Nevada
Tombstone Daily Nugget (1880). Arizona
Tombstone Epitaph (1880). Arizona
Tombstone *Weekly Nugget* (1880). Arizona
Truckee Republican (1873–1874)
Truckee Tribune (1868–1869)
Tucson *Arizona Daily Star* (1880). Arizona
Tucson *Arizona Weekly Citizen* (1880). Arizona
Tucson *Daily Record* (1880). Arizona
Tuolumne City News (1868–1869)
Virginia City *Evening Virginia Chronicle* (1877). Nevada
Virginia City *Territorial Enterprise* (1859–1880). Nevada
Watsonville *Pajaro Times* (1864–1867)
Weaverville *Weekly Trinity Journal* (1856–1900)
Yreka Journal (1860–1900)
Yuma *Arizona Sentinel* (1880). Arizona

PUBLISHED WORKS

Books

A. W. Morgan and Co.'s San Francisco City Directory, September, 1852. . . . San Francisco: A. W. Morgan and Co., 1852.

Alinder, James, ed. *Carleton E. Watkins: Photographs of the Columbia River and Oregon.* Carmel, California: Friends of Photography and Weston Gallery, 1979.

American Stereographs: A Selection from Private Collections. New York: Grey Art Gallery and Study Center, New York University, 1980.

Andrews, Ralph W. *Picture Gallery Pioneers, 1850–1875.* New York: Bonanza, 1964.

Arkelian, Marjorie Dakin, et al. *Thomas Hill: The Grand View.* Oakland: Oakland Museum Art Department, 1980.

Baird, Joseph A., ed. *Images of El Dorado: A History of California Photography, 1850–1975.* Davis: Memorial Union Art Gallery, University of California, 1975.

Ballinger, James K., and Andrea D. Rubinstein. *Visitors to Arizona, 1846 to 1980*. Phoenix: Phoenix Art Museum, 1980.

Bean, Walton. *California: An Interpretive History*. New York: McGraw-Hill, 1968.

Bentley, William R. *Bentley's Handbook of the Pacific Coast*. Oakland: Pacific Press, 1884.

Blake, William P., ed. *Reports of the United States Commissioners to the Paris Exposition, 1867*. Washington, D.C.: U.S. Government Printing Office, 1870.

Boddam-Whetham, J. W. *Western Wanderings*. London: R. Bentley and Son, 1874.

Buyers' Manual and Business Guide. San Francisco: J. Price and C. S. Haley, 1872.

Cahn, Robert, and Robert Glenn Ketchum. *American Photographers and the National Parks*. New York: Viking Press, and National Park Foundation, 1981.

California, the Cornucopia of the World—Room for Millions of Immigrants—43,795,000 Acres of Government Lands Untaken, Railroads and Private Lands for a Million Farmers, a Climate for Health and Wealth Without Cyclones or Blizzards. Chicago: published for the California Immigration Commission by Rand, McNally & Co., 1883.

Campbell, Dudley M. *A History of Oneonta From its Earliest Settlement to the Present Time*. Oneonta, New York: G. W. Fairchild, 1906.

Catalogue of the Arriola Relief Collection. [San Francisco]: Edward Bosqui, [1872].

Colville's San Francisco Directory. . . . Vol. 1. San Francisco: Samuel Colville, 1856.

Constitution of the San Francisco Photographic Artists' Association. San Francisco: printed for the association, 1866.

Cornelius, Fidelis, Brother. *Keith: Old Master of California*. New York: G. P. Putnam and Sons, 1942.

Crocker-Langley's San Francisco City Directory. San Francisco: R. L. Polk, 1896–1916.

Current, Karen, and William R. Current. *Photography and the Old West*. New York: Harry N. Abrams, 1978.

Darrah, William Culp. *The World of Stereographs*. Gettysburg: privately published, 1977.

Doremus, Charles A. *Photography at Vienna*. Washington, D.C.: U.S. Government Printing Office, 1875.

Earle, Edward W., ed. *Points of View: The Stereograph in America, a Cultural History*. Rochester, New York: Visual Studies Workshop, 1979.

Egan, Ferol. *Frémont: Explorer for a Restless Nation*. New York: Doubleday, 1977.

Fardon, George Robinson. *San Francisco Album: Photographs of the Most Beautiful Views and Public Buildings of San Francisco*. San Francisco: Herre and Bauer, 1856.

Farquhar, Francis P. *History of the Sierra Nevada*. Berkeley: University of California Press, 1965.

————, ed. *Up and Down California in 1860–1864: The Journal of William H. Brewer*. 3rd ed. Berkeley: University of California Press, 1966.

————. *Yosemite: The Big Trees and High Sierra, a Selective Bibliography*. Berkeley: University of California Press, 1948.

Frémont, John C., et al. *The Mariposa Estate*. London: Whittingham and Wilkins, 1861.

Galloway, John D. *Early Engineering Works Contributory to the Comstock*. Publications of the Nevada State Bureau of Mines and the Mckay School of Mines. Geology and Mining Series No. 45. Carson City, Nevada: State Printing Office, 1947.

Goetzmann, William H. *Exploration and Empire: The Explorer and the Scientist in the Winning of the American West*. New York: Alfred A. Knopf, 1966.

Goldberg, Vicki, ed. *Photography in Print: Writings from 1816 to the Present*. New York: Simon & Schuster, 1981.

Gordon-Cumming, Constance Frederica. *Granite Crags of California*. Edinburgh: William Blackwood and Sons, 1886.

Greeley, Horace. *An Overland Journey from New York to San Francisco*. San Francisco: H. H. Bancroft & Co., 1860.

Gudde, Erwin D. *California Place Names*. Berkeley: University of California Press, 1969.

Haas, Robert Bartlett. *Muybridge: Man in Motion*. Berkeley: University of California Press, 1976.

Heyman, Therese. *Slices of Time: California Landscapes 1860–1880, 1960–1980*. Oakland: Oakland Museum, 1981.

Hickman, Paul, and Terence Pitts. *George Fiske: Yosemite Photographer.* Flagstaff: Northland Press with The Center for Creative Photography, University of Arizona, 1980.

Himelfarb, Harvey, and Roger D. Clisby. *Large Spaces in Small Places: A Survey of Western Landscape Painting, 1850–1980.* Sacramento: Crocker Art Museum, 1980.

Hively, William, ed. *Nine Classic California Photographers.* Berkeley: Friends of the Bancroft Library, University of California, 1980.

Hoobler, Dorothy, and Thomas Hoobler. *Photographing the Frontier.* Toronto: Academic Press, 1981.

Horan, James D. *The Great American West.* New York: Crown Publishers, 1959.

Humphrey, John. *Photographs of the Permanent Collection.* San Francisco: San Francisco Museum of Modern Art, 1978.

Huntington, Willard V. *Oneonta Memories.* San Francisco: Bancroft, 1891.

Hurd, Duane Hamilton. *History of Otsego County, New York.* Philadelphia: Everts and Fariss, 1878.

Jackson, Helen Hunt. *Bits of Travel at Home.* Boston: Roberts Brothers, 1878.

Jareckie, Stephen B. *American Photography: 1840–1900.* Worcester, Massachusetts: Worcester Art Museum, 1976.

Johnson, Joe William. *The Early Pacific Coast Photographs of Carleton E. Watkins.* Water Resources Center Archives Series, Report no. 8. Berkeley: University of California, 1960.

————. *The Hearst Collection of Photographs of Carleton E. Watkins, Pioneer Pacific Coast Photographer.* Berkeley: University of California Press, 1956.

King, Clarence. *Mountaineering in the Sierra Nevada.* London: Sampson, Low, Marston, and Searle, 1872.

————. *Report of Geological Exploration of the Fortieth Parallel.* Washington, D.C.: U.S. Government Printing Office, 1870–1880.

King, Thomas Starr. *A Vacation among the Sierras: Yosemite in 1860.* Edited by John A. Hussey. San Francisco: Book Club of California, 1962.

Kingsley, Rose Georgina. *South by West.* London: W. Isbister, 1874.

Koch, Robert. *19th and 20th Century Photographs.* Berkeley: privately printed, 1981.

Langley's San Francisco City Directory. San Francisco: R. L. Polk, 1858–1895.

Lavender, David. *The Great Persuader.* Garden City, New York: Doubleday, 1970.

Le Count and Strong's San Francisco Directory for the Year 1854. . . . Compiled by Frank Rivers. San Francisco: Le Count and Strong, 1854.

Lindquist-Cock, Elizabeth. *The Influence of Photographs on American Landscape Painting, 1839–1880.* New York: Garland Publishing, 1978.

Lloyd, Benjamin Estell. *Lights and Shades in San Francisco.* San Francisco: A. L. Bancroft and Co., 1876.

Lotchin, Roger W. *San Francisco, 1846–1856: From Hamlet to City.* New York: Oxford University Press, 1974.

Lux, Charles, et al. v. Haggin, James B., et al. . . . *In the Supreme Court of the State of California. Charles Lux et al., Appellants, v. James B. Haggin et al., Respondents. . . .* Nos. 8587 and 8588 in the Supreme Court of California. 10 vols. in 6. [San Francisco? 1882–1885.]

McCullough, Eliza Hall Park. *Within One's Memory.* North Bennington, Vermont: Catamount Press, 1974.

Mechanics' Institute. San Francisco. *Descriptive Catalogue of the Fifteenth Industrial Exhibition of the Mechanics' Institute.* San Francisco: Dewey, 1880.

————. *Descriptive Numerical Catalogue of the Fifth Industrial Exhibition of the Mechanics' Institute.* San Francisco: Dewey, 1865.

Moffat, Frances. *Dancing on the Brink of the World.* New York: G. P. Putnam, 1977.

Naef, Weston J., with James N. Wood and Therese Heyman. *Era of Exploration: The Rise of Landscape Photography in the American West, 1860–1885.* New York: Albright-Knox Art Gallery and the Metropolitan Museum of Art, 1975.

New York. Christie's East. *Nineteenth and Twentieth Century Photographs.* Auction catalogue, Sale 137 "Basilisk," 11–12 November 1980.

————. Swann Galleries, Inc. *Photographica.* Auction catalogue, Sale 1218, 23 April 1981.

_____. Swann Galleries, Inc. *Rare Books*. Auction catalogue, Sale 1141, 10 May 1979.

Nordhoff, Charles. *California: for Health, Pleasure, and Residence: a Book for Travelers and Settlers*. New York: Harper and Brothers, 1882.

Norton, Russell. *The Professor Spencer F. Baird Collection of Early Signed Yosemite Photographs by Carleton E. Watkins*. New Haven: privately published, 1976.

Ostroff, Eugene. *Western Views and Eastern Visions*. Washington, D.C.: Smithsonian Institution Traveling Exhibition Service, 1981.

Palmquist, Peter E. *Lawrence & Houseworth/Thomas Houseworth & Co.: A Unique View of the West, 1860–1886*. Columbus, Ohio: National Stereoscopic Association, 1980.

Phillips, Catherine Coffin. *Jessie Benton Frémont: A Woman Who Made History*. San Francisco: John Henry Nash, 1935.

Polk's San Francisco City Directory. . . . San Francisco: R. L. Polk and Co., 1858–1916.

Rasmussen, Louis. *San Francisco Ship Passenger Lists*. 4 vols. Coloma, California: San Francisco Historical Record and Genealogy Bulletin, 1966.

Richardson, Abby Sage, ed. *Garnered Sheaves from the Writings of Albert D. Richardson*. Hartford: Columbian, 1871.

Roper, Laura Wood. *A Biography of Frederick Law Olmsted*. Baltimore: Johns Hopkins University Press, 1973.

Sacramento City Directory. By J. Horace Culver. January 1, 1851. Sacramento City, California: Transcript Press, 1851.

Sacramento Directory for 1853–4. By Samuel Colville. Sacramento, California: 1853.

Sanborn, Margaret. *Yosemite: Its Discovery, Its Wonders and Its People*. New York: Random House, 1981.

Sandweiss, Martha A. *Masterworks of American Photography: The Amon Carter Museum Collection*. Birmingham, Alabama: Oxmoor House, 1982.

San Francisco Art Association. *Constitution, By-laws, and List of Members*. San Francisco: E. Bosqui & Co., 1872.

San Francisco Business Directory, for the Year Commencing January 1, 1856. . . . San Francisco: Joseph Baggett and Co., 1856.

San Francisco City Directory, for the Year Commencing October, 1856. . . . San Francisco: Harris, Bogardus and Labatt, 1856.

San Francisco Directory, for the Year 1852–53. . . . San Francisco: James M. Parker, 1852.

San Francisco. *Great Register of the City and County of San Francisco. . . .* Supplement, April 1879.

Sargent, Shirley. *Yosemite's Historic Wawona*. Yosemite: Flying Spur Press, 1979.

Smith, Herbert L., ed. *The Mines of the Comstock Lode, from the Mrs. Phoebe Apperson Hearst Collection of Watkins Photographs in the Hearst Memorial Mining Building*. Berkeley: University of California, 1938.

_____. *The Placer Mines of California, from the Mrs. Phoebe Apperson Hearst Collection of Watkins Photographs in the Hearst Mining Building*. Berkeley: University of California, 1938.

Snyder, Joel. *American Frontiers: The Photographs of Timothy H. O'Sullivan, 1867–74*. Philadelphia: Philadelphia Museum of Art, 1981.

_____, and Doug Munson, eds. *The Documentary Photograph as a Work of Art: American Photographs, 1860–1876*. Chicago: David and Alfred Smart Gallery, University of Chicago, 1976.

Soulé, Frank, John H. Gihon, and James Nisbet. *The Annals of San Francisco*. New York, San Francisco, and London: D. Appleton and Company, 1855.

Starr, Kevin. *Americans and the California Dream, 1850–1915*. London: Oxford University Press, 1973.

Stone, Irving. *Immortal Wife*. Chicago: Consolidated Book Publishers, 1964.

Taber, Isaiah West. *Taber Pacific Coast Tourist Guide and Catalogue of Views*. San Francisco: privately published, [1882].

Taft, Robert. *Photography and the American Scene*. New York: Macmillan, 1938.

Truman, Ben C. *Tourists' Illustrated Guide to the Celebrated Summer and Winter Resorts of California*. San Francisco: H. S. Crocker, 1883.

Turrill, Charles B. *Catalogue of the Products of California, Exhibited by the Southern Pacific Company, at the North, Central and South American Exposition, New Orleans*. New Orleans: Press of W. B. Stansbury, 1886.

Union Guide to Photographic Collections in the Pacific Northwest. Portland: Oregon Historical Society, 1978.

United States. Coast and Geodetic Survey. *Report of the Superintendent.* Washington, D.C.: U.S. Government Printing Office, 1879.

————. Coast and Geodetic Survey. *Report of the Superintendent.* Washington, D.C.: U.S. Government Printing Office, 1880.

Vance, Robert H. *Catalogue of Daguerreotype Panoramic Views in California.* New York: Baker, Godwin, 1851.

Vanderbilt, Paul, comp. *Guide to the Special Collections of Prints and Photographs in the Library of Congress.* Washington, D.C.: U.S. Government Printing Office, 1955.

Vischer, Edward. *Vischer's Pictorial of California.* San Francisco: J. Winterburn, 1870.

Watkins, Carleton E. *Watkins' New Series Stereoscopic Views of Southern California and S.P.R.R. of Arizona.* San Francisco: privately printed, n.d.

————. *Watkins' Stereoscopic Views of Southern California, S.P.R.R., the Old Missions, etc., etc.* San Francisco: privately printed, n.d.

Welling, William. *Photography in America: The Formative Years, 1839–1900.* New York: Thomas Y. Crowell, 1978.

Wendte, Charles W. *Thomas Starr King: Patriot and Preacher.* Boston: Beacon Press, 1921.

Whitney, Josiah Dwight. *Report of Progress for 1860–1864.* Vol. I of the *Geological Survey of California.* Philadelphia: Caxton Press of Sherman and Co., 1865.

————. *Notice of the Two Masses of Meteoric Iron Brought from Tucson to San Francisco, 1862 and 1863.* San Francisco: Town and Bacon, 1863.

————. *The Yosemite Book.* New York: J. Bien, 1868.

Wilkins, Thurman. *Clarence King: A Biography.* New York: Macmillan, 1958.

Wilmerding, John, ed. *American Light: The Luminist Movement, 1850–1870.* Washington, D.C.: National Gallery of Art, 1980.

Yosemite. San Francisco: Fine Arts Museum, Downtown Center, 1979.

The "Yosemite", by M. I. W. 1866. Being the Journal . . . of a Trip on Horseback to the Yosemite Valley in June 1866. San Francisco: Munson School for Private Secretaries, 1942.

Articles

Albright, Thomas. "Early Views of Yosemite." *San Francisco Chronicle,* 16 November 1973.

————. "Rediscovered Landscape Albums." *San Francisco Sunday Examiner & Chronicle World,* 21 October 1979.

"America." *Illustrated London News,* 14 September 1867.

Anderson, Ralph H. "Carleton E. Watkins: Pioneer Photographer of the Pacific Coast." *Yosemite Nature Notes* 32, no. 4 (April 1953): 33–37.

"Art and Yosemite." *Oakland Tribune,* 5 August 1951.

"Art Jottings." *California Mail Bag* 7, no. 2 (June 1875): 116–117.

"Art Notes." *Overland Monthly* 12, no. 1 (January 1874): 90–94; no. 2 (February 1874): 191–192.

"Art Notes." *San Francisco News Letter and California Advertiser,* 22 November 1873.

"Artists in Yo-semite Valley." *Mariposa Gazette,* 5 August 1865.

Avery, Benjamin Parke. "Art Beginnings on the Pacific." *Overland Monthly* 1, no. 1 (July 1868): 28–34; no. 2 (August 1868): 113–119.

————. "Ascent on Mount Shasta." *Overland Monthly* 12, no. 5 (May 1874): 466–467.

————. "Summering in the Sierra." *Overland Monthly* 12, no. 1 (January 1874): 79–82; no. 2 (February 1874): 175–183.

Bartlett, Richard A. "Will Anyone Come Here for Pleasure?" *American West* 6, no. 5 (September 1969): 10–16.

Beatty, M. E. "C. E. Watkins, One of the Early Photographers of Yosemite." *Yosemite Nature Notes* 15, no. 3 (March 1936): 17–18.

Bell, Virginia. "Trenor Park: A New Englander in California." *California History* 60, no. 2 (Summer 1981): 158–171.

Bell, William. "Photography in the Grand Gulch of the Colorado River." *Philadelphia Photographer* 10, no. 109 (January 1873): 10.

Bendix, Howard E. "Glass Stereo Views: A Statistical Survey." *Stereo World* 1, no. 3 (1974): 2–4.

Blum, Walter. "One Man's View of the West." *California Living Magazine,* 18 November 1979.

Bogart, Sewall. "Four Turn-of-the-Century South Country 'Gentle-

man's Farms': Thurlow Lodge—Sherwood Hall." *La Peninsula* 19, no. 2 (Fall 1977): 4–13.

Busch, Akiko. "A Small Town's Second House." *Americana* 10, no. 3 (July/August 1982): 56–60.

"California Photographs." *Humphrey's Journal* 18, no. 2 (15 May, 1866): 21.

"California Photographs." San Francisco *Alta California*, 15 January 1867.

"California Photographs in Vienna." *Overland Monthly* 12, no. 1 (January 1874): 94.

"California's Representation at the Paris Exhibition." San Francisco *Alta California*, 13 January 1867.

"California Scenery in New York." *North Pacific Review* 2, no. 7 (February 1863): 208.

"Card Photographs." *Mining and Scientific Press*, 6 January 1866.

"Carleton Emmons Watkins." *Mendocino Historical Review Newsletter* 10 (June 1982): 1–11.

"Centennial Awards." *Philadelphia Photographer* 13, no. 155 (November 1876): 321–322.

"Centennial Pictures and Pictures Shown by the Photographers." *San Francisco Chronicle*, 28 June 1876.

"The Chilean Exposition." *California Mail Bag* 9, no. 2 (June 1876): 54–55.

"CHS Art Sleuths Find Rare Painting by Virgil Williams." *California Historical Courier* 26, no. 4 (May/June 1974): 1ff.

"Collection of Rare Photographs." U.C.L.A. *University Bulletin*, 22 November 1954, p. 98.

Coplans, John. "C. E. Watkins at Yosemite." *Art in America* 66, no. 6 (November/December 1978): 100–108.

Davis, Douglas, with Cathleen McGuigan. "One Picture's Worth $10,000." *Newsweek* 93, no. 22 (28 May 1979): 92–94.

Dicker, Laverne Mau. "Watkins' Photographs in the California Historical Society Library." *California History* 57, no. 3 (Fall 1978): 266–267.

Doherty, Amy S. "Carleton E. Watkins, Photographer: 1829–1916." Syracuse Library Association *Courier* 15, no. 4 (1978): 3–20.

Duncan, Robert G. "Watkins' Albums Bring $75,000 at Auction." *Photographic Collector* 1, no. 4 (Winter 1980/1981): 26.

"The Falls of Oregon." *Mining and Scientific Press*, 11 January 1873.

"From Yosemite Valley." *Mariposa Gazette*, 13 July 1878.

"General Review of Exhibition." *Mining and Scientific Press*, 5 September 1868.

Giffen, Helen S. "Carleton E. Watkins: California's Expeditionary Photographer." *Eye to Eye* 6 (September 1954): 26–32.

"A Gift of Photographs of the Mariposa Estate." *California Historical Quarterly* 12, no. 4 (December 1928): 410.

Gill, Frank B. "Oregon's First Railway." *Quarterly of the Oregon Historical Society* 25, no. 3 (September 1924): 172–235.

Goldthorpe, Sandra. "West Coast Views: The Eternal Art of Carleton Watkins." *Sacramento Magazine* (November 1979): 28–30.

Grenbeaux, Mary Pauline. "Before Yosemite Art Gallery: Watkins' Early Career." *California History* 57, no. 3 (Fall 1978): 220–241.

Hanks, Henry G. "Casa Grande." *The Californian* 2, no. 8 (August 1880): 101–106.

Hickman, Paul. "Carleton E. Watkins (1829–1916)." Arizona State University Art Department *Northlight* 1 (January 1977).

————. "Carleton Watkins and the Yosemite Valley." *Artweek* 8, no. 33 (8 October 1977): 16.

Hill, Eric. "Carleton E. Watkins." *Stereo World* 4, no. 1 (March/April 1977): 4–5.

"Ho! For the Yo-semite Valley." *San Francisco Daily Times*, 15 September 1859.

"Holiday Reception." San Francisco *Illustrated Press* 1, no. 1 (January 1873): n.p.

Holmes, Oliver Wendell. "Doings of the Sunbeam." *Atlantic Monthly* 12, no. 69 (July 1863): 1–15.

Hood, Bill, and Mary Hood. "Yosemite's First Photographers." In *Yosemite: Saga of a Century, 1864–1964*, edited by Jack Gyer. Oakhurst: Sierra Star Press, 1964.

Hood, Mary V. "Charles L. Weed, Yosemite's First Photographer." *Yosemite Nature Notes* 38, no. 6 (June 1959): 76–87.

————, and Robert Bartlett Haas. "Eadweard Muybridge's Yosemite Valley Photographs, 1867–1872." *California Historical Quarterly* 42, no. 1 (March 1963): 5–26.

Hoover, Catherine. "Pantoscope of California." *California Historical Courier* 40, no. 3 (July 1978): 3, 7.

Huth, Hans. "Yosemite: The Story of an Idea." *Sierra Club Bulletin* 33, no. 3 (March 1948): 46–78.

"Industry Rewarded." *California Mail Bag* 1, no. 4 (October/November 1871): xxix.

"John M. Watkins." Oneonta (New York) *Herald*, 1 May 1890.

Johnson, Joe William. "Early Engineering Center in California." *California Historical Quarterly* 29, no. 3 (September 1950): 192–209.

————. "Historical Photographs and the Coastal Engineer." *Shore and Beach* 29 (April 1961): 18–24.

Kearful, Jerome. "Carleton E. Watkins: Pioneer California Photographer." *Westways* 47 (May 1955): 26–27.

————. "Historic Watkins Photographs of 1861 Show Yosemite as It Was." *Nature Magazine* 48, no. 6 (June/July 1955): 305–308.

King, Clarence. "Shasta." *Atlantic Monthly* 28, no. 170 (December 1871): 710–720.

Kozloff, Max. "The Box in the Wilderness." *Artforum* 14, no. 2 (October 1975): 54–59.

Krainik, Cliff. "Cincinnati Panorama." *Graphic Antiquarian* 3, no. 4 (April 1974): 7–12.

Kurutz, Gary F. "California Books Illustrated with Original Photographs." *Biblio-Cal Notes* 7, no. 2 (Summer/Fall 1974): 3–16.

"La Belle Cascade." *Mining and Scientific Press*, 17 August 1878.

"Letter from Yosemite." *Mariposa Gazette*, 10 August 1878.

"Library Gains Rare Collection of Carleton Watkins Photographs." *California Historical Courier* 27 (November 1975): 7.

Lifson, Ben. "Notes for an Historical Fantasy." *Village Voice*, 23 October 1978.

Ludlow, Fitz-Hugh. "Seven Weeks in the Great Yo-Semite." *Atlantic Monthly* 13, no. 80 (June 1864): 739–754.

Lynes, Russell. "The Care and Feeding of White Elephants." *Architectural Digest* 39, no. 3 (March 1982): 50–54.

McCormack, Don. "Photographing the Old West." Berkeley *Independent and Gazette Sunday Magazine*, 6 July 1980.

McDermott, John Francis. "Gold Rush Movies." *California Historical Quarterly* 33, no. 1 (March 1954): 29–38.

McDonald, Gerald D. "Photographs of Yosemite." New York Public Library *News of the Month* 56 (July 1952): 374–375.

McIntosh, Clarence F. "The Carleton E. Watkins Photographs of the Golden Gate and Golden Feather Mining Claims." *The Diggin's* 8, no. 1 (Spring 1964): 3–21.

"The Mechanics' Fair." Sonora *Union Democrat*, 22 August 1868.

"Mechanics' Industrial Fair." *Illustrated San Francisco News*, 9 October 1869.

"Mechanics' Industrial Fair." *Mining and Scientific Press*, 17 September 1864.

"The Mendocino Coast in Pictures." *Bancroftiana* 15 (November 1956): 8.

"Mendocino Memories: 1860 Cameraman." Oakland *Tribune*, 3 December 1956.

Monson, Frederick I. "Photographing Under Difficulties." *Camera Craft* 1 (May 1900): 9–13.

Moore, Edwin R. *In Old Oneonta*. Yearbooks, vols. 1–6. Oneonta, New York: Upper Susquehanna Historical Society, 1962–1970.

Morton, H. J. "Photography in the Fields." *Philadelphia Photographer* 1, no. 5 (May 1864): 65–67.

————. "Yosemite Valley." *Philadelphia Photographer* 3, no. 36 (December 1866): 376–379.

"Mr. Vance's California Views." *Photographic Art-Journal* 2, no. 4 (October 1851): 252–253.

Mullens, James. "Landscape Photography." *Philadelphia Photographer* 10, no. 117 (September 1873): 466.

Murray, Joan. "Carleton Watkins: New Discoveries." *Art Week* 11, no. 8 (1 March 1980): 13.

————. "Early Yosemite and Mission Views." *Art Week* 4, no. 40 (24 November 1973): 11.

————. "The Watkins Albums." *Art Week* 10, no. 34 (20 October 1979): 1–2.

Newhall, Beaumont. "Documenting the Photo Document." *Image* 14, no. 3 (June 1971): 4–5.

"Northridge Man Gives Rare Photo Collection to UCLA." Van Nuys *News*, 25 November 1954.

"Nugget of Crystallized Gold." *Mining and Scientific Press*, 3 May 1873.

"On the Origin of Yo-Semite Valley." *Mining and Scientific Press*, 9 November 1867.

Palmquist, Peter E. "Alfred A. Hart and the Illustrated Traveler's Map of the Central Pacific Railroad." *Stereo World* 6, no. 6 (January/February 1980): 14–18.

————. "The California Indian in Three-Dimensional Photography." *Journal of California and Great Basin Anthropology* 1, no. 1 (Summer 1979): 89–116.

————. "California's Peripatetic Photographer, Charles Leander Weed." *California History* 58, no. 3 (Fall 1979): 194–219.

————. "Carleton E. Watkins at Work (A Pictorial Inventory of Equipment and Landscape Technique Used by Watkins in the American West, 1854–1900)." *History of Photography* 6, no. 4 (October 1982): 291–325.

————. "Carleton E. Watkins's Oldest Surviving Landscape Photograph." *History of Photography* 5, no. 3 (July 1981): 223–224.

————. "The Daguerreotype in San Francisco." *History of Photography* 4, no. 3 (July 1980): 207–238.

————. "Imagemakers of the Modoc War: Louis Heller and Eadweard Muybridge." *Journal of California Anthropology* 4, no. 2 (Winter 1977): 206–241.

————. "Robert Vance: Pioneer in Western Landscape Photography." *American West* 18, no. 5 (September/October 1981): 22–27.

————. "Taber Reprints of Watkins Mammoth Plates." *Photographic Collector* 3, no. 2 (Summer 1982): 12–20.

————. "Yosemite's First Stereo Photographer—Charles Leander Weed." *Stereo World* 6, no. 4 (September/October 1979): 4–11.

————. "Watkins—The Photographer as Publisher." *California History* 57, no. 3 (Fall 1978): 252–257.

————. "What Price Success? The Life and Photography of Carleton E. Watkins." *American West* 17, no. 4 (July/August 1980): 14–29.

"Panorama of Yosemite." *Mariposa Democrat*, 29 April 1857.

"Photographer Watkins." Oakland *Tribune*, 25 April 1948.

"Photographic Mining Views." *Mining and Scientific Press*, 4 November 1871.

"Photography in California." *Philadelphia Photographer* 12 (1875): 292–293. Photocopy held by Peter Palmquist.

"Photography in California." *Photographic News* 11 (October 1867): 488.

Polley, E. N. "Pristine Yosemite, Lonely Mission Sites Subjects of Focus Gallery Photographs." Vallejo *Times-Herald*, 11 November 1973.

Ramella, Rich. "The Triumphs and the Tragedy of a Pioneer Local Photographer." Berkeley *Gazette*, 9 November 1973.

Reilly, John James. "Outdoor Work on the Pacific Coast." *Philadelphia Photographer* 11, no. 127 (July 1874): 211–212.

Rieman, George. "[Letter]." *Philadelphia Photographer* 13, no. 146 (February 1876): 46.

Roper, Laura Wood. "The Yosemite Valley and the Mariposa Big Trees: A Preliminary Report (1865) by Frederick Law Olmsted." *Landscape Architecture* 43, no. 1 (October 1952): 12–25.

Rudisill, Richard. "Watkins and the Historical Record." *California History* 57, no. 3 (Fall 1978): 216–219.

"The S. F. Art Association." *San Francisco Illustrated Press* 1, no. 1 (January 1873).

Sargent, Shirley. "Picture from Yosemite's Past: Galen Clark's Photograph Album." *California Historical Quarterly* 45, no. 1 (March 1966): 31–40.

Savage, Charles Roscoe. "A Photographic Tour of Nearly 9000 Miles." *Philadelphia Photographer* 4, no. 45 (September 1867): 287–289, 313–316.

Sexton, Nanette. "Watkins' Style and Technique in the Early Photographs." *California History* 57, no. 3 (Fall 1978): 242–251.

Simpson, G. Wharton. "Photography at the International Exhibition at Paris." *Philadelphia Photographer* 4, no. 43 (July 1867): 201–204.

"A Splendid Set of Views." Portland *Morning Oregonian*, 7 May 1868.

"Stagecoach Days in S. L. O." San Luis Obispo County *Telegram-Tribune*, 8 May 1956.

Thornton, Gene. "Photography View: Spectacular Bidding Defeats the Met." *The New York Times*, 27 May 1979.

Time-Life Books, ed. "Carleton Eugene Watkins," in *Life Library of*

Photography: Great Photographers. New York: Time-Life Books, 1971.

Turrill, Charles B. "An Early California Photographer: C. E. Watkins." *News Notes of California Libraries* 13, no. 1 (January 1918): 29–37.

United States. Coast and Geodetic Survey. "Report of the Measurement of the Yolo Base [Line], Yolo County, Cal.," in *Report of the U.S. Coast and Geodetic Survey . . . Year Ending with June, 1882.* Washington, D.C.: U.S. Government Printing Office, 1882.

"The Valley of the Grisly [*sic*] Bear." London *Art-Journal* 9 (1870): 252.

Van Haaften, Julia. "Original Sun Pictures: A Check List of the New York Public Library's Holdings of Early Works Illustrated with Photographs, 1844–1900." *Bulletin of the New York Public Library* 80, no. 3 (Spring 1977): 355–415.

"Visit from an Artist." Portland *Morning Oregonian*, 15 July 1867.

Vogel, Hermann. "German Correspondence, October 1, 1867." *Philadelphia Photographer* 4, no. 47 (November 1867): 360–363.

_____. "Medals Awarded at the Vienna Exhibition." *Philadelphia Photographer* 10, no. 118 (October 1873): 487–488.

_____. "Paris Correspondence, April 28, 1867." *Philadelphia Photographer* 4, no. 42 (June 1867): 172–174.

"Waiting to Take a Picture." Portland *Morning Oregonian*, 20 July 1867.

Waldsmith, John. "The Cleveland Convention of 1870." *Stereo World* 5, no. 1 (March/April 1978): 4–5.

"Watkins' Stereos." *Philadelphia Photographer* 11, no. 123 (March 1874): 96.

"Watkins' Yosemite Art Gallery." San Francisco *Alta California*, 13 April 1872.

Weinstein, Robert A. "North from Panama, West to the Orient: The Pacific Steamship Company as Photographed by Carleton E. Watkins." *California History* 57, no. 1 (Spring 1978): 46–57.

Wilson, Edward L., ed. "Photography at the New Orleans Exhibition." *Philadelphia Photographer* 22, no. 254 (February 1885): 33–35; no. 256 (April 1885): 97–101; no. 257 (May 1885): 129–133; no. 258 (June 1885): 161–172; no. 259 (July 1885): 216–221; no. 261 (September 1885): 280–286.

_____. "Views in the Yosemite Valley." *Philadelphia Photographer* 3, no. 28 (April 1866): 106–107.

Wollenberg, Charles. "Pictorial Resources: Carleton E. Watkins Photographs." *California Historical Quarterly* 53, no. 1 (Spring 1974): 83–86.

"The Yo-hem-i-ty [*sic*] Valley and Falls." *Country Gentleman*, 8 October 1856.

Ziebarth, Marilyn. "After 1875: Watkins' Mature Years." *California History* 57, no. 3 (Fall 1978): 258–263.

Zimmerman, C. A. "On Landscape Photography." *Philadelphia Photographer* 10, no. 117 (September 1873): 447–449.

SET INTO FOURNIER TYPE BY G&S TYPESETTERS

AND PRINTED BY HART GRAPHICS, BOTH OF AUSTIN, TEXAS.

DESIGNED IN NEW YORK CITY BY THOMAS WHITRIDGE OF INK, INC.